TH. NAST

HIS PERIOD AND HIS PICTURES

Th: Nast.

TH. NAST

HIS PERIOD AND HIS PICTURES

BY

ALBERT BIGELOW PAINE

A facsimile of the 1904 edition

The Pyne Press
Princeton

Library of Congress Catalog Card Number 74-80488

SBN 87861-079-0

Printed in the United States of America

This Pyne Press edition is a
republication, unabridged and unaltered,
of original material published by
The Macmillan Company, New York
and London, 1904.

TO THE MEMORY OF

FLETCHER HARPER

WHOSE UNFAILING HONESTY AND
UNFALTERING COURAGE MADE POS-
SIBLE THE GREATEST TRIUMPHS OF

THOMAS NAST

CONTENTS

PART ONE: THE ROVER

PART TWO: THE PATRIOT

PART THREE: THE REFORMER

PART FOUR: THE DEFENDER

PART SIX: THE CONSUL

ILLUSTRATIONS

A full Index of Illustrations will be found at the end of this volume

The Illustrations in this volume, when not otherwise stated, are reproduced from the pages of Harper's Weekly, by permission of the publishers, to whom all acknowledgments are due.

TH. NAST

HIS PERIOD AND HIS PICTURES

Th: Nast.

HIS PERIOD AND HIS PICTURES

A WORD OF INTRODUCTION

It is nearly forty years ago that a boy of five, whose home was a square, white farm-house on one of the big bleak prairies of the middle West, was lying flat on the rag carpet before the open wood-fire, poring over a wonderful double-page picture in Harper's Weekly.

It was really a combination of several pictures, each of which depicted some important scene in the daily life of the merry old fellow whose home is at the North Pole, and who toils busily all the year through that good children everywhere may be made happy on Christmas Day. The little boy had the firmest faith in Santa Claus, and this picture, coming as it did just before the holidays, was of immense value.

There was the interior of Santa Claus's shop, with the old chap busily at work and about him a number of finished toys. The little boy had tried to imagine this scene. Now here it was, all truly set down, and he found a deep and lingering joy in wondering which of the articles might be intended for him. Then he looked at the other pictures—the one where Santa Claus is starting off with his loaded sleigh—another where he is filling

the stockings, and still another—perhaps the most valuable of all—Santa Claus leaning over a high battlement of his icy home, sweeping the world below with a long spy-glass.

The boy knew about spy-glasses, and he understood now how it was that Santa Claus could tell the good children from the bad. Just opposite, there was a companion picture which showed Santa Claus looking through a huge book wherein the names of all the children are kept, with good and bad marks carefully set down. The boy could not read, but his mother had assured him that his name did not appear. Perhaps it would be on the next leaf. He tried to lift the edge of the pictured page with a pin. It was no use. He turned the paper over and looked through from the other side. Then once more he spread the paper before the fire that shone bright in the dim winter afternoon, and forgot everything else in the world in them. Indeed, he scarcely realized that they were merely pictures. The Santa Claus they presented henceforth became his Santa Claus through all the coming years.

One remains a little boy such a brief time. Santa Claus becomes careless as we grow older, and the picture, though never forgotten, was laid away. The boy became interested in other things, even in politics, or at least in such politics as caused him to hurrah wildly for Grant and Colfax when a schoolmate sent up a shout for Seymour and Blair. Also, he found new pleasure in the pages of Harper's Weekly, for there were humorous pictures of these and other public men which his father helped him to identify when they looked through the paper together.

And by and by some of the pictured men were evil-doers who needed punishment and quite often were getting it. The boy and his father laughed together at the mishaps of these wicked ones, and the boy learned that the caricature pictures which he could tell as far as he could see them, and recognize the different faces, were the work of a wonderful artist—the great cartoonist,

THE DOUBLE PAGE CHRISTMAS PICTURE OF 1866

Thomas Nast. He still remembered the Santa Claus picture, long before laid away, but he never connected it with these— never in any way associated it with them for thirty-five years.

At the Players' Club of New York, in the corner next the dining-room, the old cartoonist, whose years were so nearly ended, and the writer, who had once been a boy on the prairies of the middle West, sat discussing an unwritten book whose purpose was to tell the story of Thomas Nast.

" I was brought up on your pictures," the writer said. " I would undertake the work gladly, if you think I am qualified."

We considered the possible qualifications of one whose early point of view and politics had been shaped by those pictures. Presently Nast said, thoughtfully:

" If we do this thing, I should like to put in some of my Santa Claus pictures."

" Your Santa Claus pictures! I didn't know—" And then, all at once, I did know, for the years had rolled backward and there rose before me the old farm-house, with its rag carpet, its open fire and the boy lying flat before it, poring over the pages of Harper's Weekly. " Do you mean to say that away back in the sixties you did a double-page in a Christmas Harper, entitled " Santa Claus and His Works? " I asked, " and that it showed Santa Claus in his shop, and on the top of his ice-palace with a spy-glass? "

" Why, yes," he said. " Of course I did! "

Then I told him what that picture had meant to me. " And I will do the book." I said, " if you will let me. It shall be the story of your work by one who was brought up on it, and that the reader may better understand, I will introduce it with that farm boy poring over the Christmas Harper, before the open fire."

ALBERT BIGELOW PAINE.

PART ONE: THE ROVER

CHAPTER I

A LITTLE LAD OF LANDAU

In Germany it is the stork that brings the babies, and it was on the 27th of September, in the year 1840, that the stork visited the military barracks of Landau, a little fortified town near Alsace, and left in the Nast household a very small baby boy, who was called Thomas. The family was not a large one. There was only an older sister, and the mother and father—the latter a gentle-hearted, outspoken German musician, who played the trombone in the Ninth Regiment Bavarian Band.

It was not often that babies came to the Landau barracks. The soldiers found many excuses for seeing this one, and as the little fellow grew older and gained daily in size and wisdom, they made him their pet. Presently, in the field back of the barracks he was playing " soldier "—a game in which he was always " captain," and the Commandant confided to a proud mother that little Thomas, with that head of his, certainly would become nothing short of a general officer. Prophecy could go no further in Landau. Even the most gracious of commandants could not foresee that the " little captain," with that head of his, was one day to attain a rank which generals would regard with awe—to which presidents and kings might yield their homage.

He was to suffer a defeat, however, in this early time. Among the sheep that used to feed behind the barracks was a pet lamb

that had sprouted a pair of horns—also, a desire to use them. Little Thomas had nurtured and fostered this lamb as his own. Now, all at once, it became ungrateful, and charged and pursued its benefactor, much to the entertainment of his soldier friends. It was an early lesson in misplaced confidence.

He acquired other impressions, some of which were to linger and perhaps color the coming years. On Sunday afternoons he used to walk with his mother and sister past a triangle called the " Napoleon Hat " to a little graveyard where his two brothers lay buried. Box grew about these graves, and its faint odor was ever afterward associated with the scene.

His early religious impressions were confusing. There were both Protestants and Catholics in Landau, and once at a Catholic church he saw two little girls hustled out rather roughly for repeating some Protestant prayers. The incident disturbed him deeply. He resented the treatment of these little girls. It may have marked the beginning of a bitterness which long after was to mature in those relentless attacks upon bigotry which won for him the detestation, if not the fear, of Pope and priest.

But on Christmas Eve, to Protestant and Catholic alike, came the German Santa Claus, Pelze-Nicol, leading a child dressed as the Christkind, and distributing toys and cakes, or switches, according as the parents made report. It was this Pelze-Nicol— a fat, fur-clad, bearded old fellow, at whose hands he doubtless received many benefits—that the boy in later years was to present to us as his conception of the true Santa Claus—a pictorial type which shall long endure.

With his father, when the regiment band made music for the local theatre, he attended plays, mostly of a military character and strongly French in sentiment. His favorite play was " A Daughter of the Regiment," whose dashing followers had borrowed the musicians' hats to complete their costumes.

It is but natural that the boy's earliest art impulses should

have been of a military nature. Everywhere were the soldiers, and such pictures as he saw were either portraits of the nation's heroes or scenes of war. In his own home hung prints of the King and Queen, while in the parlor of an aunt there was an engraving of Napoleon's tomb and another of " Who Goes There? " in which Napoleon finds one of his pickets asleep. It was not long until the boy's nimble fingers began to give expression to something of what he saw. He fashioned little soldiers —not with pencil or brush, but of beeswax—perhaps from his mother's work-basket—and these he pressed against the window panes. They attracted the attention of some ladies who often looked from the upper windows across the way, and the young modeller received his first reward in the form of cookies—brown cookies with holes in them—lowered to him at the end of a string.

But now came a sudden change in the affairs of the Nast household. The German revolution was brewing. Europe was in a turmoil. The elder Nast, though far from being a disturber, was a man of convictions which he took little pains to conceal. Some of his sentiments were not in accord with the existing Government. Called aside one day by the friendly Commandant, he was advised that America was really the proper place for a man so fond of free speech. He took his departure from Landau, to join a French man-o'-war. Later he enlisted on an American vessel.

The family remained for a brief time in the old place. Then, presently, they, too, made ready to go. They would sail for New York, to be joined there when the father's enlistment had expired. They left Landau by diligence for Paris in the summer of 1846, probably in June, as the child noticed fireflies about their door for the first time on the night of their departure. Now and then a firefly soared high into the zenith. They were the shells of military practice.

The journey to Paris was a rare joy to the Nast children. There was the ever-changing scenery—Strasburg with its wonderful clock—inns and villages where refreshments were to be had. Then came Paris, and some friends who took them to see the sights.

Three lasting impressions remained to the little boy from this wonderful journey. The first was the distinctly different odors of the various cities. The second was the vastness of the Nôtre Dame Cathedral. The third and best of all was the memory of some daintily dressed little Parisians, who were sailing toy boats such as he had never seen in Landau. Then came Havre, where, with a cousin, they took passage for New York in a beautiful American brig.

Their stateroom was near the captain's, and the captain's wife, who was aboard, became friendly with the little Bavarian and doctored him during a brief illness with wine and quinine. When America was almost in sight a great storm arose. The sea darkened. The vessel rolled and pitched—the cordage screamed in the gale. The little German boy saw the American captain's wife at her prayers and followed her example in his own tongue. Next morning all was clear again. The brig had been little damaged, though other vessels in sight had lost masts and rigging. By evening the sea was calm and beautiful. Coming up the Narrows, the scenery on either side made another deep and enduring impression on the lad of six, who now for the first time announced himself as glad he had come. Well he might have been, for he was entering the world which he was to conquer, in his own good time and way.

CHAPTER II

A NEW LAND AND A NEW LIFE

THE ORIGINAL OF THE TAMMANY
TIGER.
Loaned by W. C. Montanye

They took up their residence in Greenwich Street, then a neighborhood of respectable dwellings. There was a school near by, to which the little boy, who could not speak a word of English, was sent.

It was all foreign and strange to him on that first morning, and he did not know where to go. Mischievous children directed him here and there. One rogue of a boy pointed to a line that seemed to be some sort of a class, and the little German lad took his place in it. Those were the old days of rod and ruler, and this was the line marked for punishment. The sharp-faced woman principal entered a moment later to perform her duty. She could not understand German, and the little boy's fervid explanation in that tongue was of no avail. He hurried home at recess and refused to return to a school where the first lesson was applied to the patch on a little boy's trousers. His mother tried to explain that a mistake had been made. It was no use. He had tried to explain that, himself. He preferred not to risk another mistake—at least not in the same spot.

His second American experience was hardly less discouraging. It took place next morning when he was strolling down Greenwich Street, enjoying the sights of the new world. Suddenly, from a cellar directly in front of him, there leaped a rude boy wearing a fireman's hat, and with a long trumpet, upon which he blew a blast that carried terror to the heart and flight to the heels of the small Bavarian.

His mother soon removed her little family to the quiet neighborhood of William Street, near Frankfort. But the house was said to be haunted. Some former occupant was believed to have acquired the habit of walking about at night, between twelve and one o'clock, and these were not peaceful hours for a little lad who happened to be awake. Altogether he became less sure that he was glad they had come to this land of unusual things.

Yet there were compensations. Next door to the haunted William Street house was a man who made crayon sticks for artists. Often there were faulty ones, and these he gave to the little Nast boy, who took them to school—a new school, where German was a circulating medium—and drew pictures for the other pupils. One of these—a picture of an African capturing a lion—excited their admiration. Also, perhaps, their envy, for a larger boy, seizing the slate, hurried with it to the teacher. It was expected that punishment would fall on the young artist's head. Instead of which, there were laurels of praise. The little lad of Landau, who was one day to destroy evil-doers and make presidents, had won his first triumph in the New World.

His second conquest came a few days later, at the same school. A big boy—perhaps the one who had exhibited his drawing—was in the habit of imposing upon him at play-time. The little Nast boy endured this for a season. Then, one day, he suddenly turned upon his tormentor with such fury and violence that it was found necessary to rescue the big screaming bully

to save his life. The little boy was not molested again. Indeed, he became something of a hero, and decided that perhaps America was not such a bad place as he had at first thought.

He found a great joy in running to fires. In Landau he had never seen a fire, except once when the coal yard had smoked a little and the regiment had paraded with beating drums, as if the world were coming to an end. Now, there were fires almost daily. The little boy was at first terrified, then fascinated. He made a fire engine of his own and became chief of the crew. Less than a dozen blocks away the Big Six—the fire company of which big Bill Tweed was chief—had its headquarters. On the engine of the Big Six was painted a tiger's head—a front view with fierce distended jaws, reproduced from a French lithograph, a copy of which hung in an art store on the northeast corner of James and Madison Streets.* The boy Nast used to regard this tiger's head, as it appeared in the lithograph and upon the engine of the Big Six, with admiration and awe. Little could he guess then what use he would make of that sinister emblem in later days. For it was the Big Six tiger that was to go with Tweed into Tammany Hall, and it was Thomas Nast, the man and cartoonist, who was first to emblazon it as the symbol of rapacious plunder and of civic shame.

But in that long ago time, the Big Six boys with their polished engine and glaring tiger meant only excitement and joy. He pursued them when fires broke out—running and shouting with a crowd of other boys that mingled with a tangle of frightened teams and a score of yelping curs. The Big Eight, a hated rival, also had headquarters not far away, and sometimes it happened that the two companies would forget the fire to engage in a bloody conflict in the public streets. Whatever may

* The head on the engine is believed to have been actually painted from another copy of this tiger lithograph, borrowed by Tweed from the father of W. C. Montanye, in whose possession the picture still remains. (See page 9.)

be the present conditions, New York in those days was hardly a model of law and order and good government. The Macready and Forrest riot, perhaps the most remarkable event in all dramatic history—a city plunged into lawless bloodshed because of a jealousy between two actors—took place at this period, an episode which the little boy, now nine and accustomed to scenes of carnage, both witnessed and enjoyed. He also saw the burning of the old Park Theatre—on Park Row opposite the present post-office—a fine big fire from which only a wooden statue of Shakespeare survived.

And all the time he drew—anything and everything. His desk at school was full of his efforts, and the walls of the haunted house on William Street were decorated with his masterpieces. It may have been for this reason that the ghost gave up its nightly rambles.

Sometimes his love of art led him into difficulties. A poster on a dead-wall, at the corner of Houston and Eldridge Streets, attracted his attention one quiet Sunday morning, when his mother and other good people were at services. It was a picture of a beautiful full-rigged ship, and he wished to draw it. He cut it out with his knife, though not before a big policeman had slipped across the street and seized him quite suddenly from behind. But the young artist was versatile. He voiced a yell that rent the Sabbath stillness and caused the terrified policeman to drop him hastily. The captain of the district appeared on the scene, also the landlord of the haunted house, who interceded for the youthful draftsman. The incident closed with a lecture from the captain on the evil of over-enthusiasm, even in art.

But now a very important thing happened. This was nothing less than the arrival of the elder Nast, whose term of enlistment had ended. His coming had been announced by a comrade, and great excitement immediately ensued. The little

boy was despatched hastily to the corner bakery to buy an extra large pfann-kuchen for the great occasion. Returning, he was passed by a closed cab which suddenly stopped. Then a man leaped out and, seizing him, thrust him quickly inside. The little boy thought he was kidnapped, but an instant later found himself in his father's arms, with the precious big pfann-kuchen being crushed between them. Of course he was happy, but the prospect of his mother's grief at sight of the ruined cake saddened him. However, the cake did not prove a total loss. Its slight damage was quickly forgotten in the joy of treasures from afar, and in listening to the father's tales of travels in many lands. This was in 1850, when young Thomas was ten years old.

Nast senior was a skilled musician and a man to make friends. He became a member of the Philharmonic Society, and of the band at Burton's Theatre in Chambers Street. To the latter place, Nast junior often accompanied him—sitting, as he had done in the little theatre of Landau, in a special seat in the

A SCENE FROM "TWELFTH NIGHT," DRAWN ABOUT 1853-4

orchestra—storing memories and often making crude sketches
of Burton and other popular actors of that time. It was from
these sketches and memories that fifty years later he painted
the fine character portrait of Burton which hangs in the Play-
ers' Club to-day. Frequently he carried his father's big trom-
bone to the theatre, and this was a privilege, as it entitled him
to remain to the performance. Lester Wallack, Mr. and Mrs.
Boucicault, Charlotte Cushman, Placide, George Holland—these
were among his favorites of those days. At Castle Garden he
heard Jenny Lind. The boy saw and sketched them all in his
untrained way, and the influence of those early efforts and sur-
roundings was continually cropping out in the great work of
after years.

When young Thomas Nast was about thirteen years old, a
number of foreign military celebrities came to New York City.
Europe was still disturbed and their recent enterprises there
had become unpopular. Kossuth was one of those visitors, and
Garibaldi, whom, a few years later, the boy would join in his
grand march from Marsala to Naples, but who now was igno-
miniously making tallow candles on Staten Island. The young
artist had heard something of these heroes and their struggles
for freedom. With his father, he saw Kossuth in a parade, after
which he wore a Kossuth hat and drew pictures of the different
exiled noblemen. One picture of Kossuth—a copy from Glee-
son's Pictorial, with a rising sun marked "Hungary" in the
background—was praised and framed by the school-teacher and
hung by the principal's desk. This school, it may be said, was
on Chrystie Street, near Hester—a most respectable neighbor-
hood at that time. A little later, by advice of his father, he
attended a German school, though only for a brief period. He
left when required to confess, regarding his sins as too many
and too dark for the confidences of the priest's box. A brief
period at another German school followed, and a term at a

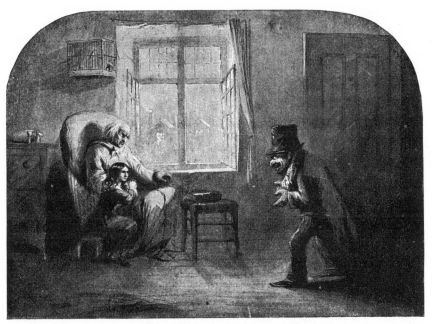

A SCENE FROM "OLD CURIOSITY SHOP" (1856)

Forty-seventh Street academy, considered then very far uptown. It was all of no avail.

"Go finish your picture, Nast," the teacher would say to him. "You will never learn to read or figure;" the picture in question being usually a file of soldiers, a pair of prize fighters, a character from "Hamlet," or perhaps something remembered from far-off Landau, such as a little girl leading a pet lamb, or old Pelze-Nicol with his pack. This was his last school.

Efforts made by his father to induce him to learn music or a trade also ended in failure. The boy was an artist. Attempts at any other education did him little good.

CHAPTER III

IN THE WAY OF ART

He attended a drawing class taught by Theodore Kaufmann, a historical painter, a graduate from a German painting academy. Kaufmann taught in his studio at 442 Broadway, and on the same floor were the studios of Pratt, Loup and Alfred Fredericks--all well-known painters of those days. Of these, Fredericks in particular became a valuable friend and adviser of the boy artist, who immediately joined in the bohemian life and customs of the old building. One day a fire broke out. Kaufmann's studio and pictures were ruined—his class abandoned. The boy's art education came to a temporary halt, though he pursued his studies at home, aided by a set of "Harding's Drawing Copies." Through the guidance of Alfred Fredericks, he entered the Academy of Design, having been admitted on a drawing from a cast—the first offered.

The Academy was then on Thirteenth Street, just west of Broadway. Young Nast was soon elected to the life class, of which Mr. Cummings was the head. Academy methods were somewhat primitive in those days, and it was mainly due to Fredericks that the young man received proper guidance. Fredericks was at the time painting a panorama of the Crimean War, and allowed his protégé to help him. Once, when the day was cold and both money and fuel were short, young Nast

painted their stove red, which was regarded as a huge joke by visitors. One of these showed his appreciation by inviting both Fredericks and his assistant to luncheon. Thus the red stove supplied genuine comfort.

At the Academy with young Nast were a number of students who have since become well known. Samuel Coleman was there, also Eugene Benson, Hennessy, Whittaker, Walter Shirlaw and others destined to make their mark. With Fredericks and his fellows he spent many spare moments in visiting the art galleries—studying, admiring and criticizing, as art pupils do to-day—have always done and always will do until the " last great picture is painted."

It was about this time that a wealthy man, named Thomas Bryan, brought to New York a collection of paintings, among which were a number of genuine old masters. The collection is now the property of the New York Historical Society, and considered of great value. Yet for some reason its genuineness was questioned at first, and its popularity waned. But to the students, and especially to young Nast, it became a mine of wealth. Nast was allowed to take his easel there and to copy some of the rare paintings. Visitors were attracted by the fat little boy's work (he was very fat and German in those days) and prophesied well for his future. Bryan himself took an interest, and eventually made him door-keeper, allowing him all he took in over a certain number of admission fees of twenty-five cents each. It is possible that Bryan might have done something further for the lad, had not the latter, all at once, created an opportunity of his own.

He gathered up a bundle of his drawings one morning, and went over to call on Frank Leslie, who had already founded the Weekly which still bears his name. The great publisher looked at the round-faced German boy of fifteen and remarked that he was pretty young—a fact already known. Then Mr.

Leslie examined the sketches and observed they were pretty good—a fact equally obvious. Presently he rose from his chair and stood looking down on the short, moon-faced lad—a scene of which Nast has left us a caricature.

" So you want to draw pictures for my paper? " he said.

The small German looked up at the great man and nodded.

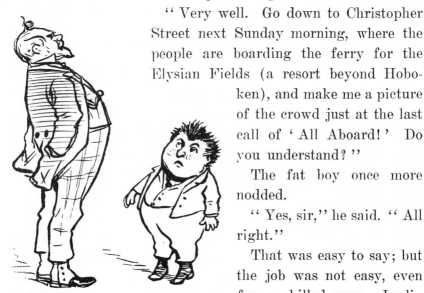

" Very well. Go down to Christopher Street next Sunday morning, where the people are boarding the ferry for the Elysian Fields (a resort beyond Hoboken), and make me a picture of the crowd just at the last call of ' All Aboard! ' Do you understand? "

The fat boy once more nodded.

" Yes, sir," he said. " All right."

That was easy to say; but the job was not easy, even for a skilled man. Leslie afterwards told James Parton that he had " no expectation of the little fellow's doing it, and gave him the job merely for the purpose of bringing home to his youthful mind the absurdity of his application."

NAST'S CARICATURE OF HIS FIRST INTERVIEW
WITH FRANK LESLIE.

Nevertheless the boy went early and worked late. Patiently, between boats, he drew the details of the scene—the approach with its heavy uprights, its cross-pieces and its hoisting chains; the huge balance weight; the swinging sign-card; the wide outlook to the river, with the hills outlined beyond. Then when the boat came, and the gates opened to let the crowd push through, he made swift mental pictures, and when all was quiet again, added to his drawing the racing boy, the barking dog and

the steadier-going men and women, whose holiday attire has become so quaint with the lapse of time. There would seem to have been some curious foreshadowing in this first assignment, for it was from this very spot that through all his later years Thomas Nast was to cross into New Jersey to reach his Morristown home.

On Monday morning he appeared once more before Mr. Leslie, who looked at the drawing and then at the young artist.

" Do that alone? " he asked.

" Yes, sir."

Leslie turned to his desk and took therefrom a half-page engraving block.

" Take this up-stairs," he said, " to Mr. Alfred Berghaus,

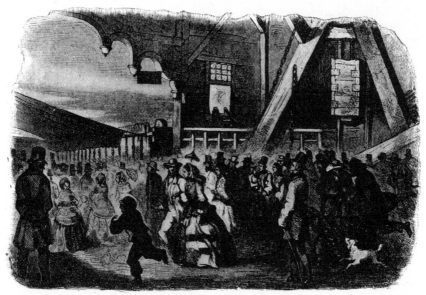

ALL ABOARD FOR THE ELYSIAN FIELDS! AT THE CHRISTOPHER STREET FERRY.
NAST'S FIRST ASSIGNMENT.

our staff artist. He will show you how to whiten it. Then redraw your picture on this block."

The boy went eagerly. Berghaus was a large, blond German with the arrogant, pompous manner of a Prussian officer.

"So Mr. Leslie send you, heh? And I was to show you how to viten? Vat does Mr. Leslie dink I am here for, heh? Well, here are de dings—I guess you can do it."

The boy took the things and went at it. Berghaus watched his rather awkward attempts. Then, out of pity, or impatience, took the materials and completed the work.

"SCENE FROM RICHELIEU" (1856)

"Now," he admonished, "make your drawing on dis block just der opposite as you have it on dot paper."

Carefully, and with great pains, the boy obeyed. When it was finished, he took the boxwood block back to Mr. Leslie, who looked at it, smiled, and said,

"What do you make where you are?"

"It differs—sometimes twenty-five cents a week—sometimes six dollars."

"Will it average four dollars?"

"Perhaps."

"Very well, I will give you four dollars a week to come and draw for Leslie's Weekly."

A great lump came into the boy's throat. He could not answer at once for joy.

The little lad of Landau had found his place in the New World.

CHAPTER IV

The Leslie office proved a great practical school to the young artist. Photography had not yet become the "handmaid of art," and on a weekly illustrated paper there was much to do. Even before the ferryboat picture was engraved a big fire broke out up-town and the new man was assigned to the job. Daily papers were not then illustrated, and fire and flood pictures were the favorite material of the weekly press. They took precedence over most other features; hence it happened that young Nast's first public appearance was made with his fire picture, instead of the "All Aboard" which had won him his place.

The Leslie publication office was at that time on Frankfort Street, between William and Nassau. It comprised a front and a rear building—the front for publishing, the rear for the presses. In the rear, also, were the editorial offices, and here, in a large room, together with Col. T. B. Thorp and Henry Watson, editors of that time, worked Alfred Berghaus, the arrogant but capable chief of the art staff; Sol Eytinge, afterward celebrated for his humorous negro drawings of the "Small Breed Family," and young "Tommy" Nast. Mr. Leslie also had a desk there which he sometimes used, perhaps when he wished to seclude himself from too persistent callers down-stairs.

The Leslie editorial office was frequented by most of the illus-

trators and writers of that period. Miss Croly, who signed herself " Jenny June," was often there. Also came Richard Henry Stoddard, then in the fulness of early manhood and power; Mortimer Thompson, whose pen-name was " Doesticks "; and all the rest of that blithe and talented crew. " Doesticks " was regularly employed on the Tribune, but did frequent assignments for Leslie's, and Eytinge or Nast, sometimes both, accompanied him.

Often in their rounds they brought up at Pfaff's beer-cellar, on Broadway near Bleecker Street—a bohemian resort, long since vanished and now become historic. Here they would find " Miles O'Reilly," George Arnold, Frank Bellew, Fitz-James O'Brien and a host of other good fellows. The boy was happy to be seen in this crowd of notables and felt that he was getting on. In turn, they doubtless found the " fat little Dutch boy " amusing. They took him to theatres and other cozy resorts and " showed him the town." It was not so big a town then, but one feels, somehow, that there was more comradeship, more characteristic personality, more of the feeling and flavor of art than we find here to-day.*

Meantime, " Little Tommy Nast " was in truth progressing.

* Among the friends made by Nast while at Leslie's was John P. Davis, one of America's leading wood-engravers, then of the Leslie employ. In a recent letter to the writer Mr. Davis refers to this early acquaintance as follows:

" With Nast especially I formed the pleasantest relationship. I had but recently married, and the little fellow—he was but a lad of seventeen—found pleasure in visiting my home a couple of evenings a week. He was seriously inclined for his years; with an outlook upon life entirely unsophisticated, a quaint humor brightening his expression of opinion or narrative of events, which was partly racial, no doubt, but wholly charming to the American sense. He took me to visit his own home at this time. The walls of his room were hung with many of Tom's drawings and the closet drawers were also filled with them. I was surprised by the boy's industry. The subjects were generally chosen from plays in vogue; the style of drawing a simulation of that of John Gilbert, the English illustrator coupled with remnants of Frederick's influence. But industry was the principle master; the only token of originality was noticeable in the crudeness with which his pencil had traced the lead of his protagonists."

He rose at four in the morning to practice drawing and labored far into the night to complete his work. He was bound to justify his employer's good opinion—to fulfil the promise of his beginning. He well-nigh gave way under the strain but it paid. Frank Leslie was likely to be peculiar in his business methods, but he appreciated industry and talent and pushed the boy along. He did not always pay salaries, but he always did furnish work, which was of vastly more importance. He invited the boy to spend Sunday with him at Long Branch, and allowed him to put in the day making sketches of the Ocean House, then owned by Warren Leland and the most fashionable resort on the coast.

At times, however, the financial situation became acute. Once, when the art department had not been paid for three weeks, a general demand was made on the treasurer, an Englishman named Angel Wood, who told them to come back after luncheon. Rejoicing in the belief that they were to be paid, the staff indulged in a rather expensive repast, and lingered over it a bit longer than usual. The item of delay was fatal. When they reached the office, Wood informed them, with averted gaze, that Mr. Leslie had just taken what money there was and gone.

" Gone! Took the money! "

" Yes, he's bought a yacht and needed the money to pay for it."

There was but one thing to do. The art department struck. Two days later, when Mr. Leslie returned from his trip, he found the easels empty, and flies crawling over the half-finished sketches. He promptly sent for the deserters. When they appeared, he made a plea, by the side of which Mark Antony's address seemed but a feeble thing. He shed tears himself and brought tears to the eyes of his hearers. They went back to work, ashamed, and with never a hint of money for a week. Then all were paid. Immediately afterward there was a meeting of Leslie's creditors, and his affairs experienced one of those periodical readjustments which were a necessary part of his

early career. Nevertheless he was a good general—persuasive in his manner, brilliant in his conceptions and methods, fearless of purpose and excellent in discipline. Once young Nast returned from an assignment with the report that there was nothing there to sketch.

" Go back," commanded Leslie. " Do just what I told you. I will be the judge of its value." The boy hurried away and did not forget this lesson in obedience.

He was receiving seven dollars a week at this time, which may have made him proud. Also he was doing important work. Single-handed, Leslie had undertaken to demolish the " swill milk " evil, then the city's bane, and Berghaus and Nast were making the sketches. It proved a fight as bitter and as fierce, though not so prolonged, as the Tweed Ring battle of later years. Leslie's life and office were threatened by owners of the diseased cows that were milked rotting in their stalls. City officials were in league with the wretches, and it was hard to get action. Leslie did not despair or flinch. He sent his men directly into the miserable barns, and each week gave more space to depicting the vile conditions. The end was a complete triumph for the paper. It brought great and deserved credit to Frank Leslie, and it gave to young Thomas Nast his first insight into corrupt city government, likewise a striking illustration of the power of the pencil in correcting evil.

From Sol Eytinge the boy received much of his technical training. Eytinge was a master of his craft, willing to expound the gospel of art, allowing his pupil to work as hard as he liked, in return. Comradeship and even intimacy existed between the two. They planned for the future together, and when in 1857 the first number of Harper's Weekly appeared, they resolved to associate themselves with the new sheet.

But in October of 1858 Nast was still on Leslie's, assigned with Thompson to report the Morrissey-Heenan prize fight,

a contest between John Morrissey, the prize-fighting politician, and John C. Heenan, the " Benicia Boy " (of Benicia, California), one of the husbands of Ada Isaacs Menken.

The battle took place on October 20th, at Long Point, Canada, a place of sand—the party on this side embarking from Buffalo in three top-heavy, unseaworthy steamers. Nast and " Doesticks " were on the " Kaloolah," of which " Doesticks " in his account says:

At 11.30 the floating coffin left the dock and steamed in a dismal manner up the lake. The crowd gave her a mournful cheer as she shoved off, and several persons on the shore, who knew the boat and had friends on board, bade them a sad farewell and weeping turned away.

John and Paddy Hughes, Mike Cudney, Tom the Boatman, Big-headed Kelly of Buffalo, Izzy Lazarus and many other celebrated and distinguished individuals, now happily dead, were aboard, and among these " Doesticks " was rather startled to see Billy Mulligan, a notorious gentleman whose criminal record the journalist had elaborated for the Tribune not long before. In earlier days Mulligan had left San Francisco by order of the Vigilance Committee, and it may be noted in passing that eventually he met his death there for a double murder.

But Mulligan was very much alive at this particular time, aboard the " Kaloolah," and " Doesticks " could think of no good way to get ashore. That the newspaper man would be pointed out to " Billy " was almost certain, and in that lawless crowd the chance of escaping the ruffian's vengeance seemed poor. " Doestick's " concern, however, was chiefly for his companion, the young artist, whom he cautioned to " make himself scarce " if he saw Mulligan coming in that direction.

Then suddenly the journalist was seized with an inspiration. With jaunty bravado he walked over to Mulligan, and holding out his hand invited the outlaw to the bar.

A SCENE FROM " GIL BLAS " (1857-8)

The plan worked perfectly. Mulligan accepted the invitation with good nature, and a little later was confiding to " Doesticks " the story of his wrongs. It seemed a narrow escape.

The Morrissey-Heenan fight was a sanguinary affair. Morrissey, being over confident of success, was nearly killed in the first round. He was in perfect condition, however, and presently recovered and lasted long enough to wear out Heenan, who, being ill, became exhausted from the very effort of pummelling Morrissey. The latter closed the contest in the eleventh round, a tottering tower of blood, but victorious.

FROM " GIL BLAS " (1857-8)

He was too far gone to speak, says " Doesticks," but he made an attempt to smile, which was a most ghastly thing to see. His

A SCENE FROM "GIL BLAS" 1857-8

eyes were nearly closed, his mouth cut, his lips and tongue swollen, his nose literally battered flat to his face. Heenan, on the contrary, scarcely showed a mark, having been beaten through sheer weariness.

" Doesticks " and Nast, both ardent supporters of the " Benicia Boy," returned to New York disgusted with the affair

and with pugilism in general. Yet it was the pictorial results of the encounter that were to win for Nast the more important assignment — the great Heenan-Sayers battle, in England—the following year.

For the present he contented himself with regular assignments, completing at odd times some rather ambitious sepia sketches—illustrations for " Gil Blas " begun the

FROM "GIL BLAS" 1857-8

year before. These he exhibited in the National Academy of
Design, then on Broadway, between Prince and Spring Streets,
over a church.

The young illustrator's art influences at this time were likely
to be humorous in their tendency. Eytinge was humorous, at
his best, while the three great English Johns—Leech, Gilbert
and Tenniel—were the boy's avowed and exalted models. A
cartoon—the British Lion and the Bengal Tiger—one of Ten-
niel's earliest and best, fired him with a desire for like achieve-
ment. Yet his daily work was purely journalistic—serious and
prosaic enough—important only in the added skill it gave to
his pencil and the literal knowledge it brought to him.

Eytinge meanwhile began to do occasional work for Har-
per's. Nast helped him on the drawings, and the Harper ambi-
tion grew. Then at last, Eytinge went to the paper in body and
spirit, and the boy felt left behind. In any event he could not
remain at Leslie's, for a financial stress was upon the land, and
the Leslie salaries had been reduced. This was now important,
as his father, the gentle-souled musician, had recently died, and
the lad was obliged to contribute to the family's support.

He gave up, one day, and walked out of the old place where,
more than three years before, he made his beginning. They
had been three priceless years, crowded with vital experience
and valuable instruction. In return, he had rendered faithful
service, and now, still a boy, being but little past eighteen, he
felt ready to face the world.

Naturally he drifted to Eytinge, who worked in a studio of
his own and allowed Nast to assist on his drawings, with some
financial result. Yet it was due to Alfred Fredericks, whose
friendship for the " litte fat Dutch boy " never wavered,
that his first entry into the alluring Harper pages was made.
Fredericks was himself on the Harper staff, and recognizing
the creative ability of his former pupil, one day said,

THE NEW YORK METROPOLITAN POLICE.
A PICTORIAL ANALYSIS OF THE REPORT TO THE LEGISLATURE.

. These gentlemen, finding the garroting business on the decline, resolve to become guardians of law and order, and enter the Metropolitan Police.

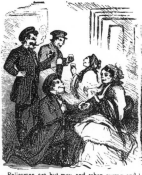

Policemen are but men, and when young and fascinating women happen to get into the police-stations, who can blame them if they are civil and gallant?

As to poor devils, houseless wretches, with no good looks, and steeped in poverty and misery, can a high-bred policeman be expected to cringe to such as these? No,. no; let them eat the bread of sorrow.

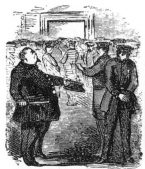

The powers that be ask no favor, but when they want new clothes a friendly captain goes round with the hat, and as for the patrolman who declines to put in a quarter, he had better emigrate to California by the next steamer.

The consequence of which is, that the poor patrolman is unable to procure the food which his sick wife requires, and his children go without stockings and without new frocks.

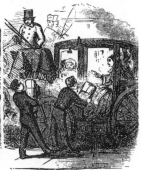

The police service continues, however, to be admirably efficient, and quite a number of hack-carriages are actively employed on pressing police duty, as above depicted.

SOME OF THE "POLICE SCANDAL" PICTURES
(From Nast's first contribution to Harper's Weekly, March 19, 1859)

"Why don't you make us a page of 'Police Scandal'?"

Police scandal, a perennial development in New York, was then, as ever, a subject of unfailing interest. Nast prepared the page and prompt acceptance followed. Published in March, 1859, it was his first appearance in the great weekly where he was to make his fame. It seems fitting that it should have been a protest against civic abuse.

CHAPTER V

LOVE AND A LONG JOURNEY

More than two years were to elapse before any regular connection with Harper's Weekly began. Young Nast was not idle. Encouraged by the success of the police sketches, he assailed the gambling houses. With a detective he made the rounds, and a paper called the Sunday Courier published his work. He also contributed quite frequently to the Comic Monthly and to Yankee Notions—the illustrated humorous papers of that day.

But now something wholly unexpected came into the young man's life. He fell in love. At 745 Broadway, in the old residence later occupied by Charles Scribner and Sons, there dwelt in 1859 the " jolly Edwards family "—a household wherein a lack of wealth was more than offset by an abundance of merry entertainment and good will. James Parton was a cousin of this family, and the home of the talented Edwards girls and their brilliant mother was a favorite meeting place for many of the gifted ones of that time. Parton brought his friends, and his friends in turn brought others. Books, painting, theatricals and even politics were discussed in a lively and exhaustive manner by the members of that clever, fun-loving circle, which included " Doesticks," Thomas Butler Gunn—a descendant of Samuel Butler of " Hudibras " fame—J. G. Haney, publisher

THOMAS NAST IN 1859

of the Comic Monthly, and many others, now dead and almost forgotten. They were all young then and many were the festivities they planned and carried out together. Each year a grand theatrical performance was given at the Théâtre des Edwards (sometimes spelled "Edouards" on the printed announcements), and these

entertainments w e r e really very wonderful affairs, with plays, poems and scenery prepared for each occasion, and with programmes very pretentious indeed.

It was during the early summer of 1859 that publisher Haney one evening introduced his young contributor, Tommy Nast, to this blithesome crew. They promptly dubbed him

MISS SARAH EDWARDS
(From a sketch by Nast, 1859)

CARICATURE OF THE ARTIST OF THE PIC-
NIC BOOK, BY HIMSELF

"Roly-poly" — a title sup-
posed to conform to his
physical characteristics — and
set him to work in their
preparations for a famous
Fourth of July picnic, which
took place near Nyack on
the Hudson, and was sub-
sequently celebrated in a poem
by Edward Welles, with pic-
tures by

"The young artist friend who
　　along with us came,
And is rushing along on the
　　turnpikes of fame."

"THE COMPANY" AND "THE FIRST EX-
CURSION"
(From the Picnic Book)

The poem as preserved is in
the form of a little sketch-book,
wherein the written lines fall
exactly beneath the proper
illustrations, showing that ar-
tist and amanuensis must have
worked side by side—perhaps,
at times, even hand in hand—
for the amanuensis was no
other than one of those fas-
cinating Edwards girls, Sarah,
with whom the young artist
had immediately fallen in
love.

Their courtship must have
run very smoothly that pleas-
ant summer of 1859, and on the

Christmas programme of the Théâtre des Edwards of that year we find the name of one " Thommaso " Nast set down as " Scenic Artist in Chief." Farther down appears a certain " Signor Nastonetti " as " Bibbobobo-bubble, a valet and barber," in the pièce de résistance of the evening, while in the Christmas poem he is appreciatively referred to as

" that young artist of high and rare promise
 Whose surname is Nast and whose prænomen Thomas."

I have bothered my head for a rhyme on the name
Of the young artist friend who along with us came

(And who's rushing along on the turnpike of Fame)

" THE POET AND THE ARTIST "
(From the Picnic Book)

Oh if I could flourish the pen of a Thackeray
I think I'd immortalize somehow Nyack or a
Spot which was near it selected

As the site of the jolliest picnic I ere knew

" THACKERAY " AND " THE PICNIC "
(From the Picnic Book)

It is recorded that Tommy Nast had a most infectious laugh in those days, and a rich musical voice, and that on this evening he gave an impromptu imitation of a popular and very fat Italian opera favorite, Amodio, which " brought down the house," and doubtless enshrined him still more deeply in Miss Edwards's affections.

But the time of matrimony was not yet. In November, another weekly, called the New

York Illustrated News, had been started, and both Eytinge and Nast were members of its staff. Nast had been sent out on many important assignments, including the funeral of John Brown on December 8th, at North Elba, New York, where one of the pall-bearers was Wendell Phillips, who, on the same evening, at Burlington, Vermont, made a speech which stirred the young artist to his depths. This was followed by " Backgrounds of Civilization "—a series illustrating the vice and misery of New York tenements—and by other leading features of the new sheet. The young artist felt that he was really beginning to " rush along the turnpike," especially as he was receiving the comfortable salary—considered really magnificent in those days—of forty dollars a week.

Perhaps, in spite of his tender years, he now considered himself equal to the responsibilities of a household. Many a boy of nineteen with less salary and fewer prospects has assumed family cares without a qualm. But just at this point there was presented an opportunity which could not be overlooked, even for matrimony. The Heenan-Sayers fight—an event of international interest, one that overshadowed even the bitter politics of that time—was to be " pulled off " in England in 1860. It had been arranged by George Wilkes, editor of the Spirit of the Times, and the News offered Tommy Nast the assignment as " our special artist " faithfully to picture the great battle.

He sailed February 15, 1860, with two most important contracts for contributions—one with the News, the other with Miss Edwards. He kept both, faithfully. Every steamer brought letters and pictures to his paper (some of the letters were published) and, as well, to the lady of his choice. He arrived safely in London and put up at the Round Table Inn, a typical English tavern, frequented by most of the sports. Here he prepared a pictorial record of his stormy voyage on the " City of Manchester," a souvenir still carefully preserved.

PICTORIAL SOUVENIR OF THE VOYAGE TO EUROPE, 1860
(From the original sketches)

A PAGE FROM NAST'S LONDON SKETCH-BOOK

CHAPTER VI

THE HEENAN-SAYERS FIGHT

Concerning the Heenan-Sayers episode, it may be said here
that never in the history of nations has there been a sporting
event that even approached it in public importance. America
and England were not on the friendliest of terms in those days,
just prior to the Civil War, and this was to be a grand test of
physical supremacy.

Notwithstanding his defeat by Morrissey, the " Benicia Boy "
was regarded as America's foremost pugilist, while Tom Sayers
wore the belt of England. Their names were upon every lip.
Prince, poet, pauper and politician alike could talk and think
only of the coming event. Two great nations had become mere
bottle holders, as it were, for their pugilistic favorites. Even
the staid London Times had articles and editorials on the
approaching conflict, and most other papers on both sides of the
water gave up pages, double pages and even entire numbers to

pictures and accounts of the champions, their trainers, their training quarters and the smallest details of their daily life. In justification, these journals attempted to reconcile pugilistic with spiritual development in editorials which have acquired humor with age.

" Our special artist " of the News soon met both Sayers and Heenan—the latter at his training quarters, then at Harnham, Wiltshire, near Salisbury. Heenan promptly characterized him as " The Little Dragsman "—a play on the word draughtsman, and something very nearly approaching friendship sprang up between the two. This was most fortunate for Nast, for though the News had made a flaming announcement of his departure,

SINGING HEENAN-SAYERS SONGS
(From Nast's London Sketch-book)

and boasted weekly of " our special artist " in the field, devoting almost entire issues to his pictures—pictures in which " our special artist " usually appeared prominently, as was the custom of those days—they failed to send " our special artist " his remittances, and with his own means exhausted, he was presently in financial straits. It

THE RECEPTION OF OUR SPECIAL ARTIST, THOMAS NAST, ESQ., BY JOHN C. HEENAN,
THE BENICIA BOY, AT THE HOUSE OF THE LATTER IN HARNHAM, WILTSHIRE

A gentleman from New York J. C. Heenan Heenan's trainer The cook
 Heenan's trainer Thos. Nast Reporter of N. Y. Clipper

(Reproduced from a cut in the New York Illustrated News)

was Heenan who came to the rescue, and entertained the " little
dragsman " as his guest at his various lodging houses, for while
Sayers was allowed to train in peace, the upholders of British
sporting supremacy made life most uncomfortable for the Ameri-
can pugilist, and officers dogged him from place to place to pre-
vent his acquiring proper training.

" They talk about British ' fair play,' " wrote Nast, " but
I fail to see much of it here. Sayers is at Newmarket, and left
alone. Poor Heenan is hounded constantly, and has a hard time
to train at all."

Sometimes the " little dragsman " himself took a turn at
training, and managed to hold his own with the " Benicia Boy "
in long walks about Harnham, Bath, Winchester, Portsea,
North and South Wallop, until finally they were left undis-

turbed. In Derbyshire, Heenan had been arrested, but crowds, who wanted to see the fight, whooped and called for his release.

The battle finally came off at Aldershot, on April 17, 1860. Men of every degree were at the ringside. Charles Dickens had money laid on the outcome. Even Thackeray is said to have been among the spectators, though this he subsequently denied. Business of every sort was suspended. Parliament adjourned for the occasion.

Lord Palmerston, the Queen's Prime Minister, deplored the public importance of a sporting event of so mean an order.

" Nevertheless," thoughtfully continued his lordship, " if the affair must come off, I hope Sayers will win."

On the morning of the event London forgot business to join in a general holiday. From the railroad station to the ringside there was a wild rush over hedge and marsh. Noblemen, shopmen and professional " sports " raced and scrambled over one another in their mad haste to reach the scene of conflict.

THE RECEPTION OF OUR SPECIAL ARTIST, MR. THOMAS NAST, BY THOMAS SAYERS,
THE ENGLISH CHAMPION, AT HIS RESIDENCE, NEWMARKET

Mr. Bryant, correspondent of the N. Y. Clipper Col. Wilkes, editor of Wilkes' **Spirit of the Times**
 Mr. Th. Nast Mr. Thomas Sayers
(Reproduced from the New York Illustrated News)

VIEW OF THE FARM-HOUSE OF JACOB POCOCK, NEAR BATH, ENGLAND, THE SECOND
ON ACCOUNT OF A COMPLAINT BEING LODGED
From a sketch taken on the spot
(Reproduced from the New

English papers had freely condemned American rowdyism, such as had been shown at the Morrissey-Heenan contest, but nothing in America ever outdid the rowdyism displayed on this occasion. The fight lasted forty-two rounds, and the fair play was thoroughly in keeping with those tactics which had made it hard for the American champion to train.

From beginning to end it was Heenan's fight. Sayers was knocked down so continuously that one only wonders at his ability to stand punishment. His friends and backers repeatedly endeavored to take a hand, and called on the police to interfere. More than once his seconds got in Heenan's way and received well-deserved punishment. At last it became simply an effort on the part of Sayers to keep alive until the police should come to his rescue. This they did, at last, in the forty-second round, when Sayers's friends rushed in and Heenan promptly and properly cleaned up the whole ring.

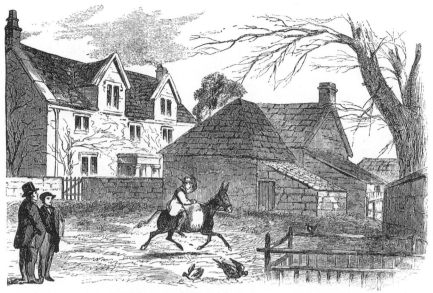

TRAINING PLACE OF THE "BENICIA BOY," WHICH HE WAS AGAIN OBLIGED TO LEAVE
AGAINST HIM BEFORE THE MAGISTRATES
by our artist, Thomas Nast, Esq.
York Illustrated News)

" It is too bad," said the police, " that two such good men
should continue to ' punish each other,' " and the " Benicia
Boy " was dragged ·from the mêlée and started for the train
amid an excitement that was well-nigh a general riot. As he
emerged from the ugly, snarling crowd, he saw Nast.

" Hello, Dragsman," he said, " wasn't it pretty? "

The English sporting public decided that it could not sur-
render the belt, but awarded one to each of the champions in
appreciation of the great " drawn battle," and permitted them
to give exhibitions together, which on the whole were doubtless
more profitable than the fight.

The News made a vast display of the pictorial report of
" our special artist." It devoted an entire issue to the great
battle, with portraits of all concerned, including a large one of
Nast himself, and another of A. V. S. Anthony, the engraver,
who had hurried across with the blocks, engraving on ship-

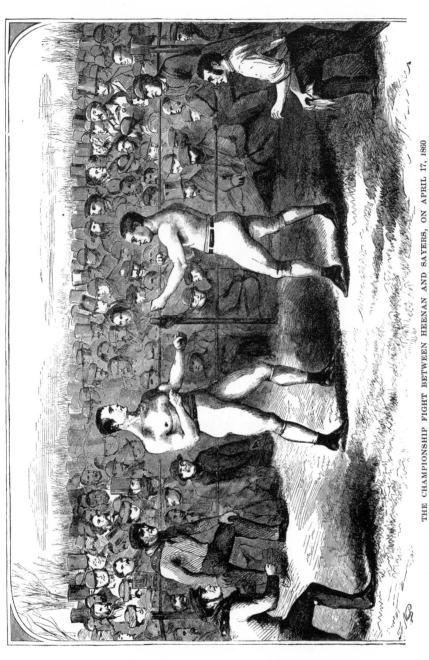

THE CHAMPIONSHIP FIGHT BETWEEN HEENAN AND SAYERS, ON APRIL 17, 1860

Jack Macdonald Billy Mulligan Joseph Cusick The "Benicia Boy" Thomas Sayers Morrissey Jemmy Welsh Harry Brunton

From a sketch by our artist, Thomas Nast, Esq. Engraved by A. V. S. Anthony, Esq., on board the "Vanderbilt," on her return passage.

(Reproduced from double-page cut in the New York Illustrated News)

board as he came. In extenuation they announced that they had no choice in the matter. Pugilism had assumed the first place in public importance, not only in America, but " in the whole civilized world. . . . We must not only be up to the mark," they said, " but put all competition under our feet by the superiority of our record." Leslie's efforts in the same direction they denounced in no feeble terms. Yet Leslie, with his usual enterprise, had printed a vast " extra " in London, and this, with a four-page " authentic " picture (also supposed to have been prepared in London, but really in New York), was

REPORTER OF THE LON-
DON SPORTING LIFE
(From pen sketch)

ready to sell when the steamer touched the dock. The News shrieked " Fraud! " at his achievement and displayed flaring evidences of its own triumph and prosperity.

Still it did not remit, and " our special artist " was presently wholly without means. Doubtless he was greatly sustained during this trying period by those delicate missives which came by every steamer; but such notes, however welcome, are not negotiable, and there are certain material comforts which mere sentiment cannot supply.

And now, all at once, there came news of the invasion of Italy by Garibaldi, the Italian " Liberator." In spite of homesickness and the girl beyond the sea, the young artist who had been born in the barracks of Landau felt all the old love of the military revive within him, and with it an eagerness to join the legions of the red shirt, whereby he might draw pictures of battle on the field itself.

There was an inviting market for his work, for besides the paper in New York, in which he still had hope, the London News was willing to use his sketches, though he did not feel justified in asking them for expense money. He was beginning

to despair, when he met Heenan, to whom he confessed his difficulties.

" Why," said Heenan, " we'll fix that. I've no money, but I'll get an advance from the fellow that's going to have Sayers and me in a public exhibition."

He did, in fact, produce twenty pounds that same afternoon. Nast gave him in exchange an order on the New York News for one hundred dollars, and a second for a like amount on his mother, in case the one on the News should not be paid. Heenan tore up the order on Nast's mother.

" I'll make them pay *me*," he said, and he did. When asked later how he accomplished it—for the News was in difficulties—he laughed. " I told them I'd punch their d——d Dutch heads off," he explained, " if they didn't pay," and Nast wished he had given Heenan his full account for collection.

THE TROPHIES FOR WHICH HEENAN AND
SAYERS FOUGHT
(From pencil sketch)

CHAPTER VII

No figure in all the world's warfare can be more picturesque or noble than that of Giuseppe Garibaldi, a pàtriot whose religion and whose motto were combined in the one word, "Liberty." Brave to the point of rashness, simple-hearted, unselfish and pure in spirit, he may be counted the military Sir Galahad of modern times, forever seeking the golden grail of Freedom.

The name of Garibaldi was literally one to conjure with. At sound of it, armies equipped and eager for war sprang up as if by magic. In youth, exiled from his native land for insurrection, he had become the foremost hero of South America, where, against fearful odds, he had battled on, penniless, half-fed, half-clothed; captured, imprisoned and tortured; wounded again and again, yet never despairing and never sheathing his sword. Triumphant, and a world's hero, he had returned to his native land, once more to offer his sword in that cause which of all the gifts of earth he held most dear.

He had found Italy in a pitiable state. There was no central government and no union. Petty dynasties dominated by Austria were wrangling among themselves and allowing a beautiful country to go to ruin. It was for Garibaldi, the fisherman's son, to conquer, to abolish and to reform. What Joan of Arc had been to France, so Garibaldi became to Italy.

Inspired and aided by the patriot Mazzini, whose pupil and follower he was, he had made a noble and well-nigh successful effort in 1848, defeated only through the treachery of France. Now, in 1860, the hour once more seemed propitious. Though

THE "CAFE DELLA CONCORDIA," AT GENOA, THE PRINCIPAL MEETING PLACE OF THE
FRIENDS AND SYMPATHIZERS OF GARIBALDI
From a sketch taken on the spot by our own artist, Th. Nast, Esq.
(Reproduced from the New York Illustrated News)

ostensibly discouraged by most of the monarchs of Europe, including his own sovereign, the Piedmontese king, Victor Emmanuel, he was secretly indorsed by such Powers as were not in alliance with Austria, and was assisted to some extent with money and arms. Characterized as the "Great Filibuster," and with no regular orders from king or country, he set up the Piedmont banner at Genoa, and the veterans of 1848, with a horde of other soldiers of fortune, rallied to his standard.

It was this great final attempt for Italian union and freedom which young Thomas Nast had determined to join. The pictur-

esque, impetuous Garibaldi was just the figure to attract a boy artist, full of romance and military memories.

Nast's financial complications had made him late in starting. Already, upon his arrival at Genoa, Garibaldi had conveyed two shiploads of his recruits to Sicily—the famous " thousand," and had conquered at Calatafimi and captured Palermo. Through the American consul, however, the artist learned that two more vessels, the " Washington " and the " Oregon," were making ready to follow. At the Café della Concordia, the favorite resort of Garibaldians in Genoa, he was introduced to Captain (afterwards Colonel) John W. Peard, one of the veter-

THE EMBARKATION FOR SICILY ON THE " OREGON " AND THE " WASHINGTON '
(From the original sketch)

ans of 1848, and known as " Garibaldi's Englishman "; also to others of that valiant and variegated band. Nast must have made a favorable impression on the Garibaldians, for he was allowed to join the second expedition, which was to be commanded by Colonel Medici, an Italian nobleman, devoted to

GIUSEPPE GARIBALDI IN 1860
(From a photograph)

Garibaldi. On June 9th, with Captain Peard, Nast went on board the "Washington." To all appearances she was an American vessel, for the Stars and Stripes floated above her, doubtless with the connivance, certainly with the consent, of the United States officials. At midnight they were under way for Sicily and war.

There was much to enliven the voyage. The Garibaldians were of every rank and nation. Their talk was a babel of confused tongues. Men of title were there—some of them as officers, bearing their own names—others as privates, wearing any name that might suit the occasion and perhaps conceal a past that was better forgotten. Men had forsaken every profession and trade, their homes and their sweethearts, to engage in the trade of war. Men had even broken out of jail to join the expedition that was to free Italy. They danced, they gamed and they sang. Their music floated out over the Mediterranean, and brought joy to such as were not too seasick to be happy.

There were other diversions. An officer who called himself De Rohan, a fire-eating soldier of fortune—a brave man but a fretful soul—was constantly hurrying about the deck, giving orders and preparing for an attack from those Neapolitan gunboats which he avowed must presently swoop down and destroy them. Upon the young artist in particular he strove to impress the fierce dangers of war, as well as the desirability of getting back to his mother at the first opportunity. When at last a sus-

picious vessel really appeared upon the horizon, De Rohan came
striding aft, shouting, " Make yourself useful, young man!
Don't flinch! " And the young man promptly made himself
useful by helping to hoist the American flag, kept handy for
such emergencies.

They reached Sicily safely, arriving off Castelamare, on the
night of June 17th. Early next morning Nast, standing on the
bow of the " Washington," saw a fishing boat coming through
the mist. It was pulled by sturdy red-shirted men, and one of
these, as they came under the bow, leaned over to wash his
hands in the sea. Captain Peard came up just then.

" Why," he said, " it's Garibaldi! "

And so it was. The great leader with a few fishermen had
rowed over from Palermo, a distance of perhaps forty miles, to
receive his reinforcements, and to make known his commands.
Amid cheers of welcome, he came on board to confer with
Medici and Peard. Then, once more, he took his seat in the

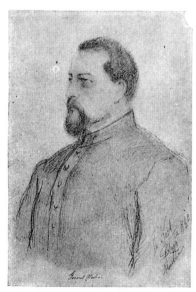

GENERAL MEDICI, 1860
(From Nast's sketch-book)

fishing boat, laid hold of an oar,
like the others, and pulled away
into the mist. The quiet unpre-
tentiousness of this man who
held in his hand the fortunes of
a nation made an impression on
the young artist which the years
never effaced. Garibaldi was his
hero from that hour.

They landed and marched
through the country already pos-
sessed by the " thousand." It
was rough life and hard march-
ing. Sometimes the artist had a
horse, and he learned to sleep in
the saddle. Once he travelled all

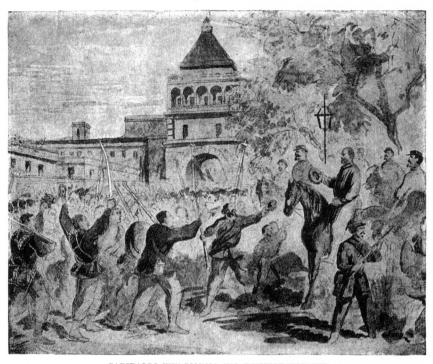

GARIBALDI WELCOMING HIS REINFORCEMENTS
(From a damaged sketch, by Nast)

night in a springless wagon with Captain Peard, to whom he presently became " Joe, the fat boy of Pickwick," and a close friend. Yet it was a triumphal march. The Sicilians rejoiced in their freedom from the galling yoke of the Neapolitans—the troops were greeted with bands of music, and lavishly entertained.

The expedition reached Palermo and Garibaldi on the 21st of June. Garibaldi rode out to meet the army and was greeted with the wildest enthusiasm. A little later the patriot chief, arrayed only in gray trousers and the red fisherman's shirt to which he has given his name, welcomed his officers to the royal palace, where he had established headquarters. Upon De Rohan's introduction the Liberator held out his hand to Nast.

" I am glad to make your acquaintance," he said. " As you are a friend of my friend De Rohan, you are my friend also."

CHAPTER VIII

With Peard and other officers, Nast stopped at the Hotel Trinacria, and next morning set out early to view the city. And now, for the first time, he realized some of the horrors of war. There had been a fierce bombardment from the Neapolitan vessels, also from the Palermo citadel and royal palace, before the final surrender. Ruined palaces were on every hand. Whole districts were in ashes. In some of the houses, families had been burned alive. A multitude of men and women, led by monks and armed with pickaxes, were destroying the hated citadel whose capture had cost them so much. Of this scene the artist made a careful sketch, which appeared in the London News of July 28th.

All Palermo was wild with excitement. " Garibaldi " was the name on every lip. Red shirts, red skirts, red feathers and red ribbons billowed everywhere like a tossing vermilion sea. The price of red cloth doubled, trebled, quintupled. The young artist hastened to secure himself a red shirt before the supply was exhausted, also the proper trousers, and a hat as nearly like Garibaldi's as he could find.* Then he strapped on a large knife, such as the Sicilian grocers use to cut cheese, and felt equipped

* Garibaldi once told Nast that the idea of using the " red shirt " uniform had been suggested to him by the dress of the New York City firemen.

NAST AS A GARIBALDIAN
(July, 1860)

for war. At night he attended a theatre, where the representation was of recent events, and an actor, overcome by a frenzy of excitement, died with the name of Garibaldi on his lips.

Indeed, Garibaldi had become to the Sicilians a second Messiah. Many of them really believed him to be so. His enemies declared that he had sold his soul to the devil, and could shake their bullets from his body into his loose red shirt and empty them out at his leisure.* The artist could never vouch for this story, as he did not see the bullets. What impressed him most was the simplicity of the great commander's life. Calling one morning at the palace, he found Garibaldi at a breakfast which consisted of nothing more than a little fruit, some bread and a glass of water.

Through Captain Peard, who had proved a true friend—advancing money when remittances were delayed—Nast was permitted to take a run up to Naples on an English man-o'-war. He found Naples in a state of mighty excitement. A review of Neapolitan soldiers by their Bourbon king, Francis II., had resulted in a sanguinary riot. Everywhere were the portraits and colors of Garibaldi. Evidently the inhabitants were ready to receive their conquerors with open arms. With the officers of the English vessel, Nast went over the city and made a trip to Pompeii. Then he was low in funds again, and the remittance he had expected at Naples did not come.

* "Life of Garibaldi," by J. Theodore Bent.

" Artist of the Ill. News," he wrote on a card, to identify himself with the landlord, to whom he owed a respectable bill. " When I come back, with Garibaldi, I will pay you."

The landlord studied the card carefully.

" You are artist of ze ill news. Dat mean bad news? "

Nast explained. The landlord took ten piasters from his money drawer and laid them before his guest.

" Do you mean that you will advance me that? " gasped the artist.

The money was pushed toward him without further comment. Two months later, when he returned as he had promised, the landlord refused to accept payment or even to remember the transaction. It was a Neapolitan way of contributing to the Garibaldian cause.

Nast returned to Palermo just in time to see Garibaldi's troop ships leaving for Milazzo, the next point of conquest. He followed on another vessel which sailed the same evening, arriving on the following afternoon to find that he was once more too late for the fighting. Milazzo had fallen on the 20th, after a stubborn defence. Only the citadel still remained in the enemy's hands. Closed shops and the ruin of battle everywhere confronted him. He went about and made sketches, and, tired and without food, slept that night on paving stones.

The surrender of the citadel took place on the 25th of July, instead of the 21st, as has been erroneously stated. General

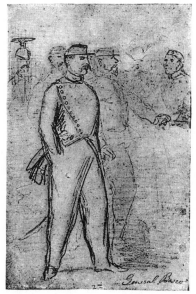

GENERAL BOSCO
(From pencil sketch)

Bosco, a Neapolitan commander who had really made a fierce resistance, marched out, followed by his army. This must have been humiliation for the proud Bosco, who but very recently had referred to his enemies as " those ragged Garibaldians." Nast made sketches of this and other scenes of the day, and his pictures were used on both sides of the water, with pay from only one, though the New York News continued to boast of " our own special artist with Garibaldi."

At Milazzo many Neapolitans came over to the Garibaldian ranks—glad to be captured—glad to escape from that terrible citadel, where dead men lay unburied in the sun, and where the wells were as poison. A powder train was found laid to the magazine, ready for explosion, though Bosco denied all knowledge of this violation of the code of arms.

The Garibaldians now moved on to Messina, where the inhabitants, hardly knowing what to expect, had put out to sea, in boats of every description. But the Bourbon forces at Messina did not care to fight. The very name of Garibaldi, and the fact of his arrival, were sufficient for their conquest. Finding there was to be no battle, the citizens returned and pulled down all the Bourbon emblems, including a statue of Francis II. The streets were quickly filled with red costumes and dancing. The public square became a vast

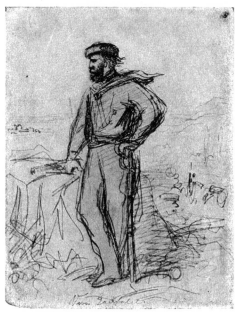

GARIBALDI, " DICTATOR OF ITALY "
(From Nast's sketch-book)

ballroom. Nast made many sketches of these characteristic scenes.

From this time on until the siege of Capua, on the Volturno, beyond Naples, the Garibaldian expedition has been termed a " military promenade." There was some sharp fighting at Reggio, just after crossing the straits, but for the most part the awe-stricken and half-starved Neapolitans were only too eager to lay down their arms and be taken into camp.

Support now came from all quarters. English recruits—chiefly sportsmen who hoped to bag a few Neapolitans, pheasant shooting having been rather poor at home—were constantly arriving, while the English navy, under Admiral Mundy, was always lingering about to get in the enemy's way. When Mundy was absent and danger threatened, the American flag did good service. The champion of liberty was no longer the " Great Filibuster," but the " Commander of the Army of the South " with the three Ms—men, muskets and money—at his command. His forces numbered fully forty thousand men, well disciplined and well equipped. All his life long, against every obstacle, he had yearned and fought for this recognition. Now, at last, it had come to him. He was Dictator of Italy, with the victor's laurels within reach.

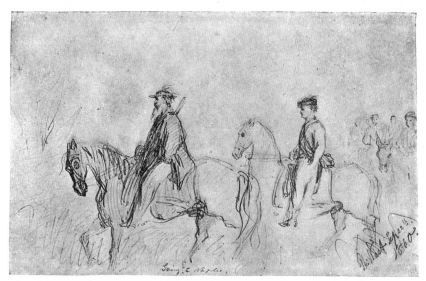

BOUND FOR NAPLES. ONE OF THE DAYS WHEN "JOE" HAD A HORSE
(From pencil sketch)

CHAPTER IX

ON TO NAPLES

The march northward was not warfare, save as it may be presented in the opera bouffe. The Neapolitan troops literally fell over one another to surrender their arms and be safe. Heavy firing sometimes took place, but only for stage effect and at very long range. The cannon balls, when they did reach, came bounding along like baseballs, and were sometimes caught by the soldiers. At one point, Neapolitan officers who had not as yet had a chance to surrender, sent a messenger to apologize for the shots of the night before, offering as an excuse that the men were restive and difficult to control. Doubtless this was true. They were eager for the moment of surrender, and celebrating its approach.

The Garibaldian officers now travelled as rapidly as they pleased. Colonel Peard had been ordered to go ahead and spy out the promised land, and Nast accompanied him. Peard rode

a rather bony horse, while " Joe, the fat boy," was usually mounted on a small, but loud-lunged jackass, so that the two bore considerable resemblance to Don Quixote and his faithful squire. Now and again, weary with riding, the " fat boy " would nod, and Peard would call to him:

" Now, Joe, you're asleep again," or, " Don't go to sleep, Joe, you rascal! " And so they wiled away the long, hot Italian afternoons. Much of the time they were wholly unescorted; yet, in the midst of the enemy's country though they were, they did not feel especially afraid, for the Neapolitans had been awe-stricken by the name of the approaching Garibaldi, and were only too anxious to fire their last few shots in the air and come capering into their conqueror's camp.

Sometimes, at the villages, Peard was mistaken for Garibaldi, whom he slightly resembled, and the inhabitants flocked about, kissing his hand and calling him their preserver. Even the fat boy on the noisy donkey received attention.

This mistaking of Colonel Peard for Garibaldi resulted in certain incidents that should not be overlooked by the writers of opera bouffe. Arriving one afternoon at the crest of a hill, the advance guard of two suddenly found itself face to face with a large Neapolitan detachment. Quick volleys of handkerchiefs were fired, i. e., waved, on both sides. Then the pseudo Garibaldi and his loyal squire sallied down and accepted the joyful surrender of an army, with artillery and side-arms. Still farther on, when the advance guard had lain down in a vineyard for a brief siesta, it awoke to find itself surrounded by a Neapolitan army of seven thousand men. Peard promptly asked to be taken to the commander. This time he did not impersonate Garibaldi, but merely said,

" You are our prisoners—Garibaldi is close behind."

The officer regarded him doubtfully—uncertain as to whether he was really their prisoner, or they his. Nast was despatched

to bring up the General and thus settle the matter. This he did without loss of time.

He found Garibaldi combing his hair sailor fashion, before a small mirror, while his soldiers rested.

" Tell them I'll be along to accept their surrender by the time they get the papers ready," he laughed.

Nast returned with the great commander's message, and a little later Garibaldi's appearance in person ended all dispute. Far-

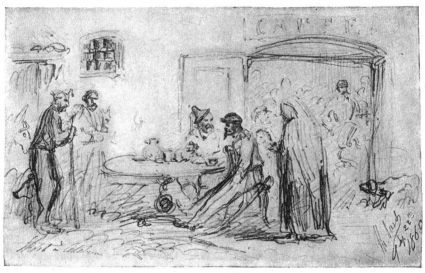

" IN CALABRIA." A HALT AT A WAYSIDE HOSTELRY
(From pencil sketch)

ther along, Colonel Peard accomplished the evacuation of Salerno merely by sending a telegram over Garibaldi's signature.

The English sportsmen who had come out to pot a few Neapolitans began to complain of their hard luck. They were to have their chance on the Volturno, where the Bourbon dynasty under Francis II. made its last stand. For the present, however, they grumbled at uneventful marches under the hot sun and through the miasmatic swamps that set their bones aching and filled their veins with fever.

But to return to our gallant pair of conquerors. Just before

reaching Salerno, they were informed that some gendarmes were coming in that direction, seeking trouble. Here was a real danger. The gendarmes were Neapolitan police and under no obligations to surrender. Peard drew his sword and Nast his trusty cheese knife. Then they secluded themselves in the brush and waited for the squad to pass. This was humiliating, of course, after accepting the surrender of thousands, but the thousands had been in a surrendering mood. They lay in breathless silence, praying fervently that the donkey would restrain any ambition he might have to voice his feelings. Perhaps he was alive to the situation, for he merely wagged his ears in silence, and the danger passed.

After Salerno, donkeys, horses and even carriages were no longer needed. Here Garibaldi and his faithful ones took the train for Naples. But it was a train that moved at a snail's pace. On either side was a vast cavalcade of cheering, waving men and women. At times, the engineer was obliged to halt, to avoid

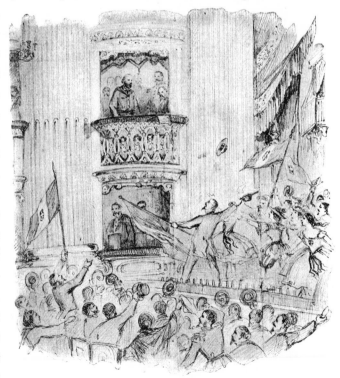

" GARIBALDI APPEARS IN THE THEATRE, AT NAPLES "
(From pencil sketch)

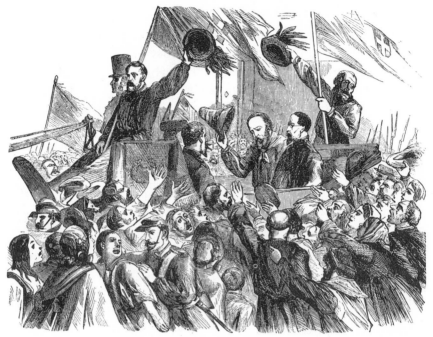

THE TRIUMPHAL ENTRY OF GARIBALDI INTO NAPLES
(From a drawing by Nast in the New York Illustrated News)

crushing the eager ones who crowded upon the track ahead. At
every station, a throng swarmed over the coaches and filled the
engine.

Arrived at Naples, the guard kept a semblance of order in
the station but just outside pandemonium had broken loose.
Crowds shouted and sang and danced in a perfect delirium
of joy. " Viva Garibaldi! Viva Vittorio Emmanuele! Viva
l'Italia! " was on every, lip. Only at the gloomy garrison of
St. Elmo were those—Bourbon officers and gunners—who as yet
took no part in the triumph. Their guns were trained on the car-
riage of Garibaldi and his staff. And Garibaldi knew that they
were there—that the guns were shotted—that the gunners stood
by with lighted fuse.

" Drive slower," he said to the nervous coachman. " Stop! "
and the carriage halted directly before the guns.

" Fire! " commanded the Bourbon officers. " Fire! *Fire!* "

But Garibaldi had risen in his carriage and was looking directly at the artillerymen. And then, all at once, the gunners threw away their fuses, and flinging their caps high in the air shouted with the multitude,

" Viva Garibaldi! Viva Vittorio Emmanuele! Viva l'Italia! "

Now came riotous days of rejoicing at Naples, and voting for the annexation of Naples and Sicily to Piedmont, with Victor Emmanuel as king. The result was almost unanimous for union, and the beginning of the great end for which Garibaldi had struggled and fought was at hand. Nast made sketches of the election, of the streets and of whatever appealed to him as picturesque or important; also, a number of characteristic water-color paintings—striking bits of Italian life and scenery—four of which are still preserved. He accompanied Garibaldi to the shrine of Piedigrotta, and of this made a large drawing for the London News. September 27th being the artist's birthday, his military friends gave him a feast to be remembered.

On October 1st began the fighting before Capua and along the Volturno, where Francis II., with forty thousand adherents, made a final determined stand. Here, at length, was genuine warfare. Nast climbed Santa Maria Hill for a view of the field. At first there seemed to be panic among the Garibaldians. Then the great commander himself arrived and the troops rallied. Yet it seemed to the observer that vast confusion reigned below. Runaway horses tore through the ranks. Fallen men were all about, and scores of wounded were dragging themselves from the fray. The English sportsmen had found amusement at last.

Presently a shell exploded not far away.

" Pretty close," said an officer who stood near.

Another shell passed still closer, and fell a few yards distant.

" On your faces! " shouted the officer, and the spectators

rolled over like automatons. " All right! She's dead! " called
the spokesman a moment later, and once more, though rather
reluctantly, the audience sat up.

" Guess I've got sketches enough," said Nast.

Presently there was a little sally of infantry up the hill, to

SHORTHAND BATTLE SKETCH ON THE VOLTURNO. " HAND TO
HAND FIGHT "

capture the spectators. It was a futile attempt. The spectators
were not handicapped with arms. Even the artist, short and fat
and laden with a sketch book, escaped. He decided that he had
seen enough war, and returned to Naples that night.

A few days later, at Caserta, Garibaldi, victor over all, sat
to him for his portrait. The great general—foremost figure in
the public eye, lauded to the skies, besieged and beset for favors
by thousands of men and women of all nations—was patient and
polite during the sketching, and left, as usual, the impression
of being the gentle-hearted patriot that he was.

And so the war ended. King Francis had retired to the citadel
of Gaeta, and Garibaldi at last confronted the Army of the North,

commanded by Victor Emmanuel, king of Italy united. On a morning early, each at the head of his army, these two met— the sovereign and the fisherman's son who had won for him a crown. It was the supreme moment of Garibaldi's life. The vast concourse looking on were for an instant silent. Then, as, leaning from their horses, king and soldier clasped hands, there arose once more the oft-repeated shout that told of Italy free. The conqueror's mission was accomplished. He had defeated the invader, he had united a nation, he had crowned a king. Alas, that nations are not always just, nor kings often grateful!

A few days later the Liberator bade good-by to his friends and followers. Among his soldiers he distributed medals. His voice failed as he took leave of them, while they, in turn, wept at the parting. Then, penniless as he had begun the struggle, having borrowed a few pounds with which to pay his debts, he set out for his home, Caprera, a small barren island off the Sardinian coast. In return for his great gifts to Italy and her king, he had accepted only the assurance that his army should be cared for—a promise readily made, and never fulfilled. Nast saw him for the last time on board the English flagship " Hannibal," where Garibaldi bade farewell to Admiral Mundy, who had rendered him faithful service.

It was the " Liberator's " final word of good-by. The steamship " Washington " was waiting for him, and a little later was hull-down on the horizon, leaving a free and united Italy behind.

CHAPTER X

On Friday, November 30, 1860, the young artist, Thomas Nast, bade good-by to his friends of Italy. Colonel Peard kissed him, as a father would a son. Their adventurous association had made them lifelong friends.

In his journey northward he passed by Gaeta, where Francis II. was still besieged. A feeble and desultory bombardment was in progress, and Nast and two travelling companions paused to observe it. Nast was sketching, when suddenly they were surrounded by soldiers and put under arrest. Friends were far behind, at Naples. The strange soldiers jeered at them as they were marched away.

They were taken before the commanding officer, who was dining in good style on the veranda of a handsome hotel. A band near by was making excellent music. The captain explained who the prisoners were and added that they seemed hungry; whereupon the commandant invited them to dine. They accepted, highly pleased at their capture. Now and then a shell burst near by, but the music did not stop, and the dining went on. It was the last spectacular touch of a picturesque and theatrical war.

After dinner they were discharged, and Nast set out for Rome. Here he visited the galleries, also the Coliseum, which made a

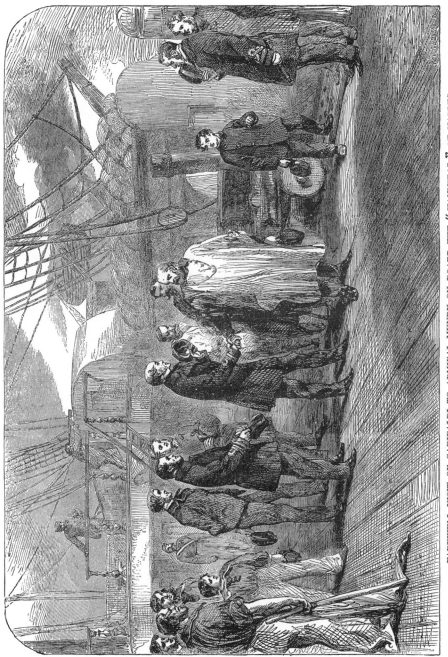

FAREWELL VISIT OF GARIBALDI TO ADMIRAL MUNDY ON BOARD THE "HANNIBAL" AT NAPLES

(Reproduced from the London Illustrated News. Drawn by Thomas Nast. Redrawn on wood by John Gilbert. Engraved by W. L. Thomas)

5

mighty impression on the artist. He made a sketch of the ruins, which later became a factor in some of his most important cartoons. Florence and Milan followed, and Genoa, where he recovered a trunk which he had abandoned to join the Garibaldians. From Genoa, via St. Gothard to Switzerland—thence to Germany and his childhood's home. How small Strasburg and its cathedral had grown since the visit with his mother, fourteen years before.

" What have you under your coat? " asked the customs officer, beyond the Rhine.

" The other steeple of the cathedral," answered Nast.

He had intended this as a joke, but the officer could not find the steeple and the joker narrowly escaped arrest for deception.

On December 21st he reached Landau by diligence, and found the old place just as he had left it, only shrunken in its proportions. The guard house seemed no longer grim and terrible. The drawbridges were miniatures—the city walls almost a joke. The parade ground had dwindled to a mere patch.

He found his aunt alive, and on her walls were the same old pictures of Napoleon and his tomb. It was Christmas-time in Landau, and while far across the sea, at the " Theatre des Edwards," they were reciting lines about their brave and absent comrade,

" We have a friend this year with glorious Garibaldi,
Of Théâtre des Edwards the capital Grimaldi,
Not least in our esteem, though mentioned last,
Health and a swift return to artist hero, Nast— "

the " artist hero " was being feasted and wined in that tiny Bavarian fortress at all hours of the day and night. The hardships of Italy were forgotten, except as he was called upon to recite them. Perhaps the crowning joy of his Landau visit was the payment to him of forty dollars by a distant relative, who claimed to have borrowed it from his mother.

But he was homesick for America and the girl he had left there. From Landau he journeyed to London, by way of Stuttgart, Munich, Nabburg—the last being his father's birthplace—where he saw another aunt, whose husband was kapelmeister. Here, he remained over night and slept in the little steeple room where, as a boy, his father had slept, and in the same hard bed. In the evening he was serenaded, and the burgomeister and priest called to hear the story of his adventures.

Through Germany his trip was a succession of art galleries and cathedrals. He saw tourists rhapsodizing before pictures which to him, fresh from the stirring action of real life, seemed crude and unreal. The tourists were worshipping a tradition, rather than a reality. He was tired of it all and wanted to get home. Crossing the channel, he heard talk of the war brewing in his own land.

Once more he stopped at the Round Table Inn, and remained a few days to straighten financial matters with the London News. W. L. Thomas, an engraver on the News, had looked after Nast's pictures and remittances while in Italy, and now tried to persuade him to remain with the paper. But £2 2s. per double page is not the way of wealth. He sailed on January 19th at noon, on the steamer "Arabia," and on February 1, 1861, after a year's absence, arrived in New York City with a dollar and a half in his pocket. It was the proper financial condition for a returned Garibaldian. The great patriot himself had been not much poorer on his return to Caprera.

His paper, the News, was in a very bad way indeed. The owners could pay nothing at all. The company was soon reorganized by Leggett Brothers, who had lent the firm money, and now took charge. The old proprietors had not paid, but they had been most lavish in their advertising of " our special artist," which, on the whole, had been of value. The new company employed him at a modest salary, with a quantity of work,

as usual. Take it all in all, he was happy. He was young and hopeful and full of health. His sweetheart and friends had remained faithful.

He began saving at once for a home, for he was resolved to be married on his twenty-first birthday. To this, Miss Edwards' parents had given consent, regarding a lack of funds as no obstacle to a young man of talent, industry and exemplary habits. His first purchase was a three hundred and fifty dollar piano, on credit. With his fondness for music, he could not resist the temptation, and the weekly payments on this joy of the household continued through the first year of married happiness.

The wedding came off the day before his birthday, which fell on Friday. It was in that dark and gloomy time following the outbreak of the Civil War. September 26th was a day of prayer, offered for the torn and stricken Union, so they were married early in the morning, that their pastor might hurry away to the public services. Then, after breakfast, the parents took their children, for they were little more than that, to the train and started them for Niagara Falls—that Mecca where the honeymoon never sets—where, by its light, newly-wed lovers have watched the tumbling waters from generation to generation, and shall continue so to watch, " as long as the river flows."

It was not until they were on the train and the train had started that the young man realized what he had done. Those older people had gone off and left him with a wife. The dangers of Italy suddenly dwindled to a poor thing in comparison. In Italy there had been only himself. Now, there were two, and one of them a young woman, who was wholly in his charge. This was responsibility. This was life. The curtain had fallen upon the epoch of early youth.

PART TWO: THE PATRIOT

CHAPTER XI

MEETING ABRAHAM LINCOLN

" Thomas Nast has been our best recruiting sergeant," said Abraham Lincoln near the close of the Civil War. " His emblematic cartoons have never failed to arouse enthusiasm and patriotism, and have always seemed to come just when these articles were getting scarce."

The emblematic semi-historical drawings referred to by President Lincoln did not begin until near the end of the second year of the struggle, though from the very commencement of his war work there had been strong sentiment and pictorial value in the young artist's drawings, undoubtedly due to his own intense loyalty to the Union; and these did not fail, through the medium of his forceful skill, to awaken a wide and eager response.

Sixty-one was a turbulent time, especially in New York City, where Fernando Wood, then Mayor, not only applauded the seceding South, but advised the secession of the metropolis. There was in New York a large element of foreign immigrants whose natural instinct seemed to be to destroy the nation that had sheltered them. Also, there was a multitude of merchants who had sold goods south of the Mason and Dixon line, and knew that for them war might spell ruin. Even the press was inclined to be lukewarm in its patriotism, and to argue rather liberally on the right of the Southern States to secede. Union talk was

plentiful enough, but it was likely to be " Union without war " and " Peace at any price." Men who were for " Union before all," and especially those who declared for abolition, were apt to be roughly dealt with, and at times found police protection welcome, not only in New York, but on the streets of patriotic Boston.

The policy of the newly elected President, Lincoln, was eagerly awaited. He had declared against slavery, and expressed his belief that a nation half slave and half free could not endure. Yet, during his debate with Douglas, he had protested mainly against extending the evil, offering no definite plans for correcting it. His enthusiastic reception in New York City, on his journey to Washington, showed that the larger element believed that the Man from the West, with his gentle spirit and wide humanity, would avoid a war.

On February 19, 1861, at Thirty-fourth Street and Eleventh Avenue, Thomas Nast, a boy not yet twenty-one, awaited the arrival of Abraham Lincoln, after that long triumphal journey from his home in Springfield. There were poor police regulations in those days. The President-elect and his companions were hustled and almost overwhelmed by the eager crowds. Nast, however, got a glimpse of Lincoln, and observed that the latter wore a beard and did not much resemble the sketches and caricatures which had already appeared. The artist made a sketch on his own account and later attended the reception given at City Hall. Here he made additional sketches, and was almost torn to pieces, trying to get near the guest of honor.

Being young and strong, he pushed his way through. Suddenly he found himself face to face with Lincoln, who likewise had suffered at the hands of the populace. The great man's cloak was torn and his hair dishevelled, but he was trying to look pleased. With an air of mutual commiseration, Nast held out his hand.

" I have the honor, sir."

Lincoln's face lighted up as he acknowledged the salute. He smiled, but it was a smile of sadness—a token of the underlying tragedy of it all, concealed for the moment by the humors of circumstance and the fanfare of welcome.

Nast was ordered by his paper, the News, to proceed to Philadelphia and on to Washington for the inaugural ceremonies. He was near Lincoln during the celebrated speech and flag-raising at Independence Hall, where Lincoln laid off his coat that he might with greater ease hoist the Stars and Stripes above the birthplace of Liberty. Later, the artist heard the address made from the balcony of the Continental Hotel, at which Lincoln and his party were staying.

It was nearly night, and the hotel windows were lit. The streets were thronged and jammed. Men were pushed and trampled by the masses of humanity, half crazed in a desire to see

LINCOLN AT THE CONTINENTAL HOTEL, PHILADELPHIA
(From Nast's pencil sketch)

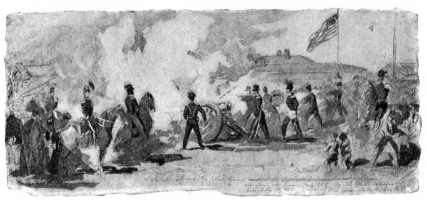

THE " SALUTE OF ONE HUNDRED GUNS "
(From the original drawing)

the tall rail-splitter of the West, who was to guide them safely through a labyrinth of political bypaths and turnings. The hosts were eager to follow, but only a few there were who realized that the one way of Union lay straight ahead, even though it led across the sombre fields of war.

Nast now hurried to Baltimore. Owing to the disturbed conditions there, the definite plans of the Presidential party were not made known. It was thought that disorder and perhaps open assault might occur in that hot-bed of dissension, where a crowd of roughs was said to have organized in a plot for Lincoln's assassination. Lincoln did not credit the report, and it is more than likely that no concerted plan of action had been formed. Yet there was always a mob about the Baltimore station, and had his presence been known, it is by no means unlikely that an attack might have been made. Certainly it seems best that the President-elect allowed his friends to prevail, and convey him by night through the disloyal city. The story of Lincoln's Scotch cap and plaid disguise, however, was wholly a canard, invented by an irresponsible newspaper man, who later in the war was imprisoned on a charge of forgery.

Nast did not see Lincoln in Baltimore, but from a description

supplied by the railway superintendent there, made a drawing more nearly correct in its details than any published at the time. Sad to relate, the editors of the News altered it to conform to the absurd " Scotch cap and plaid " fraud, which had gained credence, Lincoln was much ridiculed in consequence, and considerably humiliated.

At Washington, Nast stopped at the Willard Hotel. Being Lincoln's headquarters, it was thronged with politicians, including an army of office-seekers. The artist made sketches about the lobby, also of the arrival of the Peace Conference, headed by ex-President Tyler, and of the " salute of a hundred guns," fired on the last day of February to ratify the results of this meeting. On the 27th he had attended the farewell ceremonies between President Buchanan and the city's mayor and board of aldermen—a custom of that time—and on the same day, in the House of Representatives, made a sketch in which Roger

LINCOLN AT BALTIMORE
(From Nast's original drawing)

PENCIL SKETCH MADE IN THE HOUSE OF REPRESENTATIVES

A. Pryor appears prominently in the foreground, though Nast did not then know whose was the striking face of that excitable advocate of the Southern Cause.

In his later life Nast remembered much of this Washington experience with that feeling of shuddering horror with which we recall a disordered dream. The atmosphere was charged with foreboding. Even the busy days about the Willard Hotel were strewn with ominous incidents.

" I am from Maryland, and stand by my colors! " Nast heard a man mutter at his elbow, one evening in the hotel lobby, where Horace Greeley and others of the Abolition faith were gathered.

" I am from Virginia and stand by you! " was the muttered answer of another bystander.

Somewhat later a crowd of Southerners, with John Morrissey, surrounded Horace Greeley and a group of his friends, and expressed their sentiments with an emphasis doubtless augmented by liquor.

For it was not a time of loud talking. Knots of men on the street corners conversed in whispers. At night the streets were hushed and almost deserted.

The day of inauguration was one of gloom and mutterings. Military was carefully posted to prevent hostile demonstrations.

The weather was bleak. With his cane laid across the manuscript to keep the sheets from flying away,* the President-elect, pale and anxious, read that memorable address in which he said, "We are not enemies, but friends."

There was not much applause. The city drew a great breath of relief when it was over and there had been no outbreak. Yet the tension was not relaxed. The men who had sworn that Abraham Lincoln should never take his seat were not gone. Night came down, brooding danger.

"It seemed to me," said Nast, "that the shadow of death was everywhere. I had endless visions of black funereal parades, accompanied by mournful music. It was as if the whole city were mined, and I know now that this was figuratively true. A single yell of defiance would have inflamed a mob. A shot would have started a conflict. In my room at the Willard Hotel I was trying to work. I picked up my pencils and laid them down as many as a dozen times. I got up at last and walked the floor. Presently in the rooms next mine other men were walking. I could hear them in the silence. My head

A SOUTHERNER GIVING HORACE GREELEY A PIECE OF HIS MIND

was beginning to throb, and I sat down and pressed my hands to my temples.

"Then, all at once, in the Ebbett House across the way a window was flung up and a man stepped out on the balcony. The

* "The National Capital," by George C. Hazleton, Jr.

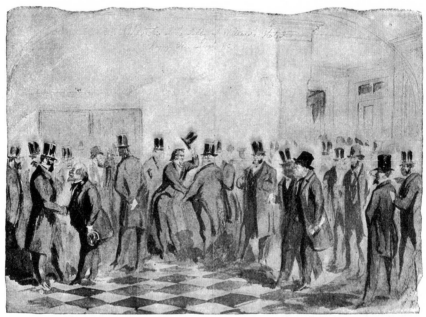

Frank Leslie Horace Greeley

OFFICE SEEKERS IN THE LOBBY OF THE WILLARD
(From the original drawing)

footsteps about me. ceased. Everybody had heard the man and
was watching breathlessly to see what he would do. Suddenly,
in a rich, powerful voice, he began to sing ' The Star Spangled
Banner.'

" The result was extraordinary. Windows were thrown up.
Crowds gathered on the streets. A multitude of voices joined the
song. When it was over the street rang with cheers. The men
in the rooms next mine joined me in the corridors. The hotel
came to life. Guests wept and flung their arms about one an-
other. Dissension and threat were silenced. It seemed to me,
and I believe to all of us, that Washington had been saved by
the inspiration of an unknown man with a voice to sing that
grand old song of songs."

A ZOUAVE

And now came the long, fierce struggle. The Nation was in a state of war before it was willing to admit the fact. Union stores and armament had been seized. State after State had seceded. As far back as January 9 (1861) the '' Star of the West,'' a merchant vessel sent with supplies and reinforcements to relieve Fort Sumter, had been fired upon by the guns of Fort Moultrie and compelled to return with her cargo to New York. This had caused great rejoicing in the South, where secession was eager for the trial of arms, but it was not until the bombardment of Sumter on the 13th of April that the North really awoke to the ghastly fact of a civil war, the end of which no man could foresee.

Then, suddenly, the lines became sharply drawn. Men were either for or against the Union. Hundreds of merchants who had favored peace at almost any national sacrifice now came forward with funds and offers of service. Even Fernando Wood became vice-president of the first great war meeting in New York City, and delivered an address full of patriotism, urging his hearers to unite in the common cause of Union. President Lincoln issued a call for volunteers, and they came pouring in.

Drilling and arming were everywhere. The clamor of fife and drum was on the wind. The North was aroused at last.

The news of the assault on the Sixth Massachusetts by the roughs of Baltimore came on April 19th, on the day that the

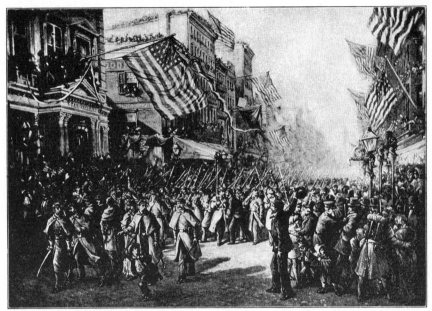

THE MARCH OF THE SEVENTH REGIMENT DOWN BROADWAY, APRIL 19, 1861

Seventh of New York—the crack regiment of the New York National Guard—marched down Broadway to the ferry for departure. The city went fairly mad that day. Old and young screamed themselves hoarse, and a million banners waved above the line of march. Nast made a drawing and, years later, a large oil painting of the scene. It hangs to-day in the armory of the Seventh, the only pictorial record of an event which New York will never forget.

But marching regiments and a cheering populace are not always the prelude of victory. The months following Abraham Lincoln's accession were full of dark days for the Union. The war was almost a succession of defeats for the National forces,

with the result of fierce exuberance and augmenting courage in the South; while at the North there grew a wide sense of depression that became well-nigh despair. Of course the Administration was attacked. The press and the stay-at-homes began to cry out against Lincoln, against the War Department, against the generals in the field, against everything, in fact, except themselves and their own pet nostrums for the cure of the Nation's sorry case.

Horace Greeley and his Abolition associates attacked Lincoln daily, through the Tribune, demanding emancipation, overlooking the fact that without armed possession he might as easily emancipate the slaves of the Soudan as those of the Secession States. Another and larger faction advocated Union before all, but they wanted it quicker, and these also denounced the Administration and abused the generals and their armies for not ending the conflict without further delay. There was still another class—smaller, it is true, but more dangerous than either of the others—the men who cried out for peace at any cost, who avowed the war to be a failure, who were secessionist at heart—the " Copperheads " of our Civil War.

THOMAS NAST IN 1862
(From a photograph)

Amid these besetting factions Lincoln's life was a succession of heart-sick days; of joyless nights; of mornings that only too often brought ill tidings of defeat. If the President walked the floor and wept, as he is said to have done when matters were going from bad to worse; when those like Horace Greeley and

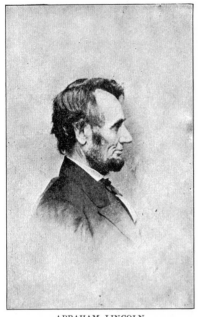

ABRAHAM LINCOLN
(From a photograph)

Carl Schurz—who should have stood at his right hand instead of blinding themselves to his wider understanding — were assailing his methods and criticising his motives, it is no wonder, and our hearts ache to-day for that sublime, gentle-souled man—the wisest the Nation ever chose to be its guide.

Abraham Lincoln seldom made any reply to his critics, but the following extract from a letter written by him to Carl Schurz, November 24, 1862, may be noted:

" You think I could do better; therefore, you blame me already. I think I could not do better; therefore, I blame you for blaming me. I understand you now to be willing to accept the help of men who are not Republicans, provided they have ' heart in it.' Agreed. I want no others. But who is to be the judge of hearts or of ' heart in it '? If I must discard my own judgment and take yours. I must also take that of others; and by the time I should reject all I should be advised to reject, I should have none left, Republicans or others—not even yourself. For be assured, my dear sir, there are men who have ' heart in it ' that think you are performing your part as poorly as you think I am performing mine.''

AN EARLY PHOTOGRAPH OF JOHN HAY

It is easy then to understand Lincoln's appreciation of a man like Thomas Nast, who never cavilled at circumstance or ridiculed the country's cause in that dark hour, but in his simple and untrained way struck home every time. Long afterward, when Nast had become a national figure, he was accused b y his enemies of having caricatured Lincoln as a drunken sot, but the picture referred to was done by another hand. Nast never caricatured Lincoln in his life —never criticised him in a single word or line.

After his marriage in sixty-one, the young artist continued on the News, doing a vast

THE DESPATCH ANNOUNCING THE FALL OF FORT SUMTER

amount of work, mostly of a journalistic sort, yet always filled with a spirit of patriotic fervor. His campaign in Italy had prepared him for his work now. He knew how a battle looked, how soldiers behaved under fire, all the horrors of the red field. Such men were in demand, and one morning early in sixty-two Frank Leslie sent for his old protégé and offered him a weekly salary of fifty dollars. This was more than he was receiving from the News, and, after some hesitation, Nast accepted. The engagement continued but a brief time. Perhaps Leslie had

6

one of his periods of financial stress. He presently reduced the artist to thirty dollars, and then let him go altogether.

For a moment this seemed a calamity. Nast had a young wife, and a piano not yet paid for. Also a family was not without the range of possibilities. Yet the Leslie incident proved a blessing in disguise. Some drawings sent to Harper's Weekly were promptly accepted and liberally paid for, as prices went in those days. Others followed. In the summer of sixty-two he was assigned to regular staff work. And so, quietly enough, began a pictorial epoch which was to endure almost unbrokenly for a quarter of a century and stand in history without parallel in the combined career of any one man and publication.

Thomas Nast's real service to his country began about at this point. Harper's Weekly had become the greatest picture paper in the field, with an art department of considerable proportions. Nast did not find the art room a satisfactory place to work, and was soon allowed to make his drawings at home, with pay at space rates. This proved a profitable arrangement, as he was a rapid worker, and soon more than doubled his former salary. Fletcher Harper, one of the original " Brothers," who made the publication of the Weekly his especial province, took a deep interest in the industrious and capable young artist. More than once he exhibited the quality and abundance of " Tommy's " work as a means of stimulating other members of the staff. The friendly relations between the future cartoonist and his employer, once begun, grew and augmented as the years passed, and it is due to Fletcher Harper more than to any other one person that the Nast cartoons and Harper's Weekly became identified with the Nation's history.

Almost from the first, Nast was allowed to follow his own ideas —to make pictures, rather than illustrations—and these, purely imaginative and even crude as many of them were, did not fail to arouse the thousands who each week scanned the pages of the

Harper periodical. "From a roving lad with a swift pencil for sale he had become a patriot artist, burning with the enthusiasm of the time." * "John Morgan Sacking a Peaceful Village" would stir to-day those whose relatives and friends might become factors in a similar scene. "A Gallant Color Bearer" was a picture stimulating to patriotism while a "Guerrilla Raid in the West" was calculated to arouse men to frenzy at the inhuman practices of border warfare.

MRS. NAST AND HER FIRST BABY
(From a pencil sketch)

Pictures like these made recruits, and were soon recognized as a force that would fan many a feeble spark of patriotism into a fierce flame of valor. John Bonner, then art manager of the Weekly, one day said,

"Nast, how does a field look after the battle? Can you draw that? Suppose you make it night."

So another—a double page, this time—was added to the scenes that inspired men to go forth and avenge their country's wrongs. In November he supplied a drawing entitled "Little Mac Making his Rounds," an adaptation of the old picture "Who Goes There?" so familiar to his childhood, and this was followed by a succession of other fierce portrayals of the bloody trade of war.

Matters were going very well indeed with the young artist. He

* James Parton in "Caricature and Other Comic Art."

was earning what seemed a good deal of money, and his domestic venture had proved a happy one. A baby girl had come to the little household on West Forty-fourth Street, Number 282, a part of a house—there were no flats in those days—and with increased prosperity, and the piano—which had been paid for within the year—the little family had entered into the possession of a happiness that was the wonder and perhaps the envy of their friends. " Give my love to Sally," wrote Parton, who, it will be remembered, was Mrs. Nast's cousin; " I think you are a lucky fellow to have so good a wife, and she is a lucky wife to have so good a husband."

Thomas Nast always loved his home, and preferred to work there. In those early days his young wife read to him as he worked, and when social demands were made upon them they would groan and protest, and yield with great unwillingness. They were dubbed " old grannies " at last, and abandoned to their fate. But it was a happy fate, and the close of sixty-two found the household of young " Tommy " Nast as peaceful and restful a spot as there was in all the great strife-riven nation.

Sixty-three marked the beginning of those semi-allegorical cartoons through which Thomas Nast made his first real fame. The earliest of these was entitled " Santa Claus in Camp," a front page of the Christmas Harper, representing the good saint dressed in the Stars and Stripes, distributing presents in a military camp. But of far greater value was the double centre page of the same issue. This was entitled simply " Christmas Eve," and was one of those curious, decorative combination pictures so popular at that time. In a large Christmas wreath was the soldier's family at home, and in another the absent one by his camp-fire regarding the pictures of his loved ones. Smaller bits surrounded these—well-drawn and full of sentiment.

Wherever Harper's Weekly went, that picture awoke all the tenderness that comes of absence in the dark hour of danger—

THE DOUBLE-PAGE CHRISTMAS PICTURE OF 1862-3

all the love for home and country that is born in every human soul. Letters from every corner of the Union came to the Harper office with messages of thanks for that inspired picture. A colonel wrote to tell how it had reached him on Christmas Eve, and had been unfolded by the light of his own camp-fire, and how his tears had fallen upon the page.

" It was only a picture," he said, " but I couldn't help it."

" KINGDOM COMIN'." " WE MOVED OUR THINGS INTO MASSA'S PARLOR JUST TO KEEP IT WHILE HE'S GONE "
(From the original sketch)

It was only a picture, but thousands besides the colonel had shed tears upon those pages and been ennobled and strengthened in their high resolve.

The success of this picture meant the continuation of Nast's double-page decorative drawings. " War in the Border States " was another grave arraignment of guerrilla warfare, while

THE WAR IN THE BORDER STATES.

ONE OF THE EFFECTIVE DOUBLE-PAGE WAR PICTURES
(From Harper's Weekly)

" Emancipation," on January 24th, depicted negro life as it had been, and as it was to be in the new day soon to come. For Lincoln, with more successful armies at the front, had at last issued the Proclamation that offered freedom to the slaves of every State in active warfare which had not returned to the Union

A New Plan to frighten Fine Old English Gentlemen

THE FIRST HARPER CARICATURE

with the beginning of the year. None of these had returned, and their slaves were free, so far as a Northern edict could be sustained in a land still far from conquered.

Indeed, the successful outcome of the war was by no means certain at this time. The general who was to lead the armies to victory was still unidentified. Harper's Weekly on January 17, 1863, asks, " Have we a general? " and enumerates those who have already met with a measure of success, with but a slight mention of Ulysses S. Grant, who a year before had taken Fort Donelson and subsequently saved the armies of Shiloh, but who was not yet recognized as the military Moses who was to lead to the Promised Land of Peace.

In January also appeared Nast's first caricature cartoon—a boy frightening John Bull with the cry of " Here Comes General Butler! "—the latter having been denounced as " a brute " by the London Times. The picture was good enough, but it gave no promise of the power and style which would make his individual caricature famous. " Southern Chivalry " was another savage delineation of the supposed methods of Southern warfare.

Perhaps never in the history of the world were two sections of a nation more bitter in their beliefs and more violent in their thirst for revenge than were the North and South at this mo-

ment. Women forgot everything except the fact that husband
and brother had been shot down—perhaps with horrible muti-
lation—to die in lingering agony. Guerrilla atrocities were con-
tinually reported and magnified in the North. In sections of the
South a Northern soldier was likely to be regarded as a wild beast.
Sixty-three was a poor time to investigate. Nast simply used the
material that came to his hand, and each resulting picture
brought volunteers to the Northern cause. They also brought
scores of threatening letters to the Harper office from the in-
furiated South, and Nast would have been burned at the stake
had he been captured during the occasional trips he made to the
front. We cannot consider these pictures fairly at this time.
Fierce they were, and brutal as were the times and scenes they
depicted, appealing in their sentiment to those elemental im-
pulses which always leap uppermost in the hour of impending
evil, especially during the ever-present dangers of civil war.
Even the more domestic drawings of this period were done in
a spirit of homely melodrama little in vogue to-day. They were

" BALLOON OBSERVATIONS "
(From a sketch made at the front, 1863)

not works of art—Nast did not so consider them. War is not
a time of culture and discrimination, but of blows, and those
dealt by Thomas
Nast were Swift
and savage and
aimed to kill.

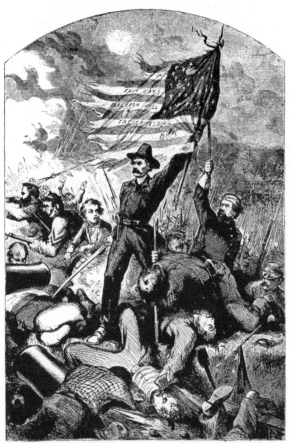

CAPTURE OF THE HEIGHTS OF FREDERICKSBURG
(Nast afterwards painted his " Saving the Flag " from this picture)

During the
spring of sixty-
three, on a trip to
Fort Moultrie,
Nast first met
General Butler,
and made a sketch
from life of the
face he was to
caricature so fre-
quently in the
days to come. He
also made for his
paper the " Ar-
rival of a Federal
Column," f r o m
which, somewhat
later, he painted
his large picture
" '61 to '65." Dur-

ing these trips to the front he met and became the friend of
General Sheridan, who invited the artist to establish head-
quarters in his camp.

In July of sixty-three, Lee was in Pennsylvania, and Nast was
anxious to get additional sketches of armies in action. Through a
rather humorous complication with one of Mrs. Nast's English
relatives, under arrest at Harrisburg for wearing as a sash the

Confederate flag, Nast himself was held for a few days, during which time the battle of Gettysburg was fought. Meantime, he enjoyed the freedom of the camp, and upon being discharged hurried to the scene of action, meeting at every stage of the journey wounded men, painfully making their way northward. At Carlisle he was among those who were shelled by the Confederate forces, and secured some sketches. The portrayal of this scene appeared in Harper's for July 25th. The front page of the same issue bore a fine portrait of Major-General U. S. Grant, now styled the " Hero of Vicksburg," and " Unconditional Surrender " Grant, and recognized as the commander whom the paper had endeavored to point out the year before. Nast greatly admired Grant's picture, and perhaps foresaw in it the nation's hero, but little he guessed how closely they were to be allied in the days to come, or what assistance his pencil was to render that serene and stalwart man.

" THE RESULT OF THE WAR" (From the original drawing)

Bluebeard of New Orleans

(Specimen carte de visite sold by E. and H. T. Anthony)

Returning to New York, Nast found himself in the midst of the Draft Riots—the streets of the city a bedlam of insurrection. All the " Copperhead " roughs of the metropolis were united—ostensibly to oppose the Draft Act, which had made all men between the ages of eighteen and forty-five subject to active service— but mainly for the purpose of arson and plunder, and for the destruction of inoffensive negroes and their friends.

" Down with the negroes! " " Down with the Abolitionists! " " Hurrah for Jeff Davis! " were cries heard everywhere. Terrified citizens locked and barred their doors. Those who had negro servants concealed them, often to have them dragged forth and murdered before their eyes.

Nast, mingling with the mob, saw the assault on the Tribune office, also the burning of the colored orphan asylum, where many of the fleeing inmates were overtaken and beaten—some of them slaughtered and left in the streets. At one place he saw

a dead Union soldier—the children of the rioters dancing about him and poking at him with sticks. It would have been madness to attempt any interference with the inflamed and drunken

ORIGINAL SKETCH FOR "THE DOMESTIC BLOCKADE"

mobs, which were not unlike those of the French Revolution. He made sketches as best he could and hurried home to look after the safety of his family.

Horatio Seymour, Democratic Governor of New York, came down from his home in the quiet lake country to quell the mob by calling the rioters his " friends," and by assuring them that he would " have the draft suspended and stopped." This sentiment, though cheered, was not of a nature to check the reign of lawless carnage. The police, aided by the military, at length suppressed the insurrection, but not before a thousand persons had been killed or wounded and more than two million dollars' worth of property destroyed. Houses had been burned and buildings sacked. New York showed in this incident the temper of a foreign element which has not improved with time,

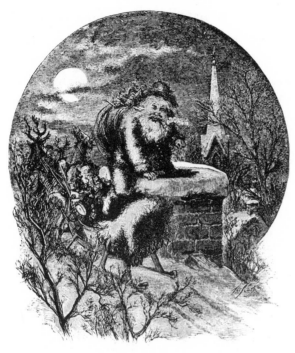

NAST'S FIRST PUBLISHED SANTA CLAUS
(From "Christmas Poems," issued by J. M. Gregory, 1863-4)

except to become more cowardly, and which, should it ever become aroused in force, may lay waste a great city.

Nast's work had now become recognized as a potent factor in the progress of events. A great number of persons subscribed to Harper's Weekly mainly to get the pictures, and among the illustrations his were considered of chief importance. Yet he was not without able associates. A. R. Waud, an artist in the field; Winslow Homer, Theodore R. Davis, Sol Eytinge, Frank Bellew, W. L. Sheppard, one or more of the Beard family, W. S. L. Jewett and C. G. Bush—the veteran cartoonist of to-day— were all associated with the great "Journal of Civilization," and their work was masterly, considering the methods of those days and the time allowed for its preparation. Yet in the drawings of Nast—often less notable for their technique— there was a feeling which appealed more directly to the emotions than could be found in the work of his fellows. It must have been the throb of his own fierce loyalty—his determination to destroy whatever stood in the path of his conviction. It was the same quality that a few years later was to

demolish corrupt politicians and city officials. It was the handling of metal at white heat—a trade at which he was the master craftsman of them all. There was to come a day when the metal would cool and the workman's hands would fail to shape it to the public taste. But that time lay far away and concealed behind the curtain of the years. Now, he was just in the beginning of his triumphs, with the greatest yet to come.

Many publishers began to seek his work. To some of these he sold paintings which were reproduced in color and sold widely. "A Domestic Blockade"—two children fortified in the parlor against the domestic of the household, became familiar to almost every family of that period For E. and H. T. Anthony he made a set of caricatures which were photographed in cartes de visite and sold by the thousand. They are only interesting now as showing a tendency to caricature which eventually was to dominate his work. War histories, "Tribute Books" and

SPECIMEN ILLUSTRATION FROM "ROBINSON CRUSOE," ILLUSTRATED BY NAST

juvenile publications were illustrated with his designs. A volume of Christmas poems presented his first published conception of Santa Claus as the Pelze-Nicol of his childhood—the fat, fur-clad type which the world has accepted as the popular portrayal of its favorite saint. In the Weekly he still continued

"A CHRISTMAS FURLOUGH"
(From Harper's Weekly)

his illustrative and half-allegorical cartoon work. "Honor the Brave," "Thanksgiving Day at the Union Altar," "The Story of Our Drummer Boy," and "A Christmas Furlough," which closed sixty-three, added much to the artist's rapidly growing fame. Letters came to him from all directions, fondly praising or bitterly condemning the pictures, according to the sympathies and geographical location of the writers.

CHAPTER XIV

With the beginning of sixty-four, Thomas Nast showed the pity and human sympathy with distress which was always so large a part of his nature. The cartoon was " New Year's Day, North and South," and in contrasting the comparative luxury of the North with the destitution of the overwhelmed but still struggling South, his inner tenderness for those in sorrow is clearly manifest. Later in January, Nast contributed a double-page, " Winter in Central Park." In the centre of this picture is a skating group, wherein a number of portraits of prominent persons appear. To introduce public characters into imaginative drawings seems to have been a custom in those old days. From a title page by Nast of a small and short-lived weekly entitled " Mrs. Grundy," one familiar with the faces of that time may pick out nearly one hundred notables.

" Columbia Decorating Grant," to whom Congress had just accorded a vote of thanks and a gold medal in acknowledgment of continued victories, was a Harper page of February 6th, sixty-four, and this was Nast's first published drawing of the man who with Lincoln and Garibaldi should claim to the last his admiration and his honor. Throughout the year the single and double-page cartoons continued, growing more domestic and less savage as the South gradually gave up the struggle and the days

7

of peace seemed nearer. " On to Richmond," published June 18th, was perhaps the most spirited of the summer's work, but as the weeks passed and the presidential campaign grew fiercer, there appeared two cartoons that stirred the Nation more than any pictures hitherto published.

The first of these, " Compromise with the South," appeared a few days after the Chicago Convention, which had been controlled by Fernando Wood and Clement L. Vallandigham. The latter was an avowed " Copperhead," already once imprisoned for treason, and only through Lincoln's generosity allowed to be at large. The declared principles of this convention were to obtain peace at any price, yielding to the South any point that might bring the seceding States back into the fold. It asserted that the war was a failure, notwithstanding the fact that the situation even then was in the hands of the Union forces, and failure could result only through adopting the Chicago platform. The cartoon of Nast represented the defiant Southerner clasping hands with the crippled Northern soldier over the grave of Union heroes fallen in a useless war. Columbia is bowed in sorrow, and in the background is a negro family, again in chains. In the original design there had been a number of smaller accompanying pictures, but Fletcher Harper considered the central idea sufficient and made of it a full page.

The success of this picture was startling. An increased edition of the Weekly was printed to supply the demand, and the plate was used for a campaign document of which millions of copies were circulated.

As stated, the Chicago Peace Party Convention had been controlled by Wood and Vallandigham and others of their political faith, including Samuel J. Tilden and Horatio Seymour *—both patriots of the Vallandigham school and future candidates for the Presidency. The nominees were George B. McClellan, who

* Mr. Seymour was chosen to preside over the Chicago Convention.

THE GREAT "COMPROMISE CARTOON." FIRST PUBLISHED IN HARPER'S WEEKLY. AFTERWARDS CIRCULATED AS A CAMPAIGN DOCUMENT

DEDICATED TO THE CHICAGO CONVENTION.

TITLE PAGE FOR MRS. GRUNDY, MADE IN COMPETITION

This drawing won a prize of one hundred dollars. About one hundred easily recognized faces may be picked
out among those in the galleries and boxes. When it is remembered that these were drawn on wood and
are here only slightly reduced, the ingenuity of the draughtsman will be realized)

resigned from the army to accept—the greatest mistake a great
man ever made—and George H. Pendleton of Ohio. The plat-
form was "Copperhead" throughout, and on October 15th
Harper's Weekly published the second destructive cartoon, de-
picting in Nast's most ferocious manner just what the platform

NAST'S PICTORIAL ELUCIDATION OF THE CHICAGO PLATFORM OF 1864. FIRST PUBLISHED IN HARPER'S WEEKLY. AFTERWARDS CIRCULATED AS A CAMPAIGN DOCUMENT

meant. It was an intricate double-page affair—a combination of something like twenty pictures—interwoven and interwound with pertinent extracts from the hated document.

Nobody can ever estimate what these two cartoons added to the majorities of Lincoln and Johnson, but it is believed that they gained many thousands of votes for the Union cause. Harper's Weekly, in an article somewhat later, referred to them as " prodigious batteries whose influence upon the glorious results of the campaign was undeniable."

And then, once more, the gentler spirit of Thomas Nast was manifested. In the big Christmas cartoon of sixty-four, Lincoln is represented as pointing to the empty chairs at the National dinner-table, inviting the recreant States to come in from the storm and cold and take their seats. And this proved a real prophecy, for Abraham Lincoln, who was so soon to lay down his life as the price of Union, with that sublime impulse of forgiveness which filled every corner of his great and gentle heart, did almost precisely what the artist had foreseen.

The war was not yet ended, but the people of the North had declared that it should be pushed to its legitimate conclusion. The seceding States would be welcomed back, but the terms must be made by the victors.

" Fondly do we hope, fervently do we pray," said Lincoln in his second inaugural address, " that this mighty scourge of war may speedily pass away. But if God wills that it continue until all the wealth piled by the bondsman's two hundred and fifty years of unrequited toil shall be sunk, and until every drop of blood drawn with the lash shall be paid with another drawn with the sword, as was said three thousand years ago, so still it must be said that the judgments of the Lord are true and righteous altogether."

So the sad, useless struggle went on long after the end was in sight. Finally a point was reached when the North itself was

ABRAHAM LINCOLN INVITING THE SOUTHERN LEADERS TO TAKE THEIR PLACE AT THE NATIONAL TABLE

shipping supplies to the starving citizens of Savannah, and the papers of the South were assailing Jefferson Davis, by whom, it may be said, they had stood far more loyally than most of the so-called Union papers of the North had ever stood by Lincoln. Finally, late in February of sixty-five, colored troops singing " John Brown's Body " marched through the streets of Charleston, where the first shots of the war had been fired. Then, a few weeks later, came the fall of Richmond, and on April 4th Lincoln entered the Confederate capital and was almost overwhelmed with the demonstrations of a rejoicing multitude. Nast made a large drawing and later a painting of this triumphal hour, and then there appeared from his pencil an emblematic page entitled " The Eve of War and the Dawn of Peace." Facing this page, drawn by another hand, was the scene of one of the saddest and most dastardly tragedies in all history—the assassination of Abraham Lincoln, on the night of April 14th, at Ford's Theatre, Washington.

The war had ended, and with it had ended the life of the purest, the gentlest, the wisest man whose name has ever been written on the page of history.

The Nation's grief was depicted by Nast in a representation of Columbia mourning at Lincoln's bier, and later by another, entitled " Victory and Death." On the Fourth of July, there followed a fine double-page entitled " Peace," a scene suggested by Grant's magnanimous order—" Let them keep their mules and horses—they will need them for the spring ploughing." Later the artist reproduced a portion of this picture in a canvas entitled " Peace Again," a pleasing and inspiring scene.

And so the war, with its four years of stress and grief and bitterness and martyrdom, had been added to the past. The surviving soldier had returned to his farm, his workshop, and his office. His sword had been laid down for the pen, his musket for the plough and the tools of trade.

COLUMBIA MOURNS

CHAPTER XV

RECONSTRUCTION

THE CARTOONIST AND THE
KING

(From an unused cut)

General Grant, when asked " Who is the foremost figure in civil life developed by the Rebellion? " replied, without hesitation, " *I* think, Thomas Nast. He did as much as any one man to preserve the Union and bring the war to an end."

Grant's opinion was echoed by many Northern generals and statesmen of that time. Letters of thanks came from all quarters. Yet the majority of men and women to-day do not associate Nast with the war period. They remember him as the destroyer of Tweed and recall his connection with the campaigns of Greeley and Blaine. It is mainly because of this that we have dwelt on a period of his work which, if less brilliant, was no less useful to the nation as a whole than his later and more startling achievements. We shall consider as briefly as possible the bitter days of Reconstruction, which were now at hand.

During the months following the death of Lincoln the artist busied himself with painting and book illustrations, including a number of juvenile volumes published by Lee and Shepard of Boston. But one cartoon appears between July and November

of 1865, a double page entitled " Pardon and Franchise," which struck firmly the most strident note of the Reconstruction

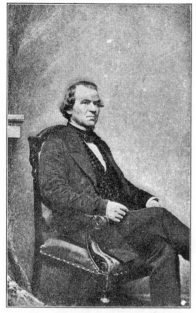

ANDREW JOHNSON
(From an old photograph)

discord. On one hand Columbia, anxiously regarding the leaders of the late Secession, says " Shall I trust these men? " and on the other, with her hand on the crippled negro patriot, adds " And not this man? "

Before the appearance of the next cartoon, November 11th, the changed policy of Andrew Johnson had become known. When elected to the Vice-Presidency he had been, though a Southern man, fiercely radical in Union sentiment and an avowed enemy of the slaveholder. It was feared upon his succession to the Presidency that he would be unduly severe with the returning States and destroy such good-will as had been inspired by Lincoln's policy of gentleness. The Democratic press denounced him savagely as a Nero and Caligula—a tyrant who would set his heel upon the conquered. The Republican papers hoped for the best and waited.

The waiting was not long. Johnson went over, body and soul, to the enemy—to those whom he had sought for years to crush and destroy—to those who had reviled him in words such as newspapers no longer print. Why Johnson should have done this remains an unsolved problem. It would seem, almost, that the suddenness of his elevation had

THOMAS NAST IN 1866

THE FIRST "ANDY" JOHNSON CARTOON
(From an unused woodcut)

turned his head and destroyed his mental balance. Such a view is at least charitable.

It was but natural that this apostasy should result in an altered attitude of the press. Nast illustrated the Democratic change of heart toward Johnson. On the one hand the party is assailing him with missiles, and on the other bombarding him with bouquets. It was the first published of the now famous "Andy" Johnson cartoons.

It was not, however, the first Johnson picture to be drawn. The President's "Proclamation of Amnesty and Pardon" had already suggested a picture which was engraved but not used. In the upper half of the page Johnson is scattering pardons to the secession prodigals, while Stanton looks grimly on. Below, Seward is washing the stains from the battle-flags which Gideon Welles is hanging on the line. Seward was always held, at least in some measure, responsible for Johnson's change of front, while Welles, also, was thought to be too freely disposed to promiscuous forgiveness. The Amnesty proclamation was not at first regarded with much favor, but it being more fully comprehended, the use of this cartoon was deemed inadvisable. A Thanksgiving illustration of " Peace " and a large Christmas draw-

SECRETARY STANTON
(From a photograph)

ing which contained one of the jolliest of Nast's Santa Claus pictures closed the year.

Domestic cartoons for the Bazar, book illustrations, and a series of unsigned caricatures for a paper entitled Phunny Phellow occupied most of the early part of 1866. The Phunny Phellow work was a secret, and the cartoonist was a little surprised one day when a friend remarked: " You'll have to look to your laurels, Nast; that chap on Phunny Fellow is after you."

This evidence of success as his own rival encouraged him to continue his similar work on the

SECRETARY SEWARD
(From an old photograph)

GIDEON WELLES
(From a photograph)

Weekly, and the impulse was further strengthened by the success of a series of life-size caricatures exhibited at a grand masquerade opera ball given by Max Maretzek on the night of April 5th. This " Opera Ball " was given in the old Academy of Music, and sixty of the large caricature paintings of public men and women surrounded the room. During the preparation of these pictures, especially those of the women, Maretzek, horrified, frequently exclaimed, " Oh, she vill kill you! Oh, she vill stab you in ze back!"

But the display proved a great success. Apparently every guest present enjoyed hugely the comic characterization of each face save, perhaps, his own, which he was likely to declare a " rather poor likeness." Men and women seeing their faces caricatured for the first time were usually a bit startled at first,

A PAGE OF THE OPERA BALL CARICATURES, WITH A GLIMPSE OF THE EVENT

and then either amused or slightly disturbed. The women accepted theirs much more meekly and good-naturedly than did the men, usually exclaiming " How very clever Mr. Nast is! "

This mammoth exhibition immediately ranked Nast as the foremost American caricaturist and greatly added to his popularity. Maretzek presented him with a handsome gold watch as a special testimonial.

A week after the ball, the " comics " were auctioned off at a good figure. Eventually most of them found their way to Thomas's saloon—at that time on Broadway, near Twenty-third Street—where crowds came to see them—men often bringing their wives during the morning hours when the place was comparatively empty. Among the pictures appeared the first caricature of John T. Hoffman, then Mayor, later, as Governor of the State, so notoriously associated with " Boss " Tweed and his " Ring."

THE SANTA CLAUS OF 1864

A fine " Andy " Johnson caricature—a double page in which Johnson as Iago is endeavoring to convince the colored man that he is still his friend—touched high water mark for 1866. The picture is notable in the excellence of its conception and drawing; also as being the beginning of Nast's favorite custom of using a Shakespearian situation as the setting for his idea.

Nast had never been an enthusiastic adherent of Johnson, and now took especial pains to caricature him in a manner as careful as it was severe. He alternated, and often associated, him with bitter portrayals of the " Ku-klux " outrages, then disgracing many of the defeated Southern States. He depicted him as " St. Andy " the injured—as a bully—as a would-be

king. Yet however bitter his portrayals, they were but the expression of a sentiment aroused by the President himself, in his attitude toward the party which had elected him. His former supporters regarded him as a traitor, and his offensive public utterances were considered a national disgrace. He was accused of endeavoring to set himself up as dictator—even of being concerned in the assassination of Lincoln. Two years later (February, 1868), after his attempt to remove Stanton and to discredit Grant, he was impeached, and was saved only by a single vote from being expelled from office.*

The " Andy " Johnson cartoons constituted Nast's great beginning in the field of caricature. They were by far his most important work in 1866, which closed with what the writer of this record considers the best of all Santa Claus pictures, because for him, then a boy of five, it made " Santa Claus and His Works " something that was real and true and gave to his Christmas a new and permanent joy.

Through 1867 the struggle over Reconstruction issues continued. Legislation with a view to the re-enfranchisement of the South, and concerning the social and civil rights of the manumitted slaves, was conducted under the most turbulent conditions. These were days less bloody but hardly less bitter than those of actual warfare. The situation in many of the Southern States was so dire that one capable authority is reported to have said that if he owned both hell and Texas, he would select the former as his dwelling place.

It was early in 1867 that a caricature of the " Government of the City of New York " marked the beginning of a crusade for civic reform, the success of which, alone, would perpetuate the name of Thomas Nast.

* The impeachment of Andrew Johnson was a measure hardly justified under the law, and would never have been undertaken but for the President's generally offensive attitude toward Congress. The unprecedented event crowded the galleries of the Senate, and special tickets of admission were issued.

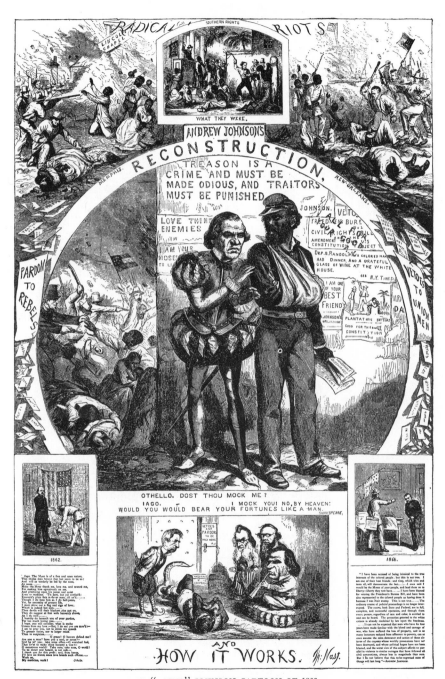

AN "ANDY" JOHNSON CARTOON OF 1866
(The beginning of Nast's custom of using Shakespearian situations as settings for his ideas)

8

There were no individual faces in this first picture. It merely showed the City Government in the hands of a corrupt element, roughs and gamblers, with the " Steal Ring " suspended behind the chair of the chief officer. It was by no means an able effort as compared with the " Ring " cartoons which were to appear a few years later; but if we except the page of " Police Scandal " in 1859, it was the earliest of Nast's " corruption " cartoons, and constituted a sort of manifesto of a future crusade. During the remainder of the year " Andy " Johnson pictures predominated, and further portrayals of those " Ku-klux " and other Reconstruction phases which we may well afford to forget.

THE MEETING OF NAST AND NASBY

It was in 1867 that Nast first met David R. Locke, who as Petroleum V. Nasby had been doing the " Confedrit Crossroads " papers—a humorous political series which Nast, in common with a multitude of other Northern readers, had followed with delight in Locke's paper, the Toledo Blade. The two men met with great rejoicing and became good friends. The artist subsequently made a drawing of their first meeting, and was the illustrator of two of Nasby's books—" Swingin' Round the Cirkle " and " Ekkoes from Kentucky." " Nast and Nasby " made an attractive advertising phrase which the publishers used with telling effect.

The cartoonist's most important work this year was his double page " Amphitheatrum Johnsonianum," which represented Johnson as Nero regarding with composure the " Massacre of the Innocents," a race riot which had occurred at New Orleans, July

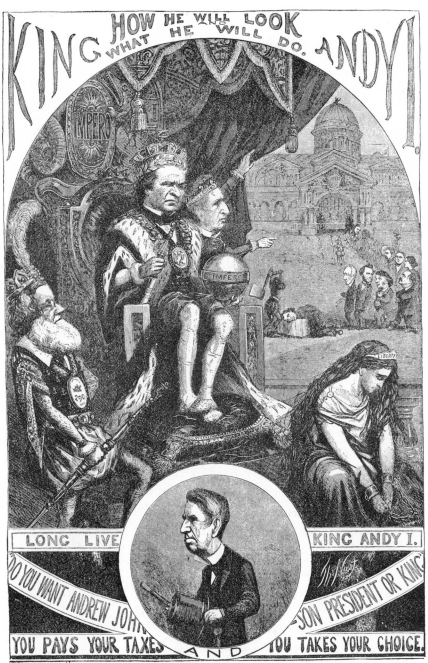

JOHNSON AS KING SUPPORTED BY SEWARD AND WELLES. IN THE DISTANCE, HENRY
WARD BEECHER, WENDELL PHILLIPS, CHARLES SUMNER AND OTHER ABOLITIONISTS
ARE FORMED IN A LINE FOR EXECUTION. AT THE END OF THIS LINE IS NAST HIMSELF

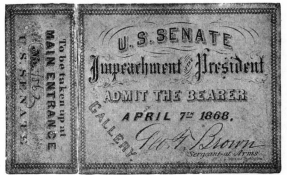

30th, 1866.'' The por-
traits in this car-
toon are striking
and unmistakable,
as was always the
case in the work of
Nast. Even among
the concourse of
little figures in the
crowded Coliseum galleries, we may to-day pick out the familiar
faces of history. Nast almost never thought it necessary to label
his characters, as is the custom now. Johnson was always John-
son, whatever the guise. Seward, who had kept his place in the
Cabinet, and lost prestige thereby, was usually prominent and
never could be mistaken. Welles, Greeley, Stanton, and all the
rest—wherever they appeared and under whatever conditions—
retained their features and character and needed no cards of
identification. Many cartoonists have found it necessary to exag-
gerate features to obtain results, often at the expense of likeness.
Nast, on the other hand, merely emphasized characteristics and
so gained rather than lost, in establishing identity.

On May 11, 1867, Harper's Weekly published a fine full-page
portrait of Nast himself, with a sketch of
his life and work. In summing up his posi-
tion in caricature, the writer said:

'' Gilray is the only political draftsman
who can be at all named with Nast, but Gil-
ray's work is gross and prosaic caricature,
compared with the subtle and suggestive
touch of Nast.''

Yet this was when the artist was but
twenty-seven years of age, with his great-
est work still undreamed.

THE PRESIDENT'S JOY AT
THE RESULT OF THE IM-
PEACHMENT TRIAL

AMPHITHEATRUM JOHNSONIANUM

(President Johnson viewing the massacre of New Orleans. In the lower left-hand corner Grant is staying the sword of Sheridan. Among the little faces in the distance, Manton Marble, Hoffman, Greeley, Logan and many others are recognizable)

CHAPTER XVI

Little of Nast's work appears in Harper's Weekly during the latter half of 1867. He was chiefly engaged during this period in illustrating a variety of books, including some histories of the war, a portion of Mrs. Dodge's "Hans Brinker," and a lot of toy books for McLoughlin Brothers—the most popular series ever issued by that firm. Also, he was employed in painting for exhibition a large series of fierce political cartoons—a venture encouraged by the success of the " Opera Ball " display. This " Caricaturama " was badly managed, for Nast was never a financier, and was abandoned after a brief season of New York and Boston, during which it excited considerable admiration, a share of resentment, and resulted in no profit whatever.

The ambitious cartoonist was not discouraged. He put the big failure away and went back to his boxwood and pencils. A weekly illustrated paper entitled the News had entered the Chicago field, and in order to command immediate attention engaged Nast to contribute cartoons. He was not then bound by a retainer to draw only for the Weekly, and the Chicago work, chiefly Johnson caricatures, proved profitable. This was in the early part of sixty-eight, during the great Impeachment Trial, for which Nast received one of the special admission tickets, though he did not attend. In May, when the Republican

National Convention came along, the artist went to Chicago to be present.

It was settled beforehand that General Grant was to be the Republican presidential candidate. The great soldier had maintained a calm and noble dignity through all the trying days of conflict between Congress and the recreant Johnson, and was now honored almost as much for his diplomacy as for his success at arms. Indeed, the mantle of sweet renown left by Lincoln would seem to have been laid upon the shoulders of Grant, and he wore it with becoming grandeur and humility.

Realizing that the convention would name Grant as its choice, Nast prepared a little surprise for the event. He painted upon a large curtain the White House entrance, with two pedestals, one on each side, bearing the words " Republican Nominee, Chicago, May 20th," and " Democratic Nominee, New York, July 4th," respectively. On the Republican pedestal was seated the figure of Grant, while Columbia stood pointing to the empty place, opposite. Below, were the words, " Match Him! "

This curtain, with a blank curtain before it, was suspended at the back of the convention stage. At the instant when General Grant was announced as the unanimous presidential choice of his party, the blank curtain was lifted and the great cartoon " Match Him " was suddenly exposed to full view.

The occurrence was so unexpected that the throng was silent for a moment, taking it in. Then, realizing that it was a spectacular climax—the pictorial expression of a universal sentiment—the assembled multitude gave vent to an enthusiasm that turned the great hall into a pandemonium of exultation.

This incident added greatly to Nast's popularity. The " Match Him " picture was redrawn for publication, and then another, entitled " Matched," with Schuyler Colfax, the Republican vice-presidential candidate, seated on the opposing pedestal. Poems and songs called " Match Him " and " Matched "

were written and sung, and articles of commerce were given these names as mascots. Harper Brothers urged him to take up his work once more for the Weekly, and promptly advanced his rate to one hundred and fifty dollars per double page. This was a figure five times as great as he had at first received, and accounted fabulous, as indeed it. was, for that period.

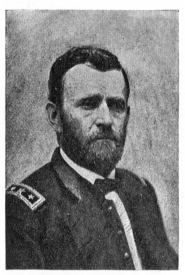

In fact " Tommy " Nast, as he was still called by his old-time associates, was making stout strides " along the turnpike of fame." He was without a rival in his new field. The elder Bellew did an occasional caricature, but his work, though not without charm, had little political importance. When Nast did not contribute, the Weekly confined its caricature to small pictures, mostly of a domestic nature.

He no longer lived at his little quarters on West 44th Street, but had moved twice—in 1863 to York-

GENERAL ULYSSES S. GRANT
(From a photograph)

ville, a pretty countrified place (now 89th Street and East River), and a year later to a house of his own in Harlem, on 125th Street near Fifth Avenue—a property that increased rapidly in value and proved a fine investment. He had been made a director in a well-known savings bank, and had become a member of the Union League Club and of the Seventh Regiment. Club and Regiment friends were fond of driving in " Harlem Lane " on Sunday afternoons, and of dropping in on the cheerful Nast household, where the latch-string was always out and the tea-table made long, to accommodate all who came.

To the Harlem cottage came also many friends of former days, and among these were comrades of the Garibaldian campaign—

light-hearted soldiers of fortune, who, following the trade of war, had cast their lot with the Union—most of them low in purse, now that their occupation was gone. Nast bade them welcome and helped them with a liberal hand. Among them was the impetuous and fretful De Rohan, reduced but still unsubdued—scolding his former protégé while accepting his bounty—and a certain Colonel Percy Wyndham, once the bravest of the brave, now, alas, acting as a dispenser of subscription books until such time as the call " to arms! " should summon him to new fields of conquest.

But with the exception of Sunday the Nast home life was usually a quiet one. The artist had built in the rear of his lot a large studio where he worked steadily, while the young wife cared for the babies—there were three now—or discussed his work with him, frequently helping him with the lines that were to go beneath his pictures, verbal expression being ever his weak point. It was Mrs. Nast who had suggested the words " Match Him! " for his Chicago curtain; and many other of the terse and telling legends beneath his cartoons were due to her. Often she read to him as he worked, first the papers, then standard fiction (Thackeray by preference) or some book of useful information. At times he engaged certain impecunious college men who for a dollar an hour were glad to read and discuss solid books of history and science. Thus, in a great measure, did he make up for a lack of school education in youth.

In the matter of historical references—averse as he was to research—Nast seemed never at a loss to find his facts or quotations. He seemed to know as by instinct where to turn, and his wife, whose joy it was to transcribe and verify, seldom found him wrong. Their union of sympathy and labor made their home life ideal. They might have been almost continuously entertained by their friends, as well as by social and political leaders, who, recognizing in the cartoonist a new power, were

anxious to do him honor. Wisely they refrained from these things. They preferred to spend their evenings together, she with her sewing, he going over the daily papers, of which he was an inveterate reader, keeping always posted and in touch with the times—forming his own opinions—always armed and ready to strike any head that might be lifted on the wrong side. When a new picture would present itself he would walk the floor and talk to her. Such gesticulating and earnestness! He was so young then—so full of fire and eagerness! He liked to express his ideas, he said, and hear how they sounded when put into words. The very voicing of them often gave him fresh hints. Sometimes, when he seemed to have discussed the full round of subjects, his listener would say to him,

FLETCHER HARPER
(From a photograph)

" Well, once more the affairs of the universe are settled—they ought to keep so till morning. Now I will put the children to bed.''

Many of Nast's newspaper clippings are still preserved, with their multitude of interlined pencillings that as clearly express his views as would the most copious marginal commentary. His views were his own—rather than those of any particular party or faction—and it was Fletcher Harper who gave him the liberty necessary to make their pictorial maintenance a national power.

It has been claimed by detractors of Nast that George William Curtis, who in 1866 became the editor of Harper's Weekly, supplied most of the ideas for the cartoons. So far is this from

the fact that Mr. Curtis's letters, almost from the beginning, show his continual attitude of protest as to the force and multitude of Nast's ideas. Already in June, 1866, we find him advising against the Johnson caricatures, not considering it wise, as he says, " to break finally and openly with our own Administration," believing, as every writer is prone to believe, that editorial admonition may be qualified so as to be withdrawn or forgotten, when a picture would be a blow beyond recall.

GEORGE WM. CURTIS
(From a photograph)

" The pictures you suggest are, as usual, telling arguments and hard hits," he says. " Some of them are so hard that I hope it may not be necessary to use them."

It is possible that this letter marked the beginning of the two widely different policies which so often distinguish the editorial and pictorial pages of the great Journal of Civilization. Curtis and Nast were allowed to fight civilization's battles, each in his own way. One used a gleaming battle-axe and struck huge slaughtering blows—the other, the rapier and the foil, with a manual of carte and tierce, of subtle feint and thrust. When the two methods conflicted, as they were bound to do, it was Fletcher Harper who stepped in and made plain a policy that was wide enough to include both.

" The Weekly is an independent forum," he would explain. " There are many contributors. It is not necessary that all should agree. Mr. Curtis and Mr. Nast are personally responsible—each for his own contributions."

It was seldom that he refused to publish any sincere expression of opinion, whether written or drawn. It was a time of individuals rather than of policies.

And there were giants in those days.

CHAPTER XVII

A CAMPAIGN AND A RECOGNITION

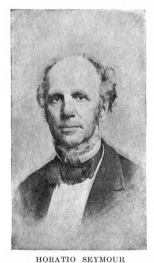

HORATIO SEYMOUR
(From a photograph)

Harper's Weekly opened the Presidential Campaign of 1868 by reprinting on June 6th the picture of Columbia decorating Grant, first published during the winter of sixty-four. This was followed by some caricature cartoons in which Chief Justice Salmon P. Chase —a candidate for the Democratic nomination—is most prominent. One of the first of these depicts Chase as a parson, wedding Democracy to the negro vote. In this picture appear Manton Marble, then editor of the World, John T. Hoffman, candidate for Governor, the elder Bennett, John Morrissey and others of the " faithful," including Horatio Seymour, whose face lent itself to the sort of caricature Nast most loved. Seymour was rather bald and had two little side locks which projected upward, like horns. Nast merely accentuated these and gave the face a slightly satanic cast. The result was as diabolical as it was humorous. Seymour, who, in good faith, had refused to be a candidate, eventually proved the choice of his party and became the demon-satyr of the campaign.

The Democratic Convention was held at Tammany Hall, then just completed on its present site. Many of the prominent leaders of the South were actively present, including General Forrest, Wade Hampton, and John B. Gordon. Friends had suggested, kindly enough, that with their records fresh in the public mind these men might properly remain in obscurity. This advice they resented with great indignation and insisted on being foremost in parliament and conclave. The result was that the decision of the Convention was not likely to be favorable to a man like General Hancock, who, though a Democrat, was a gallant Union soldier, nor to Salmon P. Chase, who had declared for universal suffrage and the

A WILD-GOOSE CHASE
POLITICAL POSITION OF CHIEF-JUSTICE CHASE
(Salmon P. Chase trying to capture the Democratic Convention of 1868)

payment of the government bonds in gold. " The same money for the bond-holder as for the plough-holder " was the cry, and " Down with military usurpation! " Wade Hampton caused to be embodied in the platform a plank which declared " that we regard the Reconstruction Acts of Congress as unconstitutional, revolutionary, and void."

After that there was but one of two things to do. They must either nominate a Confederate general or a Northern man of similar convictions. They recalled Horatio Seymour's war record, including the Draft Riot episode, and on the morning of the fourth day in spite of his protests, in a grand whirl of enthusiasm, selected him to head the ticket. For the second place they chose General Frank P. Blair of Missouri, whose chief qualification, from the Convention's point of view, seemed to be the

fact that, having fought bravely for the Union, he was now willing to engage in an effort to undo most of what as a soldier he had helped to accomplish. Blair not only subscribed to the

Time, midnight. *Scene*, New York City Hall.
LADY MACBETH—"Out, damned spot! out, I say! . . ."
SEYMOUR AS LADY MACBETH

Wade Hampton idea, but declared it to be the one real issue of the campaign. His nomination was received with wild acclaim, and incendiary speeches followed. Among these was one by Governor Vance, of North Carolina, who declared that all the South had lost when defeated by Grant, they would regain when they triumphed with Seymour and Blair. Once more, for a brief day, Confederacy was in the saddle.

Naturally, it was just the sort of a campaign to suit Thomas Nast. The issues were fierce and bitter. The war was to be fought over again.

Yet he began rather tardily, biding his time. Then, in the late summer, he opened with a page cartoon of three elements of Democracy clasping hands, each with a foot set heavily on the prostrate colored man. But this was mild and general. Seymour the Satyr, as Lady Macbeth, regarding with awesome terror the stain left by the Draft Riots, more clearly indicated what was to be the real point of attack. Indeed, this picture was presently included with the old " Compromise " cartoon of sixty-four in a fierce political pamphlet which was distributed broadcast. The campaign grew much warmer presently, and Nast always worked better when the issues began to flame and

sizzle. By the middle of September he was flinging weekly thunderbolts into the enemy's ranks. Seymour the demon-satyr tempting Columbia—Seymour the satyr leading the Ku-klux Klan—Seymour wallowing in a sea of troubles as the State elections began to tell the tale of defeat, were shots swift and sure. On October 10th appeared " Patience on a Monument "—" Patience " being the colored man, and the " Monument " a tower reciting the record of his wrongs—the tale of the Draft Riots and other outrages, in extracts from the public press. The Cincinnati Gazette reprinted the " Monument " cartoon as a special supplement. A campaign publication called the Mirror, issued " as often as occasion might require," was made up entirely of his pictures, with appropriate extracts. All these told on the feelings of men who had battled in the field for principles which now seemed likely to be sacrificed through the ballot-box. They were aroused to the point of declaring that they " would vote the way they had shot," and the returns from each State elections became fearsome handwriting on the Democratic walls.

" LEAD US NOT INTO TEMPTATION "

One of the final and most effective pictures (October 31) showed Seymour on the one hand announcing to the Draft Rioters that he is their friend and will have the draft suspended and stopped, while on the other stands Grant in uniform, and just beneath him his letter to General Pemberton at Vicksburg—written almost at the exact period when the Riots were in progress—announcing no terms save those of an " unconditional surrender of city and garrison." Even those soldiers who had followed gallant Frank Blair in the march

SEYMOUR SAYS THE NOMINATION " HAS PLUNGED HIM INTO A SEA OF TROUBLES "

"from Atlanta to the sea" grew uneasy of conscience when they thought of casting a vote for one who was now so fiercely espousing the " lost cause."

Indeed, though he had been but slightly noticed in the cartoons, it was chiefly Blair's campaign. Seymour had taken little active part in the canvass, while Blair had gone abroad in the land, scattering the most alarming utterances. The sad unwisdom of this became apparent as the returns for each State election came in. In the eleventh hour it was determined that Blair was a mistake. Those who had shrieked their enthusiasm at the moment of his nomination now demanded that he retire to the rear. Manton Marble of the World was for dismissing him altogether.

Seymour went to the front, but to no purpose. His ticket was confessedly weak. In the election he obtained but eighty of the electoral votes, while two hundred and fourteen were secured for Grant.

Yet it had not been so great a Republican victory as these figures would seem to indicate. New York had been carried for Seymour. New Jersey and Oregon had likewise gone Democratic,

while in California and Indiana the results were disturbingly close. Had Seymour received the vote of the " solid South," Grant would have been defeated.

Under the circumstances it was but natural that the successful candidates should feel grateful to a man like Nast, whose cartoons were believed to have materially aided the Republican cause. Letters of thanks came from all quarters. From John Russell Young, then managing editor of the Tribune, came a hearty line of commendation and unstinted praise. He said:

I want, as one citizen of this free and enlightened country, to thank you for your services in the canvass. In summing up the agencies of a great and glorious triumph I know of no one that has been more effective and more brilliant. I salute you on the threshold of a splendid career.

But it remained for Grant himself to pay the final word of tribute.

" Two things elected me," he said: " the sword of Sheridan and the pencil of Thomas Nast."

Tammany, it is true, through a fraud which has

PATIENCE ON A MONUMENT

9

"LET US HAVE PEACE." *MATCHED.* (?) "A MOB CAN REVOLUTIONIZE AS WELL AS A GOVERNMENT."

HEAD-QUARTERS DEPARTMENT OF TENNESSEE, IN THE FIELD NEAR VICKSBURG July 3, 1863.
Lieutenant-General J. C. Pemberton, commanding Confederate Forces, etc.:
 GENERAL,—Your note of this date, just received, proposes an armistice of several hours for the purpose of arranging terms of capitulation through commissioners to be appointed, etc. The effusion of blood you propose stopping by this course can be ended at any time you may choose, by an unconditional surrender of the city and garrison. Men who have shown so much endurance and courage as those now in Vicksburg will always challenge the respect of an adversary, and I can assure you will be treated with all the respect due them as prisoners of war. I do not favor the proposition of appointing commissioners to arrange terms of capitulation, because I have no other terms than those indicated above. I am, General, very respectfully, your obedient servant,
 U. S. GRANT, Major-General.

GOVERNOR SEYMOUR'S SPEECH TO THE NEW YORK RIOTERS.
 MY FRIENDS,—I have come down from the quiet of the country to see what was the difficulty, to learn what all this trouble was concerning the draft. Let me assure you that I am your friend, [Uproarious cheering.] You have been my friends. [Cries of "yes," "—"that's so"—"we are, and will be again."] And now I assure you, my fellow-citizens, that I am here to show you a test of my friendship. [Cheers.] I wish to inform you that I have sent my Adjutant-General to Washington to confer with the authorities there, and to have this draft suspended and stopped. [Vociferous cheering.] I now ask you as good citizens to wait for his return, and I assure you that I will do all that I can to see that there is no inequality, and no wrong done any one.—NEW YORK TRIBUNE, July 14, 1863.

(Grant at Vicksburg, July, 1863) (Seymour in New York, July, 1863)

become notorious in our political history, and of which we shall hear again, had triumphed in New York City and State: John T. Hoffman had been chosen as Governor, while A. Oakey Hall had been selected to succeed him as Mayor. There was a recognized need of a crusade for civic reform, but the conditions were not yet ripe. Once during the campaign (Oct. 10th) Nast had paused long enough to issue another manifesto of warning. This was a small cartoon of Hoffman standing before a screen, behind which a gang of thieves is busily rifling the City Treasury. Above them is the legend " Thou shalt steal as much as thou canst," signed " The Ring." No face but Hoffman's was depicted, and Hoffman doubtless gave little heed to what he perhaps considered merely a bit of campaign pleasantry. On Janu-

ary first he took his seat at Albany in the pleasant assurance that all was going well in city and State, and that for a term at least " virtue " must prosper at both ends of the line.

It was during the summer of 1868 that Anson Burlingame, one of America's noblest diplomats, then late United States Minister to China, was making a tour around the world with a retinue of Chinese officials, having been appointed by Prince Kung to act as Special Chinese Ambassador to other nations, the only such instance on record. Nast celebrated the episode in a cartoon entitled " The Youngest (America) Introducing the Oldest (China) " to the nations of the world. Mr. Burlingame admired the picture, and from Washington, in July, wrote:

My Dear Nast:
Permit me to thank you most cordially for sending to me Harper's containing your wonderful creation entitled, " The

THE YOUNGEST INTRODUCING THE OLDEST

AMERICA : " Brothers and Sisters, I am happy to present to you the Oldest Member of the Family, who desires our better acquaintance."

(Nast's cartoon in commemoration of Anson Burlingame's trip around the world as special Chinese ambassador. Mr. Burlingame is seated at the right)

A RESPECTABLE SCREEN COVERS A MULTITUDE OF
THIEVES

(A Ring cartoon of 1868—Hoffman the screen to cover
the city frauds)

Youngest Introducing the Oldest." On all hands it is pronounced the best thing of the kind yet seen. I hope to meet and talk with you about it.

Pardon this hasty note, and believe me, ever,

Yours truly,
Anson Burlingame.*

The poet-editor of the New York Evening Post, another admirer of Nast at this time, one morning sent a request that the artist drop around and meet a young lady who had found pleasure in his pictures. Nast agreed but forgot to go, and Mr. Bryant wrote a little formally to remind him.

Dear Sir:

Miss Hatfield has been here this morning in hope of meeting you. As you did not come, she desired to know if it will be agreeable to you to come next Friday, as soon after half-past nine in the morning as may suit your convenience. I shall come in on that day from the country, and she will be here.

Yours respectfully,

To Thos. Nast, Esq. W. C. Bryant.

Nast went this time and commemorated the occasion to the extent of making a good-natured caricature of the poet. That the picture did not offend the subject is shown by his comment in a subsequent letter to Miss Hatfield.

As to the caricature, it is very clever, and if the subject were any other than myself, I have no doubt that I should like it. All that could be asked of me, I think, is that I should not object to it.

* Mr. Burlingame proceeded on his tour, from America, negotiating numerous treaties for the Chinese Government. But in St. Petersburg he was taken suddenly ill, and died (February, 1870), mourned in many nations.

The years of Reconstruction had constituted an epoch of chaos and disorder. It was the inevitable transition period, when the war—shifted from the field forum—was to rage and rankle, and fade into purposeless discussions of no definite beginning, no climax and no absolute end so long as the issues themselves were not wholly dead. The apostasy of Andrew Johnson had distorted even such measures of good as had resulted from that unhappy interregnum which, viewed in retrospect, seems as a dark smirch on the nation's history.

"FAREWELL, A LONG FAREWELL, TO ALL MY GREATNESS!"

But with the return of the seceding states and the election of Grant, hostilities became less openly violent. They might develop again with another presidential contest, but four years must elapse between, and the public impulse was for peace.

Nast was in Washington for the inaugural ceremonies, and on the morning of March 3d, when everybody was mystified as to the members of the new Cabinet, he made a drawing of Grant shaking five cats out of a bag. The cats were all complete except their heads. When the sketch had proceeded thus far the artist took it around to Grant's headquarters and sent it in with a polite request that the President of to-morrow should add the heads. Grant did not comply with the request, but good-humoredly promised to do so on Friday at noon, by which the public knew that there was to be no delay in his selections.

It was in April of this year that the artist received a handsome public recognition of his services. His fellow members of the Union League Club under the leadership of Colonel Rush

C. Hawkins, formerly commander of " Hawkins' Zouaves," combined in the presentation of a beautiful silver vase, representing loyal Art armed with porte-crayons piercing the open-mouthed dragons of Secession. This vase, designed by Colonel Hawkins, bore the following inscription:

Thirty-six members of the Union League Club unite in presenting this vase to Thomas Nast, as a token of their admiration of his Genius, and of his ardent devotion of that Genius to the Preservation of his Country from the schemes of Rebellion.
April, 1869.

The Union League Club—itself an organization for devising ways and means to preserve the Union—thus conferred upon Thomas Nast its highest form of recognition.

THE " UNION LEAGUE " VASE

The presentation took place on the evening of the 27th and was a memorable affair. Many of the nation's leaders gathered to see this public honor done to one who less than a quarter of a century before had been a little Bavarian boy in the meadows back of Landau. If only the Commandant of the barracks might have been there to see it all, and to listen to the fine things that were said about the little lad of whom he had prophesied so kindly. Senator Henry Wilson, afterwards Vice-president, James Parton, Richard Grant White, and others contributed words of praise. In Nast's reply to the presentation speech he refers to himself as " standing just beyond the threshold " of his career, and had he waited to review his life through the perspective of years, he could not have expressed the truth more exactly.

FROM LONDON *PUNCH.* MAY 29, 1869.

SIR JONATHAN FALSTAFF.

PRINCE OF WALES. "HURRAH, DO I OWE YOU A THOUSAND POUND?"
SIR JONATHAN. "A THOUSAND POUND, AL'!—FOUR HUNDRED MILLION! THY LOVE IS WORTH FOUR
HUNDRED MILLION! THOU OWEST ME THY LOVE."—SHAKESPEARE (*slightly altered*).

HARPER'S WEEKLY, JUNE 26, 1869.

SIR JOHN BULL FALSTAFF.

PRINCE JONATHAN. "HERE COMES LEAN JACK; HERE COMES BAREBONES! HOW NOW MY SWEET
CREATURE OF BOMBAST? HOW LONG IS'T AGO, JACK, SINCE THOU SAWST THINE OWN KNEE?"—
SHAKESPEARE (*not altered*).

(Nast's mastery of the pencil began with this picture)

CHAPTER XVIII

THE BEGINNINGS OF A CRUSADE

It was during the summer of 1869 that the Alabama claims against England for the destruction of Union merchantmen by Confederate commerce destroyers built in British ports, merited frequent pictorial attention. The cartoon of June 26th relates to this complication and is notable for two reasons— first, in showing the better feeling which now existed between England and America, and second, the evidence in it of a marked change in the artist's method. Drawings for illustration were still made on wood blocks and engraved by hand. Most of Nast's earlier work had been done with fluid color, washed in with a brush. In the "Not Love but Justice" above mentioned, the artist, inspired by a masterly drawing in London Punch, discarded the brush and used his pencil with a care and insight scarcely comprehended before.

It was as if, all at once, he had " found himself." Former methods were used less and less, while his immediate and wonderful mastery of " cross-hatch " pencil work resulted in those inimitable drawings by which he will longest be remembered.

Domestic and moral cartoons were continued through 1869. The Weekly, on July 19th, published a page picture relating to the opening of the Pacific Railroad, and the " All Hail and Farewell " philippic with which Wendell Phillips heralded the completion of the great new enterprise. The picture is chiefly interesting now in the fact that it recalls the fierce opposition of Phillips to this particular step of progress and his violent expression of sentiments which long since have been stored amid the dust and dusk of archaic things. He says:

The telegraph tells us that the Indians have begun to tear up the rails—to shoot passengers and conductors on the road. We see great good in this! . . . Haunt that road with such dangers that none will dare to use it.

Nast drew Phillips as a redskin, knife in hand, lying across the track, with a locomotive under full steam, bearing down upon him. Long before the end of the year the locomotive had passed by and trains across the continent were running on schedule time.

College Athletics and the International Races were used as pictorial material during this year—also the terrible Black Friday (September 24, 1869) when, through the manipulation of Jay Gould and James Fisk, Jr., gold at 11.36 A.M. touched $162\frac{1}{2}$ and closed at $133\frac{3}{8}$, with a net profit to these " operators " of something more than ten million dollars. It is true they were obliged to get an injunction under a " Tweed Ring " judge to prevent the Gold Exchange from adjusting the many claims against themselves, but these were tactics not unusual to a time when the man with money got such justice as accorded with his own ideas. Nast's picture shows Wall Street blockaded with

dead bulls, with the face of "Old Trinity" grimly regarding the scene of slaughter. It would seem now that this particular phase of plunder might have been entitled to further pictorial notice; instead of which, "Sectarianism in the Public Schools" and "Chinese Exclusion"—measures to which Nast was always bitterly opposed—claimed his attention.

But in the light of later events the most notable cartoons of 1869 were two caricature drawings in which appear portraits of "Boss" Tweed. The first of these was published on September 11, 1869, to commemorate certain resolutions charging August Belmont with party misfortunes and shortcomings. It was a small picture—a cloud no bigger than a man's hand —in which Belmont is depicted as the Democratic scapegoat, while Tweed holds the chair of presiding officer. The second Tweed picture is entitled "The Economical Council, at Albany, New York," and comes at the end of the year. Governor Hoff-

"WHAT A FALL WAS THERE, MY COUNTRYMEN!"
(The wreck in Wall Street after Black Friday, September 24, 1869)

man as high-priest sits on a dais with Peter B. Sweeny at his right hand. Facing them are the faithful cohorts of high taxes and plunder—conspicuously among them appearing A. Oakey Hall, Richard B. Connolly and William M. Tweed. On Tweed's mitred headgear appear the words "Big Six" and the Tiger-head emblem. The members of the famous ring were assembled, at last. Not conspicuously and apart, as they were to appear later, but simply as integers of a powerful and corrupt political combination which Thomas Nast and his paper were first to denounce and assail.

Nast's inherent loathing for anything that resembled a combination for the purpose of unfair advantage is shown in his own retirement from the savings bank board of trustees, because that institution had voted salaries to himself and other inactive officers out of the bank funds. In his resignation he said:

" I have always understood that this was a charitable institution and that the trustees willingly gave their service gratui-

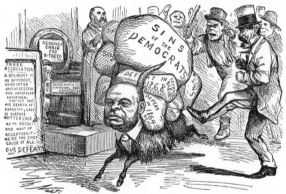

THE DEMOCRATIC SCAPEGOAT
(The first cartoon in which the face of " Boss " Tweed appears)

tously. But the resolutions passed at the last regular monthly meeting prove it to be a charitable institution for the trustees.

" You speak eloquently of gathering the crumbs of the poor, but it appears to me that after they are gathered you would put them in your own pockets. Therefore, not caring to belong to a Savings Bank ' Ring,' I tender my resignation, which shall be accepted."

A combination for looting the public treasury, however powerful might be its members, or whatever pressure might be brought to bear, could expect little in the way of mercy from the hand which had written that letter. In their ignorance or arrogance it may be that the " Ring " did not give much heed to a picture paper. Yet they must have known of the punishment of Johnson and of Seymour—who were as crucified martyrs beside these soulless freebooters—and it is likely that the cartoon of December 25th did not escape the notice of Tammany Hall. Perhaps if Tweed and Company's attention had been called to that communication, and if in the light of its meaning they had considered those few early cartoons, they might have read in these hints and signs the gradual gathering of a storm that would not " blow over."

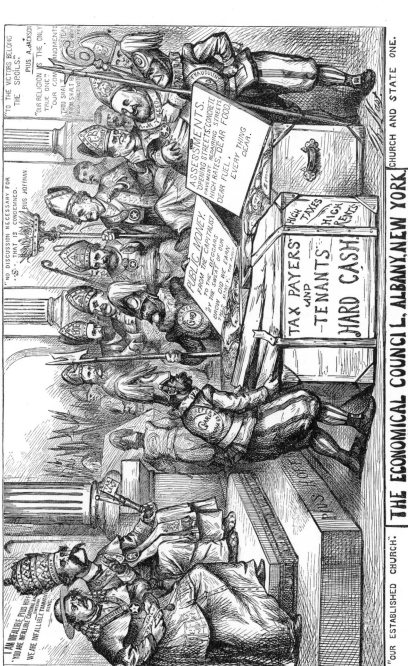

THE SECOND TWEED CARTOON. HOFFMAN SITS ON THE DAIS, WITH SWEENY AT HIS RIGHT HAND. HALL, CONNOLLY, AND TWEED ARE PROMINENT AMONG THE SUPPORTERS, AS ARE JAY GOULD AND "JIM FISK" OF THE ERIE CONTINGENT

(This is the first cartoon in which all the members of the Ring are identified)

PART THREE: THE REFORMER

CHAPTER XIX

THE RING IN ITS GLORY

THE RING
{
William Marcy Tweed, alias " Big Bill," or " The Boss."
Peter Barr Sweeny, also called " Brains " and, disrespectfully, " Pete."
Richard B. Connolly, known almost from childhood as " Slippery Dick."
A. Oakey Hall, often, by himself, written " O. K. Hall "; and by Nast, " O. K. Haul."
}

With the beginning of the year 1870, the government of the City of New York was wholly in the hands of the four men whose names and aliases are bracketed above. Their reign was as absolute as if they owned every street, public building and park of the city, with most of the inhabitants, body and soul.

They did, as a matter of fact, own or control every public office in New York City, and a working majority in the State Legislature, while the Tammany governor, John T. Hoffman, was a mere figure-head, elected and directed by the Ring.

Nor did the baleful influence of corruption end with State and city officials. Bondholders, contractors, merchants, artisans—even ministers of the gospel and philanthropists—were hoodwinked, intimidated or subsidized into aiding those gigantic pilferings which in a period of less than thirty months defrauded the City of New York of a round thirty millions of dollars,

emptied the treasury and added more than fifty millions to the public debt which, in the form of taxation, we and the generations to follow must pay.

Considered in retrospect it would seem that one-half of the city had combined in a vast alliance to plunder the other half, with Tweed, Sweeny, Connolly and Hall as captains of the enterprise.

It is difficult to understand the moral and patriotic impulses

THOMAS NAST, 1871

of a community in which such a condition could endure. It would almost seem that some dire influence of the planets was operating upon the lives and minds of those who, under normal conditions, would be expected to represent and to preserve the city's moral, political and financial integrity. As an example of the Ring's supremacy, one has but to refer to the files of that period to learn that, for a time, the great majority of the metropolitan daily press was frankly for the municipal government, while the remainder—to pervert an old line—praised it with faint condemnation, or remained silent, when silence was itself akin to crime.

It seems hardly necessary to add that the great journals which survive have changed completely, not only in their management and personnel, but most of them in politics and ownership, since that unhappy period. It is not conceivable that any respectable metropolitan paper of to-day could be bought or bulldozed, or would knowingly become a sharer in city plunder, or in any act or word abet a band of public thieves. It has been said of our press that it is less individual and less vigorous than in those

strenuous days, and it may be true; also, thank God! it is less corruptible.

But in that evil hour the blight of the Ring had extended to every corner of the city's moral and intellectual life. When it is remembered that not only men whose political and financial ambitions rendered them sensitive to its influence were bought or blinded, but that such a venerable and justly venerated man as Peter Cooper was for a time misled into public support of Tweed and his associates, it may be conceived that the general public was hopelessly confused as to facts and principles, while those whose clearer vision impelled them to reform, remained in what seemed a hopeless minority.

Even Parton, who had himself assailed the city government,* tried to dissuade Nast from his efforts against the Ring, declaring that he could never win the fight and that it was foolish and Quixotic to try.

"They will kill off your work," he said. "You come out once a week—they will attack you daily. They will print their lies in large type, and when any contradiction is necessary it will be lost in an obscure corner. You can never withstand their assaults, much less hope to win."

Well, indeed, might Tweed ask in the first days of exposure, "What are you going to do about it?" and Mayor Hall, "Who is going to sue?"

The Ring itself was a curious assortment of incongruous natures—its single bond of unity being that of sordid self-interest and gain. Tweed, the leader—supervisor and commissioner of public works, etc., etc.—who had begun his public career as foreman of the Americus or Big Six Fire Company, was a coarse and thoroughly ill-bred ward politician, a former member of

* "The Government of the City of New York," North American Review, 1866. In this article Parton stated that the aldermen, within ten years (1851 to 1861), received not less than one million dollars in bribes for granting public franchises —an aggregate that seemed trivial enough in the days of later and larger enterprises.

the " forty thieves " Board of Aldermen (1860), a drinking, licentious Falstaff, with a faculty for making friends. Sweeny —park commissioner, city chamberlain, etc., etc.—was a lawyer of education and ability, sombre and seclusive—a man who loved to control great multitudes, unseen—to direct legislation, unsuspected. Connolly, controller of public expenditures (a bank clerk who had early acquired the sobriquet of "Slippery Dick"), was a shifty human quantity without an honest bone in his body; while Mayor Hall—"Elegant Oakey," as they called him —was a frequenter of clubs, a beau of fashion, a wit, a writer of clever tales, a punster, a versatile mountebank, a lover of social distinction and applause.

GEORGE JONES, 1871

Tweed was the bold burglar, Sweeny the dark plotter, Connolly the sneak-thief, Hall the dashing bandit of the gang. This curious assembly constituted the great central Ring. Other Rings there were, and Rings within Rings—each with its subsidiaries and its go-betweens—but all tributary to the motley aggregation of four whose misdeeds have been the one reason for preserving the record of their features and their lives.

Their methods were curiously simple and primitive. There were no skilful manipulations of figures, making detection difficult. There was no need of such a course. Connolly, as Controller, had charge of the books, and declined to show them. With his fellows, he also " controlled " the courts and most of the bar. The ordinary citizen with a desire to exercise his right of inspection of the city's accounts did not fare well. Men with claims against the city—Ring favorites, most of them—were

told to multiply the amount of each bill by five, or ten, or a hundred, after which, with Mayor Hall's " O. K." and Connolly's indorsement, it was paid without question. The money was not

handed to the claimant, direct, but paid through a go-between, who cashed the check, settled the original bill and divided the remainder (usually sixty-five, sometimes ninety per cent. of the whole) between Tweed, Sweeny, Connolly and Hall— Tweed and Connolly getting twenty-five per cent. each, and Sweeny, Hall and the underlings the residue.* When the pub-

THREE BLIND MICE! SEE HOW THEY RUN!

THE "WHITE-WASHING COMMITTEE" INVITED BY THE RING CONTROLLER TO INSPECT HIS BOOKS

lic began to grumble, as it did at last, it seemed at first no great matter. A committee of six of New York's wealthiest and most influential citizens were invited to examine the Controller's books.†

Hall and Connolly picked these men, who showed their appreciation of this, and of other and more substantial favors, it

* In Tweed's confession he said that E. A. Woodward, James Sweeny (brother to Peter B.), James Watson and Hugh Smith were the Ring's financial agents. Also that it was first agreed that each member of the Ring should receive ten per cent. of the gross amount of the bills presented and paid. When a few such bills had been paid, Hall was informed that members of the Ring would have to be content with five per cent., after which the Mayor received only that sum, Woodward and Watson being directed to pay Hall five per cent., Sweeny ten per cent., and to pay Connolly and Tweed each twenty-five per cent. This last arrangement was made, Tweed said, without the knowledge of Hall or Sweeny, by which it will be seen that there was not, in this case, even the old proverbial " honor among thieves."

† John Jacob Astor, Moses Taylor, Marshall O. Roberts, George K. Sistare, E. D. Brown and Edward Schell—afterward known as the " white-washing committee."

may be, by a published " certificate of good conduct " in which they said:

We have come to the conclusion, and certify, that the financial affairs of the city, under the charge of the controller, are administered in a correct and faithful manner.

Certainly nothing could establish " Slippery Dick's " credit more firmly than such a document as this, and when we begin to look for explanation we cannot help noting the fact that it was not necessary in those days for a millionaire to claim residence in Newport to avoid his taxes. The accommodating courts had a habit of vacating assessments for what, in certain legal documents, is described as " love and affection " and a modest " sum in hand, duly paid."

Then, when the notorious " Viaduct Job " came along and we find the names of most of these gentlemen, as well as those of the leading newspaper owners—associated with the names of Tweed, Sweeny, Connolly and Hall, and some seventy other good men and true—as stockholders and directors, we begin to under-

stand how the Ring, like a great malignant cancer, had sent its fibrous growth through every tendon and tissue of the body politic, to possess, to poison and to destroy.

As we have seen, Thomas Nast, almost single-handed, had been assailing the corrupt municipal government, beginning as early as 1867, and dropping an occasional hot shot into the camp of the public enemy, until by the end of 1869 he had singled out the

LOUIS JOHN JENNINGS

chief malefactors for special assault. Once Manton Marble, of the World, had lent a hand so far as to declare of Tweed,

He thrives on a percentage of pilfering, grows rich on distributed dividends of rascality. His extortions are boundless in their sum as in their iniquity.

And just here, by not standing firm, it would seem that Manton Marble missed a priceless opportunity. Somewhat later we find him, as champion of the Ring officials, announcing,

There is not another municipal government in the world which combines so much character, capacity, experience and energy as are to be found in the city government of New York, under the new charter. The ten most capable men in the National Administration at Washington would be no match in ability and sagacity for the best ten in the New York City government, although General Grant has the whole country to select from.

"A LIVE JACKASS KICKING A DEAD LION"
And such a Lion! and such a Jackass!

THE FIRST USE OF THE "DONKEY" SYMBOL

This from the World of June 13, 1871, was written in all seriousness. Its flavor of humor has been acquired with the lapse of a generation.

But another champion of good government was ready to take up arms where Marble had laid them down. There had been a change of management in the New York Times, which, with George Jones at the helm and Louis John Jennings as editor, was to become a fierce and uncompromising organ of municipal reform. Jones was daring to the point of rashness. Jennings was a capable and unyielding Englishman, afterwards a member of Parliament. The Times under their direction, with Harper's Weekly as its great pictorial ally, prepared to engage in a mighty work of destruction, the end of which no man could foresee.

We may pause here to consider briefly certain other matters of this period. In the issue of January 15, 1870, appeared " A

"WHO GOES THERE?"—"A FRIEND"

Live Jackass Kicking a Dead Lion," the " Jackass " being the Copperhead Press, and the " Lion " Edwin M. Stanton, who had died on December 24th and whose memory had been assailed, even as he lay in his coffin. The cartoon went to the mark, but is chiefly not-able now as being the earliest in which the donkey is used to typify Democratic sentiment.

There was not much in the way of general politics in the cartoons of that year. The mutterings of war abroad and the final clash of arms between France and Germany resulted in a number of rather bitter portrayals of Napoleon III., who had been

"THE SEAT OF WAR." NAPOLEON III. TRYING
TO SEAT THE PRINCE IMPERIAL

NAPOLEON

"DEAD MEN'S CLOTHES SOON WEAR OUT."

always a disturber in European affairs and was now, as usual, on the wrong side. Nast did not forget the French Emperor's treatment of Garibaldi in 1848, and as the Franco-Prussian war continued, caricatured that sovereign in a manner which was at once prophetic, severe and just. Probably the best of the Napoleon cartoons is that of "Dead Men's Clothes Soon Wear Out"—an adaptation of "Napoleon I., after Waterloo"—showing the defeated Louis plunged in despair, and clad in the tattered uniform of his great relative.

The Chinese Labor question likewise received attention, with Nast as the avowed champion of the abused and maligned Celestial, while both in the Weekly and in the Bazar there were occasional moral and social cartoons which brought the artist many words of approval and not a few of reproof—among the latter being an open letter in the Bazar from Gail Hamilton—"A Woman vs. Mr. Nast"—roundly scoring him for suggesting, in a drawing entitled "The Lost Arts," that a woman

should do her own housework and not forget the use of
the needle, the stew-pan and the broom. A Memorial Day
picture showing the Confederate and the Union graves being
decorated side by side, brought a protest from a Union
general.

But though fewer in the aggregate the Ring cartoons were by
far the most important work of 1870. The first of these, pub-
lished early in January, was a double page entitled '' Shadows
of Coming Events,'' and it stands to-day as a prophecy. One
has but to look it over carefully and then follow the history of
1870 and '71 to see how clear and how exact in detail was the

THROWN COMPLETELY INTO THE SHADE

artist's forecast. At
the bottom of the
page there is shown
a collection of little
statues of Tweed,
Sweeny, Connolly
and Hall, surround-
ing the equestrian
statue of Hoffman,
and in this, also,
there was a note of
prophecy, for a peti-
tion was circulated
a year later to erect
a statue of Tweed.

No lengths were
too great for the
Ring to go to obtain
power. With no
sort of religion
among its members,
it lured the good

THROWING DOWN THE LADDER BY WHICH THEY
ROSE

will of the clergy with gifts and concessions— most of which went to the Catholics, for the reason that a large percentage of the foreign immigration— an important political factor—professed that creed. The union of Church and State, and proselyting in the public schools, were favorite Ring doctrines adopted to win the allegiance of Romanism. Nast assailed fiercely these phases of political chicanery. He was inspired by no antagonism to any church—indeed he was always attracted by Catholic forms and ceremonies— but his unconquerable aversion to anything that did not savor of complete religious as well as political and personal liberty resulted in cartoons against political Romanism that brought down upon him bitter and furious denunciations and even threats from the Catholic press. Finally a bill was presented to the State Legislature—a Ring provision for a school-tax levy—but chiefly prepared as an official protest against

" an artist encouraged to send forth in a paper that calls itself a ' Journal of Civilization ' pictures vulgar and blasphemous, for the purpose of arousing the prejudices of the community against a wrong which exists only in their imagination."

Curiously personal language, this would seem, to be dignified by embodiment in Assembly Bill No. 169, of March 31, 1870. Probably no other caricaturist before or since has achieved such peculiar official distinction. The bill was naturally supported

by the sectarian press, which referred feelingly to the " Nast-y
artist of Harper's Hell Weekly—a Journal of Devilization.''

It was early in 1870 that the New York Times joined in the
fight against the Ring. A Republican organ, Tammany was a
natural enemy whose iniquities, as well as the personal deport-
ment of Tweed, had received a measure of notice. The Ring
proper was now marked for special attack.

The paper began by complimenting the fearless and powerful
work of Nast. Referring to his " Coming Events,'' it said:

The sketches of New York life under Democratic rule may
not be entirely welcome to Tammany chiefs, but the great body
of citizens will sorrowfully admit that they are not in the least
exaggerated. Mr. Nast ought to continue these satires on local
and National politics.

Mr. Nast did continue as did the Times, also, and presently we
find the latter boldly branding Tweed and his associates as com-
mon thieves.

Of course this stirred up a storm on Park Row. The

SENATOR TWEED IN A NEW RÔLE

(Tweed triumphant is urged to reform. On the belt of the prostrate figure are the words " O'Brien
Democracy '')

" controlled " press denounced the Times and Harper's Weekly as disgruntled organs, inspired by unworthy motives, and seeking to create a sensation. Yet the Ring became a little uneasy, for it promptly offered Jones a million dollars for silence. A weekly paper, with only a picture now and then, did not, as yet, appear so dangerous; but a daily whose editor made a point of branding them every morning —in capital letters, singly and collec-

EXCELSIOR.

(Nast's characterization of Tammany before the use of the Tiger symbol)

tively—as thieves, seemed worth considering. Jones did not take the million, and the offer only strengthened his purpose. Editor Jennings double-leaded his leaders, and Nast increased the number and severity of his pictures. Sweeny, who had been most prominent in the earlier drawings, gradually dropped into second place as Tweed by skilful " legislation " secured a new city charter which gave the Ring still more absolutely power of political life and death over almost every city official. This was a complete triumph for the Ring over an

element calling itself the Young Democracy—an organization including James O'Brien, then sheriff; Harry Genet, John Morrissey and others, whose purpose had been to undermine the "Boss's" power. After this the name of Tweed always came foremost, while his great hulking figure dominated the pictures. In June a herald of Tammany is shown as having ascended to the peak of a high mountain, from which he waves a banner of corruption to the world. The locks of this handsome figure resemble horns. The cape on his shoulders is blown back to suggest diabolical wings. It is a striking picture.

Just before the fall election Nast contributed two especially strong cartoons. One of them was entitled "The Power behind the Throne"—the "throne" being that of Hoffman, the "power" being the sword of Tweed and the axe of headsman Sweeny. Here once more the Tiger symbol appears, rather more definitely this time—though still merely as a sign manual —while the face of Jim Fisk, an associate and co-worker, is discovered in the background. In the second cartoon, "Falstaff" Tweed is reviewing his army of "repeaters," consisting of roughs, jail-birds and tatterdemalions. Sweeny, Hall, Fisk and Gould are looking on, while Hoffman has dwindled to his great chief's sword-bearer. Above all is the sign of "Tammany Inn" with its Tiger emblem.

It was a good fight that Jennings and Nast were making for better government, but the odds were still too great. On election day many respectable but timid voters remained within doors while "repeaters" were marched shamelessly from one polling-place to another. Once more the Ring was triumphant, and the Tiger banner was flaunted victoriously in the breeze.

A word here about the Tiger emblem. Originally the symbol of the Americus or Big Six Fire Company, of which Tweed had been foreman, it had been conferred upon Tammany Hall at the time of his accession to power. Nast at first began using it sug-

THE TAMMANY RING-DOM

THE POWER BEHIND THE THRONE.
HE CANNOT CALL HIS SOUL HIS OWN.

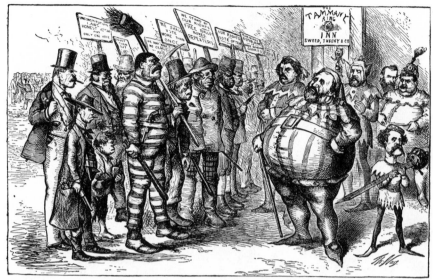

OUR MODERN FALSTAFF REVIEWING HIS ARMY

FALSTAFF—My whole charge consists of slaves as ragged as Lazarus, and such as indeed were never soldiers, but discarded serving-men and revolted tapsters. No eye hath seen such scarecrows. Nay, and the villains march wide between the legs, as if they had fetters on; for, indeed, I had the most of them out of prison.—*Shakespeare slightly varied.*

gestively, in the form of a special Tweed trade-mark or coat-of-arms, identifying the Ring and Tammany with Tweed's earlier career. But there was a curious fitness in the device. Tammany leaders had shown a tendency toward greed and stripes ever since William Mooney, called " the founder of the Tammany Society," as far back as 1809, had been superintendent of an almshouse and defaulted in the sum of five thousand dollars,[*] down through a long line of " financiers " to Fernando Wood, who escaped justice by pleading the statute of limitation, and Isaac V. Fowler, the great Tammany leader from 1855 to 1860, who defrauded the United States Government of upwards of one hundred and fifty thousand dollars.[†]

[*] Record MS. minutes of the Common Council, Vol. 20, pages 303 and 376-392.

[†] It is freely admitted, of course, that Tammany had its period of good government and courageous officials. During the corrupt period of the early fifties ('53 to '55) one Jacob A. Westervelt, Mayor, became known as " Old Veto," because of his persistent and successful opposition to aldermanic jobs and steals, and to police " graft." He was not reëlected.

Tweed's predecessors, however, had been but petty thieves, hardly worthy to be classed with the great sachem. Most of them had worked stealthily—stealing as the coyote and the hyena steal—avoiding retribution by flight and trickery. Tweed, immeasurably the boldest, mightiest plunderer of them all, gloried in the fierce emblem of his youth, and emblazoned forever on the Tammany banner that symbol of rapacity and stripes—the jungle king.

The beginning of 1871 found the Ring at the apex of its power. It is true that the blows already struck by Nast and Jennings on the brazen gates of infamy had not only attracted public attention but in a measure had alarmed the marauders concealed behind. Yet they were in no immediate danger. So securely intrenched were the offenders behind cunningly devised laws, fraudulent voting machinery and an army of accomplices, composed of capitalists, railway magnates, office-holders, prize-fighters, loafers, convicted felons and a subsidized press, that even the most ardent reformers almost despaired of ever bringing them to justice. The Times in an editorial of February 24 said:

There is absolutely nothing—nothing in the city which is beyond the reach of the insatiable gang who have obtained possession of it. They can get a grand jury dismissed at any time, and, as we have seen, the Legislature is completely at their disposal.

The Ring had imperial power over every public issue and franchise, not only in the city but the State. The Erie Railroad, with Tweed and Sweeny as directors and with Fisk and Gould as its financiers, was simply a gigantic highway of robbery and disgrace.

In the city, vast improvements were projected, some of which have since been completed for the public good. Perhaps because so little can be set down to the credit of the Ring,

the public is inclined to be unduly grateful for these blessings—forgetful that they were devised for no other purpose than to afford fresh avenues for a plunder that grew ever more enormous as the armies of the Ring increased and demanded ever

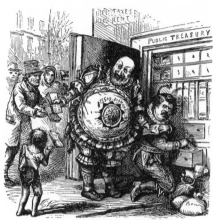

TWEEDLEDEE AND SWEEDLEDUM.
(*A New Christmas Pantomime at the Tammany Hall.*)
CLOWN (*to* PANTALOON). "Let's Blind them with *this*, and then take *some more.*"

greater largess as the price of faithfulness and silence. It was this rapacity on the part of its followers—those daughters of the horse-leech, with their insatiable cry of " Give, Give! "—the demand for more, and yet more, that resulted at last in the downfall and demolition of the Ring.

In Nast's first shot of the year 1871, " Tweedledee and Sweedledum," Tweed and Sweeny are shown as giving open-handedly from the public treasury to the needier of their followers, while they set aside still greater sums for their own account. Tweed's fifteen-thousand-dollar diamond, which has since become historic, was first depicted in this caricature. The picture was a small one, but it created a big mischief.

" That's the last straw! " Tweed declared when he saw it. " I'll show them d——d publishers a new trick! "

He had already threatened Harpers with an action for libel, and had prevailed upon deluded Peter Cooper to use his influence in behalf of the city officials.

He now gave orders to his Board of Education to reject all Harper bids for school-books, and to throw out those already on hand. More than fifty thousand dollars of public property was thus destroyed, to be replaced by books from the New York Printing Company—a corporation owned by the Ring.

The Harper firm held a meeting to consider this serious blow. A majority of the members would have been willing to discontinue the warfare on so mighty an enemy. Fletcher Harper never wavered. When at last the argument became rather bitter, he took up his hat and said:

" Gentlemen, you know where I live. When you are ready to continue the fight against these scoundrels, send for me. Meantime, I shall find a way to continue it alone."

They did not let him go, and the fight went on.

The widening and straightening of Broadway was to have been one of the most profitable of Ring jobs, but Auditor Watson, who seems to have had this particular scheme in hand, was suddenly thrown from a sleigh one night and instantly killed.

It was the beginning of the Ring's bad luck, for the result was a partial exposure of the crookedness of the affair, and Tweed found it necessary to hurry up to Albany and pass a bill abolishing the whole undertaking. Nast cartooned the situation perfectly. Then came another sectarian caricature which showed that it was not the Catholic church alone that he could criticise. In this picture the Protestant, as well, is shown with his basket laden with Ring favors.

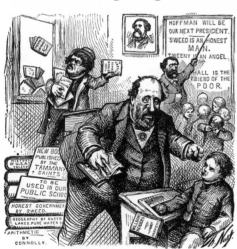

THE NEW BOARD OF EDUCATION. SOWING THE SEED, WITH AN EYE TO THE HARVEST

In the next picture Tweed is declining the statue which, in the form of an ass's head, Edward J. Shandley is trying to thrust upon him. It would be sad, if it were not humorous, to recall that while the idea of this statue was generally ridiculed by the

"GROSS IRREGULARITY NOT 'FRAUDU-
LENT'"

Boss Tweed—"To make this *look straight* is the
hardest job ı ever had. What made Watson go sleigh-
riding ?"

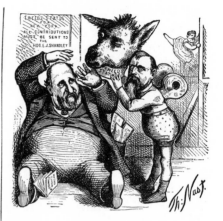

THE REHEARSAL

Shandley (as *Puck*)—"Allow me to immortalize
you, Boss !"
Tweed (*realizing his part*)--"I most emphatically
and decidedly object to it. I am not deficient in
common-sense."

press, one of the foremost journals of New York City boasted
that it had been first to propose this honor, and upon the
"Boss's" refusal of it, commented editorially:

His (Tweed's) modesty shrinks from so substantial a testi-
monial as the erection of a statue while he is still living. We
think Mr. Tweed has acted hastily. He need not have been
ashamed of such a compliment, nor need he fear it because it is
a novelty. . . . Is it too late to realize so worthy and so ex-
cellent an idea? *

Tweed as Louis Napoleon giving Hoffman, the Prince Im-
perial, his "Baptism of Fire," the shells of reform bursting
around them, came next, and May 6th the "Political Leper"—
the Republican legislator who has sold himself to the Ring.

The Times meanwhile had been hurling its fierce denuncia-
tions almost daily into the Ring stronghold, and the public was
beginning to be aroused. The paper had no absolute proof as
yet, but with the courage of its convictions it did not hesitate
to brand Tweed, Sweeny, Connolly and Hall as embezzlers and
thieves. It is a sorrowful spectacle to find most of the great

* The Sun, March 1 and 15, 1871.

papers of that day either openly and fiercely abusing Nast and Jennings for their vigorous campaign or at most expressing but lukewarm commendation. A number of them sought to divert public attention from the sins of the Ring by assailing Grant, whose distribution of offices did not please a majority of the New York Press.*

Horace Greeley was in a difficult position. His ambition to become President was already formed, yet as a Republican he was still supposed to support Grant. Furthermore, if the Ring was a bad thing, and it seemed likely that this was true, he felt

* As an example of the general attitude of the New York papers (both city and State) at this period, and to show how difficult it was to make headway against the almost universal domination of the Ring, the following brief extracts from three foremost journals are given. It must be remembered that at this period these papers were either Democratic or at least opposed to the National Administration. Also that they were in no sense the papers bearing the same titles to-day. New ownerships, new policies and new principles have given us new journals in everything but name.

From the New York Evening Post, March 10, 1871, editorial entitled "Hash":

The Times and Harper's Weekly, as administration organs looking to the next Presidential election and not to the good government of the city of New York, imagine they can help the Republican party by the outcries they raise. "The Evening Post condemns the administration of President Grant, and praises that of the Ring of the city of New York," says Harper's Weekly, and shows us the motive of its own abuse and misrepresentations. We do not condemn one or praise the other. If we were dishonest or disingenuous partisans we should probably do as the Times and Harper's Weekly do, and our praise and our blame would presently count for no more than theirs with honest and intelligent men. (It should be added that the Post had vigorously condemned the idea of a statue of Tweed as well as the "Boss" himself, personally.)

From the New York Sun, February 3 and 4, 1871:

The decline of the New York Times in everything that entitles a paper to respect and confidence has been rapid and complete. Its present editor, who was dismissed from the London Times for improper conduct and untruthful writing, has sunk into a tedious monotony of slander, disregard of truth and blackguard vituperation. . . . Let the Times change its course, send off Jennings and get some gentleman and scholar in his place, and become again an able and high-toned paper. Thus may it escape from ruin. Otherwise it is doomed.

From the New York Herald, July 4, 1871, editorial entitled "Humbug Reformers":

Every now and then there springs up, like mushrooms in a night, a crop of municipal reformers who assail the authorities with might and main, until obliged to desist from sheer exhaustion, or other causes which are not at all difficult to explain. These humbug reformers are organized bands of uneasy people who have been left out in the cold in the matter of some fat contract or other—that of the city printing and advertising being not the least of the causes that arouse their holy indignation. It is with the intention of having their silence purchased by what they call the "Ring" that all this parade of alleged extravagance, over-taxation and fraud is made.

11

that he ought to aid in its punishment. Still, there was always the chance that the Ring might be better than it seemed, at least sections of it, and these sections might unite and control national Democracy in 1872. To be sure Mr. Greeley was not a Democrat, though as surety for Jefferson Davis he had invited the friendship of the " Solid South," and held out the hand of welcome across the bloody chasm.

THE CHAP THAT CLOSES MANY A GOOD
ESTABLISHMENT

If, therefore, it should happen that the Republican party should conclude to renominate Grant, it was just possible that the many and various elements remaining might unite on Mr. Greeley, and of these elements Tammany was certain to be one. The Tribune criticised the Ring in a manner which, under the circumstances, doubtless seemed sufficiently severe. Yet gentleness had never been regarded as one of Mr. Greeley's editorial weaknesses. " Liar " was his most frequent and favorite epithet, and his vocabulary was not lacking in special terms of severity. To have led in a great reform and denounced a corrupt gang as " thieves " and " villains " would ordinarily have given joy to Mr. Greeley's heart. It seems, therefore, fair to assume that, while he was never in league with the Ring, he was unconsciously influenced by his ambition to become the choice of a great nation. It was clearly a mistake, however, for him to have become at this particular time the chairman of what was organized as the " Tammany Republican General Committee," or of any other committee that exhibited the word Tammany in its title. A Tammany Republican is a somewhat difficult species to define, even in this day of new enlightenment, and Mr. Greeley, who was not supposed to be lacking

in political acumen, must have been blinded indeed by his desire for preferment to have linked himself then with an element that assumed the meaningless title as a flimsy concealment of double-dealing and Ring servitude.

The writer has thus considered at some length what would seem to have been Mr. Greeley's personal attitude at this time, for the reason that the great editor himself was very soon to become a target for pictorial satire. It would be injustice not to add that whatever his utterances may have lacked in vigor and epithet, they were delivered on the side of reform, and Mr. Greeley's paper, the Tribune, was first to join Harper's Weekly and the Times in the crusade against the Ring.

And the crusade was making headway. Sections of a hitherto inanimate public spirit were aroused to a semblance of life and resistance. On April 4th a meeting was held at the Cooper Union to protest against a legislative bill which would give to the Ring still further emoluments and powers. This meeting

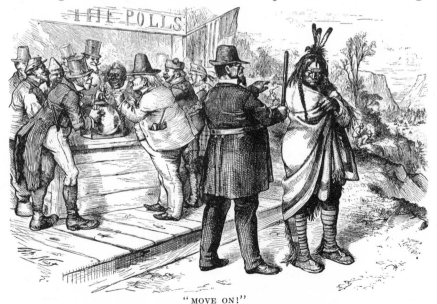

"MOVE ON!"

HAS THE NATIVE AMERICAN NO RIGHTS THAT THE NATURALIZED AMERICAN IS BOUND TO RESPECT?
THE OTHER NATIONALITIES MAY VOTE, BUT NOT THE ORIGINAL AMERICAN

was called to order by William E. Dodge, while William F. Havemeyer presided. Among the speakers was Henry Ward Beecher, also Senator Evarts, who declared that it was no longer

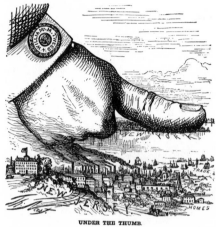

UNDER THE THUMB.

THE BOSS—"Well, what are you going to do about it?"

a pride to be a New Yorker, but a disgrace, if New Yorkers could not save themselves from infamy.

It would seem that many leading New Yorkers did not wish to "save themselves from infamy." Tweed and his friends circulated a petition for the passing of the bill and readily obtained the signatures of more than three hundred citizens of the very first rank—at least so far as wealth and public influence were concerned.* Tweed could well afford to ask of the reformers "What are you going to do about it?" and Nast's picture of the giant thumb of the "Boss" pressing hard on Manhattan Island exactly expressed the condition which inspired that famous line.

Indeed it looked as if the public would be able to do very little. "It will all blow over," said Hall. "These gusts of reform are all wind and clatter. Next year we shall be in Washington."

Hall's remark about Washington was based on the fact that at this particular time Governor Hoffman was the Tammany Hall candidate for the Presidency, and was thought to have a comparatively clear field. Nast's cartoon of June 17th shows Hoffman as the Tammany Wooden Indian on wheels being

* Looked at in the present light one must believe that men of the highest respectability then allowed their names to be used, provided they would be permitted to share profits, and that the press, which should have been guardian of the people's interests, openly sustained the general degradation of the times.—"New York in Bondage," by Hon. John D. Townsend.

pushed and pulled toward the White House by the Erie and Tweed combination.

The Ring made a fatal mistake at this point. It would far better have let national affairs alone. Samuel J. Tilden, one of the shrewdest politicians of that period—skilled at intrigue, relentless in action and an excellent hater—had presidential ambitions of his own. It was poor policy on the part of the Ring to push Hoffman in his way.

Tilden had been counsel for the Erie directors when Tweed and Sweeny were on that board, and knew them intimately. Also, as chairman of the Democratic State Committee, in 1868, he had been hand and glove with Tweed and his followers throughout that notorious campaign. Tilden therefore had an intimate knowledge of the Ring and its methods. He knew, too, by signs in the sky that the storm, which would *not* "blow over," was getting ready to break. Wisely and furtively he laid his plans, and patiently waited the hour when undeniable proof of the Ring's guilt and public indignation should make its downfall sure. Then he would be ready to strike home.

"SOME ARE BORN GREAT; SOME ACHIEVE
GREATNESS."

HOFFMAN — "It will be very difficult to sit on both of those Stools at once. You know the Proverb, Boss?"
Boss TWEED —"If you were blessed with my Figure, you could manage it."

CHAPTER XX

THE PROOFS OF GUILT

It was James O'Brien, a close political friend of Tilden and sheriff under the Ring, who secured the proofs which resulted in its fall. The writer has never seen any statement connecting Mr. Tilden with the inception of O'Brien's scheme for destroying the Ring, but in the light of collected facts it seems fair to credit the shrewder man—the man with the greater motive—with the origin of the idea.

The Ring was no longer useful to Tilden, but, as we have seen, had become a bar to his political progress. It was greatly to his interest that it should be destroyed. If he could acquire credit in its destruction, so much the better. O'Brien too had ambitions of his own and old scores to wipe out. There could be no closer political bedfellows at this particular time than these two men, and Tilden had just the sort of genius to conceive the plan; while O'Brien, who was still in the Ring's favor, was the man to execute it. O'Brien himself, in a published interview, has admitted that Tilden was present during a conference with George Jones, of the Times, when Jones was urged by Tilden to make the most of the evidence in his hands.

Concerning O'Brien's enmity to the Ring, Tweed in his confession, long afterward, testified that it began when Connolly for some reason refused to allow one of the sheriff's exorbitant bills.

O'Brien, so far as the writer can learn, has never clearly explained the inner facts of his defection. At all events there was no open break in the spring of 1871,* when Connolly and O'Brien still professed mutual friendship.

One morning O'Brien called at the Controller's office and asked that an employee be removed and that a friend of his—one William Copeland—be appointed to fill the place. O'Brien assured Connolly that Copeland was " all right " and " safe."

Connolly was in a dire state. He was equally afraid to grant or to refuse O'Brien's request. Perspiration streamed down the fat face of " Slippery Dick " and he looked pale and old. Eventually he consented, and Copeland was installed. No sooner was he at the books than, by O'Brien's orders, he began to make a transcript of the items of the Ring's frightful and fraudulent disbursements, mainly charged as expenditures on the courthouse, then building. He worked fast and overtime to get these, and within a brief period the evidence of a guilt so vast as to be almost incredible was in O'Brien's hands. Another man, one Matthew O'Rourke, in a similar manner had been installed as county bookkeeper, and in this position had also fortified himself with proofs of enormous frauds, chiefly in connection with armory rents and repairs. O'Rourke had been a military editor and was especially fitted for this job.

It was afterward testified that O'Brien used the Copeland documents to extort money from the Ring. O'Brien, on the other hand, has declared that he immediately took them to the leading papers of New York City and that, until he reached the Times, not one was to be found who would touch them. That O'Rourke has recorded a similar experience, would seem to verify O'Brien's claims. Whatever may be the facts in the case, the reports did not reach the Times until July.

Louis John Jennings, who, as we have noted, had maintained

* It has been claimed that this occurred in 1870. O'Brien has given it as above.

an unceasing warfare, was one night sitting in his office, wondering what move he could make next. Over and over he had branded Tweed and his associates as criminals, pointing out the frauds that must exist, daring the Ring to produce the city accounts. His life had been threatened, and more than once he had been arrested on trumped-up charges. Like Nast, he had been accused of almost every crime in the calendar,* and once a " tough citizen " had suddenly entered the sanctum with the information that he had come to " cut his heart out." The disturber had been promptly kicked into the street, but the experience had been far from pleasant. Pondering as to the possibilities, and the probable rewards, of American reform, the sturdy Englishman began writing, when the door suddenly opened, and James O'Brien entered.

The men were known to each other and O'Brien remarked that it was a warm evening.

" Yes, hot," assented Jennings.

" You and Nast have had a hard fight," continued O'Brien.

" Have still," nodded Jennings rather wearily.

" I said you have had it," repeated O'Brien, and he pulled a roll of papers from an inner pocket. " Here are the proofs of all your charges—exact transcriptions from Dick Connolly's books. The boys will likely try to murder you when they know you've got 'em, just as they've tried to murder me." †

Jennings seized the precious roll and sat up till daylight, studying it all out. It was only a day or two later that O'Rourke came in with the added documents, and was engaged by the Times to assist in making the great attack.

* Among other things, Nast was charged with having fled from Germany to avoid military service. The reader will remember that he was six years old when he reached America. It is a curious fact that this battle for American reform should have been conducted by two foreign-born men, Jennings and Nast—one of England, the other of Bavaria.

† Interview with Louis John Jennings, M. P.—London World, 1887.

ADDRESS OF GRAND SACHEM TWEED AT THE TAMMANY WIGWAM
(Illustrated by Nast)

Immediately it became known to the Ring that the proofs of its guilt were in possession of the Times, and an effort was made to buy them. A carefully verified report of this attempt was published in Harper's Weekly for February 22, 1890:

A tenant in the same building (the Times building) sent for Mr. Jones to come to his office, as he wished to see him on an important matter. Mr. Jones went to the lawyer's office, and, being ushered into a private room, was confronted by Controller Connolly.

"I don't want to see this man," said Mr. Jones, and he turned to go.

"For God's sake!" exclaimed Connolly, "let me say one word to you."

At this appeal Mr. Jones stopped. Connolly then made him a proposition to forego the publication of the documents he had in his possession and offered him the enormous sum of five million dollars to do this. As Connolly waited for the answer, Mr. Jones said:

"I don't think the devil will ever make a higher bid for me than that."

Connolly began to plead, and drew a graphic picture of what one could do with five million dollars. He ended by saying:

"Why, with that sum you can go to Europe and live like a prince."

"Yes," said Mr. Jones, "but I should know that I was a rascal. I cannot consider your offer or any offer not to publish the facts in my possession."

On July 8 was published the first instalment of those terrible figures that, having once been made to lie, now turned to cry out the damning truth in bold black type—black indeed to the startled members of the Ring.

The sensation was immediate. The figures showed that an enormous outlay had been charged as "armory rents and repairs" which never could have been legitimately expended. Ten lofts, mostly over old stables, had been rented at a cost of $85,000, and though these lofts had not been used, an additional $463,064 had been charged for keeping them in repair. Ten other armories had been kept in repair for a period of nine

months at the trifling cost to the county of $941,453.86. The
upper floor of Tammany Hall, worth at that time about $4,000

a year, was
charged in the list
at nine times that
sum. The Times
asserted the abso-
lute truth of these
figures, and boldly
called on the offi-
cials to disprove
them by producing
their books.

The Ring stag-
gered and began to
dread a break on
the part of its con-
stituents. "Never
mind," said Hall.
"Who is going to
prosecute?" But,
behold, on July 12
came another
stroke of ill-for-
tune—a bloody riot

"THE RICH GROWING RICHER, THE POOR GROWING POORER."

BRINGING THE THING HOME.

THE TAMMANY LORDS AND THEIR CONSTITUENTS

caused by the Orangemen's parade. The Mayor had for-
bidden the parade, at the behest of the Hibernian Society,
and public indignation had flamed up at this blow to Amer-
ican liberties. Leading papers that had hitherto supported
the Ring seized upon the Mayor's edict as an excuse for
rushing to cover—fiercely denouncing Hall. Even Governor
Hoffman rescinded the Mayor's order, though at the eleventh
hour, promising protection to the little band of Protestant Irish.

It was too late, however, to avoid bloodshed. The Hibernians, encouraged by Mayor Hall's attitude, declared for open warfare if the Orangemen paraded, with general destruction to Protestant sympathizers, adding a special threat against the house of Harper Brothers for its publication of the cartoons of Nast. The Governor's belated order had no effect. The warning and admonition of priest and bishop went unheeded. The spirit of sixty-three was abroad. The mob was ripe for bloodshed, and the burning and sacking of stores.

It proved a brief and sanguinary episode. On Eighth Avenue, from Twenty-third to Twenty-ninth Streets, the assault on the paraders took place. The military, which had been called out to escort the Orangemen, did not immediately open fire, and the rioters now boldly appeared from all sides discharging fire-arms and missiles of every sort at the procession. A woman who waved a handkerchief to the Orangemen was instantly killed. A little girl by her side shared the same fate. Then a private was shot down, and then, a moment later, the military opened fire on the mob.

The crowd of ruffians who had made up their minds that the soldiers would not shoot, broke wildly and fled, leaving almost a hundred dead and wounded behind. The riot was over. The prompt and severe military punishment had avoided a repetition of the Draft Riot scenes of 1863. Nast, marching with his regiment, had seen the fulfilment of a prophecy in "Shadows of Coming Events," published more than a year before.

A letter to Nast from General Alfred Pleasanton concerning the riot seems interesting in the view it gives us of this gallant officer's theory of handling mobs.

Washington, July 16, 1871.

My Dear Nast:

Many thanks for your kind remembrance in Harper of last week. I fear you have given me an impossible task—to teach Tammany arithmetic. Subtracting and dividing are the only

rules they practise, and the decimal point they disregard altogether.*

That was a good lesson you gave them on the 12th, but it was only a beginning. You handled them with gloves on. Fighting a mob requires different tactics from those used in fighting in the field.

In street fighting, every house from which a shot is fired should be gutted, and no one in the house should escape. Had the troops taken possession of the houses from which shots were fired on the 12th and shot every man in them, you would have struck terror into the mob and they would have dispersed disheartened.

The next time they will have more experienced leaders and will not commit the same mistakes. Remember what I tell you—*you must terrorize a mob to subdue it*—simply killing them does not answer the purpose. The survivors only run away to return with more experience. This thing will be repeated some day, when I hope to see it properly handled. I will tell you how when we meet. Accept my congratulations at your going through it safe and sound, and believe me,

<div style="text-align:right">Your sincere friend,
A. Pleasanton.</div>

The riot was a hard blow to the Ring. The public in general denounced Hall and his associates, according them full blame for the city's disgrace and sorrow. Also, the Times each day boldly emblazoned in its editorial page in big black figures the added proofs of the betrayal of public trust. Men and papers who had stood by the municipal government showed signs of desertion. There was wavering in the ranks. At any moment it might become a stampede. The tenure of Fraud had become a precarious thing.

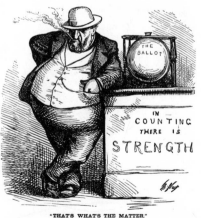

* See page 169, top of col. four.

"THAT'S WHAT'S THE MATTER."
Boss Tweed. "As long as I count the Votes, what are you going to do about it? say?"

CHAPTER XXI

THE RING'S BATTLE FOR LIFE

The excitement over the armory exposures was as nothing in comparison with the upheaval that took place on publication of the Copeland transcript of the Controller's accounts, the first of which appeared as a special sheet in the Times of July 22, 1871.

These figures, carefully tabulated and printed in full clear type, showed at a glance where millions upon millions of dollars had been paid from the public treasury, with no return to the city, worth counting.

Many of the great sums had been charged as repairs or furnishings for the new court-house, and most of them had been distributed through such " contractors " as J. H. Ingersoll & Company, Andrew J. Garvey, Keyser & Company and others, who had " arranged " whatever small part was really due for goods and labor, and deposited the huge balance to the credit of the various members and associates of the Ring.

The new court-house was still far from complete, and miserably furnished, yet it had already resulted in the neat outlay of $11,000,000, when the most liberal estimate placed its value, finished and luxuriously furnished, at less than three millions.

A few items will be sufficient to show the scale upon which the Ring had conducted its financial policy:

Forty old chairs and three tables had a record value of $179,729.60.

A charge for repairing fixtures, through J. H. Keyser & Company, was $1,149,874.50.

Thermometers, $7,500.

Another charge for furniture, through Ingersoll & Company, $240,564.63.

City and County Advertising—paid to the newspapers of New York City, $2,703,308.48—a large proportion of this vast sum having been paid in the early months of 1871.*

A single item of stationery was set down at $186,495.61. What, in heaven's name, could the .61 have paid for with stationery bought at Ring rates? Possibly it represented the actual cost of the entire outlay.

Then there were carpets, shades and curtains, also supplied by that marvellous firm, Ingersoll & Company, at the fairly comfortable figure of $675,534.44. Why always these odd cents? It must have been worrisome to make change in those days of opulence. But one cannot help admiring the two liverymen who in a few brief days earned nearly fifty thousand dollars by supplying the aldermen with carriages, mostly for funerals. That must have been a busy season for aldermen, keeping up with all those obsequies. Nor must we overlook one G. S. Miller, a carpenter who was set down as having received $360,747.61 (another .61—fatal sum) for one month's work. "Is not," asks the Times, "this Miller the luckiest carpenter alive?"

But Garvey, Andrew J. Garvey, the plasterer! Generations of plasterers yet unborn will take off their hats to his memory! $2,870,464.06 had he earned at his humble trade in the brief

* The entire amount disbursed by the Ring during a period of about thirty months for public advertising and printing was $7,168,212.23—the greater part of which was paid to the New York Printing Company, owned by the Ring.

period of nine months. Fifty thousand dollars a day was his record for an entire month! Surely never was a month so well plastered as that long-ago June! " As G. S. Miller is the luckiest carpenter alive," comments the Times, " so is Andrew J. Garvey the Prince of Plasterers. His good fortune surpasses anything recorded in the Arabian Nights. A plasterer who can earn $138,187 in two days (December 20 and 21), and that in the depths of winter, need never be poor. With a total of $2,870,464.06 for the job, he could afford to donate the .06 to charity."

It is unnecessary to go further into the details of this monster and monstrous fraud, $5,663,246.83 of which had been paid through the single " firm " of Ingersoll & Company. An illustrated pamphlet poem, " The House That Tweed Built," distributed by the American News Company, contained this stanza, which we may add as a final touch:

> " This is Boss Tweed
> ∷ Nast's man with the Brains.
> The Tammany Atlas who all sustains,
> (A Tammany Sampson, perhaps, for his pains)
> Who rules the city where Oakey reigns,
> The master of Woodward and Ingersoll,
> And all the gang of the city roll,
> And formerly lord of ' Slippery Dick '
> Who Controlled the plastering laid on so thick,
> By the controller's plasterer, Garvey by name,
> The Garvey whose fame is the little Game
> Of laying on plaster and knowing the trick
> Of charging as if he himself were a brick
> Of the well-plastered house that TWEED built."

As heretofore stated, during thirty months of Ring rule, thirty millions of dollars had been stolen out of hand. The city debt had increased more than fifty millions and was doubling every two years. No wonder the shores of Long Island Sound were lined with the elegant homes of the city contractors and financiers. Matthew J. O'Rourke, who since that time has made a

careful study of the city's finances, states that counting the vast issues of fraudulent bonds, the swindling of the city by the wealthy tax dodgers, by franchises and favors granted, by blackmail and extortion—the total amount of the city's loss through the Tweed Ring stands at not less than Two Hundred Millions of Dollars.*

And now there was indeed excitement.

The public was up in arms, and the papers— with the exception of such organs as the Leader and the Star, established and supported by the Ring —were either breaking for cover or preparing to do so by maintaining a discreet silence until the

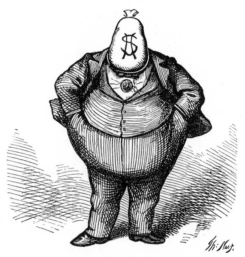

THE " BRAINS "

(This remarkable characterization of "Boss Tweed" is probably the best known of Nast's caricatures)

Times's exposures could be verified. It is true, they were inclined to display the resentment that comes of defeat and to belittle the achievement of the rival paper. One leading journal made the rather remarkable claim that the Times exposure was an old story, so far as it was concerned, though it failed to explain why it had remained the ally of corruption, and why it still, though rather feebly, to be sure, defended the Ring from the vengeance of an outraged public.

The Tribune suggested that, if the Ring was not guilty as charged, it should proceed to establish its innocence by suing the Times for criminal libel. This suggestion the Times eagerly welcomed, as it would have forced the city accounts into court. It even dared the Ring to sue. It called upon Connolly, Sweeny

* New York Herald, January 13, 1901.

12

and Hall to produce the Controller's books and prove its published statements false.

Tweed was not at first assailed. O'Brien had stipulated that "The Boss," who had remained his friend, should be given a chance to resign his office and make public acknowledgment of his own account. It is perhaps to Tweed's credit that he refused to desert his fellows and took his punishment with the others. Possibly he believed that, with a share of the press still faithful, and with a powerful constituency, the public, after all, could really do nothing about it—that nobody would sue—that the storm would " blow over."

As for Thomas Nast, he was now in his glory. His long beating at the gates of brass had finally aroused the whole city—even the nation itself to arms! This was just the sort of a savage conflict for justice that always filled his veins with fire, and made his pencil more to be dreaded than the most ghastly engine of war.

He had already humorously illustrated Tweed's Fourth of July oration, before the first of the Times disclosures, and had depicted Connolly's " Whitewashing Committee " as blind mice whose tails had been amputated by the Times's sharp editorials. Then when the riot had occurred he had contributed a double-page which had brought down upon him the fiercest threats and denunciations of the Hibernian organs, and he had followed it with a caricature of Hall as the " Sick Mare " in the Tammany stall. A little later a small cartoon showed Horace Greeley weeping over the " Mare," in whom, it may be said here, the great editor never entirely lost confidence. In this picture Connolly is fanning " Mare " Hall with a " ten thousand dollar city-fan," while Tweed and Sweeny are furtively looking on. " Not a Bailable Case," is the title of the picture, and underneath is an extract from the Tribune of July 21—the day before the great exposure of the Controller's accounts. The extract em-

bodies Mr. Greeley's explanation of his hitherto temperate style of attack upon the ring. It proved an unfortunate utterance, for the reason that, as a rule, Mr. Greeley's lack of temperate expression was one of his most distinguished characteristics.

But this cartoon was of slight importance as compared with the one that followed, this being no less than the now famous page, the lower half of which, " Who Stole the People's Money? " has been so often reproduced. In the upper picture Greeley again appears, asking " Who is Ingersoll's Company? " and Tweed and his numberless cohorts are there as a reply. In the lower picture the Ring and its friends are formed in a circle, pointing accusingly, one to the other, as an answer to the Times's pertinent question, " Who Stole the People's Money? "

" You have never done anything more trenchantly witty than the ' Co.' of Ingersoll," wrote Curtis, " and the ' 'Twas Him! ' My wife and I laughed continuously over them. They are prodigiously good."

It is believed that this page, and the certainty of others of its kind to follow, did more to terrify the Ring than any previous attack.

" Let's stop them d—d pictures," proposed Tweed when he saw it. " I don't care so much what the papers write about me —my constituents can't read; but, d—n it, they can see pictures!"

Threatening letters were received by Nast, one containing his own picture with a thread, as a rope, about his neck. Also, the family began to notice rough characters loitering about the home premises. But for the personal friendship of Police Captain Ira Garland, it is not unlikely that an attack would have been made on the artist of reform. Garland was promptly removed from that precinct, but Nast, owing to a malarial epidemic then prevalent in Harlem, somewhat later decided to remove his family to Morristown for a brief period of change. Nast himself was

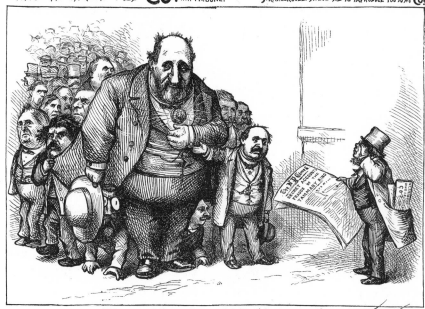

"WHO IS INGERSOLL'S CO?" N.Y. TRIBUNE. MR. INGERSOLL. "ALLOW ME TO INTRODUCE YOU TO MY CO?"

TWO GREAT QUESTIONS. Th. Nast.

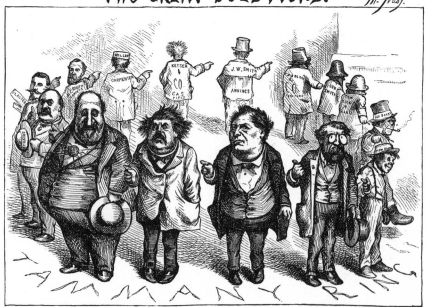

"WHO STOLE THE PEOPLE'S MONEY?" — DO TELL. N.Y.TIMES. 'T.WAS HIM.

troubled with a serious throat affection at this time, and the higher altitude of the Jersey hills proved generally beneficial, though he returned to work each day in the Harlem studio.

The Ring now resorted to new tactics. They determined to buy where they could not intimidate. A lawyer friend one day intimated to Nast that, in appreciation of his great efforts, a party of rich men wished to send him abroad, and give him a chance to study art under the world's masters. The friend was probably innocent enough—an unconscious tool of the Ring.

Nast said very little except that he appreciated the offer and would be delighted to go, but for the fact that he had important business, just then, in New York. He fancied that he detected the far, faint odor of a mouse under the idea, but he did not mention this to his friend. On the following Sunday an officer of the Broadway Bank, where the Ring kept its accounts, called on Nast at his home. He talked of a number of things. Then he said:

" I hear you have been made an offer to go abroad for art study."

" Yes," nodded Nast, " but I can't go. I haven't time."

" But they will pay you for your time. I have reason to believe you could get a hundred thousand dollars for the trip."

" Do you think I could get two hundred thousand? "

" Well, possibly. I believe from what I have heard in the bank that you might get it. You have a great talent; but you need study and you need rest. Besides, this Ring business will get you into trouble. They own all the judges and jurors and can get you locked up for libel. My advice is to take the money and get away."

Nast looked out into the street, and perhaps wondered what two hundred thousand dollars would do for him. It would pay the mortgage on the house in the city. It would give him years

WHOLESALE.

N.Y. CITY TREASURY.

BAKERY AND

RETAIL.

of study abroad. It would make him comfortable for life. Presently he said:

" Don't you think I could get five hundred thousand to make that trip? "

The bank official scarcely hesitated.

" You can. You can get five hundred thousand dollars in gold to drop this Ring business and get out of the country."

Nast laughed a little. He had played the game far enough.

" Well, I don't think I'll do it," he said. " I made up my mind not long ago to put some of those fellows behind the bars, *and I'm going to put them there!* "

The banker rose, rather quietly.

" Only be careful, Mr. Nast, that you do not first put yourself in a coffin! " he smiled.

It was not until two years later that he met Nast one day on Broadway.

" My God, Nast! " he said; " you did it, after all! "

THE COLLAPSE OF THE RING

On July 15 Harper's Weekly had published a portrait and biographical sketch of Mr. Jennings, showing his highly successful career in various London editorial positions and establishing his absolute reliability, clean record and capabilities beyond question. On August 26 it republished the full-page portrait of Nast and referred to him as the "most cordially hated man in New York—hated by men whose friendship

NAST'S SELECTION FOR A TWEED NATIONAL TICKET AND CABINET

would be a dishonor." Farther along it added, " His inventive powers seem to be inexhaustible."

Of his pictures it said, " His caricatures of Tweed, Sweeney, Connolly and Hall are admirable in their grotesque fidelity. Each one is so marked that if you catch only the glimpse of an eye-glass, the tip of a nose or a straggly bit of hair, you recognize it." Of the Ring's effort to suppress him: " Believing that ' every man has his price ' they have tried to buy him off. To their astonishment they found they were dealing with a man who was not for sale. Then they tried the efficiency of threats. Letters of the most violent character have poured in upon him . . . threatening violence and even death. . . . The pages of this paper show and will continue to show that threats are quite as impotent as bribes with Mr. Nast."

And in good sooth, now, did the thunderbolts begin to fall. In the issue containing the above-mentioned sketch, the Ring and its accomplices were caricatured as the " cut and dried " national ticket and Cabinet for 1872. On September 2, the Ring is shown at one of its palatial resorts, drinking and feasting, while their poorer constituents in New York City are starving. A little later a similar idea was used to show the " wholesale " thieves walking out of the city treasury unscathed, while the beggar is arrested and beaten for stealing a loaf of bread.

Hall, still jaunty and defiant, meeting Nast on the street one day, said:

" I have seen your ' handwriting on the wall,' of late."

" You will see more of it, presently," answered Nast, without pausing.

Tweed, who had earlier declared his intention of horse-whipping Nast on sight, one morning, driving in Central Park, met him face to face. The artist smiled and tipped his hat jauntily as was his wont. The " Boss " forgot his threat and returned the salutation.

A GROUP OF VULTURES WAITING FOR THE STORM TO "BLOW OVER."—"LET US *PREY*"

And each week the " handwriting " became more telling—
more terrible in its clear statement of fact. There was to be
an election in November, and it must be with wide-open eyes
that the public should render judgment.

The Ring was thoroughly frightened at last. Connolly gave
out inexplicable statements of his accounts, and Hall published
in his paper—the Leader—incoherent denials of his responsi-
bility, and explanations that did not explain. The guilty ones
were grabbing wildly at straws, and were presently reduced to
an unverified statement, made through the Star, that they were
" high-toned gentlemen of probity, and of honor—sensitive to
the stigma upon their party and anxious to redeem it from its
peril." They added that they were " representative men of the
city "—a remark that at least savored of fact.

It was all no use. " High-toned gentlemen " were going at a
discount. Ring supporters were making a grand rush for safety,
trampling their former benefactor in the mad stampede. When
the citizens " Committee of Seventy " was appointed to inves-
tigate, the Mayor, with Tweed and Sweeny, decided to make a
scapegoat of " Slippery Dick," and asked that an examination
be made of the Controller's books.

The " Booth Committee," consisting of eight private citizens,
four aldermen and one supervisor, with William A. Booth as
chairman, was appointed for this purpose, September 6. On
the following day, Judge George S. Barnard, formerly an
associate of the Ring, granted an injunction restraining Tweed
and his associates from further levies or use of public funds.
This was a serious blow. Following Barnard's example, recruits,
by the wholesale were now added to the ranks of reform. The
German Democrats repudiated the Ring, and Nast's cartoon
shows the doomed four being flung bodily from the good ship
" Germania." " A Group of Vultures Waiting for the Storm
to ' Blow Over,' " in the same issue, was one of the surest hits
of the campaign.

On Saturday, September 9, the Booth Committee asked Controller Connolly to produce certain vouchers on the following Tuesday. Curiously enough, before Monday morning these very vouchers disappeared from the Controller's office. Somebody with a diamond had cut a hole in the window, large enough to admit a man's arm. By this means the window had been unfastened and the intruder had been able to enter and select the very

"WE KNOW NOTHING ABOUT THE STOLEN VOUCHERS." "TOO THIN!" "WE ARE INNOCENT."

vouchers demanded by the Booth Committee for beginning the examination.

It seemed a remarkable coincidence, and the general opinion expressed when Connolly and his friends protested their innocence was that the device was "too thin," a title adopted by Nast for a cartoon that was afterward used as an election document, distributed by the thousand.

Wild Oats, a small illustrated paper, published an adaptation of this cartoon, entitled " Too Thick," showing the Ring, fattened with plunder, handcuffed together, and in stripes. It has been stated that Nast was first to depict the Ring in stripes; but the credit is due, not to the great master of caricature, but to one of his countless followers, C. Howard. The sale of Wild Oats was forbidden on the news-stands by Mayor Hall under penalty of revoked licenses, and a similar edict was prepared against Harper's Weekly, but never enforced.

Mayor Hall now made a ludicrous show of virtue, demanding Connolly's resignation for gross negligence in allowing his office to be robbed. Connolly replied in effect that Hall was as much implicated as he was, and declined to abdicate. On September 13 there was almost a riot in front of his office, caused by the unpaid city workmen demanding their wages, which, because of Barnard's injunction, Connolly could not distribute. Men grew savage and endeavored to force an entrance.

" Bring out ' Slippery Dick,' " they called; " we'll make him sign the rolls."

Connolly in an interview with his friends was advised to quit the country without more ado. Instead, he took legal counsel of Samuel J. Tilden, who had thus far shown but a general interest in the movement for reform.

This was pure luck for Tilden—a play directly into his hand. His advice was that Connolly, under promise of protection, should resign in favor of Andrew H. Green—a man in whom

EMPTY. "WHAT ARE YOU GOING TO DO ABOUT IT?" FULL.

EMPTY TO THE WORKMEN THE FOUR MASTERS THAT EMPTIED IT.

WHY IS THE TREASURY EMPTY?

Tilden and O'Conor tell you the "Boss" took out of it ONE MILLION OF DOLLARS in three months, and his friends took FIVE MILLIONS in the same time. No wonder you can't get your bills paid.

DOWN with the CITY THIEVES. VOTE the REFORM TICKET.

United Reform County Ticket.

Register ... FRANZ SIGEL.
Supreme Court GEORGE C. BARRETT.
Common Pleas CHARLES P. DALY.
Superior Court JOHN SEDGWICK.
Marine Court WILLIAM E. CURTIS.
... ALEX^r SPAULDING.

Senatorial Nominations.

4th Dist...J. O'DONOVAN ROSSA. 7th Dist .JAMES O'BRIEN.
5th Dist...ERASTUS C. BENEDICT. 9th Dist .DAN'L F.TIEMANN.
6th Dist...Dr. AUGUSTUS WEISSMAN.

Assembly Nominations.

Dist.	Candidate	Dist.	Candidate
1	JAMES HEALY.	12	HENRY R. CRAMPTON.
2	HENRY O. LEASER.	13	GEO. H. MACKAY.
3	HENRY F. WEST.	14	JOHN A. FOLEY.
4	JOHN BECKER.	15	FREDERICK KILLIAN.
5	DAVID B. PAGE	16	NICHOLAS HOUGHTON.
6	ISAAC WOOD.	17	CHAS. A. FLAMMER.
7	HORATIO N. TWOMBLY	18	SAMUEL J. TILDEN.
8	CONRAD GEIR.	19	HORATIO SEYMOUR.
9	STEPHEN FELL.	20	SEVERN D. MOULTON.
10	H. H. HAIGHT.	21	WM A. WHITBECK.
11	RUSH C. HAWKINS.		

(This picture and the printing below it show the use made of the cartoons as campaign documents)

the public had the utmost confidence, and a business friend of Tilden. This Connolly did, and took heart.

The remainder of the Ring was now in a bad way. Under the leadership of Hall, they endeavored to stir up a riot among the unpaid street and park laborers. Such journals as were left to them declared that there should be a great meeting at the Fifty-ninth Street park entrance, and that, failing to get their money, the mob should proceed to the homes of the villains who had brought about this state of affairs—said villains being the leaders in the reform crusade, whose names and addresses were carefully given—and " pull their houses down about their ears."

But the riot did not come off. The laborers were beginning to understand who were the villains that had emptied the public treasury, and to make this truth still more clear Nast gave

the public a cartoon entitled " The City Treasury—Empty to the Workmen, and the Four Masters who Emptied it."

Thousands of workmen who did not read the daily papers could understand that picture at a glance, and it was conspicuously displayed on the stands. Later it was included in a campaign pamphlet and scattered broadcast. In another cartoon Nast summed up the Ring's attempt to retain power through concessions to the Church in the " American River Ganges " which stands to-day as the most terrible arraignment of sectarianism in the public schools, as well as one of the most powerful pictures that Thomas Nast ever drew.

" The Only Way to Get Our Tammany Rulers on the Square," the " Square " being that of a carpenter, set up as a gallows with a noose at the end, and " Honest Democracy Kicking Mayor Hall into Space " were two smaller cartoons in the same issue.

The shots were dropping thickly now, and the withering fire laid waste the ranks of infamy. Every respectable journal in New York was in line at last, and every organization was crying " thief." Even the " W. M. Tweed " Association denounced the corruption of the city officials, while the officials themselves were chiefly engaged in recriminations against one another. It was clearly a case of " Stop Thief! ", and Nast's cartoon of that title, published October 7, so exactly portrays the situation, and is withal so full of spirit and action that one feels impelled to join in the mad race and to take up the accusing cry.

Yet in the obscure Land of Politics Tweed himself was still a power. At the State convention held at Rochester he was complete master. Mr. Tilden did, in fact, make a show of dissent, but was scornfully rebuked, and, realizing that the time was not ripe for his *dénouement*, instantly succumbed. In the Weekly for October 1, Nast shows the " Brains " of the Rochester convention—that now famous picture of Tweed with a money bag for a head, and no features save those expressed by the

THE AMERICAN RIVER GANGES.

dollar mark. The same issue contained " The Mayor's Grand
Jury "—twelve pictures of the Mayor himself—and that fearful
front page—the Ring in the shadow of the gallows—Tweed
lifting his hat, and the others cringing cravenly at sight of
" The only thing they respect or fear."

It is doubtful if caricature in any nation had ever approached
in public importance such work as this. Certainly America had
never seen its like. The crushing of the Ring had become a
national issue and, next to Grant himself, Thomas Nast, as leader
of the greatest reform movement New York City had ever
known, had become the conspicuous national figure. Carlyle
once said: " He that would move and convince others must first
be moved and convinced himself." Thomas Nast had long been
moved and convinced in his crusade against the Ring. Now in
a perfect frenzy of battle he had risen to achievements of attack
and slaughter hitherto undreamed.

And just here came Samuel J. Tilden's great moment of en-
trance. His appearance on the stage was as dramatic as it
was effective. It was the moment in the melodrama when the
avenger rushes from the wings, holding high the damning proof
that makes conviction sure.

The Booth Committee was ready to make its report. Through
Andrew H. Green, Mr. Tilden knew precisely what that report
would be. Two or three days previous he " happened causually,"
as he says in his affidavit, to drop into Mr. Green's office, and
was there shown some startling figures from the books of the
Broadway Bank. Traced through the bank's entries, these
figures showed just how an account against the city—a
sum of $6,312,641.37—had netted a clear profit of $6,095,309.17
to Tweed and his friends, and just in what measure the transac-
tion had been arranged. Why the bank had not rendered so
important a public service before, does not matter now. Neither
does it matter why Mr. Tilden, who later acknowledged that he

"STOP THIEF!"

"They no sooner heard the cry, than, guessing how the matter stood, they issued forth with great promptitude; and, shouting 'Stop Thief!' too, joined in the pursuit like *Good Citizens.*"—"OLIVER TWIST."

13

knew as far back as 1869 that the Ring "was opposed to all good government," should have waited until this particular and supreme instant for strenuous action. It is enough that it was the supreme instant, and with his affidavit and the clear and full statement of the Broadway Bank, Mr. Tilden strode

 into the lime-light, and the Public rose up in a concord of cheers and commendation. Tilden in that moment must have believed that the greatest gift of the American people would be his reward.

On the next day the report of the Booth Committee removed the last breath of doubt. On that day William Marcy Tweed was arrested,

THE BOSS STILL HAS THE REINS

and, though released on a million dollar bond, supplied by Jay Gould and others, that first arrest marked the beginning of the end. Samuel J. Tilden, like an avenging angel, with all the skill and knowledge and ambition of his kind, had linked his legal acumen with the brilliant daring of the Times and the relentless genius of Nast! The glory of dishonor was waning dim. In its declining day, long shadows of sombre prison walls reached out to enclose the Ring.

Yet perhaps hope was not wholly dead. In the issue of the Weekly prior to election week there was but one small cartoon, and this represented Tweed still holding the Democratic reins. It may be the Ring gleaned a grain of comfort from this confession of the "Boss's" strength, and believed it to be the last small shot of battle. Little did they guess that with the next number—issued two days before the election—Thomas Nast would fling into their midst a pictorial projectile so terrific in

its power, so far-reaching in its results, that Ring rule and plunder the world over shall never cease to hear the echo of its fall.

It was a great double page of that Coliseum at Rome which the young Garibaldian had paused to sketch on his way out of

THE ONLY THING THEY RESPECT OR FEAR

"We presume it is strictly correct to say that the one consequence of thieving which they would now dread is a violent death. Public scorn, or even the penitentiary, has little terrors for them."

"We do not know how the affair may end, but we do know that if they close their careers in peace, and ease, and affluence, it will be a terrible blow to political and private morality."—*The Nation.*

Italy. Seated in the imperial enclosure, gazing down, with brutal eager faces are Tweed and his dishonored band, with the Americus emblems above and below. But it is only the centre of the amphitheatre that we see. There, full in the foreground, with glaring savage eyes and distended jaws, its great, cruel paws crushing down the maimed Republic, we behold the first complete embodiment of that fierce symbol which twenty years before had fascinated a little lad who had followed and shouted behind the engine of the Big Six. The creature of rapacity and stripes, whose savage head Tweed had emblazoned on the Tammany Banner, had been called into being to rend and destroy him. In all the cartoons the world has ever seen none has been so startling in its conception, so splendidly picturesque, so enduring in its motive of reform as '' The Tammany Tiger Loose— What are you going to do about it? '' In the history of pictorial caricature it stands alone—to-day as then, and for all time —unapproached and unapproachable.

Two days later the people declared what they would do about it. The Ring had plotted to stuff the ballot and use their armies of repeaters, but so great was their craven fear at this moment that a Nast picture of citizens voting into a waste-basket, with the Ring to do the counting, published with four others in the great Tiger issue (six altogether), frightened them into a fairly honest count which swept them out of power. The Ring was shattered. It existed but in the history of its misdeeds.

The Nast pictures of the results of the great defeat were worthy of the man who had made them possible. Tweed, wounded, bandaged, disgusted and disgusting, is shown as Marius among the ruins of Carthage. The '' Boss,'' it is true, had been reëlected to the State Senate—the vote in his district not being a matter of moral conviction—but he had lost all desire to claim his seat. On another page, '' Something That Did Blow Over '' graphically and humorously portrayed the ruins of

THE TAMMANY TIGER LOOSE.—"What are you going to do about it?"
(The first use of the famous Tiger symbol)

"WHAT ARE YOU LAUGHING AT? TO THE VICTOR BELONG
 THE SPOILS"

the House of Tammany—the Ring and its adherents either crushed or escaping, with only Hall, whose term had not expired, still clinging to a tottering fragment. Opposite to this is still another page, "The Political Suicide of Peter 'Brains' Sweeny" —Sweeny having resigned from office and withdrawn from public life the day following the fatal election. In his letter of resignation he declared that henceforth his official duty would be confined to the single act of voting. Mr. Sweeny, it may be added, subsequently made a flying trip to Canada, later to join his brother James, also concerned in Ring financiering, in France. Eventually he paid four hundred thousand dollars to the city and was forgiven.* It has been

* Mr. Sweeny's "Bill of Health" was obtained and the money restored to the city in the name of James M. Sweeny, who had died subsequent to the Ring exposures. This subterfuge was freely condemned at the time, as the following brief extracts will show:

Evening Post, June 7, 1877:

Of course, nobody will be deceived by this disgraceful and offensive sham. The suit of the people was not against James M. Sweeny. He is dead. The proceedings are not against the estate. It is not believed that he had any estate. It is known that he lived by the breath of his brother, that he was but a mere miserable tool, and that nobody would have been more astonished than himself if it had been suggested that he should pay to the city of New York, or to anybody else, several hundred thousand dollars, or any other sum.

said that he never really participated in the Ring profits. If this be true, then the writer may be permitted to add that Mr. Sweeny paid a very large price for the privilege of keeping very bad company.

Mr. Tilden, who, with James O'Brien, had been elected to the Legislature, must have forgotten his agreement to protect Connolly, for on November 25th the latter was suddenly arrested on a complaint to which the only affidavit was made by Tilden himself. Connolly realized

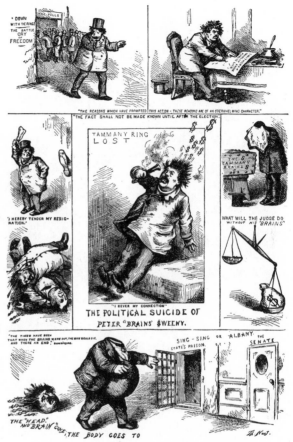

MR. SWEENY RETIRES FROM PUBLIC LIFE

Evening Express, June 8, 1877:

The release of Sweeny on the payment of $400,000 is an insult to the tax-payers of the city and an outrage on justice. . . . It is nominally paid out of his dead brother's estate, but even Lawyer Peckham admits that this pretence is too thin to be believed; and it is justified on the scoundrel's ground that compounding with felony pays better than to exact square-handed justice of the felon. And then to give Sweeny a certificate of character on top of this transaction, shows that somebody's ideas of decency are strangely demoralized and that the " Brains " of the old Ring still has his pals where they can do the most good.

There was much more of this, and the sentiment was echoed by the public and the press generally. Several later attempts have been made to rehabilitate Mr. Sweeny's reputation; but these efforts have met, and are likely to meet, with slight encouragement. The official obloquy recorded against his dead brother's memory remains a serious flaw in Mr. Sweeny's title to exoneration.

SOMETHING THAT DID BLOW OVER—NOVEMBER 7, 1871

that he had been trapped and offered to settle for a million dollars. A million and a half was demanded. Connolly's wife, who was present, demurred.

" Richard, go to jail," she said, and " Slippery Dick " that night slept behind the bars and remained there until January. Then he secured bond and joined the " Americans Abroad," the number of which increased with each outgoing steamer. Almost a score of indictments were prepared against Tweed, but it was not until the winter of 1873 that he was behind prison bars, and then for misdemeanor. Later he was imprisoned in Ludlow Street jail in default of a three-million-dollar bond. Thence he escaped to Europe, to be captured, as we shall see later, in a manner which would add the final touch to a triumphant crusade.

Hall—brazen, defiant and shameless to the last—clung to the wreckage until his term of office expired, " The Last Thorn of Summer," as Nast depicted him. Neither the Herald nor the

Tribune was ever fully convinced of his guilt, and Nast, in a cartoon, showed the younger Bennett and Mr. Greeley white-washing him until his real identity was almost lost. In another place Greeley as Diogenes is "discovering" him as the one honest man. One reflects that "Elegant Oakey" must have had a most winning personality to have inspired ever so little confidence in these shrewd journalists, when ruin and wreck lay all about him, and only oblivion and exile before. The colony of expatriates claimed him in due season, and when, long after, he returned to his native land, broken in body and fortunes, he eked out a paltry living by a petty law practice, and through contributing archaic humor to the comic weeklies.

Of all the fortunes acquired by the Ring and its adherents, scarcely the remnants of a single one exist to-day. Less than a million of the loss was recovered by the city, but the men who had sold themselves for plunder had not the ability to preserve their ill-gotten price. Some of them died in exile, others in prison. Some were allowed to return and testify against their fellows, and all, or nearly all, have perished from the sight of men, and left only dishonored names behind.

WHAT THE PEOPLE MUST DO ABOUT IT

LET THE GOOD WORK (HOUSE-CLEANING) GO ON

Miss Columbia—" Uncle Sam, you keep on cleaning the ballot-box, while I give this a scrubbing—goodness knows, it needs it!"

CHAPTER XXIII

AFTER THE BATTLE

Nast had done much besides the Ring work in 1871, for he was an indefatigable worker, and two booklets, one entitled " Dame Europa's School," a humorous portrayal of affairs in Europe, and another, " Dame Columbia's Public School, or Something that did Not Blow Over "—both of which were numerously illustrated with Nast drawings—had a world-wide, though of course brief, popularity. The first " Nast Almanac " also appeared this year, an amusing booklet of the months, to which Mark Twain, Josh Billings, Nasby and most of the " funny men " of the time contributed. Then there had been regular cartoons in Phunny Phellow, also social and moral cartoons in both Harper's Bazar and Weekly, and these had not failed to arouse discussion, for no matter what the subject might be, the cartoons of Thomas Nast were likely to be radical and to command attention.

But with the overthrow of the Ring, all else was forgotten. Letters of congratulation and even telegrams poured in. One of the latter, from " Two Patriots of Vermont " said:

God alone can fully appreciate the blessings you have conferred upon the country by your noble reform. May your health be spared to enjoy the perfect happiness you deserve.

From the Vice-President came an enthusiastic line.

Dear Mr. Nast:
With a heart full of joy over the magnificent results of last Tuesday, I write you again, as I did in the fall of 1868, to recognize the large share you have had in its achievement. Week by week I have looked at and studied your telling and speaking pictures and wondered how you could find so many new and striking ideas for your pictorial bombardment. Everybody I have heard speak of the campaign concurs with me that nothing has been more effective. Rejoicing with you that these returns prove that General Grant can be elected far more triumphantly in 1872 than in 1868, I am, sincerely your friend,

Schuyler Colfax.

In an editorial on the Ring's downfall the Nation said:

Mr. Nast has carried political illustrations during the last six months to a pitch of excellence never before attained in this country, and has secured for them an influence on opinion such as they never came near having in any country. It is right to say that he brought the rascalities of the Ring home to hundreds of thousands who never would have looked at the figures and printed denunciations, and he did it all without ever for one moment being weak, or paltry, or vulgar, which is saying much for a man from whose pencil caricatures were teeming every week for so long.

The Post (Nov. 23, 1871), quoted the above, and added,

The fact is that Mr. Nast has been the most important single missionary in the great work, and it is due to him more than to any other cause that our municipal war for honesty has, from a local contest, widened to a national struggle.

No respectable paper was bold enough to defame him now. Even those who, perhaps in a spirit of rivalry, refused to accord

credit to the Times for its great work, united in the most ex-
travagant praises of Thomas Nast. The Times itself generously
acknowledged that the pictures of Nast, which even the illiterate
could read at a glance, had been the most powerful of all the
engines directed against the stronghold of civic shame. Every
leading paper in America had an editorial in his honor. Poets
sang his praises and ministers of the gospel offered blessings
from the pulpit. The circulation of Harper's Weekly had in-
creased from one hundred thousand to three times that number,
a result accredited almost entirely to the Ring cartoons of Nast.
Collectors began to gather his pictures. Many wrote for infor-
mation concerning his earlier work. Among them was Augus-
tine Daly, whose collection was to become world-famous.

But it was not only in the market-place that his name and
achievements were recognized. In the most isolated farmhouse
of the West, in the woodsman's hut and in the miner's cabin, car-
toons of Tweed and his fellows decorated the walls, and the men
and women who put them there knew that they were drawn by
Thomas Nast. They knew that with his marvellous pencil and
his unfaltering courage he had triumphed over these men who
had brought a great city to the verge of ruin, and who, but
for him, might have destroyed the Nation. They told these
things to each other about the fire at evening and the stories
grew with the telling.

Nor was this honor confined to America alone. London papers
were filled with the story of his achievements and his fame.
By the Times, the Spectator, and other London journals he was
hailed as the Hogarth, the Doré, the Cruikshank, the John
Leech, of America. Such papers meant to be generous, com-
plimentary and sincere. But Nast was as none of these. He was
the Thomas Nast of America, an individuality as absolute, and
as noble as any of those with whom he had been compared.
Most of them surpassed him in mere technique, and Nast him-

self was always the first to make this admission. But in fertility of thought, in originality of idea, in absolute convictions and splendid moral courage, in achievements that shall make men revere his name and memory, Thomas Nast was the peer of them all.

His great triumph had been accomplished in spite of his lack of early study and academic training. His mastery of line and color value was then, and remains to-day, a matter of discussion among artists and critics. It is a matter of small moment. Neither then nor later was " The Tammany Tiger Loose " studied for its technique or for the lack of it. It was accepted without a question as " the most impressive political picture ever produced in this country "* and every American cartoonist at once appropriated it as his own—not surreptitiously but openly, as the pupil copies the master. The symbols and ideas of the first American cartoonist became without question the property of his followers. In the Weekly for December 2, 1871, C. S. Reinhart, then young and devoted to Nast, made use of the Tiger symbol without hesitation. To him and to others it was like the sudden discovery in science of some new element or principle. It belonged to the world—the world of art.

* Times.

THE LAST THORN OF SUMMER

PART FOUR: THE DEFENDER

CHAPTER XXIV

"ANYTHING TO BEAT GRANT"

HAUL "TURNED UP"
"Here we are again"

The beginning of 1872 found Thomas Nast surrounded by comfortable conditions and a happy household. His earnings for the year just closed had aggregated more than eight thousand dollars, of which about five thousand had been paid to him by Harper and Brothers for his cartoons against the Ring. The fact that he might have had one hundred times the last named amount for discontinuing the crusade did not disturb him. He had won the fight, and the approval of worthy men. His loyal wife rejoiced with him in his triumph. His own health and that of his family had been regained. With fair prospects ahead they planned the purchase of the beautiful Morristown home—a place of ample grounds and spacious rooms —an ideal abode for a successful man with a sturdy and growing family. The new house was acquired in March, and they took possession in August. Mrs. Nast, who a year before had come to the country expecting to remain but a brief time, never saw the inside of the little Harlem cottage again.

Of the children there were now four—Julia, Tom, Edith and Mabel—the last a December baby of the year just gone. " We

had a 'glorious fourth' on the Fifth" he had announced by telegraph to Fletcher Harper, in the characteristic and joyous manner which remained with him to the end. Less than thirty-two years old, with health, fame, an ideal household— with long years of prosperity almost certainly assured— truly fortune had smiled upon the young artist who had begun with the beeswax soldiers in the dim old barracks of Landau.

CAN THE LAW REACH HIM?—THE DWARF AND THE GIANT THIEF

In the midst of the fierce campaign against Tweed and his fellows, the cartoonist had somewhat neglected those who, clamoring for reform of another sort, found their interest and pleasure in decrying the administration and personality of General Grant. Now that the Ring was in flight, he began to give attention to such individuals and party elements as were assailing the hero of Donelson, Vicksburg and Appomattox Court House. Being a presidential year, national affairs were of first importance. Besides the natural enemies of the Republican

party, there had developed a formidable opposition in its own ranks. In New York City, the Sun had long been printing a daily double-column headed "Useful Horace Greeley" and "Useless S. Grant." The Post and the Herald criticised or denounced the Administration. The Tribune, which only a little time before had declared that Grant was the logical candidate, better fitted for the presidency in 1872 than he had been in 1868, now united in the outcry against him, asserting that there were at least half a dozen better candidates, of which galaxy Mr. Greeley perhaps believed himself to be the bright particular star.

At Washington the anti-Grant faction consisted of a group of Republican senators, led by Charles Sumner, of Massachusetts, and including such men as Carl Schurz, of Missouri; Reuben E. Fenton, of New York; Thomas W. Tipton, of Nebraska, Lyman Trumbull and—though somewhat less prominently—John A. Logan, of Illinois. A curious cabal it was, whose able members had submerged the various questions upon which they differed, to unite on the single issue and in the hostile battle-cry, "Anything to beat Grant!"

"STONE WALLS DO NOT A PRISON MAKE."—*Old Song.*
"No Prison is big enough to hold the Boss." In on one side, and out at
the other.

A PROPHECY THAT WAS TO BE TWICE
VERIFIED

The causes which had led to this defection were, in the main, a personal opposition to the President's foreign policy and to his distribution of political patronage. Party leaders, failing to obtain profitable offices for their chief constituents, were loud in their outcries of "corruption" at every reported irregularity, and eager in their demands for a civil service reform. It was inevitable under the prevailing custom that many offices

should be filled by unworthy candidates unduly recommended, and the President had made some unfortunate appointments. For this he was now held personally responsible, and when frauds developed here and there, as they have in every administration since the formation of the Republic, Grant was charged as being directly to blame if not actually a participant in the profits of dishonesty.

That Charles Sumner, with a noble record behind him, should have been a leader in this ignoble warfare upon America's great-

CHARLES SUMNER
(From a photograph)

est soldier and one of her most honored Presidents, is not now a pleasant recollection for those who would revere that great statesman as the embodiment of all that is unselfish, high-principled and splendid—the Bayard of politics, the Chesterfield of debate. It was in 1856 that Preston S. Brooks, of South Carolina, incensed at Sumner's arraignment of slavery, struck him down at his desk with a gutta-percha cane. Neither then nor afterward did the Massachusetts statesman ever make any retaliation, and when, after a long illness, he returned once more to his accustomed place he was welcomed as a martyr and honored as a demi-god. It has been said that from the blow of " Bully " Brooks he never fully recovered, and perhaps we may accept this as an excuse for the fierce intolerance and personal vindictiveness of his closing days.

Sumner was a man of debate and oratory—a chevalier of fiercely passionate eloquence and finely rounded periods. Grant

14

was a soldier—a man of deeds—with words few and simple. Sumner was splendid in physique and bearing. Grant was small, unpretentious, almost uncouth. Sumner was willing to honor Grant as a soldier and a hero, but the man from Galena must have been weighed and found lacking in much that the Massachusetts senator would have deemed gratifying in the nation's Chief Magistrate. As Chairman of the Committee on Foreign Relations, Sumner resented the military simplicity and policy of his little commander, and was likely to appear condescending in their enforced intercourse. On the other hand, Grant was altogether willing to pay tribute to Sumner's superior culture and experience, and to accord deference to his desires.

It was this inclination on the part of the President that led to the break in their friendly relations. Grant's West India policy tended to the annexation of San Domingo, and in January, 1870, he had called one evening at Sumner's house to discuss the question and secure coöperation. The Senator was at dinner and perhaps did not wish to be disturbed during that function. Furthermore, though favoring, himself, the annexation of Canada, he vigorously opposed, as coming from the President, any annexation in the direction of the West Indies. He afterwards avowed that the President had come to him under the influence of liquor. Whatever may have been the details of the meeting, it is recorded that from that night Sumner became the bitter personal opponent of Grant—decrying in public, and to any one who would listen, not only the administration but the character of Grant in the most violent and opprobrious terms.

Those who knew and loved him best were amazed at his behavior. One of them, R. H. Dana, wrote:

Sumner has been acting like a madman. . . . If I could hear that he was out of his head from opium, or even New England rum, not indicating a habit, I should be relieved. Mason,

Davis and Slidell were never so insolent and overbearing as he was, and his arguments, his answers of questions, were boyish or crazy, I don't know which.

If Charles Sumner's mind was clear at this period, it is not easy to apologize for his demeanor. Openly and abusively hostile, both to the administration and the President, he might with perfectly good taste have resigned his post of honor instead of using it to impede legislation and to delay the Alabama adjustment, then for the first time made possible.

For England, who had permitted Confederate privateers to be constructed in British waters and to sail through British statutes to destroy American shipping, had long since realized that she had established a dangerous precedent which might be followed to her own vast undoing. She had made for herself a bed not conducive to repose, especially after Grant's declaration, in his annual message, 1871, that " Our firm and unalterable convictions are just the reverse " (of those of

THE JOINT HIGH COMMISSION.

PEACE TO JUSTICE: "AFTER YOU, MADAME"

England), and his announcement that the United States would take over the ownership of all the private claims and thus be nationally responsible for all demands against Great Britain.

The eagerness of England to make an end of the matter now became acute. Through Hamilton Fish—Grant's Secretary of State—and Sir John Rose, of England, was consummated the Treaty of Washington, an international agreement looking to the settlement of the Alabama claims and questions concerning

"WELL ROARED, LION!" AND "WELL SHONE, MOON!"

SECRETARY FISH AND GENERAL GRANT AMUSED AT THE ENGLISH OUTCRY OVER THE ALABAMA CLAIMS

certain fisheries and boundaries. Still deferring to the Massachusetts Senator, the President sent Secretary Fish with a memorandum of the proposed Alabama clause to Sumner's house to obtain his approval. Sumner's reply was, that as a condition of settlement the withdrawal of the British flag from Canada could not be abandoned, and added, " To make the settlement complete, the withdrawal should be from this hemisphere, including provinces and islands." *

As this demand would virtually have stopped negotiations, General Grant, who had paid little attention to Sumner's per-

* Address by Charles Francis Adams, N. Y. Hist. Society, November 19, 1901.

sonal attacks, now made up his mind that the Senator's removal from his post of influence was not only desirable, but necessary. Being a military man, he did not hesitate to reduce, in any manner that might prove effective, a subordinate who impeded, and was likely to destroy, a measure of such manifest importance. On the 9th of March, 1871, in a Republican senatorial caucus, Charles Sumner was deposed from the chairmanship of the Senate Committee on Foreign Relations—a position he had held with honor for many years. The Treaty of Washington was concluded—the Alabama Claims being finally arbitrated at Geneva, Switzerland, in the summer of 1872. For damages to American shipping England paid to the United States the sum of $15,500,000—an amicable adjustment, due to the combined efforts of President Grant, Secretary Fish, and Sir John Rose.

It will be seen from the foregoing how naturally Sumner —still the foremost statesman of the time—had been made leader of the anti-Grant senatorial faction of 1872. Carl Schurz, with grievances and ambitions of his own, espoused Sumner's cause and became his closest adherent and counsellor. Fenton, Trumbull, Tipton and others, each with his own axe to grind, rallied about them, rejoicing in the leadership of one who for a second time had been "struck down"—this time, as it was then declared,"because of his opposition to the San Domingo scheme"—a martyr to "military rule," a victim of the ruthless soldier, Grant.

" LET US CLASP HANDS OVER (WHAT MIGHT HAVE BEEN) A BLOODY CHASM"

Nast began the campaign of 1872 by dividing his attention chiefly between the Greeley movement in Printing House Square and those who waged war upon the President at the capital. Early in January he published a cartoon entitled " What I know about Greeley "—on the one hand, the " Sage of Chappaqua " in the " sacred old white hat and coat " offering bail to Jefferson Davis, and on the other, flinging mud at the imperturbable Grant. Later in the month there appeared a picture which made a most decided stir. Grant had been by no means deaf to the cry for Civil Service Reform. He was, in fact, the first President to show any interest in the theory. In his message he had declared for it in unmistakable terms. Perhaps this was not altogether a pleasant surprise for those who had been denouncing him as a military despot and spoilsman. Civil Service, after all, might not prove a savory broth to Senators long accustomed to arbitrary appointments for services rendered. Nast's cartoon represents their disgust at being compelled to take the potion they had been so clamorously demanding.

The picture was a shot home and contained a humor which perhaps the disaffected Senators failed to see. They cried out against any such treatment of their dignified body. It also

brought a protest from Curtis, himself chairman of the Civil
Service Commission at Washington, editing the Weekly at long
range. Curtis was the intimate friend of most of the members
of the anti-Grant cabal, especially of Sumner, for whom he

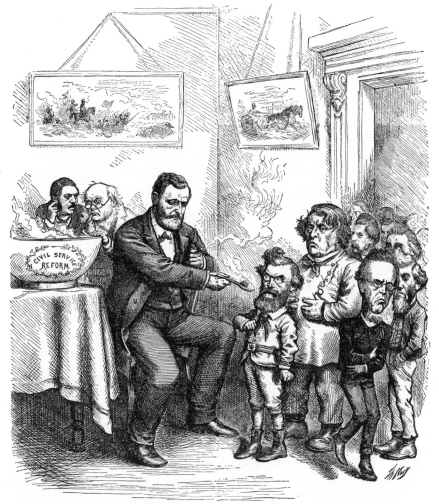

"CHILDREN CRY FOR IT."

U. S. G. "IF YOU CAN STAND IT I CAN."

"If bad men have secured places, it has been the fault of the system established by law and custom for making appointments, or the fault of those who recommend for government positions persons not sufficiently well known to them personally, or who give letters indorsing the character of office-seekers without a proper sense of the grave responsibility which such a course devolves upon them. A civil service reform which can correct this abuse is much desired.—*Grant's Message.*

GRANT OFFERS THE CIVIL SERVICE BROTH TO SCHURZ, SUMNER, TRUMBULL, FENTON
AND OTHERS. THIS PICTURE GREATLY DISTURBED MR. CURTIS

cherished an affection that found expression in a fine eulogy
after the death of that statesman in 1874. Nevertheless, Curtis
was at this period loyal to Grant and did not himself hesitate
in his carefully worded editorials to mildly reprove the dis-
senting faction, hoping thereby to lead them step by step back
into the fold. Already he had sought Nast's coöperation, in
a pleasant and characteristic letter.

My Dear " Nephew ": Washington, Jan. 13, 1872.
 I wrote to Mr. Harper a day or two ago about punching the
Honorable Horace Greeley. Affairs are taking an aspect not ex-
actly foreseen, and, in my opinion, there can be no doubt that it
is not wise to hit any of those with whom we must finally coöp-
erate. The " President's friends " will perhaps be found firing
on him by and by, for he is fully in earnest about the Civil
Service, and they are bitterly hostile. You remember what I
said some months ago about Sumner, Schurz and Greeley, and
I am of the same mind. It is not with the President's differences
with Republicans, but with the Ku-Klux Democracy, that we
ought to deal *in picture*, because it is so much more powerful and
unmanageable than writing.
 I am an old gentleman and my faculties are doubtless clouded,
but think of what I say, and of Your affectionate
 " Uncle! "

But the policy of fair words in no wise suited the resolute and
aggressive temperament of Nast. He had little faith in the idea
of conciliation and he cared not at all for vague and indirect
possibilities. He saw in a straight line very clearly, and he
struck accordingly. To him Sumner was simply a defamer of
Grant, who had met a well-deserved fate. Greeley was an " old
humbug " who dressed for effect, and who had pledged a sup-
port which he now repudiated. The cartoon " Children Cry
For It " was the " Nephew's " rather startling reply to the
" Uncle's " request, and the shock was general. Curtis wrote
immediately:

My Dear Nast:
 I am confounded and chagrined by your picture of this week,
in which my personal friends and those whom I asked you

especially to spare are exposed to what I think is not only ridicule but injustice. Your picture implies that the President adopts the reform for the purpose of commending a distasteful potion to those who have concocted it. I think, and therefore I say it frankly, that it injures everybody and the cause concerned. The one thing for which I have striven in the conduct of the paper is unity of sentiment. I don't think the pictures and the text should be at variance, and it is possible to criticise a man severely in words without the least ridicule, but it can't be done in pictures. I do not know how I can more strongly protest than I have already done against the fatal policy of firing upon Republicans. Success is not assured by alienating those who up to the nomination have exactly the same rights as

ourselves. Remember it is not the body known as "the President's friends" who hate the reform,* but it is the very men you ridicule who have really supported the movement and who mean what they say.

I do not assume any right whatever to control your action or to dictate in any manner. I protest to you as a friend against the injustice done to other friends and in a way of which I must bear the responsibility. Nor is it a personal protest only. The cause of the party, and therefore of the country, is injured. I support

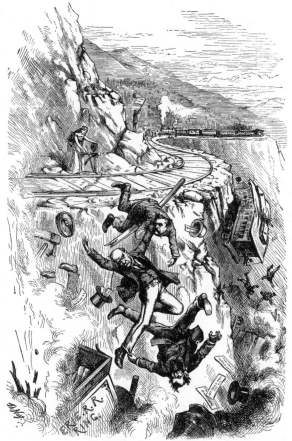

JUSTICE ON THE RAIL—ERIE RAILROAD (RING) SMASH UP.

* Compare with the preceding letter.

THE OVERTHROW OF THE ERIE RING

the President sincerely, but I respect the equal sincerity of my friends who differ. The situation is difficult, and our cause requires extreme delicacy of treatment. To-day I am to dine with Mr. Sumner, but how can I eat his bread, knowing that the paper with which I am identified holds him up to public contempt? Yesterday, when I defended the President to Mr. Schurz, he shook my hand warmly, and said, " At least we agree upon the point of Civil Service." What will his feelings be when he sees " my paper " ?

My dear Nast, I am very sorely touched by your want of regard for my friendship, for I asked you not to do this very thing. I know, if you will excuse me, better than you can possibly know, the mischief.*

Very truly yours,

George William Curtis.

However much this rather remarkable letter may have appealed to Nast from the personal point of view, it was far from convincing him as a guide to warfare. That Curtis should consider his own personal affiliations before the greater cause of the nation's welfare was, to a man like Nast, who had never considered even life itself as against the cause of justice, a matter for scorn and contempt. That the editor should feel any delicacy in boldly attacking and satirizing the men who were attempting to destroy the President seemed to him silly and " Miss Nancy-ish " to an extreme degree. Curtis, with all his gifts, never understood the value of the open and direct warfare of Nast, while Nast found little to admire in the smooth and gentle rhetoric of Curtis.

" When he attacks a man with his pen it seems as if he were apologizing for the act," Nast once expressed himself. " I try to hit the enemy between the eyes and knock him down."

Curtis's was the policy of pacification, while Nast's was that of annihilation.

" What I have written I can modify or recall later," Curtis

* It is likely that Mr. Curtis overestimated the possible effect of the pictures. If a dignified body of senators could be alienated from their party by pictorial satire, their allegiance was hardly worth preserving.

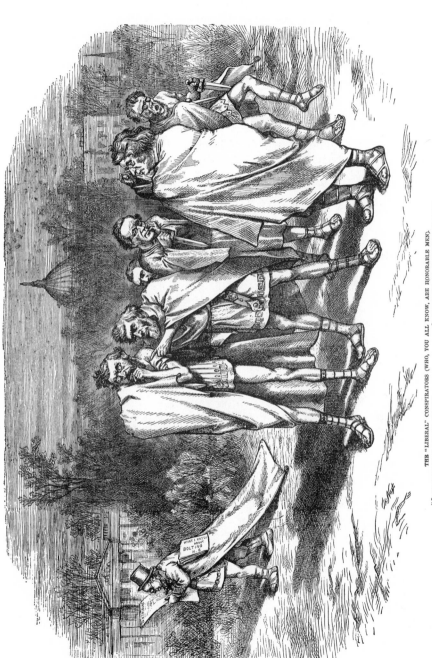

THE "LIBERAL" CONSPIRATORS (WHO, YOU ALL KNOW, ARE HONORABLE MEN).

"O, LET US HAVE HIM; FOR HIS SILVER HAIR
WILL PURCHASE US A GOOD OPINION,
AND BUY MEN'S VOICES TO COMMEND OUR DEEDS:
IT SHALL BE SAID, HIS JUDGMENT RUL'D OUR HANDS;
OUR YOUTHS, AND WILDNESS, SHALL NO WHIT APPEAR,
BUT ALL BE BURIED IN HIS GRAVITY."—*Julius Cæsar.*

THE DISAFFECTED SENATORS—SCHURZ, FENTON, TRUMBULL, SUMNER AND TIPTON—CONSIDER THE SELECTION OF MR. GREELEY
AS THEIR PRESIDENTIAL CANDIDATE

once said in the midst of a discussion with the artist. " You cannot do that with a picture.''

'' I only draw what I believe to be right,'' retorted Nast, '' and I do not wish to recall it.''

Gradually there grew up between them a definite antagonism, which Nast with his usual frankness took little pains to conceal. On the other hand, Curtis, the courtier and diplomat, seldom displayed any feeling, always greeting the cartoonist with a smile, and not infrequently going out of his way to oblige and conciliate, as is shown by a number of letters in which he congratulates Nast on his excellent work, or seeks to arrange for him certain profitable engagements. The oft-repeated statements of a partisan press that Thomas Nast was merely a tool to serve the will, and give expression to the ideas of George William Curtis, appear rather absurd in the face of these developments.

With the beginning of February appeared a cartoon entitled '' Cincinnatus ''—one of the best of the year, and, as was so often the case, a prophecy. Greeley the editor is offering the combined Republican and Democratic nominations to Greeley the farmer, while in the background appears the Democratic Donkey kicking fiercely at being yoked with a rather unhappy ox, intended to typify Mr. Greeley's Republican following. It was not believed at the time that Greeley was a Democratic presidential possibility. Nevertheless, Nast, with his usual insight, did not fail to strike the precise situation as it developed a few months later.

CHAPTER XXVI

WASHINGTON HONORS AND SOME LESSONS IN STATESMANSHIP

Nast now made a trip to Washington to look over the situation at close range. He had expected to make a brief visit, but social events detained him. That he was to be a power in the approaching campaign was recognized at the capital. The " Sword of Sheridan " had become as a memory. The " Pencil of Nast " had never been so keenly and trenchantly alive as at this moment. Dinners attended by Cabinet officers and presidential possibilities were given in his honor. At the White House, General Grant and his family received him in their home circle, and a life-long friendship began between the artist and soldier-president.

In frequent letters to the wife at home Nast, now in the first full tide of his great fame, tells us of his triumphs at the capital. What wonder if he was carried off his feet a little by the swing of it all—delighted yet dismayed—made dizzy yet keeping his head as best he could—always holding fast to the life-line that anchored at his own fireside. In his first letter he speaks of his coming, and of the recent difference with Curtis.

The Harpers wanted me to go, and they did not. They thought it would be good to go, and they thought it would not, and I came near coming home again. But I decided that if I did not go now I would not go at all, and then I might be sorry for not going before the nominations. Mr. Curtis sent me another

note. He was very much hurt. He did not think I would be so unkind as to hit his friends. He asked, "How can I eat the bread of Sumner after you have ridiculed him?" One of the Harpers said: "He must not eat the bread of Sumner." Fletcher, Jr., said: "Curtis may send in his resignation." I spoke to Fletcher, Sr., about it, and he said the Weekly could stand it if Mr. Curtis could, and I do think they would rather have Curtis go than have the Weekly not show its strength. He also said he thought I was oftener right than Curtis, and he would rather have my opinion on this question than Mr. Curtis's.

I will call on Mr. Curtis to-day and hear what he has to say, but will say very little myself, as he can talk so much better than I can.

The Chipmans dined with General Grant the other day, and told him they thought I was coming on soon. The President said: "I would very much like to see Mr. Nast again." Grant is sure to be nominated, but Curtis's friends will do all they can against him. Grant tells Chipman * it is awful the way the politicians try to get him to do this and to do that, and because he does not do just as they say he should, they get mad and kick him, more than they ever did any President before.

Later. After I got through with my breakfast I called on Mr. Curtis. I found the lion in his den. He didn't say anything more about making fun of his friends, so I didn't say anything, either. He tried to explain things as they are in Washington, and it seems to me that he is awfully muddled up. However, I didn't care, as I am here to see myself how things are—at least as I can see them.

The President found out I was here, and sent word he would like to see me. So after I got through with Curtis I called on the President. I had a very pleasant chat with him about everything in general, and I was very much pleased with the open way in which he spoke to me. I was with him about an hour. When we got through, he asked me to come and dine with him and his family at five P.M.

I went to dine with Grant and his family at five and did not get away from the White House until nearly ten. Had a very pleasant time. It seemed very homelike indeed. No nonsense, no show, but the real thing. I also met the Vice-President there —a great difference between him and Grant!

At the dinner there were only the family and General Wilson and wife. General Wilson is the man who captured Jeff. Davis. It is thought a great honor to be asked to dine with the President at his private table.

* Col. N. P. Chipman, Congressional Delegate from District of Columbia.

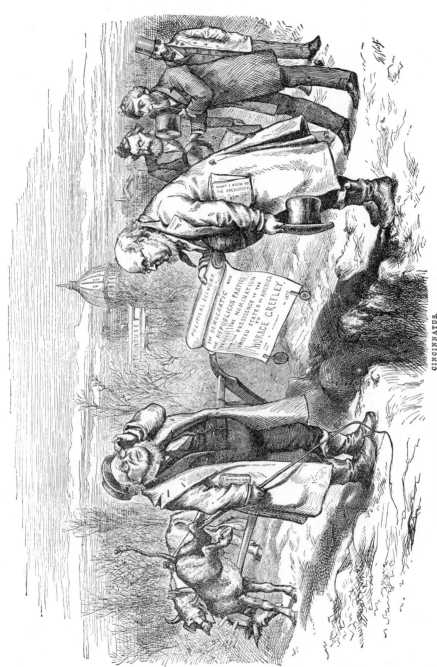

CINCINNATUS.

H. G. THE FARMER RECEIVING THE NOMINATION FROM H. G. THE EDITOR

Everybody knows me, everybody is glad to see me, everybody thanks me for the work I did during the Tammany war. The Chipmans are going to have a big man-party to meet me here. Colonel Chipman thinks it was a very good thing—my coming here—as everybody knows I don't want anything, and everybody tells me everything, just as if I was a great peacemaker. From the President down, they all have their little troubles to pour out, and I listen to them all.

I was on the floor of the Senate and of the House of Representatives yesterday, and had quite a reception. Senators to pay their respects to me! What do you think of that? Now, if you were only here, it would be all right! ''

Feb. 2. Last night Colonel Chipman gave a man's party for the big men of Washington to meet me, and I can tell you they came! The Vice-President came, judges from the Supreme Court, the Secretary of War, the Secretary of the Treasury, a great many senators, some members of the press—in fact, all that could come were here. The President was coming, but was tired after his reception at the White House; but the generals that are on his staff came and excused him. Mr. Curtis was asked and sent a note of regret, but to our astonishment he came in about ten. I do not know what to make of Curtis. I am afraid there is going to be a row, but I think the Harpers will be on my side. I dine with the Governor of the District to-morrow, with the Speaker, and so on. Nothing but dinners, calls and parties, and I cannot do much work, but am getting a great deal of material. Don't be surprised to see me home any day, but they are trying to keep me as long as they can.

Feb. 5. Dined with Speaker Blaine last night. At the dinner I sat between Mrs. Ames (Blanch Butler) and Gail Hamilton —the latter very plain, the former very handsome. I think Gail Hamilton did not like it that I talked with Mrs. Ames more, and afterwards she told me so, but the real reason was that she was too strong-minded for me, and the other was not.

Feb. 6. I send a few lines, but only a few. You have no idea how my time is taken up from morning until night—in fact, midnight. Everything here goes so well I am afraid something will happen at home.

The dinner that Mr. Hastings gave me last night was really very fine, and the Secretary of State * was on my right, and he talked to me so much during the evening that they called it a '' Nast-y—Fish '' dinner. But he told me a great many matters of State that I was very anxious to know.

* Hamilton Fish.

Yesterday I made calls on ladies with Mrs. Chipman, and it does seem strange, but they are all as much interested in my pictures as the men-folks.

I see the President nearly every day, and he is always pleased to see me. It certainly is funny how all the senators are in a flutter about my being here, and are all afraid that I will do them up. Senator Trumbull, whom I made a picture of in my drawing of civil service, is very polite and very kind. He wants to be President.

The power I have here frightens me. But you will keep watch on me, won't you? You will not let me use it in a bad cause.

I want to come home but must see what Harpers say about it.

COLONEL N. P. CHIPMAN, 1872

Feb. 8. Last night dinner at the Chipmans'. We had a good many members of the House of Representatives. Kelly, Roosevelt of New York, Governor Ashley and others. Joe Harper is coming on about copyright business, so I must stay. General Grant and family have been asked to dine at the Chipmans' with me. They put it off till next week.

But I must stop these goings on. I can't get any work done —it is too much of a good thing.

Feb. 10. This morning I got a telegram from Joe Harper. He says stay and see Hubbard. Hubbard is a copyright man. I have seen him often, and he thinks I can do a great deal of good by staying. I want to go home: not that I am not having a good time, but I am getting homesick.

Yesterday evening called on the President—stayed two hours. Was asked to dine with him again on Sunday—an honor that even Chipman was surprised at. Went to Blaine's reception with the Chipmans. The Leslie crowd was there. Mrs. Chipman said they watched me very closely. She said Carl Schurz and his wife watched me, too. Fenton said he would give me another portrait—that the one I was using was not good.

15

Each one seems so anxious I should have his best picture to work from.

Feb. 13. Yesterday was the first day of real hard work. I was at the copyright meeting all day, listening to the speeches,

SENATOR FENTON

and I was never so played out in my life; but I must stand it till Joe Harper comes, which will be Wednesday. The President will dine here then, and Mr. Harper also.

There is a great pressure against me for making fun of Schurz, Sumner, etc., but I hear that the Harpers will stand by me, no matter what happens, and if things come to the worst, it will be Curtis who will go. I am anxious to have Mr. Harper come on, so I can see him here, and then have a long talk as we go home.

Dined with the President again Sunday—had a fine time. General Porter told me that no one had been so nicely received at the White House as I was. I wanted to go home just for a day or so, and then return to end the copyright business, but they were afraid I would not come back; and they were about right. They are all so nice and kind to me, but I am homesick.

A few days later he had left the whirl and whisperings and tumult of the capital behind. Reading the old letters now, one cannot but be faintly reminded of the diary of Mr. Pepys amid the gayeties of London. What seems surprising is that he should so soon have wearied of the adulation of statesmen and the confidences of a nation's chief. For he was little more than a boy—not yet thirty-two—and in the first great glory of a triumph such as the nation had not seen.

Of course this Washington episode did not go unnoticed by the opposition press. Nast's victory over the Ring was too recent to be forgotten, but it was avowed that while Tommy Nast could

not be bought with money, he could be influenced by adulation and fine dinners—and had left Washington, pledged to Grant and the Administration. Thomas Nast was indeed pledged to Grant; not in words, but in his spirit of loyalty to a hero who, with malice toward none and with charity for all, had led the nation's armies to victory—unswervingly and uncompromisingly fighting it out on a single line to that final hour when to a vanquished enemy he could say " Let us have peace."

HORACE GREELEY, 1872

And Grant needed the loyalty of just such a relentless and unflinching champion as Nast. His enemies were legion, his assailants fierce and vindictive. The press of the period hesitated at no charge that would serve to blacken an enemy, and caricature was restricted only by the limits of imagination. Frank Leslie, who, during the summer and autumn of 1871, had repeatedly endeavored to secure Nast, later had brought Matt Morgan from England to oppose him. Morgan, in England, had made a successful failure of a small paper called the Tomahawk—successful in the fact that it had given him a reputation, a failure from the financial point of view—and was now regarded as worthy of his great American opponent. But Morgan in America was to prove a poor investment. More academic than Nast, he lacked conviction and insight and, worst of all, humor. Never has the proverbial " English lack of humor " been more conspicuously exemplified than in Morgan's Grant cartoons. From beginning to end they do not produce a single laugh. On the other hand, Nast's portrayals of Horace Greeley, however savage, seldom lacked the humorous note.

It is true Morgan had the weak side of the case. Grant was

charged with enough crimes and shortcomings to have de-
stroyed him utterly, but they were only charges, and had a habit

CARL'S BOOMERANG.
LITTLE CHILDREN SHOULD NOT INVESTIGATE (FRENCH) FIRE-ARMS.

of melting into impalpability
under the light of investiga-
tion. He was a despot. He
had wilfully made corrupt ap-
pointments and shared in the
profits of fraud. He had
abetted the sale of the nation's
surplus arms to agents of
the French Government during
the Franco-Prussian War—a
charge made by Schurz and
supported by Sumner. He
wanted to be President again, perhaps even a third time—
Sumner and Schurz found it necessary to prepare a bill restrict-
ing the presidential period to one term only. He owned a stone
quarry in Seneca, New York, whence large quantities of stone
for government building were said to have been taken. He
had appointed countless relatives to office, and was therefore
guilty of "nepotism," a word which did not fail to find place
in Sumner's classic vocabulary. He was accused of being
fond of fast horses and expensive cigars. Worst and most
heinous offence of all, it was said that he drank whiskey! Sum-
ner had smelled it on his breath that eventful night of the San
Domingo quarrel. It was the same charge which had been made
against him during the war, and to which Lincoln, who never
himself touched a drop of liquor, had replied: "Well, if Grant
drinks whiskey, I wish some of the other generals would get
hold of the same brand."

To portray Grant as a besotted despot in the midst of a satur-
nalia was hardly convincing to those who had followed his
march from Donelson to Appomattox, and under his administra-

tion had seen the national debt reduced at the rate of nearly one hundred millions a year. Lacking the touch of humor, such a picture was more than likely to become a boomerang, or a lighted grenade, tossed straight into the air. '' All that goes up must come down,'' and the Grant cartoons by Morgan fell destructively on the heads of those who had given them flight.

On the other hand, Horace Greeley was accused of none of these sins. It was unnecessary to charge him with anything save the fact that he had not remained steadfast in his faith and works. His career had been one of brilliant vacillations and distinguished credulities. His own printed utterances, re-printed categorically, became his accusation and his conviction. Adding together the evidences of his erratic record, his eccentricities of dress and manner, his own fondness for fierce invective and wordy warfare, with the further addition of Nast's unfailing touch of humor, and the Greeley cartoons were bound to become the effective weapons of the campaign. Indeed, if there was ever an ideal subject for pictorial satire it was found in the person and career of Horace Greeley. It has been charged against Nast that he assailed a feeble old man. On the contrary, Greeley was not yet sixty-two at his death, and certainly during the earlier months of the campaign was anything but feeble. Even had both charges been true he would have been all the more unfit for the high office he sought; and, always unsparing in his own warfare, he could hardly have hoped for mercy in return, especially as Grant, Nast's hero, was continuously reviled and caricatured as a drunkard, a loafer, and a thief.

THE BATTLE-CRY OF SUMNER.
C. S. "Here comes Nepotism!"

CHAPTER XXVII

The cartoons of Schurz, Sumner and their associates continued, becoming more drastic with each issue. Curtis did not protest again, and presently found it necessary to tighten his editorial strictures, whether from his own inclinations or because of urgent hints from Franklin Square cannot now be known. In an editorial of March 28 he said:

When Senator Schurz declared that the General Order swindle * was sustained by a power higher than the Secretary of the Treasury, he hinted that it was the President, because he is the only power which, in that sense, is higher than the Secretary. . . . Those who in the investigation of frauds in the Administration seem much more anxious to smear the President than to punish guilty agents, ought to consider whether by so clear an exhibition of personal animosity they do not harm the cause of simple, honest reform.

Nast had made another trip to Washington earlier in the month, and while there, had been presented to Schurz, who looked down with sinister contempt on the little man before him.

" You will not be allowed to continue your attacks upon me," he said rather fiercely.

" Why not, Senator?" queried Nast.

" Your paper will not permit them!"

" Oh, I think it will," ventured the artist pleasantly.

* In the New York Custom-house.

CARL SCHURZ. THE BRAVE

"THE TOWER OF STRENGTH."

"Well, then, I will not!" declared the tall statesman with a threatening air. "I shall publicly chastise you!"

Nast laughed his happy, infectious laugh, in which many joined. That the man who had defied and destroyed the Tweed Ring, with its legions of bullies and thugs, could be intimidated by Senator Schurz perhaps seemed to them humorous. In the issue with the Curtis editorial above noted appeared "Carl Schurz the Brave" as a "Tower of Strength," the most pronounced caricature thus far of the Missouri senator. On the same page Roscoe Conkling, as Macduff, the fearless defender of Grant, makes his first appearance, and a little later we find Schurz as Quixote, fighting the U. S. Windmill. Logan was left out of the cartoons now, or appeared very dimly in the background, sometimes turning his back on his former associates.

Colonel Chipman, always a faithful friend of Nast, was very close to Grant and in frequent letters kept the artist posted as to the situation at the capital. In one of these the President had sent word:

Logan is all right. I remember him in the field. He was always critical and fault-finding until the order came to move. Then he was in the front rank and ready to charge. Logan is loyal.

So Logan escaped after one or two hard knocks, but as the conventions drew nearer, the dissenting faction grew, and its members with the Democratic leaders were combined by Nast in a motley

assembly, of which Horace Greeley was portrayed as general spokesman and chief. Greeley, as Mr. Pickwick, addressing a convention of disaffected Republicans and a number of his former enemies, including Horatio Seymour,

THE ONLY "EMERGENCIES" WE NEED FEAR (?)
Don Carlos Quixote and Sancho Tiptoe Panza on "the Path of Duty"

"Andy" Johnson and Fernando Wood, was a humorous summary of "liberal" political conditions.

Colonel Chipman was a faithful correspondent. Near the end of March he wrote:

Your last pictures are excellent. I fell in with the President this morning during his morning walk. He says you are not only a genius but one of the greatest wits in the country. He says your pictures are full of fine humor.

I am glad you are working on the Supreme Court picture. The fact is, (David) Davis, Field and Chief Justice Chase are really the only members that have the fever at all. Nelson would have, but he is too old now.

I spoke of your idea to Judge Miller; he thinks it excellent, but he hopes he will not be brought out as a President-seeker, as he surely is not. He is a sturdy, straight-out Grant man and Republican, with no ambition beyond the Bench, and with fair outlook for the Chief Justiceship in Chase's place. I infer

THE CINCINNATI CONVENTION, IN A PICKWICKIAN SENSE.

Horace Pickwick. "Men and Brethren! A new leaf must be turned over, or there are breakers ahead. The Cincinnati Convention may prove a fiasco, or it may name the next President."

THE NAMES OF THE PICKWICKIAN GUESTS, BEGINNING AT THE LEFT, ARE (JEFFERSON) DAVIS, SEYMOUR, JOHNSON, WOOD, TIPTON, (DAVID) DAVIS, GEORGE FRANCIS TRAIN, FENTON, TRUMBULL, GREELEY, BLAIR AND SCHURZ, WITH A BACK VIEW OF B. GRATZ BROWN, WHOSE PICTURE WAS UNOBTAINABLE

from your not asking any points that you have all the information you want on these details.

Did you see what Greeley said of you the other day, editorially? Speaking of Harper's he spoke of you as the "blackguard of the paper, paid to defame, etc., etc.'' The Patriot has a mean attack on Harper, Curtis and Nast, and quotes the Tribune, so you see you catch it all around.

I infer that Greeley gives up the Phila. Convention to Grant. So far as I can discover, the Cin. movement does not strengthen.

I have very little gossip to send you.

Again in April, General Chipman wrote to Nast:

THE PRESIDENTIAL FEVER ON THE SUPREME BENCH.
Chief Justice. "Mark but my fall, and that that ruin'd me.
Judge Davis, I charge thee, fling away ambition;
By that sin fell the angels; how can man, then,
The image of his Maker, hope to win by't?"—*Shakspeare.*

CHIEF JUSTICE CHASE ADMONISHES JUDGE DAVID DAVIS
UPON HIS PRESIDENTIAL AMBITION

Greeley's conduct is now worth studying. His daily twistings and turnings. . . . You are looked for weekly as the political sensation we are to have. . . . The Democrats rely a good deal on Morgan, but I think the taste of intelligent people will reject the coarse in caricature as it will in writing.

The Democrats and Liberal Republicans go there (to Leslie's) for comfort and to solace themselves after your batteries have fired.

And once more:

Just now you must expect severe criticism. Keep a stiff upper lip and follow your instincts, so unerring as they are, and you will not go far wrong. . . . When I state facts you may rely upon them but my conclusions will be open to review.

. . . It is a perilous thing to furnish ammunition to so dangerous a gunner·as you are.

Perhaps an extract from a long editorial in the Brooklyn Eagle, entitled "Harper's Picturesque Insults" (March 22), will convey an idea of the feeling of the press on both sides concerning Nast's cartoons at this time:

They do not stir action, affect settled religious or political conviction, or influence a man's business, ballot, or other tangibilities. The prevailing, gushing idolatry of them is as shallow as to quote, in an age of Wall Street and steamship, "Let me write the ballads of a Nation and I care not who writes its laws."

It will be seen that the "Campaign of Caricature," or the "Battle of the Artists," as it was variously called, was already under way before the leaders were officially chosen.

It seems unnecessary that we should enter into the details of the several national conventions. That of the Liberal Republicans * was called for the 1st of May, and "Robinson Crusoe" Sumner being urged to forsake his "Man Friday" (the colored man),

WHICH IS THE BETTER ABLE TO POCKET THE OTHER?

"Schurz and the Vote he 'Carries in his Pocket.'—Senator Schurz goes to New York next week, and will, by invitation, speak at the Cooper Institute, as a part of the plan to mass and carry the German vote and sentiment of the country to the support of the Cincinnati platform and candidate."—N. Y. Herald, April 3.

to embark on the boat bound for Cincinnati, was one of the cartoons incident to the event.

Horace Greeley, who, in his paper, had pledged himself to the support of the regular Republican candidate, "whether the present incumbent or some other nominee," a little later, as New York member of the National Republican Committee, had refused to sign a call for the regular Republican convention. He

* The so-called Liberal Republican movement began with a convention held at Jefferson City, Mo., January, 1872.

had not, however, hesitated to sign a call for this most irregular meeting, which had no plan, no delegates, and no definite principles not embodied in the combined motto and war-cry, "Anything to Beat Grant!"

The assembly convened at Cincinnati, May 1—3, and after selecting Carl Schurz as permanent president, and agreeing to disagree on a most important issue—the tariff—it proceeded to choose Horace Greeley and Governor B. Gratz Brown, of Missouri, as its nominees. Later in the day, it is said, Schurz expressed his disgust with American politics, and followed by a few sympathizers retired to a friend's house, where, being a skilled musician, he gave vent to his true feelings on the piano, while the assembled guests shed tears. The "Liberal Mountain" that had rocked and groaned and brought forth a mouse, was Nast's characterization of the result, and throughout the Republican ranks, on every hand there was a wide smile of amusement at the assembly's choice.

WILL ROBINSON CRUSOE (SUMNER) FORSAKE HIS MAN FRIDAY?
The boat's crew that is going over

For Horace Greeley, honored though he was, was beloved rather for the lack than the possession of those qualities which are supposed to be the necessary attributes of a good President. Curtis never wrote a truer line than when he said:

If there is one quality which is indispensable to a President it is sound judgment. If there is one public man who is totally destitute of it, it is Horace Greeley.

It was H o r a c e Greeley's dogmatic and radical earnestness in any position that he assumed, his sudden and startling changes of base, his frequent yieldings to impulse and tenderness of heart, his simple credulity,

" GREAT EXPECTATIONS "

" A (Mud) Mountain was once greatly agitated. Loud Groans and Noises were heard ; and crowds of People came from all Parts to see what was the Matter. After long expectation and many wise conjectures from the by-standers, out popped a—*Mouse !* "

and, with it all, his brilliant editorial performances, that had won for him the fondness, rather than the trust, of the American people.

Easily the leading journalist at a time when editors were greater than their papers, Horace Greeley's personal following was a vast multitude throughout the land. That he should have mistaken this popularity for political allegiance is not strange,

considering his continuous pursuit of public office, which apparently rendered him oblivious to the immutable laws of cause and effect. He had dissolved the " firm of Seward, Weed and Greeley " because, as he acknowledged, he felt that he stood a

better chance of official recognition alone. He had eagerly seized upon any office, small or large, that came within his reach. The possibility of being selected as a candidate for the Presidency, by any party whatsoever, was calculated to make him forget that his record, brilliant though it had been, was such as to make his election a miracle not likely to occur.

HURRAH FOR HORACE GREEDEY FOR PRESIDENT

For though a fierce and avowed champion of right, as he saw it, Mr. Greeley had been unfortunate in not being able to maintain a steadfast point of view. Beginning as a Henry Clay protectionist Whig, he had remained with that party even after it had accepted the Fugitive Slave Law and the Compromise of 1850. Later he had become a powerful element of the Abolition Movement, but in the early days of Secession he had been willing to let the dissatisfied States " go in peace." Subsequently he was denouncing the Confederacy—its soldiers, its citizens and its women—exasperating Lincoln with the cry of " On to Richmond," and with a demand for immediate emancipation of the slaves. Still later we see him blundering into the disgraceful Niagara Peace Conference, disobeying Lincoln's positive orders and putting the President in a false attitude before the nation. When the Confederate Army entered Pennsylvania, he had been for fighting one battle and surrendering everything if the Union forces were beaten. Again in the dark-

est hour of the war he had declared in favor of making peace at any financial cost, and in 1864, after Lincoln was nominated, he had signed a letter to the loyal governors, substantially asking why Lincoln should not be set aside and a new candidate chosen. In the matter of finance he had been ever full of schemes, visionary, experimental and rash. His record was that of a turbulent and disordered career.

It is no longer considered good taste to question Mr. Greeley's motives. His shortcomings are ascribed to gentleness of heart, impulsive action and errors of judgment. Careful examination of the evidence may not always convince the impartial historian of the justice of these conclusions. But admitting all the virtues claimed, and denying all the calumny ever charged, it must be acknowledged to-day that Horace Greeley was the last man in public life to be selected by any party as its presidential candidate.

The first to congratulate Mr. Greeley on his nomination was Colonel Wiliam F. Church and John Swinton.

" This is all Tom Nast's work," declared Greeley, shaking hands.

His idea was that, Nast having made sport of his candidacy, the Convention had vindicated him before the people.

That the personality of Governor Brown did not appear in the cartoons which followed was at first due to the fact that no photograph of the Missouri candidate could be procured. When another week went by and the photograph had not been obtained, Nast was at his wits' end to represent the Vice-Presidential candidate, in a picture of the " old white hat and coat." At the last moment he put a tag labelled " Gratz Brown " on the tail of the sacred emblem. The popularity of this cartoon showed that the makeshift had made a hit. Brown's photograph was no longer sought. The tag on the old coat represented him through-

WILLIAM TELL WILL NOT SURRENDER OR BOW TO THE
OLD HAT
(It was in this cartoon that the vice-presidential candidate was attached
as a tag to Greeley's coat)

out the campaign, much to the Missouri man's humiliation.

The Republican National Convention assembled at Philadelphia on June 5th. On the Friday preceding. Charles Sumner had aimed his final shaft at Ulysses Grant. For four hours he had arraigned the President in a speech that has no parallel in the annals of public denunciation. Even Curtis, who loved Sumner, and whose eulogy of him is one of the fairest tributes ever laid on a dead man's grave, gave way at last, and editorially chastised his friend.

He (Sumner) said all that anybody ever said and more. No charge escaped him. He depicted the patriot whom all men know, and the Chief Magistrate who has given us peace and security, as a monster of ignorance, indolence, lawlessness and incapacity, whose influence is pernicious in the highest degree, and whose example degrades the youth of the land. The reply of the Republican party was the renomination of the President with enthusiastic unanimity by one of the most intelligent conventions ever assembled in the country. So wholly unjust is the

spirit of Mr. Sumner's speech that it may be truly said not to represent accurately a single fact.

Judge Settle, of North Carolina, presided at the Republican Convention, and Grant's nomination was made without a single dissenting vote. Senator Henry Wilson, of Massachusetts, was then selected for the Vice-Presidency, and the old-line Republican party was ready for the campaign.

The Democratic Convention went into session at Baltimore on July 9, and ratified the Cincinnati nominations. It was strongly Confederate in tone —an assembly of the elements which Horace Greeley for a period of years had denounced in the severest terms he knew. Generals Gordon, Hardeman, Fitz-Hugh Lee and many other Secession leaders were there. Governor Hoffman, who in his annual message had execrated and repudiated the Ring of which he had been the figure-head, led the delegation from New York, and good Tammany and bad

THE LAST SHOT OF THE HONORABLE SENATOR FROM MASSACHUSETTS—HE PULLED THE LONG BOW ONCE TOO OFTEN

(Nast's caricature of Sumner after the violent speech against Grant)

16

Tammany, the white sheep and the black, gathered to Mr. Greeley's fold.

In its desire for a President—in its eagerness to do " anything to beat Grant "—the convention was willing to go to the limits of stultification. Not only did it accept Horace Greeley as its candidate, but it indorsed the " enfranchisement of the negro; " the " equality of all men before the law "—it remembered " with gratitude the heroism and sacrifices of the soldiers and sailors of the Republic " ; it avowed that the Democratic party should never " detract from their justly earned fame, nor withhold the full reward of their patriotism "; it denounced " repudiation in every form and guise." In a word, the convention was ready to demolish the existing Democratic faith, pillar and cornerstone, for the possibility of aiding in the election of a man who had applied to most of its delegates every opprobious epithet known to the English tongue.

" DROP 'EM ! "

And Horace Greeley promptly accepted their nomination and became the leader of legions he had formerly reviled to the limits of his forceful idiom—to the extremes of his marvellous vocabulary. His position was only equalled by that of Charles Sumner, who, as one adding a final evidence of mental disorder, now came forward with an open letter addressed to certain colored voters, advising them to repudiate Grant and Wilson and cast their ballots for Greeley and Brown. In view of his life-long devotion to the cause of abolition; the bitter sectionalism and race prejudice of that period; the fact of his Civil

Rights bill—the idol of his heart—then pending, and certainly damned before a Democratic Congress, it seems positively incredible that Charles Sumner in his right mind should have done this thing.

He was scored by Nast as a matter of course, also by Curtis, though the latter pleaded that the Massachusets Senator might be spared. In his letter, dated August 1st, Curtis said:

My Dear Nast:
Since Webster's " Seventh of March " speech nothing in our political history has seemed to me so sad as Mr. Sumner's letter. He is my dear friend, a man whose service to the country and to civilization have been immense, who deserves all honor and regard from all honorable men. The position of such a man may be criticized in writing, because in writing perfect respect may be preserved. But it is not so with the caricaturing pencil. You see what I am coming to. You are your own master, and your name is signed to your work. But it is nevertheless supposed that I, as editor, am responsible for what pains me the more because of my friendship and my difference. Besides, the caricature puts a false sense upon what is written, and covers the expressions of the most sincere regard with an appearance of insincerity. There are thousands of good men who feel as I do about it, and I hope that your friendship for me will grant my request that you will not introduce Mr. Sumner in any way into any picture.
Very sincerely yours,
George William Curtis.

Just why Mr. Sumner should have been spared on personal grounds, as against the nation's welfare, is not clear. Certainly such an argument was likely to avail little with the impetuous artist in the midst of a fierce campaign. His reply to Curtis was to the effect that the fact of Sumner's heroic past, and the prestige derived therefrom, made the Senator's present attitude all the more of a menace to the cause of right. He called attention to the fact that earlier, Curtis had asked that he should not caricature others of the group who were now, as they had been from the first, Grant's bitter enemies. To this came a reply on August 22:

My Dear Nast:

I am very much obliged by your note. I did ask you not to caricature Sumner, Greeley, Schurz and Trumbull, because at that time I thought it was bad policy—and I think so still!

The exact difficulty which I feel is this, that it is wrong to represent as morally contemptible men of the highest character with whom you politically differ. To serve up Schurz and Sumner as you would Tweed, shows, in my judgment, lack of moral perception. And to one who feels as I do about those men, *and who knows* that he is about right! every picture in which you defame them is a separate pain. There is a wide distinction between a good-humored laugh and a moral denunciation.

You are very good to have answered me at all. I know how I differ from you and from our friends in Franklin Square upon this point, and I have wished only to free my conscience by protesting. I shall not trouble you any more, and I am,

Very truly yours,
George William Curtis.

Yet at this time Nast was saying with his pencil almost precisely what Curtis was saying with his pen. The difference was, that the editorial, to Curtis, was a sort of inductive mode of warfare, with due preliminaries and approaches, whereas the cartoon came as a sudden and unqualified blow. To Curtis the cartoon was not a gentleman's weapon, at least not a weapon to be used on gentlemen. That he could distinguish no difference between Nast's methods of treating Sumner and Tweed would indicate that his own " moral perception " was more delicate than his visual discernment. Like the bomb and the bayonet, the cartoon to him seemed brutal. But great battles are not fought with the single-stick or even the rapier, and " those vile guns " have persuaded many a man not to be a soldier.*

Sumner abandoned the campaign and hurried away to Europe

* In one of the pictures Nast cartooned Sumner as strewing flowers on the grave of " Bully " Brooks. As satire this was a failure, for it conveyed the Massachusetts Senator's real spirit of forgiveness for the man who had struck him down. Sumner, when shown the picture, regarded it sadly.

"What have I to do with Brooks now?" he said. " It was not he, but slavery, that struck the blow."

for rest. That the blow of " Bully " Brooks, more than a quarter of a century before, had left its mark and shadow upon that splendid intelligence can scarcely be doubted. Yet, even had this been realized at the moment, it could not have been considered as a reason for failing to combat a pernicious doctrine, which must be crushed all the more promptly and surely because of the fair name and far-reaching influence of its advocate.

" PLAYED OUT ! "

CHAPTER XXVIII

THE CAMPAIGN OF CARICATURE

WHAT'S IN A NAME?
Whoever calls this an "organ" is "a liar, a villain, and a scoundrel"

Meantime the conflict was at its height. Upon his nomination, Mr. Greeley had promptly surrendered the editorship of the Tribune to Whitelaw Reid, and declaring that his paper was no longer a " party organ " had set about the business of politics. Nast cartooned him as holding out the " New York Trombone," announcing vigorously in his characteristic phraseology that the instrument "was not an organ." Yet, despite his withdrawal, the Tribune did not fail to bear the marks of Mr. Greeley's personality, and with the Sun and the World, and such Democratic journals as had not repudiated the choice of the Báltimore Convention—with Leslie's as their pictorial exhibit—they made whatever fight was possible for their candidate. The World, it is true, had at first declared against Greeley; and it must have given joy to General Frank Blair to see Manton Marble, who had been for throwing him (Blair) overboard four years before, now turned Sinbad, with an " old man of the sea " on his shoulders.

"SOMETHING THAT WILL BLOW OVER"

Of the daily papers in New York City, the Times led the campaign for Grant, seconded by the Commercial Advertiser and other regular Republican journals. The Post, though it had criticised the Administration, also fell into line. Even the Herald accorded a lukewarm support, for which, it did not hesitate to say, it expected to dictate Grant's cabinet policy in event of his election.

But it was distinctly a campaign of caricature — the first great battle of pictures ever known in America. Morgan portrayed Grant more besotted and more villainous with each issue of Leslie's, and each week Harper's showed some new inconsistency in Mr. Greeley's political attitude.

For the most part the Nast pictures, in the beginning, were

One of the least severe of the Morgan cartoons against Grant

WEIGHED IN THE BALANCE AND FOUND WANTING

U. S. G.: "Well, who'd have thought that the old white hat, boots and axe would have more weight than all these hangers-on of mine?"

(President Grant depicted as an intoxicated military tyrant, with Secretary Fish, Senator Morton, "Boss" Tweed and others as hangers-on)

not bitter. Greeley the editor hurrahing for Greeley the nom-
inee—Greeley as Mazeppa—Greeley trying to carry off Grant's
shoes—Greeley's white hat and coat on a pole, storm-tossed and
labelled " Something That Will Blow Over "—Greeley splitting
the Democratic Log—Greeley as the Trojan Horse in which
Democracy is trying to enter Washington—these were at once
good-natured and humorous pictures at which the sage himself
might have laughed. But the picture battle did not end here.
Morgan's portrayals of the President became more scurrilous.
Grant as Belshazzar—Grant leering and sodden on his throne—
Grant as drunken Jeremy Diddler, dancing before Tweed—
Grant as an embezzler more than ten times as great as the
" Boss "—Grant arrested as a drunken malefactor by the
Tribune and the Sun—such pictures as these did not tend to
temper the pencil of Nast,* and presently we find Whitelaw
Reid grinding the " Organ " and Horace Greeley as a monkey
collecting votes from the assembled Democrats of Tammany,
new and old. As Mr. Greeley's continuous performance in at-
tempting to justify, or deny, or apologize for his past record,
furnished daily matter for the amusement columns, this picture
was pretty generally applauded and but slightly condemned,
even by the " Liberal " press. But, such cartoons as Greeley
shaking hands with the Baltimore rough, over the fallen soldiers
of the Sixth Massachusetts—Greeley joining hands with the
worst element of Irish Romanism—" Old Honesty " marshalling
his army of jail-birds and " Ring " associates—(anything to
beat Grant)—these brought down upon Harper's Weekly and
the head of Nast a fierce outburst of condemnation from every
anti-Grant journal and voter in the land. Letters, papers and
clippings poured in, demanding, threatening and pleading. Dig-
nified journals sought to divert Nast by praising his former

* Roscoe Conkling, Grant's foremost " champion in the field," characterized the
struggle as a " campaign of hate."

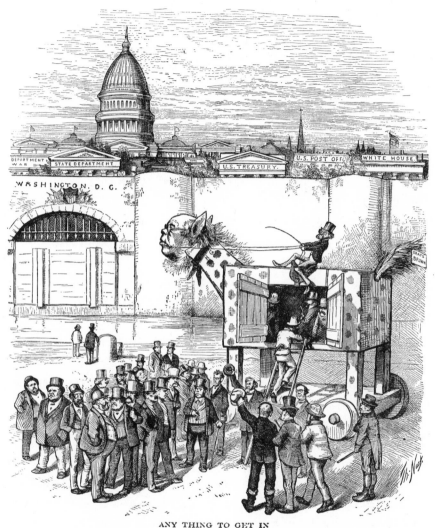

ANY THING TO GET IN
YOU CAN'T PLAY THE OLD TROJAN HORSE GAME ON UNCLE SAM

work and pointing out his mistake in " holding up to ridicule and condemnation a man so widely respected as Horace Greeley." A letter came suggesting that the " Irish vote was likely to be alienated " by introducing " Pat " into the pictures. Fletcher Harper forwarded this letter to Nast with a note of indorsement on the back:

If it is right to hit " Pat," hit him hard. Our paper is run for the good of our country. It is *not* a party organ. So go ahead. F. Harper.
To Professor Nast.

Curiously enough none of these documents of protest found anything to condemn in the mendacious editorials and libellous caricatures that were daily and weekly directed against the serene soldier who had led the nation's armies to victory. They pointed to Horace Greeley's " splendid record " and reviled Nast as a blackguard and Harper's Weekly as a " Journal of Degradation."

So Nast took up the record of Horace Greeley, as shown by editorial expressions from his own paper. " Another Feather in His Hat " depicted the Sage adding the " Cincinnati Nomination " to a collection of other plumes, among which were " Peaceable Secession, 1860," " On to Richmond, 1861," " Peace Negotiations at Niagara, 1862," " Down with Lincoln, 1864," " Bailing Jeff. Davis, 1865," and " Anything to Beat Grant, 1872."

But this was mild. In a single issue there were three terrible exhibits. The first, a front page, showed Greeley in charge of a whipping-post, swinging the Tribune cat-o'-nine-tails and branding " thief," " liar," " convict," and " black-leg," (his own words, formerly applied to Democrats,) on the bare backs of those whose suffrage he now sought. The second picture, also a full page, entitled " Bringing the Thing Home," showed Greeley gloating over the ruin of Southern firesides, and, underneath, this extract:

When the rebellious traitors are overwhelmed in the field, and are scattered like leaves before an angry wind, it must not be to return to peaceful and contented homes. They must find poverty at their firesides, and see privation in the anxious eyes of mothers and the rags of children.

By some mischance the date of this cruel expression—cruel indeed for one reputed as a tender-hearted man—was put down

as November 26, 1860. Immediately the Tribune published a scornful denial. Fatal step! Both the Times and Harper's Weekly promptly looked up the true date (May 1, 1861), the picture was immediately reprinted as a campaign document, and upon its back four columns of other damning extracts. The third exhibit of this memorable issue of Harper's

ANOTHER FEATHER IN HIS HAT

Weekly was a small picture on the back page, entitled " Red Hot! " and depicted Greeley eating a porridge of " My Own Words and Deeds.'' And this also, with three others, was republished in a pamphlet, entitled " Greeley Illustrated,'' with still another series of the Sage's unfortunate utterances, including his famous declaration concerning the Democratic party:

May it be written on my grave that I never was its follower, and lived and died in nothing its debtor.

In another place:

A purely selfish interest attaches the lewd, ruffianly, criminal and dangerous classes to the Democratic party.

And still farther along:

What I demand is proof that the Southern people really desire separation from the Free States. Whenever assured that such is their settled wish, *I shall joyfully cooperate with them to secure the end they seek.*

" RED HOT! "

The last sentiment had been expressed as late as January, 1861, and there were columns

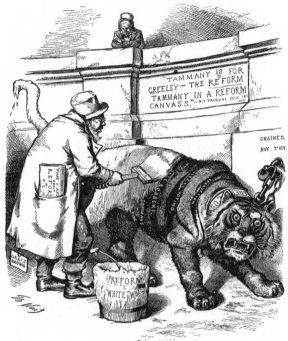

"WHAT ARE YOU GOING TO DO ABOUT IT," IF "OLD HONESTY" LETS HIM LOOSE AGAIN?

more of a similar nature. The dragon's teeth which Horace Greeley had been so long and industriously sowing had come to a ripe and ruinous harvest.

It was not condemnation alone that Nast received for his telling warfare. Scores and hundreds of letters of commendation poured in upon him. Grant papers rejoiced and sang his praises. Every journal in the land printed column editorials for or against him, comparing his work with that of Morgan, according to their lights and political convictions. General Horace Porter, then private secretary to Grant, wrote him from Long Branch, " Your pictures of Greeley branding the Democrats, and of the starvation of mothers and rags of children, ought to be in the hands of every Southern white man."

In October, Colonel Chipman, who had just been reëlected to his seat, wrote:

My majority of 5,400 was a great triumph.
Speaking of Grant, I called there yesterday—Wednesday. The conversation turned on the means of electioneering and he asked me if I had seen the last Harper's. He went into his bedroom and brought out your " Tidal Wave." He said he was with you and your pictures like the fellow who travelled with

the menagerie because he knew that some day the lion would bite the man's head off and he wanted to be there to see. The President said he hoped never to see you break down, but he felt your services had been so great and your genius so unprecedented that he was looking weekly to see you fall off in power, but that you got better and better.

The campaign of caricature ravaged on. Each week Morgan strove to rise to new heights of vilification—each week Nast produced more of the blighting testimony from Greeley's own pen, illustrated in a manner more savage and more scathing. Greeley whitewashing the Tammany Tiger (an idea used many times since)—Greeley with the sacred white hat and coat covering the "Monument of Infamy" erected by his former enemies—Greeley clasping hands across the wide grave-fields of Andersonville, the "Bloodiest of Chasms"—Greeley clasping hands with the Shade of Wilkes Booth over the grave of Lincoln: pictorial ferocity could go no further, and the terrible shots did not fail of their mark—the political apostasy

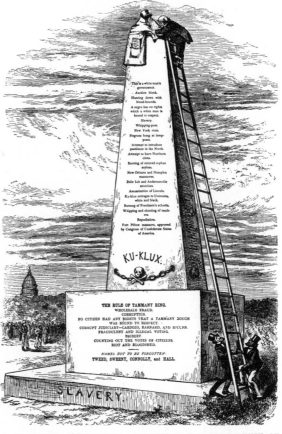

THE WHITED SEPULCHRE. COVERING THE MONUMENT OF INFAMY WITH HIS WHITE HAT AND COAT

of Horace Greeley. Men to-day can judge better the cruel vin-
dictiveness of that struggle through a contemplation of its cari-
catures than by the reading of any printed page.*

It is hardly necessary to say that the pictures went too far.
They are deplored now, and they were deplored then. The Post
in a two-column editorial lamented that such means were con-
sidered necessary to the end in view. The Atlantic Monthly
gave Nast credit for " cleverness and effectiveness " but cited
instances as far back as Socrates and the days of the Pelopon-
nesian War to show why caricature should be good-natured. It
further expressed a conviction that, after all, the " Tammany

MIXING DAY AT HARPERS'.—MAKING MUD TO FLING AT GREELEY.

Editor Curtis.—" Don't spit in it, Thomas ; it is not gentlemanly."

ONE OF THE CARTOONS AGAINST CURTIS AND NAST, BY BELLEW

 *Nast himself did not escape. In an illustrated paper, the Fifth Avenue Jour-
nal, he was caricatured almost weekly—his friend Bellew having been engaged to
do the work. One of these pictures, entitled " Mixing Day at Harper's—Making
Mud to Fling at Greeley," shows Curtis, prim and immaculate in all save his hands,
saying to Nast, across a bowl of filth:

 " Don't spit in it, Thomas; it is not gentlemanly."

AS USUAL, HE PUT HIS FOOT IN IT SURE THING. BETWEEN TWO STOOLS, YOU KNOW

Tiger Loose '' should '' never have been drawn,'' for the reason
that the traditions of the Roman arena were not wholly in keep-
ing with the sentiment which the artist had meant to convey.
Then it gravely adds: '' It may be urged in reply to this criti-
cism that the people of New York are not classical enough to be
affected by such considerations.''

The fierce farcical campaign drew toward its sorrowful end.
Near its close, Mr. Greeley himself made a Western tour, ad-
dressing vast crowds daily, and many times a day, for more than
a fortnight. His case was a sorry one, but he presented it in a
manner which won him the vast applause of the multitudes.

The personal following of Horace Greeley was enormous and
the Republican managers became alarmed as to the effect of his
superb oratory. Never had he been more brilliant. Never had
he been more forcible; never more convincing as a debater, a
mover of masses, a man of ready thought and strong idiomatic
speech. It has been said that '' he called out a larger proportion
of those who intended to vote against him than any candidate
had ever before succeeded in doing.'' *

For the moment, Mr. Greeley must have believed in his

* Blaine: '' Twenty Years in Congress ''

"NONE BUT THE BRAVE DESERVES THE FAIR"
MISS COLUMBIA MAY to H. G. DECEMBER—"Do you see anything
Green in my Eye?"

election. The masses crowded about him and cheered at every pause. Even when, as at Pittsburg, he was led into some unfortunate remarks which were construed as indicating a lingering belief in secession and a regret of the old Abolition creed, there was nothing but commendation for "Old Horace," whose paper the people had read and loved so long.

The first blow to his hopes came with the State returns from Vermont and Maine, which gave increased Republican majorities. Georgia brightened the horizon for an instant. Then the returns from Pennsylvania, Ohio and Indiana came in, three of the States he had canvassed, and his defeat was sure.

At this trying moment, his wife, long ill with consumption, died. Mr. Greeley spent many hours at her bedside, and, with the burden of the campaign upon him, his own health was undermined. When election day came with its overwhelming defeat —when it was reported that Pennsylvania had given more than one hundred and thirty-seven thousand majority for Grant, and that other States had surpassed any former record—he was crushed and heart-broken.

Yet in spite of everything, he promptly returned to his editor-

THAT "TIDAL WAVE."—"WE ARE ON THE HOME STRETCH"

ship of the Tribune, " relinquished," as he stated, " on embarking in another line of business," and with the added statement that it would henceforth be an independent journal, resumed his old work.

But his strength was gone, and his intellect gave way. Less than a month later, on November 29th, he lay in his coffin. America's greatest editor—erratic in conviction yet matchless in battle, courageous and daring, whether right or wrong—had slipped out of the tumult and sorry warfares of men.

MR. GREELEY ON THE MORNING AFTER ELECTION
(From the original sketch)

As was natural, the papers that had supported Greeley now took occasion to overwhelm Nast with his own wickedness, to point out that he had been the cause of the great editor's death. From no possible point of reasoning was this true. Mr. Greeley was in perfect health when he set out on his tour. The strain of that tour would have prostrated many a younger man. The added sleepless vigils during his wife's illness completed his physical ruin.*

" I have not slept one hour in twenty-four for a month," he said to a friend. " If she lasts, poor soul, another week, I shall go with her."

On his return it had been rumored that he was ill and Nast had sent over to the Tribune office for the facts. Already, upon

* See also the Tribune's reply to Senator Depew—footnote, pages 536-38.

CLASPING HANDS OVER THE BLOODLESS (SAR)C(H)ASM

learning of Mrs. Greeley's illness, he had suppressed a cartoon showing Greeley by the open grave of Democracy. Nast had considered that its idea and purpose were likely to be misconstrued, though Fletcher Harper had written concerning it:

" If you say so, we will publish it, as you and Mrs. Nast and your children are the responsible parties."

Nast was prepared now to discontinue the pictures altogether if the rumor of Mr. Greeley's illness was verified. But word came back from the Tribune office:

" The report is a lie. Do your worst."

It is quite possible that Mr. Greeley was not really ill at that time, for this was several days prior to the election. But then came the strain of those last days of waiting, the death of his wife followed by the final crushing realization that those who had admired and applauded him as an advocate had rejected him as a counsellor and a guide. Horace Greeley had fallen a victim to ambition, self-deception and overwork; yet more than all, perhaps, to his own record, which, with or without Nast, must have accomplished his defeat.

"HOME-STRETCHED."

MR. GREELEY DISMOUNTED FROM THE DEMOCRATIC STEED

The final cartoon of the campaign was a picture of Nast, by himself, published immediately after election, showing the artist left desolate—his occupation gone. Then followed a fine allegorical picture on the Boston fire which had occurred November 9, and later, his last drawing of the year, a cartoon of Sumner, who had returned from abroad with a bill "To strike from the U. S. Flags and Army Register all record of battles fought

COLUMBIA LAYS ASIDE HER LAURELS TO MOURN AT THE BURNING OF HER BIRTHPLACE

with fellow citizens." It was for this measure that the Massachusetts senator received a vote of censure from the legislature of his own State, though the resolution was rescinded prior to his death in 1874. He did not live to see his Civil Rights Bill become a law. Sumner's great career, like that of Horace Greeley, closed in sorrow and disappointment, and, it is only fair to believe, under the shadow of a mental cloud, the price of his martyrdom.

CHAPTER XXIX

QUIET AND CONGRATULATIONS

CARL'S POSITION.

With the second election of General Grant, the admiration of the Republican party for Thomas Nast became something near idolatry. His daily mail was a vast budget of congratulations, invitations, offers of gifts and ideas.

The invitations and gifts he rarely accepted. The ideas for pictures he did not use, having always more than enough of his own.

There came to him likewise many requests. Social reformers, believing it within his power to correct any evil, eagerly besought his aid. Legislators urged him to take up his pencil in behalf of certain measures, while candidates for official promotion endeavored through him to obtain the ear of Grant. As a maker of pictures concerned with the affairs of a great republic, his position was absolutely unique. Never in the history of nations had it been approached. Never is it likely to be again.

At the close of the campaign the Republican National Committee had expressed its obligation in a letter of thanks.

We feel that we shall not fully perform our duty (wrote the secretary), without thanking you cordially for the efficient aid we have derived from your skilful hand and fertile but truthful imagination.

When the results of the election became known, Samuel L. Clemens sent an enthusiastic line:

Nast, you more than any other man have won a prodigious victory for Grant—I mean, rather, for Civilization and Progress. Those pictures were simply marvellous, and if any man in the land has a right to hold his head up and be honestly proud of his share in this year's vast events, that man is unquestionably yourself. We all do sincerely honor you and are proud of you.

<div align="center">Yours ever,</div>

<div align="right">Mark Twain.</div>

In another letter Clemens wrote:

The Almanac has come and I have enjoyed those pictures with all my soul and body. Your '' Mexico '' is a fifty years' history of that retrograding chaos of a country, portrayed upon the space of one's thumbnail, so to speak, and that '' Sphinx in Egypt '' charms me. I wish I could draw that old head in that way.

I wish you could go to England with us in May. Surely you could never regret it. I do hope my publishers can make it pay you to illustrate my English book. Then I should have good pictures. They've got to improve on '' Roughing It.''

I thank you for your kindness to me and my friend Charley.

The Charley referred to was Charles M. Fairbanks, now a well-known newspaper man, then a boy with a good deal of artistic talent and an unbounded admiration for the work of Nast. He had come with a letter from Clemens and the cartoonist had made him welcome and assisted him with advice and encouragement. The boy was most grateful and remained always one of Nast's loyal and devoted friends.

From the first great champion of our dumb companions and servitors there came a characteristic word of praise:

I wish I could determine which of your inimitable pictures is best, but I cannot. The one in this week's Harper's Bazar, of Santa Claus among the animals, seems to me worthy of a frame of solid gold and precious stones. Those two cats upon a bench have nothing extant their superior.

Whenever you should be at a loss for a subject, do illustrate our work with your magic pencil!

　　　　　Your profound admirer,

　　　　　　　　　　　Henry Bergh.

James Parton wrote hastily:

No one has contributed to this glorious and astounding victory of Honesty over Humbug as much as Thomas Nast. Apply at once for the Paris consulship, and *please don't* get it!

Gratifying as these attentions must have been, they could not altogether bring happiness to the young illustrator, who, now that the stimulus of battle was gone, found himself well-nigh prostrated from the work and strain and tragedy of the battle. He had averaged three drawings a week during the year, many of them double pages, and into them he had put all the fierce conviction and vitality of his being. The result was collapse, and the death of Horace Greeley added to his depression,

22　　　*NAST'S ALMANAC FOR* 1873

THE STORY OF THE GOOD LITTLE BOY WHO DID NOT PROSPER.

BY MARK TWAIN.

ONCE there was a good little boy by the name of Jacob Blivens. He always obeyed his parents, no matter how absurd and unreasonable their demands were; and he always learned his book, and never was late at Sabbath-school. He would not play hookey, even when his sober judgment told him it was the most profitable thing he could do. None of the other boys could ever make that boy out, he acted so strangely. He wouldn't lie, no matter how convenient it was. He just said it was wrong to lie, and that was sufficient for him. And he was so honest that he was simply ridiculous. The curious ways that Jacob had surpassed every thing. He wouldn't play at marbles on Sunday, he wouldn't rob birds' nests, he wouldn't give hot pennies to organ-grinders' monkeys; he didn't seem to take any interest in any kind of rational amusement. So the other boys used to try to reason it out, and come to an understanding of him, but they couldn't arrive at any satisfactory conclusion; as I said

A PAGE FROM NAST'S ALMANAC

For in the nature of Thomas Nast there was no fibre of cruelty or injustice. No man ever lent a more willing ear to the voice of the oppressed, or was ever more generous to the needy, more tender with the suffering. A letter from Bellew, who had caricatured him so fiercely during the campaign, but who later was ill and in want, gives us a hint of the personal side of Nast.

My Dear Nast:

I have just received an envelope enclosing a cheque for twenty-five dollars, signed by you. Although no explanation accompanied the cheque, I suppose I cannot be far wrong in assuming that, having heard of my illness, you kindly intend it as a plank for the bridge to carry me over my present troubles. This is very kind of you, and I assure you I heartily appreciate both the motive and the money, which came at no inopportune moment.

At some future day, when I get my harness on, I hope you will give me the opportunity to repay that part which it is possible to repay of a considerate act like yours, by some pen work for your Almanac.

Very sincerely yours,

Bellew.

Always a lion in battle, Nast was the gentlest of human beings among his friends. That he should now be accused of having caused the death of a fellow creature, distressed him sorely. Curtis, always thoughtful, wrote him a soothing letter.

At the old Desk, Feb. 4, 1873.

My Dear Nast:

I am very sorry to hear from the Major that you are not quite well, and I think perhaps the soft sun to-day may cheer you. I am so little in Franklin Square that I never meet you, but I do not forget the good old days when you used sometimes to climb up here and say a word.

When spring comes perhaps I shall see you, with the other bulbs and flowers! But seeing you or not seeing, I shall always think of you with the kindest regard, and, as we all do, with great admiration.

Very truly yours,

George William Curtis.

Parton, too, wrote again, addressing him " My dear Tommy,"

and urging seriously his acceptance of an official appointment abroad, with a long rest.

Not inaction—not stagnation (he wrote) but rest and change. Don't put this off. Take warning by Greeley. It was forty years work and no play that destroyed him. You cannot and must not go on working your brain as you have done. Leaving out all other considerations, you are more valuable to Sally and the children than the mortgage paid off. Think seriously of this. Think of it as you would a new picture. You will answer, you will tell me, I'm another. So I am, but not so bad. And there is this difference between us; you *can* rest, and I can't. You have considerable property and I have none. I must plod on, but not nearly so hard now as before. The time is near, I hope, when I can let up on myself.

Now, Sally, consider this with all your might. Don't let him put it off. "Husbands, obey your wives," the Bible says. Do it!

But consulship with years of rest, afar from the din of battle, were little to the taste of a man like Nast, ill though he was. He had expected nothing of the Government, and desired nothing it could give. His income for the year had aggregated about eighteen thousand dollars. Twelve hundred of this was royalty from his Almanac, and most of the remainder from his cartoons. There was not enough saved as yet to pay the mortgage on the big new home, but he felt that he was more likely to achieve this end in America than as the Nation's representative in a foreign port. Colonel Chipman, always his friend, seeking in some way to relieve any anxiety as to this debt, started privately in Washington a ten thousand dollar testimonial fund, to be made up in subscriptions of one hundred dollars each. To this the President, Secretary Fish, and a host of others were eager to contribute, but Nast found it incompatible with his ideas of independence. He was urged to go abroad alone for a period of complete change, and finally planned to sail in March, 1873.

Mr. Demarest Mr. Constable Mr. Curtis Fletcher Harper, Jr. S. S. Conant Mr. Parsons Miss Booth
(Cashier) (Art Director) (of the Bazar)

SMALL POTATOES BEFORE THE SUPREME COURT *

CHAPTER XXX

CREDIT MOBILIER, AND INAUGURATION

Meantime, the artist had completed some illustrations for a Harper edition of " Pickwick Papers " and had drawn a few cartoons for the Weekly. Among the latter was a most prophetic picture entitled " The Finger of Scorn," aimed at Oakey Hall, who on the first of the year had surrendered his office to W. F. Havemeyer, the reform candidate. Hall had escaped the law, through the death of a juror on his first trial, and a dis-

* Sometimes, as in the case of the " Credit Mobilier " picture, a cartoon became a matter of discussion in the Harper rooms. Nast caricatured the situation, showing himself standing amid laurels won through former achievements, exhibiting a drawing to a court composed of the heads of various departments. The elder Fletcher Harper, when he saw it, said to Henry M. Alden, editor of the monthly: " We are the only respectable ones. He left us out." The picture hung for many years in the Harper business office, but has never before been published.

agreement on the second—seven jurors having voted for conviction, five for acquittal. No further legal action was taken, but his record was to follow him through long years and in far lands.

THE GAME OF FOX AND GEESE; OR, LEGAL TRIALS OF THE PERIOD

The partial absence of Nast's work from the pages of Harper's Weekly was quickly noticed and commented upon. Opposition journals either gloated over what they conceived to be his downfall, or published mock obituaries. Some of them declared that he was lost in trackless wilds and that an expedition should be sent out in search of him. Others maintained that he was affected with a disease of the eyes which prevented him from seeing the latest Republican frauds. They pointed to the scandalous Credit Mobilier developments and asked " Where is Nast." They demanded that he assail this chapter of disgrace which was adding shame to what was " already a disreputable administration."

Concerning the Credit Mobilier, the cartoonist had been eager to do precisely what they demanded, having been withheld by his publishers until exact knowledge could be obtained.

But investigation did not improve the aspect of this sad affair. The Credit Mobilier (Credit on movable property) was a cor-

poration in which George Francis Train, and Oakes Ames, a Massachusetts congressman, were prominently interested, and was identified with the construction of the Union Pacific Railroad. The Company at first assumed great risks, but later its stock became immensely profitable. In the later sixties Ames, foreseeing that it was likely to become a legislative issue, induced a number of congressmen to take or agree to take Credit Mobilier shares. The fact that he was willing to sell to his associates, at par, stock paying the enormous dividends of from sixty to eighty per cent., and to allow such purchasers to pay for their holdings out of accumulating profits, would seem to have been a proceeding prompted by some other motive than that of mere friendship. Far-seeing men like Blaine, Conkling, Wilson, Boutwell and others either declined the stock, or returned it, after a brief period of reflection. Others, through guilelessness or self-interest, failed to do this, and from time to time profited by the generous dividends. Then there came an hour when to own Credit Mobilier was inconsistent with impartial legislation, and presently followed the inevitable exposure,* which coming in the midst of a campaign had made men afraid to tell the truth. Garfield, Colfax and other honored names were dragged in the dust. Yet the real tragedy lay not so much in the acquisition of the stock, as in the fact that the stockholders refused to tell the whole simple story of the transaction, but persisted in denying their ownership, even before a court of investigation, until confronted by incontrovertible proof. Colonel Chipman, in a letter to Nast, January 26, presented a personal view of the matter.

My Dear Friend:
You will be pained, as all good men are, at the dreadful disclosures in the Credit Mobilier business. Was there ever such an exhibition of idiocy and cowardice! With absolutely an inno-

* In the New York Sun beginning September 4, 1872, continuing through the remainder of the year.

cent transaction to start with, the actors in the matter have by their conduct magnified it into a stupendous fraud.

I have not lost my faith in the honesty and integrity of such men as Dawes, Bingham, Garfield and Patterson, but we must have our ideas as to their sagacity greatly shocked and lowered.

I want you to understand this matter precisely as it is. The whole subject offers a rich theme for your pencil, but I doubt the wisdom of availing yourself of it. The feeling is one of deep regret rather than censure, and this I think is the sentiment generally. It is this which would make a picture unwelcome. It would " bring down the house " I admit, but at the same time we would all feel ashamed of ourselves for laughing at the calamity.

Here is the way all this was brought about.

These gentlemen had a little money to invest. They are all poor, and to turn an honest penny seemed desirable. The sly and devilish Ames gave them the opportunity for the investment, without fully acquainting them with the transaction.

Scene second. The campaign comes on; some whisperings about Credit Mobilier stock in the hands of well-known Republicans. They thought a frank confession might hurt Grant and that the public would not admit the investment in the stocks to be a legitimate thing; hence, they concealed the facts and misled the public.

Scene third. The Congressional Investigation begins. With the same stupidity they keep back the simple truth and seek again to cover up facts. Step by step the disclosures are brought out until the country is shocked, without knowing exactly why or how. It has ruined Colfax and Patterson and some others, and greatly lowered the public opinion in their integrity. All of them must suffer more or less. The whole thing is a matter of unutterable regret. I haven't time to write you the details, or to give you the views of individuals in public life. Expecting you and yours in February, I am,

As ever,

N. P. Chipman.

The Credit Mobilier investigation ended with a vote of censure for Oakes Ames (Rep.), of Massachusetts, and James Brooks (Dem.), of New York—the latter being government director in the Union Pacific Road. Both men were overwhelmed by their disgrace and died, Brooks the last day of April and Ames a week later. The whole wretched affair cast a shadow over Grant's

EVERY PUBLIC QUESTION WITH AN EYE ONLY TO THE PUBLIC GOOD.

"Well, the wickedness of all of it is, not that these men were bribed or corruptly influenced, but that they betrayed the trust of the people, deceived their constituents, and by their evasions and falsehoods confessed the transaction to be disgraceful."—*New York Tribune, February 18, 1873*

Justice (to the Slaves of the Press). "Let him that has not betrayed the trust of the People, and is without stain, cast the first stone."

second inauguration, while the bitter and gloomy weather did not tend to make the occasion more cheerful.

Both Mr. and Mrs. Nast went to Washington for the event. They were the guests of Colonel Chipman, and their visit was a succession of gay affairs. They called at the White House the evening before the re-inauguration. President Grant received them in his family circle, and Mrs. Nast was struck with his timidity of manner. He blushed and his voice trembled like that of a bashful boy. When Mrs. Nast spoke of the crowds in the city, he said:

" Yes, but I feel like a man who is going to be hung to-morrow."

The great soldier would rather have faced the legions of Lee than the multitudes who had gathered to hear his public address.

The bitterness of the weather and the crush and tumult of entertainment rather dismayed Mrs. Nast, who was of a domestic temperament and fond of the family fireside. They returned presently to the quieter joys of the Morristown home.

While in Washington, Nast had met General Garfield, but did not take his hand. Garfield reddened, and exclaimed:

" I know why you will not shake hands with me—that will all be explained some day."

But the explanation was never made, and in the Credit Mobilier cartoon of March 15 both Garfield and Colfax appear among those at whom Justice points the finger of scorn. However, the picture was a two-edged sword, for on the other hand were collected the editors who had been most " shocked and outraged " by the exposures, and Justice is saying to these " saints of the press ":

" Let him that has not betrayed the trust of the people, and is without stain, cast the first stone."

In the same issue " The Biggest Joke of the Season " showed Fernando Wood presenting articles for the impeachment of Vice-

Parke Godwin Whitelaw Reid Bennett Watterson Nast

Dana

THE MEETING OF NAST AND WATTERSON IN CENTRAL JERSEY—[Drawn on the Spot.]

"Mr. Watterson was so much overcome with joy at the sight of Nast that he felt strongly impelled to rush forward and throw his arms about the neck of the man whom he had traveled so far to find. 'The effort of restraint,' says Mr. Watterson, 'at that supreme moment of my journey, was positively painful, but in presence of those who certainly would have been unsympathetic, and possibly might have been hostile, the restraint was essential.' Then, the Kentuckian advanced and saluted the adventurous Jerseyman. 'Nast, I presume?' The artistic stranger replied, simply, 'Yes;' but the more effusive Kentuckian exclaimed, 'Thank goodness that I have been permitted to see you?' The long-lost artist calmly rejoined, 'It is quite a wonderful event.'—*Correspondency Louisville Courier-Journal*

18

President Colfax. A week later, March 22, there appeared a final pictorial comment on the subject, showing Ames and Brooks as the "Cherubs of the Credit Mobilier."

Nast now made preparation for his ocean voyage. Secretary Fish had conferred upon him the appointment of U. S. Commissioner to the Vienna Exposition, but this honor was declined, as the artist did not care to attend the great fair. Just

BLINDMAN'S-BUFF. HOW LONG WILL THIS GAME LAST?

before sailing he paid a bit of farewell attention to the newspaper jokers, who had been " organizing expeditions " to discover his whereabouts. In the issue of March 29 appeared a double-page cartoon entitled " The Meeting of Nast and Watterson in Central New Jersey." Nast, in front of his home, is welcoming the "Louisville Courier Expedition," led by Henry Watterson, and including the editors of the New York Sun, Herald and Tribune, armed with the American flag and blunderbus guns. On April 12 appeared a caricature of various members of the Tweed and Erie rings, playing Blind Man's Buff with Justice. It was Nast's last cartoon for a period of nearly five months, and the artist was already on the water when it appeared.

CHAPTER XXXI

A TRIP ABROAD AND AN ENGAGEMENT AT HOME

The cartoonist was now to undergo a new ordeal. On the vessel with him was James Redpath, proprietor of the Boston Lyceum Bureau—a lecture agency which later passed into the control of Major J. B. Pond. Redpath had been urging Nast to undertake a series of illustrated lectures during the coming season, and had taken passage on the same vessel for the express purpose of persuading the artist's acceptance of the idea. But the man of pictures was frightened at the thought of going before the public face to face. He finally agreed to consider the matter and to decide upon his return. Yet the more he considered, the greater became his alarm. Finally he pleaded as an excuse that he was thinking of accepting a foreign appointment, to which Redpath replied that he would consider the bargain closed, with the proviso that if his victim abandoned the appointment idea, he was to mount the lecture platform; thus leaving to the artist the old alternative of the frying-pan or the fire— a condition not likely to ease his already troubled state of mind.

Nevertheless, his vacation was beneficial. He visited old friends in London, including W. L. Thomas, the London News engraver who had attended to collections and remittances for him during the Garibaldian and Civil War periods. From London the artist journeyed into Cornwall and made an extended

visit at the home of Colonel Peard, where the old campaign was rehearsed, with its glories, its comedies and its results. To his old comrade, Nast was still '' Joe, the Fat Boy,'' and it was '' Joe, you rascal, don't go to sleep,'' or '' Now, Joe, you're asleep again,'' as in the old Calabrian days. After his return to London, Nast one morning received the following note, which would seem to require no explanation:

Joseph: Thou hast neglected my orders in not sending the boots. You must give an explanation of your conduct, or shall be tried by court martial. The punishment for disobedience of orders is death, and such other punishment as the court may award. Thou art also absent from headquarters, which is a grave offence. J. W. Peard, Col. Brigade.

Nast saw Redpath again in London and gave a partial consent to the lecture idea. He agreed, if Mrs. Nast approved (his last hope of escape), to let the agent send out a hundred letters to as many managers in different cities, thus to ascertain if there was really a demand for him, which he was loth to believe. Redpath did not wait for further permission, but sailed at once for America to enter into correspondence with Mrs. Nast, and to begin the campaign.

To say that the agent's expectations were fulfilled would be a mild statement. He had calculated on a possible one hundred nights, with a net return to the lecturer of as much as ten thousand dollars for the season. But the desire to look upon the man who had destroyed Tweed and helped to elect Grant—to watch him use his deft crayon and '' make faces '' before their very eyes—was more universal than even an enthusiastic Bureau Manager had dreamed.

Engagements fairly poured in. Before Nast returned in June, his doom as a lecturer was sealed. By July the amount already guaranteed had far exceeded Redpath's most liberal calculations. Every day brought, from Redpath, some line or telegram of new triumphs.

" Over thirteen thousand dollars already guaranteed," he wrote, " and the cry is still they come. You lead everybody except Gough.* Star of the evening, beautiful star! There is every reason to believe that you will be under the painful necessity of drawing twenty thousand dollars out of the pockets of your countrymen during the coming season. Are republics ungrateful?

" Now you are in for it, put yourself under the best training at once. It would play the mischief if you should break down. You will speak five times a week and therefore should get yourself in the best physical condition. Put yourself under the best elocutionist, and practise all the time to strengthen your voice."

The mental picture of himself not only writing a speech but continuously practising its delivery doubtless amused the artist as much as the thought of going before an audience terrified him. He engaged Parton to prepare his subject matter, and for the rest of the summer lay under the trees studying it and planning a programme of the sketches he was to make—" getting in condition " for the onset.

This was a period when many interviewers came and went, some to find out why his work no longer appeared, others to write about his past, present and future, including the contents of his household and the habits and characteristics of his family. It was one of the last-named variety who, drawing upon an exuberant imagination, rather overdid the matter and somewhat annoyed the subjects of his sketch. Other papers promptly corrected the misstatements, and one of these being mailed to Nast's old friend, " Josh Billings," elicited an amusing reply:

Dear Tommy:
I got your paper in which the " Interviewer " is handled. I will write some sentiments touching the " Interviewer " before long, when I get leisure, and you can illustrate it in your happy way, and between us we will scald the " kuss." Love to all.
Yours till deth,
Josh.

* John B. Gough, temperance lecturer, called by Major Pond " The King of the Lecture World."

MARRIAGE.

BY JOSH BILLINGS.

MARRIAGE is a fair transaction on the face ov it.

But thare iz quite too often put-up jobs in it.

It is an old institushun—older than the Pyramids, and az phull ov hyrogliphics that nobody can parse.

History holds its tongue who the pair waz who fust put on the silken harness, and promised to work kind in it, thru thick and thin, up hill and down, and on the level, rain or shine, survive or perish, sink or swim, drown or flote.

But whoever they waz, they must hev made a good thing out of it, or so menny ov their posterity would not hev harnessed up since and drove out.

Thare iz a grate moral grip to marriage; it iz the mortar that holds the sooshul bricks together.

JOSH BILLINGS

(Reproduced from Nast's Almanac)

The weeks went by and the artist continued to do nothing at all in the way of pictures. Fletcher Harper was willing, not only that he should rest, but that henceforth he should receive one hundred and fifty dollars a page, with a yearly retainer of five thousand dollars, as a bonus—work or play—on condition that he drew for no other paper.

It was the anti-Grant cry of " Cæsarism "—begun while Nast was abroad—which finally, in September, stirred him to pictorial activity. The New York Herald led the clamor, and Nast now cartooned the younger Bennett as " Nick Bottom " of " A Midsummer Night's Dream," frightened by an ass's ghost of his own conjuring.

The picture brought many words of congratulation from those who were glad to see the artist at work once more. The Graphic —an illustrated daily, made possible by the newly perfected process engraving—heralded the event with a caricature of the cartoonist at his old tricks again. Marshall Jewell, then Minister to Russia, wrote an enthusiastic letter. Jewell had been Governor of Connecticut, and later became Postmaster General, also a presidential candidate. He wrote at considerable length, but coming from one on the " inside of things," with an intimate knowledge of conditions, the letter seems important.

Legation of the United States.
St. Petersburg, Oct. 11, 1873.
11 o'clock, P.M.

Dear Nast:

I am so tickled to-night (glad is no name for it) that I am not going to bed till I have written you all about it. I have been greatly annoyed all thro' Europe this summer by the question " How about the third term? " " How's Cæsarism? " You know the Herald is taken more in Europe than any other paper. I scolded Russell Young about it in Vienna, for it's a shame. But how to stop it was the question. I have often said if Nast and Nasby would take hold of it they could kill it, but I had heard you were going to lecture and Nasby (bless his heart) had taken to making money.

So I refused to be comforted. I had made up my mind it had got to die a Natural Death. I knew they couldn't catch Grant —not any. He is too wise for that whole tribe. To-night I got my mail just after dinner. I first looked over the Hartford papers to see if I had failed. To my great relief I found that I had not. Then for the Times to see who had, and it took my breath away to read the list. (I wanted to send a green-back to Clews at once.)*

Then I went thro'

A MIDSUMMER NIGHT'S DREAM
OF
JULIUSCÆSARTEMPESTMUCHADOABOUTNOTHINGCOMEDYOFERRORSASYOULIKEITALL'SWELLTHATENDSWELL.

the Tribune and Herald and saw how splendidly and firmly our President withstood the pressure brot to bear upon him

* Mr. Jewell, in his mention of " failures " and the pressure brought to bear upon the President, refers to the panic of 1873, some account of which will be found in a succeeding chapter.

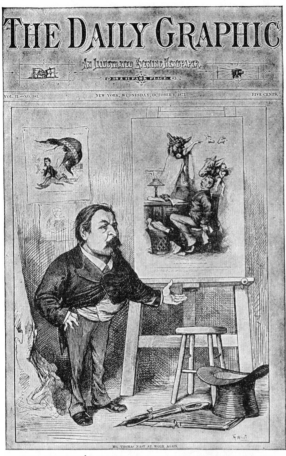

THE GRAPHIC'S CARTOON OF NAST AT WORK AGAIN

to do an illegal act.

He has the levelest old head on his shoulders of any man living. I just took the papers and read them all aloud to my wife and daughters and we gave him three cheers (mentally, for we live in apartments) and exclaimed, "I'll write Grant how glad I am before I go to bed." Madam Jewell took me down by saying, "Yes, you'll gush."

You see, friend Thomas, she knows me. She said:

"You had better read your religious literature and after that your magazines and write when you get cool." I was here directed to the Independent for my religious consolation and to Old and New, the Galaxy, Harper's Monthly, and at the bottom of the pile the Weekly. I left the best for the last (as we used to eat pie) as I not only like the pictures but like Mr. Curtis and what he says. Fancy my delight, the greater that it was unexpected.

The eyes of the Saints of old were not so gladdened by the sight of the "Promised Land" as were mine at beholding your two cartoons. I tried to take hold of your well-known "phist" in the corner and shake it.

"He's going for 'em," screamed I to my quiet family. "He'll soon stop this nonsense." I quickly explained and exhibited.

"You had better gush at Nast." (I thank thee, Mrs. Jewell. for teaching me that word.)

I am so delighted that I forgive the Editor for calling me a "pinguid" gentleman, which he did on page 874 of the same paper. I quite shook in my slippers at being called such a dreadful name till I drew consolation from Webster's Unabridged.

You have a firm grip and now you are back again I have no fear of a cessation of hostilities. Do you ever see Locke? If so say that an exile thinks the "x roads" should be heard from. I value your pencil and his pen more than all the other makers of warfare which exist in our party.

I feel a long way "off soundings" now and take to the news from America greatly.

I like the place on the whole very much indeed, tho the cold is said to be very disgusting. But the city is clean, well ordered and lighted, very attractive and pleasant. A fine looking class of people too, the men of the upper classes particularly.

Wish you could be out here this winter and see and depict the festivities. Yours truly,

Marshall Jewell.

Mr. Jewell was correct in his belief that there would be no "cessation of hostilities" on the part of the cartoonist.

The first Cæsar cartoon was followed up with other pictures of a similar nature until the Herald was ready to desist, at which point Bennett is cartooned as crying mercy to Nast, who sits Harp(er)ing asinine music to the editor's sickened ear.*

* While the Herald affected to be perfectly serious in its "Cæsarism" scare, it seems far more likely, now, that Mr. Bennett, who was in those days an irrepressible joker, was all the time enjoying the huge burlesque of the outcry. Certainly, to the present-day reader the following extracts have the ring of banter:

"What is the question in the United States? No more, no less than this: Shall we have a republican form of government? We dismiss from consideration all sentimental and fantastic questions. It is not whether we shall have protection or free trade, suffrage to one class or another, centralization or State rights. These questions will determine themselves. But shall we have a republican form of government? He (Grant) is as completely master as was ever Jefferson, Jackson or Lincoln. Never was a President so submissively obeyed. Never was a party so dominant. Every department of the government, nearly every large State, the army, the navy, the bench—even this great State and still greater metropolis which stood all the assaults of Lincoln when in the fulness and glory of triumphant war—all, all are in the hands of his followers. . . . Rome had no more living issue than when, on the Supercal, Mark Antony offered the kingly crown to Julius Cæsar. And the men who are in authority under General Grant are many of them as eager to do him honor as were the shouting Romans who surrounded Cæsar in his triumphs. . . . To dismiss our President would be a revolution, and while

"WHERE THERE IS AN EVIL" (CÆSARISM SCARE) "THERE IS A REMEDY"—(RIDICULE)

no one cares to dismiss him, we see ourselves drifting upon the rock of Cæsarism, smoothly, pleasantly, silently, swiftly drifting upon a danger even greater than that which menaced either Spain or France— We mean the third term idea. We remember that the crown was thrice offered on the Supercal, and although thrice refused, each time it was with less and less reluctance. And we can name twenty Mark Antonys in our city who would carry the crown of a third nomination to General Grant with pride and swiftness."

Expressions like these filled many columns, almost daily, and curiously enough affected not only an element of the public, but other leading journals. At another time, referring to the military qualifications of Grant, the Herald in a "communication" said:

"Grant's victories were won by a dogged determination not to know when disaster came, and though he was whipped several times during the march through the Wilderness he never knew it. Was there anything brilliant in that?"

That Grant should have been "whipped without knowing it," seems a fact worth preserving. Certainly there is no record of his enemies ever having made such a mistake. One can imagine Mr. Bennett smiling audibly when he wrote or approved that line.

CHAPTER XXXII

A MARCH OF TRIUMPH AND MUCH PROFIT

But though long postponed the inevitable must come at last. Summer waned and died, and with the advent of the entertainment season the first night of the Nast Lecture Series drew near. Long since, his schedule had been arranged, extending throughout the East and for a distance into the Middle West. His enterprising press agent had advertised him as the " Prince of Caricaturists," the " Destroyer of Tammany," and a multitude of loyal countrymen were waiting the day of his coming.

But the " Prince " himself was in a bad way—grievously frightened and half ill with the ordeal ahead. It was at Peabody, Massachusetts, on the evening of October 6th, 1873, that he made his beginning. To Redpath he said: " You got me into this scrape; you'll have to go on the platform with me." And this Redpath did, sitting in a chair close behind the artist.

Yet it seemed a tragic occasion. Redpath confessed afterward that never in his long career had he seen a man so badly frightened. The hero who had laughed at the threats of desperate men and despised the censures and derision of the press, found his lips dry and his knees as water before an audience of admiring friends. He was ghastly pale and there were heavy beads of dew upon his brow. Perhaps in that dire moment Redpath had visions of the " twenty thousand profit " slipping away.

Yet somehow the man of caricature got started. Somehow he got confidence—somehow won the goodwill of the audience. The spectators sat breathless as they watched the pictures grow under his hand, while he told them something of his work and its beginnings. Nor did they fail to cheer as each sketch was completed, nor to applaud at the proper points of his address.*

And so the thing was done—the great beginning was made. The Peabody Press spoke in terms of praise of the entertainment, only suggesting that the lecturer speak a little louder in future, and this, with growing courage and confidence, he did. He had a natural faculty for impersonation. Often at home he had amused the juvenile members of the family with imitations of the French teacher and eccentric callers. This talent now came in good play, and added to the success of his exhibitions.

Early in November he was in Boston, with a crowded house at Tremont Hall, by which time he had gained sufficient courage to have Mrs. Nast present, though Redpath had discouraged this idea. On the 18th he reached New York City, where, at Steinway Hall (in the language of the Tribune, which would appear to have become friendly once more), " his audience filled every inch of space."

Of the New York papers, only the Herald was inclined to ridicule the cartoonist's efforts in the lecture field. Mr. Bennett, who perhaps felt that he must have revenge for the Cæsarism caricatures, started a mock subscription for the indigent artist who was " obliged to go abroad in the land to relieve his family from want." " The Blackboard Martyr," " Neglected Nast," " Abandoned Thomas," "A Distressed Artist," these were some of the headings of this daily hoax column, and letters of pseudo-commiseration and crocodile lamentation were printed from day

* From Nast's letter home : "It's done ! The people seemed pleased, but I'm not. When I draw, all eyes are on me and the silence is dreadful. But when I get through, their pleasure is very loud. There was no backing out. I offered Redpath money— begged him to let me off, but all no go. Last night I slept better. Write again soon to your travelling circus boy."

to day, with a list of the articles contributed—old shoes, broken umbrellas, cancelled postage stamps, bad pennies and sometimes a few cents of genuine money.

Those were the good old days of give and take personalities, and Bennett enjoyed hugely this successful burlesque, which he kept going for a considerable period. In one issue the Herald facetiously likened Nast's entertainment to Dan Bryant's cele-brated singing of " Shoo, Fly! " which suggested to Nast his only reply—a small cartoon entitled " Shoo, Fly! " in which he de-picted himself as brushing away the Herald insect, while a carica-ture of the " Cæsar Ghost," a car-icature of a caricature, appears on the blackboard near at hand.

" SHOO, FLY!"

All this was good advertising for the lectures, had they needed it. But they did not. The name of Nast was enough. For seven months he went up and down the land in a continuous march of triumph. The wildest financial estimates of Redpath had been doubled, and forty thousand dollars was the increase when, in May, the long migration ceased. The mortgage on the home was no longer a thing of dread. The " Prince of Caricaturists " had become a comparatively rich man.

Of course the delight of Redpath was unbounded. He had made his word doubly good, and he had earned a large commis-sion for himself. In addition to the latter, Nast sent him a per-sonal check for five hundred dollars—a gift which Redpath at first regarded as a joke. Then one day it was suggested to him that he try to cash it. He did so and found it a better joke than he had thought. No one ever had played so good a joke on him before.

CHAPTER XXXIII

THE SKIRMISH LINE OF EVENTS

FINE-ASS COMMITTEE

Nast's pencil had not been idle during his lecture tour. His days were his own, and the Harper engraving blocks had followed him, to be returned bearing timely cartoons. It would have been better for him had he worked less continuously. The use of his hand, night and day, resulted in a lameness from which he never entirely recovered. Yet with the Harpers more anxious than ever for his work, it was not easy to refuse. After his Boston lecture the firm wrote him:

What a splendid advertisement the Herald has given you. I see they shut up to-day. At this writing, ten A.M., your "comic" has not come to hand. Give us all the time you can and let us hear from you as often as convenient.

The conviction of Tweed and his sentence to Blackwell's Island for twelve years the artist-lecturer recorded in a front page entitled " Justice," and among the letters received at this time is one relating to this incident which seems worth preserving.

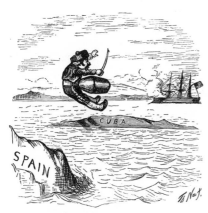

IF HE CAN'T RESPECT OUR FLAG, SEND HIM WHERE HE BELONGS

THE "LONG" AND "SHORT" OF IT IS A GENERAL "BUST" UP IN THE "STREET"

Most Excellent Nast:

Tweed is convicted, and no one has done more than you to bring this about.

There is not a good security in the United States that is not worth more to-day than it was yesterday.

There is not a knave in the country that has not reason to fear you:—there is not an honest man that does not owe you thanks.　　　　　　　　　　　　　　　　　J. B. Brown.

Newport, R. I., Nov. 20, 1873.

The Spanish-Cuban question, involving the capture of the American steamship Virginius and the shooting of her officers and crew as filibusters by Spanish authorities in Cuba, called for liberal pictorial comment. That the Virginius was a filibuster could hardy be doubted, but the slaughter of one hundred and fifty men, after little or no trial, was a drastic measure which came near resulting in the war which followed a quarter of a century later.

The panic of 1873, brought about by the failure of Jay Cooke & Co.—due to their inability to carry an over-burden of Northern Pacific securities through those troublous times—resulted in the failure or suspension of a score or more of other important houses and a second " Black Friday "—a day of madness on the Stock Exchange. It also inspired Nast to fire a direct shot for his hero,

Grant. A committee of brokers had urged the President to re-
lieve the situation by lending the treasury reserve of $44,000,000
to the city banks. This, Grant had declined to do, as being with-
out warrant of the law. He offered as a substitute to buy as fast
as offered the 5-20 bonds of 1881—a wise and conservative
measure which went far to reduce the financial fevers of an over-
wrought and over-bought market. Grant, as " Watchdog of the
Treasury," was Nast's summary of the situation, with a placard
bearing the words of his reply to the brokers.

" You can violate the law; the banks may violate the law and
be sustained in doing so, but the President of the United States
cannot violate the law."

The press united in applauding Grant for this action. The
Herald forgot its cry of Cæsarism and joined in the general ap-
proval. In an editorial it said:

The policy of the government has proved as wise as it was
moderate. We cannot too much praise the course of President
Grant, for it has probably saved the country from a great finan-
cial crash.

Yet in spite of the President's commendable panic policy, he
received a liberal share of blame for the depressed financial con-
ditions which followed. When times are unprosperous, what-
ever may be the cause, it is natural to cry out against the

PECULIAR POSITION OF SOME MEMBERS WHEN
ASKED TO REFUND THE BACK-PAY GRAB

Government; also to propose cu-
rious and absurd nostrums of
relief.

Inflation was the popular
quackery of the moment, a plan
for the expansion of the national
currency without increase of se-
curity, favored by a number of
well-known senators and con-
gressmen, who were prone to
find a brief comfort in sophistry

and a day's pleasure in rainbow pursuits. Against this imaginative contingent were arrayed those who were for specie payment, dollar for dollar, at the earliest possible moment.

Both Harper's Weekly and Nast were firmly for resumption, and the "Inflation Baby"—a money bag which blows itself up until it bursts—made its appearance on December 20, 1873. The symbol thus invented has been frequently used by later cartoonists.

BY INFLATION YOU WILL BURST

UNCLE SAM—"You stupid Money-Bag! there is just so much Money in you; and you can not make it any more by blowing yourself up."

LET WELL ENOUGH ALONE, AND DON'T MAKE IT WORSE

Money is *light*, but let it recover itself naturally, and then it will stand on a sounder basis

Stimulants or *inflation* only bring *final collapse*

The " Salary Grab " bill—a measure championed by General Butler—which increased the pay of congressmen and senators from five thousand to seven thousand five hundred dollars a year, with back pay for time served, had proven a most unpopular bit of legislation and its repeal was imminent. The situation of certain members who had drawn the back pay and were now asked to refund was humorously depicted by Nast. The law was abolished early in seventy-four, except in so far as it concerned the President, whose salary had been doubled, and the

19

THE CRADLE OF LIBERTY IN DANGER.
"Fee-Fi-Fo-Fum!" The Genie of Massachusetts smells Blue Blood.

Supreme Court Judges, whose increase was considered just. Many members had not drawn their back pay and most of those who had done so returned it. Thus was public indignation appeased.

Seventy-four was a year big with events — some of them great, others small, but often foreshadowing the larger happenings of the future. The cartoons were many, and the fact that during the first half of the year Nast was on his lecture tour did not lessen them either in number or effect.

Financial conditions continued troublesome. General Butler, the genie of the "Salary Grab" and Inflation, was portrayed as a menace to "The Cradle of Liberty," frightening Massachusetts with his grim and growing power. Again, as one of the evil shades conjured by the press, he was shown declaring that "Grant will not veto the Inflation Bill." But this was a mistaken sentiment on the part of Butler, for the expansion measure which, under the lead of Senator Morton of Indiana, Logan of Illinois, and General Butler, had been carried through both houses, met with a prompt veto from General Grant. Roscoe Conkling, its leading opponent, avowed that the bill "spurned the experience of all history and trampled upon the plighted

faith of the nation.'' Stewart of Nevada added that the
day of its passage was '' the saddest he had ever seen in the
Senate, and would long be remembered by the American people.''
The President's veto of this questionable financial measure was
declared by Curtis to be the '' most important event of the ad-
ministration.'' Nast recorded it in the '' Cradle of Liberty
Out of Danger,'' showing the genie, Butler, bottled again. Once
more the New York dailies for a brief moment united in their
approval of Grant. Even those who had been most critical
were unstinted in their praises.

Yet Grant himself was desirous of some measure of financial
relief. Earlier in the year he had expressed a belief that the
amount of circulating medium was unnecessarily small, and had
suggested '' free banking '' as a possible remedy. To a layman
it is difficult to un-
derstand how this
would have helped
matters, as, indeed,
it is always difficult
to understand any
method of financial
easement, whether
of government or in-
dividual, which does
not proceed from the
sale or pledge of
some property of
undoubted value in
exchange for a me-
dium whose integ-
rity is unquestioned
and likely to remain
unimpaired.

THE CRADLE OF LIBERTY OUT OF DANGER.
The Blue Blood of Massachusetts flows freely once more.

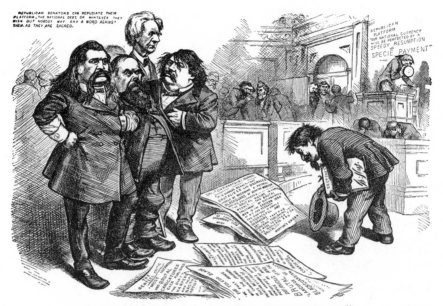

REPUBLICAN SENATORS CAN REPUDIATE THEIR PLATFORM, THE NATIONAL DEBT, OR WHATEVER THEY WISE. BUT NOBODY MAY SAY A WORD AGAINST THEM, AS THEY ARE SACRED.

REPUBLICAN PLATFORM "OUR NATIONAL CURRENCY WILL BE PERFECTED BY A SPEEDY RESUMPTION IN SPECIE PAYMENT"

"PEEVISH SCHOOLBOYS, WORTHLESS OF SUCH HONOR"
(Senators Logan, Morton, Cameron and Carpenter annoyed. Tipton, Schurz, Fenton,.
Conkling and others in the distance)

CHAPTER XXXIV

NEW SYMBOLS, AND CÆSARISM

Financial dissensions now divided and weakened both parties, and the Greenback leaders did not fail to receive punishment from Nast, who had little patience with their theories concerning the circulating value of stamped paper based on a pledge which did not exist—a promise never meant to be fulfilled.

In the Weekly for May 23, 1874, is a small cartoon entitled "Inflation is 'as Easy as Lying.'" Capital is tearing the dollar into two parts to pay Labor, the latter personified in the square cap and apron we have learned to know so well in the cartoons of to-day. The labor symbol he had made use of earlier in the year (Feb. 7) in a small cartoon, entitled "The American Twins," but the idea of dividing the dollar, which has since done duty in a hundred forms, was here used for the first time.

The faces of Logan, O. P. Morton, Simon Cameron, and Matthew H. Carpenter often appeared in the inflation pictures, and these statesmen were considerably annoyed in consequence.

" Little Nast thinks he can teach statesmen how to run the government! " Logan growled one day. " Anybody might think he runs it himself! "

" Never mind, Logan," said Colonel Chipman, consolingly, " it is a distinction to be really caricatured by Nast. Just think what it would be to be indicated by a tag."

Curtis, with whom Nast was on terms of great amity at this moment, wrote an editorial defence of the inflation caricatures, while Nast portrayed the " Greenback " group as " Peevish Schoolboys, Worthless of Such Honor," though it is doubtful if they ever discovered the point of " honor " in his attentions.

It was in 1874 that Nast began a series of pictures in defence of the Regular Army and Navy against those parsimonious legislators who sought to gain credit with their constituents by reducing the expense of maintaining the country's defenders. Such economists were quite willing that the uneasy Indians should be quieted, and that the nation's dignity and commerce should be cared for on the

" THERE IS NOTHING MEAN ABOUT US "
UNCLE SAM—" What Congress proposes to reduce our Army and Navy to."

high seas, but they saw an opportunity of personal aggrandisement in offering bills to reduce public expenditures, and it mattered little to them that soldier and sailor went poorly clad and meanly fed.

Nast symbolized the heroes on sea and shore as the " Skeleton Army and Navy," reduced by the farce of " Retrenchment " until they had become a reproach to the government they protected. These pictures brought many and grateful letters from officers who were battling Indians in the sage-brush of the frontier, or cruising the high seas, afar from home and kindred.

It was just at this time that Nast drew his only picture against Grant. It came as the result of a reappointment by the President of Alexander R. Shepherd as Governor of the District of Columbia, and the overwhelming rejection of the nomination by the

'Don't let us have any more of this nonsense. It is a good trait to stand by one's friends; but — "

NAST'S ONE CARTOON AGAINST GRANT

Senate. Shepherd, known afterwards as " Asphalt " Shepherd, had spent vast sums in the improvement of the capital, and it was generally believed that he had made a personal profit from these expenditures. As a result, the government of the District had been reorganized, and the President's reappointment of the man who had made this step necessary

was regarded as indiscreet, despite the fact of his implicit faith in Shepherd—a faith which later years are said to have justified. Lavish and even extravagant Shepherd may have been, but it is not now believed that he profited by the money he spent, while to him personally is due the fact that Washington, '' from an ill-paved, ill-lighted, unattractive city, became a model of regularity, cleanliness and beauty.''* Yet the truth of this could not be known then, and for the President—already held

"THERE IT IS AGAIN!"

responsible for many unfortunate appointments—to have thrust his personal friend directly in the face of the people who would have none of him, would seem to have justified this single stroke of censure from his ablest and most faithful defender, Thomas Nast.

The cartoon made a great stir, and it was loudly proclaimed that Nast had finally abandoned Grant. The Tribune of July 10 printed a column editorial welcoming the artist as the latest recruit to the ranks of '' Independent Journalism,'' which General Butler had characterized as having '' a forty jackass mud-throwing power.''

Perhaps on the strength of the anti-Grant cartoon, and the fact that Nast had taken his family for a brief trip abroad, the Herald felt safe in renewing its noisy cry of Cæsarism, and its

* Blaine.

INFLATION IS "AS EASY AS LYING"
THE CAP OF LABOR AND THE DIVIDED DOLLAR

protests against a third term—an honor which Grant, at that time, neither sought nor desired.

But if Mr. Bennett believed that the cartoonist had forsaken the Administration he was not long deceived. "There it is again" (a block despatched hastily from London), was one of Nast's most humorous burlesques of the Cæsarism scare, and "Cæsarphobia" was an effective summary of the situation. In this picture, the Herald owner, as Nick Bottom, is prancing about Grant, the Lion, and saying to him "Do you insist on running for a third term? Do you insist on being a Cæsar? Answer quick, or—or—or I'll bray!" Later, when the Tribune joined

THE HOBBY IN THE KINDER-GARTEN
JUNIOR BENNETT—"You must take a back seat. I was on first."

in the cry, Mr. Bennett was depicted as mounted on the "Third Term Hobby," insisting that Whitelaw Reid should be content with riding behind. These were really remarkable caricatures, notably good-humored, and doubtless enjoyed as much by the subjects of them as by the public. Henry Watterson, in the Courier - Journal — himself opposed to Grant and inclined to echo the Third Term cry—referred

to them as "the most graphic utterances from that side of the political alignment." The Herald merely suggested that Mr. Nast seemed to have "exhausted the grotesque resources of his trade in endeavoring to show that the issue (Cæsarism) had no existence."

THE MERE SHADOW HAS STILL SOME BACKBONE
"Our Standing Army" stands in spite of political false economy

Curtis and Nast appear to have been on excellent terms during this period. Among the letters we find one from J. W. Harper, Jr. (known as "Joe Brooklyn"), who was always a friend to Nast, calling attention to a complimentary editorial by Curtis on the recent cartoons, and suggesting that the artist send to the editor a word of acknowledgment. That Nast must have done so is indicated by a letter to him from Curtis, dated a few days later, in which the editor expresses thanks, and asks concerning the artist's welfare and plans. He adds that he has sent a copy of his "Sumner Address," and this copy of that beautiful eulogy on the dead statesman is still preserved.

Renewed Indian outbreaks and the promptness and bravery of the Army of the Frontier, offered occasion for another picture of the "skeleton army," hampered by red tape yet still at its post, and further letters of appreciation came from officers at the

front. One of these, from Major John Burke, of Colorado,
said:

Your caricatures, in the opinion of the enlisted men of the
army, do us more real good than all the political speeches made.
The one representing "Army Backbone" is super excellent, and
all men out on the frontier service thank you for it. We expect
after having spent all our ammunition in target practice, to have
to put up a large sign-board with the lettering " All Indians
Will Please Keep Off the Reservation, as Ammunition is Ex-
pended. The U. S. being Unable to Allow more than $3.00 per
Annum for Ammunition."

General John C. Robinson, Lieutenant Governor of New York,
wrote:

As an old officer of the Army and one having its interests at
heart, I desire to thank you for the admirable illustrations in
Harper's Weekly.
In addition to the bill for reductions of the Army, there is now
pending in the senate a bill to reduce the rank and pay of the
officers, retired from active service on account of wounds re-
ceived in battle. How soon the promises made have been for-
gotten! Very truly yours,
 John C. Robinson.

As the autumn elections drew on, it became evident that the
political tide had turned and that Democracy was likely to win
a measure of triumph. The Nation's financial condition had not
improved, and the party in power was held responsible for con-
ditions of agriculture, manufacture and trade. In the South,
anti-negro societies—known under the name of the White
Leaguers—were organized to secure a " white man's govern-
ment," old ku-klux practices were revived, and reports of riot
and bloodshed began to disgrace the nation. In New York State
Samuel J. Tilden was the legitimate candidate for the Governor-
ship, and his election over Governor Dix seemed probable. His
active leadership dated from the moment he had so opportunely
entered the fight against the Tammany Ring three years before,
and his path to Washington by way of Albany appeared broad
and plain. It was believed that he would make a worthy State

THE THIRD-TERM PANIC.

"An Ass, having put on the Lion's skin, roamed about in the Forest, and amused himself by frightening all the foolish Animals he met with in his wanderings."—SHAKSPEARE or BACON.

THE FIRST APPEARANCE OF THE REPUBLICAN ELEPHANT

official and the campaign against him was not severe. Nast caricutured him but once, representing him as " A Tammany Rat," which, having escaped from a tottering structure, had turned reformer to kick over the ruins.

The issue of the Weekly containing this picture, however, is chiefly notable for another reason, for in it appears the first " Republican Elephant " cartoon. This now familiar symbol, which so long has represented the G. O. P. (Grand Old Party) in American caricature, was originated by Nast, under the name of " The Republican Vote." The picture shows the collected animals of the forest—representing various papers, states and issues—being frightened by the donkey in a lion's skin crying " Cæsarism." The elephantine Republican Vote, alarmed like the others, is on the verge of a pitfall which is covered loosely by various and deceptive planks. The Democratic party, hitherto represented by the Donkey, which eventually became its fixed symbol, is here impersonated by a fox, whose face suggests that of Mr. Tilden. The cartoon was not only a striking but important picture, introducing, as it did, the Republican Elephant into American caricature for all time. It is a curious fact that the date of issue, November 7, 1874, was precisely three years from the publication of the first Tiger cartoon.*

Two weeks later, when the results of the various elections were known, we find the Republican Elephant plunging head first into the pitfall, toward which he had been driven by the Donkey's distracting bray. In the same issue of the Weekly was presented the assassination of the " Cæsarism Ghost" by the " Third Term " editors, now that this bogus spectre was no longer needed.

For Democracy had achieved a victory. Samuel J. Tilden had been elected Governor of New York; William H. Wickham had

* Weekly papers, in that day, were dated considerably in advance of publication. Both the Tiger and the Elephant symbols were first given to the public just prior to autumn elections.

succeeded W. F. Havemeyer as Mayor of New York City, while for the first time since it became a power the Republican party had lost control of the House of Representatives at Washington.

Nast closed the year with some pleasantries at the expense of Mr. Bennett, who, with his unfailing fondness for a joke, had announced one morning—in startling headlines, followed by six columns of solid matter—that the " Wild Animals " had " Broken Loose in Central Park " and that " Terrible Scenes of Mutilation " and a " Shocking Sabbath Carnival " had ensued.

It was an excellent hoax, and fooled and frightened many readers, but it was somewhat unfortunate in the opportunity it offered for burlesquing its perpetrator. For months to come " The Wild Animals are Loose Again " was likely to be used by Nast to characterize any unusual statement in the Herald columns and the changes were rung on the theme until Mr. Bennett perhaps wished he had kept his imaginary " wild animals " properly caged and cared for.

CAUGHT IN A TRAP. THE RESULT OF THE THIRD-TERM HOAX

CHAPTER XXXV

VARIOUS ISSUES AND OPPOSING POLICIES

MAKING A FUSS

The lost Traveller condemning the Post which points him the way

The beginning of 1875 was marked by the passage of the "Resumption Act"—a Republican measure, providing for the payment of the U. S. currency in specie—to take effect four years later. Nast commemorated this important piece of legislation in two cartoons which could hardly have pleased the opposing Democracy, or the two Republican senators and twenty representatives who had fought the sound basis issue.

It was early in seventy-five that the Louisiana contention as to whether William Pitt Kellogg (Rep.) or John McEnery (Dem.) had been elected to govern the State became especially fierce and bitter. The question was complicated by the White League element, and reports of riot and bloodshed, with interference of the Military, under General Sheridan, aroused and excited the nation.

There had been perjury, bribery and coercion on both sides and it was the duty of Congress to decide which governor should

be recognized. But Congress, says Curtis, had been busy dodging the Credit Mobilier investigation and passing the " salary grab " and refused to do its duty. It then became the duty of President Grant to take action and he recognized the Kellogg government. In doing so he unluckily gave reasons for his actions, and the reasons were unsound. Later, he did not see fit to rescind his own claim and allowed it to stand.

Grant's recognition of the Kellogg government was not wholly approved by his followers, and for a time seemed likely to cause a split in the party. This split was especially noticeable in the pages of Harper's Weekly. The editorials were distinctly against the President's policy, while the pictures of Nast supported it throughout. It frequently happened that a cartoon depicting Sheridan or Grant as heroes appeared on a page, while on the

reverse page was printed an editorial expressing precisely the opposite opinion. The inevitable controversy, with a long letter from Curtis, followed. Nast had naturally assailed the editors who had called upon Grant to resign in favor of Wilson, caricaturing Mr. Bennett as the " Hoax " editor, Don Piatt as " Don Pirate " and Whitelaw Reid as a bandit, displaying the

THE " FUNNY " LITTLE BOY IN TROUBLE
(Mr. Bennett complains that he is being ridiculed and is advised by Wisdom to give up his practical jokes)

Tribune of January 9 in which was printed a letter headed
"Bayonets and Legislation," signed J. H. H. and closing with
this remarkable paragraph:

If he (Grant) insists on fighting it out on this line, some one
will play Brutus to his Cæsar without fail, which, by the way,
would be a great blessing to the country.

It was the bayonet outcry that had suggested to Nast the in-
troduction of this weapon into his pictures; and this, in turn,
brought a characteristic protest from Curtis.

February 7, 1875.

My Dear Nast:
I wish that we met oftener, and I hope that you are quite well
again.
Mr. Harper showed me your note about the bayonet picture.
My feeling is that the country feels that there has been rather
too much bayonet, and there is nothing worse as an educator.
The sign of health in a free government is jealousy of the bay-
onet, and it seems to me a fatal error for a party devoted to
freedom to put forward the bayonet as its symbol, as if it yearned
to use it. Of course the bayonet is behind all constitution and
law and government, but it is the last, not the first, resort, and
when it is the constant reliance there is a present end of freedom.
It is true that the bayonet " would, if legal, soon put an end to
disorder." It did so at Warsaw. But it puts an end to liberty
also. Everything depends upon the who, and the when and the
how. If we accustom the country to the use of the bayonet in
peace, and for good purpose, as we say, we set the tune for the
Democrats to use it, without public consternation, for a bad
purpose. Besides, I don't doubt that Kellogg rests upon a fraud,
and to see the army maintaining a fraud in the name of Liberty
and the Republican party is to me a sin against the holy ghost.
I don't say McEnery isn't a fraud, but he isn't our fraud, and
as I have no doubt that a very large part of the party believes
with me that Kellogg is a fraud, the policy of defending all that
he does and of boosting him constantly with the bayonet is the
sure end of the Republican ascendency and the beginning of
the Democratic régime.
I look with great expectation to George Hoar's report. If he
says that the other two committees told the truth, nobody can
doubt any longer.
Don't misunderstand me. The army has a right to be in Lou-
isiana, for it must be somewhere, but it should be used only in

the strictest conformity to law, and even if Kellogg should be recognized as Governor, the circumstances under which he became so should make the Government very wary of yielding to his request. On the first of January he had no more right to order the troops than I had, and the President doesn't think or say that he had. The kind of letter which I answer in my leader this week (coming) shows how loose and demoralized people have become. The man writes just as the tories used to write in New England a hundred years ago. My dear Nast, forgive this long sermon, and believe me always most truly yours,

An old party named Curtis.

WHY IT IS NOT PARTISAN.

"With reference to Louisiana, it is to be borne in mind that any attempt by the Governor to use the police force of that State at this time would have undoubtedly precipitated a bloody conflict with the White League, as it did on the 14th of September. There is no doubt but that the presence of the United States troops upon the occasion prevented bloodshed and the loss of life. Both parties appear to have relied upon them as conservators of the public peace. The first call was made by the Democrats to remove persons obnoxious to them from the legislative hall, and the second was from the Republicans to remove persons who had usurped seats in the Legislature without legal certificates entitling them to seats, and in sufficient numbers to change the majority. Nobody was disturbed by the military who had a legal right at that time to occupy a seat in the Legislature."—*From President Grant's Message.*

This would seem a "long sermon" indeed, to result from one small and inoffensive looking picture of a personified and strictly non-partisan bayonet, used to illustrate an extract from the President's message maintaining that the troops in Louisiana had been the means of preserving law and order which the police alone could not have enforced.

But on the week following there were bayonets in plenty, for Nast gave pictorial expression to the general outcry of "Bayonet Policy!" by "letting the wild animals loose again," the cartoon being an escaped menagerie of many beasts, each with a bayonet head. Yet Curtis did not appear to see that Nast, in some measure at least, was ridiculing the very thing which he himself condemned, and felt called upon to anounce that he was responsible only for the matter found in the editorial pages. Nast would seem to have been in rather bad humor after this and retired like Achilles to his tent. It was Fletcher Harper, as usual, who pointed the path to peace and usefulness:

20

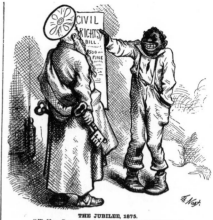

CAN A MAN BE A NURSE?
U. S. G. "Both parties say they love it. But —"

THE JUBILEE, 1875.
"Hi, Massa Peter, you can't objec' to open de gates fo' me now!"
N. B. Pure White Churches please take notice.

" I should like to have a page and two comics from you for our next paper. Don't get into a flurry, but learn to ' stoop to conquer.' Nobody out of Morristown can always have his own way. I'm sure you very well know that I don't.

" How is the Baptist minister? "

Bennett letting loose " Hoax " and " Sensation," the two " dogs of war," came in response to this letter, and in the same issue another shot is fired for the " Retrenched Skeleton Army."

In the general political upheaval of 1874-5, James G. Blaine, who for six years had been Speaker of the House of Representatives, was defeated by Michael C. Kerr of Indiana. Also, in the Senate there were many new faces, and among these was that of Andrew Johnson, who began in the Senate just where he had left off in the Presidency, seven years before. Nast signalized the return of Johnson with a small good-natured cartoon, entitled " The Whirligig of Time," and Johnson in return said,

" I forgive Tom Nast for all he ever did to me."

But he did not forgive Grant. He assailed the President and the administration in language which was all the more effective for being more dignified than his former utterances, but which failed to restore his lost prestige. On the last day of July, of the

same year, 1875, he died—perhaps the least regretted of the men who by their own efforts have lifted themselves from poverty and illiteracy to the highest office in the gift of the people.

Disagreements among the Democratic members supplied matter for a cartoon on February 27, which presented for the first time the faces of Samuel S. ("Sunset") Cox, Democratic congressman from Ohio, and that of Speaker Blaine. Cox wrote good-humoredly to Nast, enclosing a later photograph.

Loveliest of your sex and most ingenious in your business:
Allow me to send you a corrected edition of my phiz (made) since the one you evidently saw when you put me to holding John Young Brown in. If I am to be spanked, as the boy insisted, let it be with my stoutest pants on. Your picture of the Brown performance was relished all over the House.
Adieu. I hope soon to be let out of this menagerie.
Ever of thee,
S. S. Cox.

Curiously enough the same cartoon brought from T. T. Crit-

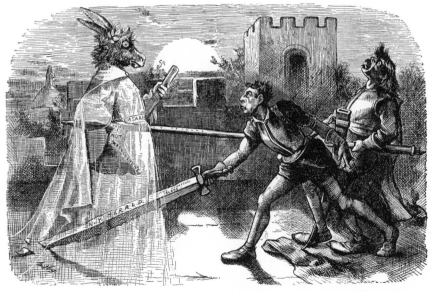

A MOONSHINE SCENE

"We do it wrong, being so majestical, For it is, as the air, invulnerable,
To offer it the show of violence; And our vain blows malicious mockery."—*Shakespeare.*

(Mr Bennett and Mr. Reid assailing the apparition of Cæsarism. In the eye of the spectre, the words "Third Term" appear)

tenden, Democratic member from Missouri, a picture of John
Young Brown. Crittenden said:

I have seen in Harper's an amusing caricature of my per-
sonal friend and fellow member, John Young Brown, of Ken-
tucky. I take pleasure in sending you an excellent photograph
of him—somewhat better than the picture you have drawn. He
is a gentleman of much modesty and worth.
 Truly yours,
 T. T. Crittenden.

THE TRUNK IN SIGHT. FIRST APPEAR-
ANCE SINCE THE FALL (ELECTIONS)

The nation's representatives were
desirous that their faces should be
truly depicted, whether in approval
or censure.

Preparations for the Philadelphia
Centennial Exhibition were now in
progress, and the disgust of Carl
Schurz, who was reported to have
said, " Let the Hundredth Anni-
versary of the Republic be a confession of its failure," once more
introduced that cynical statesman's face into caricature. Once
more, too, the bogus Ghost of Cæsar walked, to appall Park Row
and Ann Street with its ghastly " Third Term " eye. The trunk
of the Republican Elephant appeared from the pitfall, labelled
" New Hampshire " and breathing " Victory." Grant offered
the Civil Service Baby to both party-nurses, who said they
loved it, but turned away. The Colored Citizen showing the Civil
Rights Bill to St. Peter as warrant for admission through the
golden gates, and Columbia exchanging with the White Leaguer
the tools of agriculture for the arms of strife—these were a few
of the pleasantries that furnished the public with amusement
during that rather quiet spring.

CHAPTER XXXVI

POLITICS AND A NOTABLE ESCAPE

ANOTHER MYSTERIOUS DISAPPEARANCE

Meantime, Governor Tilden, who was now regarded as the logical presidential candidate, with the single war cry of "Reform," had attacked the already doomed Canal Ring, as in 1871 he had aided in the final destruction of the Tweed combination. Mr. Tilden, perhaps more than any other politician of recent times, was the favorite of fortunate circumstances. The tottering condition of the Tweed Ring; the extinguishment of the war debt, which would result in a reduction of the tax rate of nearly fifty per cent.; the amendment of the State Constitution (already passed) prohibiting any taxation or appropriation for canal expenditures—which meant starvation to the Ring by cutting off its chief source of revenue—these combined in a predestined and inevitable tide which Mr. Tilden had the shrewdness and ability to take at its flood. Holding the most important State in his grasp, and with a political genius of a very high order, he was transformed almost in a moment from a respectable figure-head

of a corrupt political organization into the absolute leader of
National Democracy, with a policy of Reform.

As a master of political tactics, Tilden has rarely been
equalled. His successful efforts in extinguishing the canal
pirates won for him the respect of those who opposed him polit-
ically, while his own party rallied to his standard, as the one
chief who could lead Democracy to National triumph. Even
Nast, whose clear vision rarely failed to penetrate every political
pretence, complimented him in a picture which portrayed the
Governor as assailing freebooters of the canal, and as driving
vultures from the horse of the tow-path. It is true he attacked
Tilden's policy of pardon for certain members of the Tweed
Ring,* though this could do little now to stem the current of pub-
lic favor that was bearing the New York Governor toward Wash-
ington. Certainly, with the disturbed conditions in the Repub-
lican ranks, and the general harmony, save perhaps on the issue
of finance, in the phalanx of Democracy, the prospects of the
party of Jackson and Jefferson for a President in 1876 grew
brighter with every passing day.

Indeed, the Republican Elephant seldom got more than the
tip of his trunk out of the pitfall during this '' off year '' and
more frequently showed the tip of his heels as he dived back,
upon receipt of news from Connecticut or some other disap-
pointing region.

On June 3, 1875, occurred the marriage of General Phil
Sheridan—an event which Nast did not allow to pass un-
noticed. He wrote early in May to know if the reports of the
coming event were true, to which inquiry Sheridan sent a feeling
reply.

* On an average about nine out of ten men who were confessedly guilty of
stealing were accepted as witnesses against the other one man, until the time came
when there was but one man against whom any testimony could be used, and it was
not considered wise to try him. It was a shameful condition of affairs.—Hon. Jno.
D. Townsend in " New York in Bondage."

CAPTURED AT LAST (JUNE 3, 1875)
PHIL SHERIDAN—"I am not afraid."

Dear Nast:

It is true. I am to be married on the 3d of June, coming, unless there is a slip between the cup and the lip, which is scarcely possible. I will not have any wedding for many reasons, among them the recent death of my father.

I am very happy, but wish it was all over.

Yours sincerely,
Sheridan.

P. S. & M. I.—I send the enclosed (photograph) for your eldest. Please send me yours to be kept for mine.

P. H. S.

Sheridan had characterized the White Leaguers of Louisiana as " Banditti " and Nast cartooned him now as garlanded and led to the altar by little " Banditti " cupids—a picture with which General Sheridan was highly pleased.

It was during this summer that General Grant's letter to General Harry White of Pennsylvania, defining the President's position on the Third Term issue, was made public. It was a simple and noble document, penned by an American patriot. The following extract conveys fairly the style and sentiment of the whole:

In the first place, I never sought the office for a second, nor even for a first nomination. To the first I was called from a life position, one created by Congress especially for me for supposed services rendered to the republic. The position vacated I liked. It would have been most agreeable to me to have retained it until such time as Congress might have consented to my re-

tirement, with the rank, and a portion of the emoluments which I so much needed, to a home where the balance of my days might be spent in peace and the enjoyment of domestic quiet, relieved from the cares which have oppressed me now for fourteen years. But I was made to believe that the public good called me to make the sacrifice. Without seeking the office for a second term, the nomination was tendered me by a unanimous vote of the delegates of all the states and territories, selected by the Republicans of each to represent their whole number for the purpose of making their nomination. I cannot say that I was not pleased at this, and at the overwhelming endorsement which their action received at the election following. But it must be remembered that all the sacrifices except that of comfort had been made in accepting the first term. Then, too, such a fire of personal abuse and slander had been kept up for four years, notwithstanding the conscientious performance of my duty to the best of my understanding—though I admit, in the light of subsequent events, subject to fair criticism—that an endorsement from the people, who alone govern republics, was a gratification that it is only human to have appreciated and enjoyed. Now for a third term, I do not want it any more than I did the first. I would not write or utter a word to change the will of the people in expressing or having their choice. . . The idea that any man could elect himself president, or even renominate himself, is preposterous. It is a reflection on the intelligence and patriotism of the people to suppose such a thing possible. Any man can destroy his chances for the office, but no one can force an election, or even a nomination.

AND THEY SAY, "HE WANTS A THIRD TERM"

To recapitulate, I am not, nor have I ever been, a candidate for renomination. I would not accept a nomination if it were tendered, unless it should come under such circumstances as to make it an imperative duty—circumstances not likely to arise.

Nast celebrated the publication of the Grant letter with a caricature of himself, surrounded by little caricatures of his numerous cartoons against "Cæsarism," his coat decorated with a peacock appendage. It may be said here that Nast has been charged with conceit, but no one ever charged it against him more directly than he did himself, and no one ever caricatured him more savagely than he did his own features.

"L'HOMME QUI RIT."
J. G. B., JUN. "If Grant isn't careful, I'll let the Wild Animals loose again."

"Please send us your photograph," wrote an unknown lady. "Those pictures you make of yourself are horrid."

As the most positive political factor of his time, it will hardly be denied that Nast belonged in many of its pictures. Other caricaturists recognized this, and no other maker of pictures was ever so continuously and fiercely cartooned as was Thomas Nast.

The Grant letter was variously received by the press. Friendly journals declared that it settled the question of his non-candidacy. Critical editors protested that it was not sufficiently direct. Violent anti-Grant papers avowed that it was clearly a bid for the nomination. Nast depicted Mr. Bennett declaring, "If Grant isn't careful, I'll let the wild animals loose again."

It was just at this period that we meet with another pictorial invention of Nast in the Greenback "Rag-baby," which Senator

Thurman of Ohio, on the morning of September 4th (in Harper's Weekly), finds deposited by his party on his door-step. The Rag-baby—the lineal descendant of the Inflation Baby killed by Grant's veto—became immediately the enduring symbol of fiat money and other bodiless and boneless measures. Like Nast's former inventions it was immediately adopted by his fellow illustrators and became a cartoon property that would not die. We see it crying "Holy Murder!!!" however, about a month later, when Governor Tilden, whose financial instincts prompted

him to the policy of hard money, is discovered choking it at the Ohio senator's threshold. A little later we find the Rag-baby tossed into an ash-barrel, with the pertinent query "Is it dead?"

The serial element in Nast's work is well illustrated in this brief comedy. He seldom drew one picture that others of a like nature did not follow it in a logical sequence, terminating in a climax effective and complete.

THAT IRREDEEMABLE BABY

THIS IS A NICE POSITION FOR A "HARD-MONEY" BACHELOR TO BE PLACED IN

(First use of the Rag-baby symbol)

"I follow your pictures just as I do a story in parts," a

correspondent wrote. '' I know when you begin a subject it will be ' continued in our next,' and the end will be worth waiting for.''

Time proved that the Rag-baby was not dead, and with its relatives it became an important feature in the political cartoons.

Meantime Mr. Tilden's war record had been raked up, as of course it would be, and it was shown that during 1863 he had been associated with other doubtful patriots in forming the '' Society for the Diffusion of Useful Knowledge,'' which issued '' pamphlets decrying the ' usurpation ' of Lincoln, and showing the blessings of slavery, the failure of emancipation, and in every way short of making an appeal to arms, giving aid to those who were engaged in attacking the Government.'' *

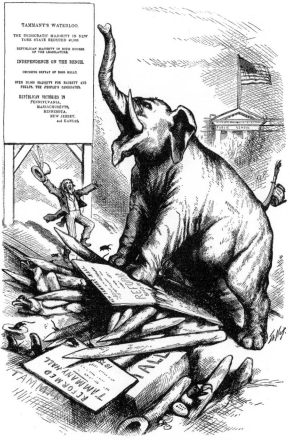

These and other developments must have had their effect, for the autumn elections of 1875 indicated Republican gains, and a new expression of confidence began to manifest itself in that party. The Republican Elephant

* Harper's Weekly, November 20, 1875.

TAMMANY DOWN AGAIN. THE "REFORM" TRAP SMASHED

climbed out of the pitfall and stood triumphant again amid the
ruins of Tammany Hall. Had it not been for the "Whisky
Ring" exposures, which began about this period, the prospects
of the Elephant remaining out of the pitfall might have been
more hopeful.

The Whisky Ring was made up of a number of prominent
Republican officials, who had been assessing the distillers, osten-
sibly for campaign purposes, but pocketing, themselves, a large
portion of the funds thus obtained. It is true that Secretary of

CALLING IN FRAUDS.
"Step up, Gentlemen. (?) Don't be Bashful!"

the Treasury, Benj. H. Bristow,
promptly and mercilessly insti-
tuted war against the offenders,
and not only punished them, but
recovered a large portion of the
stealings. Yet the disgrace was
regarded as a stain on the Ad-
ministration, and remains as
such to this day.

The release of "Boss" Tweed
after a year's imprisonment, and

the clutch of the Ring attorney, David Dudley Field, upon Tweed's
"'Big Six' Millions" became a part of the pictorial history of
1875. It is noticeable that even the money bag wore the stripes
of crime at this period, though this, it would seem, made it none
the less fascinating to Mr. Field. The hound of justice hampered
by red tape, and Tweed balancing gleefully upon the upturned,
though "upright" bench, recorded a brief period of the Boss's
triumph. But the State was desirous of obtaining for itself
the six millions of stolen money, and ere long we have Tweed,
with the striped money bag for a body, about to be squeezed by
the heavy tomes of the law. He did in fact presently find him-
self once more secluded—this time committed to Ludlow Street
prison, in default of a three million dollar bail.

"THE UPRIGHT BENCH," WHICH IS ABOVE CRITICISM

OFF THE SCENT

Yet Nast's prophecy that no prison would be big enough to hold the Boss was to be verified again before the end of the year. Tweed in Ludlow was allowed all sorts of liberties. He had the freedom of the city, and could drive out in the morning with a keeper for his coachman and a warden for his footman. In the evening he could dine at his Fifth Avenue home with a bailiff for his butler.*

It was at Tweed's home (Dec. 4) that he made his escape. The Deputy Sheriff had been invited to dine with him, and Tweed had requested that he might go up-stairs to see his wife. He did not return, and after hiding about New York for a time, fled to Cuba and eventually to Spain. That the great public offender in whose conviction he had been a chief instrument should have been allowed to escape was a humiliation to Nast. Yet the day approached which would bring that pictorial crusade, begun so long before, to its dramatic and triumphant close.

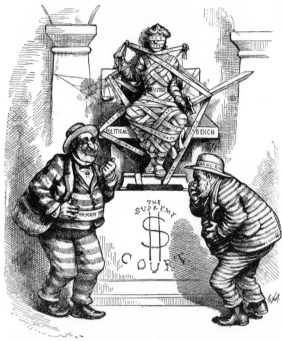

OUR MODERN MUMMY

TAMMANY TWEEDLEDEE—" She is going to punish us."
CANAL TWEEDLEDUM—" That's the best joke yet."

* Herald, December 5, 1875.

CHAPTER XXXVII

The Centennial year began in Harper's Weekly with one of Nast's happy Christmas pictures—two sleepy children, watching for Santa Claus. The Christmas spirit was always a distinct element in Nast's work and a mighty influence in his household. His own childhood in far-off Bavaria had been measured by the yearly visits of Pelze-Nicol and the Christkind, while the girl-hood of the woman who had become his wife was, as we have seen, intimately associated with brilliant and joyous holiday celebrations.

At the door of the now prosperous Nast household Christmas purchases were delivered in relays far into the dusk of Christmas Eve, and these the happy parents took a vast delight in arranging in an original and unconventional manner to make glad the brood of early risers on Christmas Morning. The children remember to-day that there was always a multitude of paper dolls—marvellously big and elaborate paper dolls—a race long since become extinct. And these the artist father—more than half a child himself at the Christmas season—arranged in processions and cavalcades, gay pageants that marched in and about those larger presents which could not be crowded into the row of stockings along the studio mantel. It was a time of splendor and rejoicing—the festive blossoming of the winter

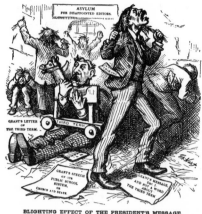

BLIGHTING EFFECT OF THE PRESIDENT'S MESSAGE.

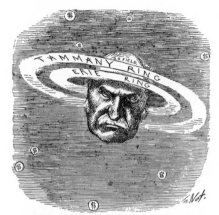

"THERE'S SOME ILL PLANET REIGNS." — Shakspeare.
The Rings are doubtless the chief glory of the Saturnian Firmament.

season—and it was a beautiful and sturdy family that made merry Christmas riot in the spacious home.

But fair and fleeting are the joys of Christmas-tide, while the affairs of nations march by in weary multitude.

The year did not open with perfect harmony in the Harper office. The third term spectre had alarmed not only the daily press, but Curtis as well, and the first political cartoon of the year—the " Blighting Effect of the President's Message " on Newspaper Row—was as much to be applied to the editor of Harper's Weekly as to those whose faces appeared in the picture.

In fact, in the same issue Curtis printed a two column leader in which he referred to the " evasion of the President's letter and Message."

Commenting on this fact, the New York Times said:

The editor of Harper's Weekly is evidently seriously disturbed by the Third Term talk, and we should judge that Mr. Nast's caricatures have not had much effect upon his mind. Recently an article appeared in the Weekly complaining that the President in his Message had made no reference to the subject, and in the same number there was a drawing by Mr. Nast, ridiculing the editors who took up the cry. The faces of some were shown, but in the background there was one whose back only was revealed to the public, thus giving rise to the horrible suspicion that this unknown personage must have been the editor of Harper's Weekly himself.

Nast never denied that the " unknown personage " was intended for Curtis, and no correspondence has been preserved from that period. Perhaps the controversy had passed beyond the mere exchange of letters.

The Post, reprinting from the Chicago Inter Ocean, added a line which would seem to show that the estrangement had become public and a matter for taking sides:

Nast and George William Curtis are rival editors on the same journal, Harper's Weekly. . . . Nast hits the nail on the head every time he strikes, because of his great singleness of purpose. Curtis strikes wildly, hurting nobody, not even the enemy.

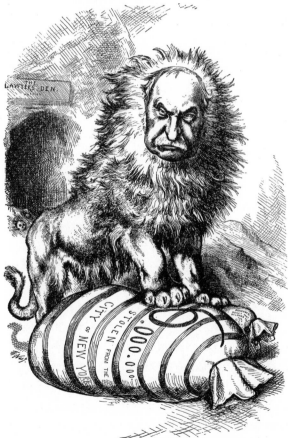

Evidently there was a lack of political unity in Franklin Square.

But there were other issues than that of the Presidency. Dudley Field as a " Lion " claiming his " legal (?) share " of the six millions of striped plunder left behind by Tweed, and Field's head as Saturn, encircled by the two Rings he had defended — the " Tweed " and the " Erie " — recorded phases of this unlovely series of public events.

THE (D. D.) FIELD OF GOLD, OR THE LION'S LEGAL (?) SHARE

THEY BOTH LIE TOGETHER IN THE WASHINGTON ARENA
DEMOCRATIC TIGER. "I have reformed, and am tame now." REPUBLICAN LAMB. "I—I believe it!"

It being the year of the Centennial Celebration there was a disposition toward harmony between the two parties at Washington, the desire being to make a pleasant showing to such foreign nations as might send emissaries and exhibits to the big national show. The "Tiger" and the "Lamb" made an effort to abide comfortably together, but it was no easy matter. Fraud and corruption were rife in both parties and in high places, and charges and recriminations were not conducive to a semblance of that brotherly love which a national Exposition to be held at Philadelphia might reasonably have been hoped to inspire.

The amnesty discussion in January did not help matters. There were still a number of prominent leaders of Secession, including Jefferson Davis—about seven hundred altogether— whose political disabilities had not been removed. Samuel Randall of Pennsylvania offered a bill providing for a general amnesty, but on a vote it fell a little short of the two-thirds necessary to its passage. James G. Blaine then moved to amend

the bill by excepting Jefferson Davis from its benefits. His
reasons as given were not that Davis had made war upon the
Union, nor because he had been chosen as President of the Con-
federacy. Blaine's argument against Davis was that, with
supreme power, both military and civil, in his hands, he had
permitted unusual cruelties to be inflicted upon Northern prison-
ers of war. Blaine believed that by excepting Davis from its
provisions the bill would pass; but the opposition refused to vote
on the measure in its amended form.

The debate became hostile and humorous by turns. Hill of
Georgia denied the Andersonville charges. Blaine replied by
quoting a resolution offered by Hill in the Confederate congress
to the effect that every Union soldier within the Confederate
lines should be put to death. S. S. Cox assailed Blaine with

facetious reference
to the "colored
heroes" of the war
and to the exag-
gerated reports of
the Southern prison
abuses. Blaine
crushed Cox with
quotations from one
of his own old
speeches on the
"Crimes of An-
dersonville." Cox
shouted back at
Blaine to "Dry
up!" and referred
to him as "the hon-
orable hyena from
Maine." As a ses-

"AMNESTY"; OR, THE END OF THE PEACEFUL (DEMOCRATIC) TIGER
(Fernando Wood, S. S. Cox and others fail to hold him)

THE TIGER GONE MAD

sion looking to peace and forgiveness it was hardly a success. According to Nast—in a picture entitled "Amnesty" —the Tiger was loose again, in hot pursuit of the lamb-like Blaine. The seven hundred un-pardoned ones re-mained without the pale. Nations look-ing on were perhaps less gratified than diverted by the spectacle.

The Democratic party, now more than ever, became the party of obstruction. With certain notable exceptions it opposed the appropriation of a million and a half dollars for the Centennial Fund. When L. Q. C. Lamar of Mississippi spoke in support of this measure, Manton Marble of the World went so far as to declare that the passage of such a bill would mean the dissolution of the Democratic party.

Democracy also continued its opposition to any measure for relief of the Army of the Frontier. "Retrenchment" at the expense of those who were keeping the Indians from scalping the settlers of the West became a Democratic watchword, and, led by Fernando Wood, who still haunted the halls of legislation, the followers of this peculiar economy were able to handicap and obstruct any bill providing for improved military conditions. Nast brought his biggest guns to bear on this "starvation" con-

tingent, and letters of gratitude from Colonel Guy V. Henry (" Fighting Guy ") and other brave officers engaged in sage-brush warfare were his reward.

The crusade of Secretary Bristow against the Whisky Ring continued to be pushed with vigor and severity. The fact that the offenders were Republicans—that Bristow himself was a Republican, and that a Republican President had said, " Let no guilty man escape "—inspired a degree of renewed confidence in the Administration. But little did the people, or Secretary Bristow, or General Grant, guess in what a high place a guilty man would be found. Not, in-deed, in connection with the Whisky Ring, but in what was still worse, the receiving of profits from the sale of a government mili-tary trading post—profits squeezed from the purses of the already reduced soldiers, who were obliged to buy where they could, and pay what they must. No one but the committee knew of a secret inves-tigation that was in progress, until one morning General William F. Bel-

BELKNAP

knap, Secretary of War, and one of Grants most trusted officials, called on the President, and in a few broken, agitated sentences confessed his disgrace and tendered his resignation.

The President was overwhelmed. It seemed to him that wherever he turned some new dishonor lay concealed. His administration had become like a nightmare. Strive as he might for good men, his search for incorruptibility seemed hopeless. Well

HAMILTON FISH

for him then that he could lean on a patriot like Hamilton Fish, in whose honor and integrity and moral purity there has never been found a flaw.

Grant was a man to stand by his friends—the last to believe in their shortcomings. A Minister to England he was reluctant to recall, even after Secretary Fish had admitted that this official was unworthy of his post. The President's own secretary, Babcock, not only had been connected with the Whisky Ring, but had misused his opportunities in the matter of

private papers; yet the President was loth to let him go. To have wilfully forfeited the trust and friendship of a loyal patriot like Ulysses S. Grant is as dark a stain as could be laid on the memory of any man.

Nast's cartoon of Belknap was a terrible arraignment—a vulture struck by lightning from a clear sky. Grant being made the " Scapegoat " by the howlers of the press, " The Crowning Insult to Him Who Occupies the Presidential Chair " was a picture of equal power on the side of the nation's hero.

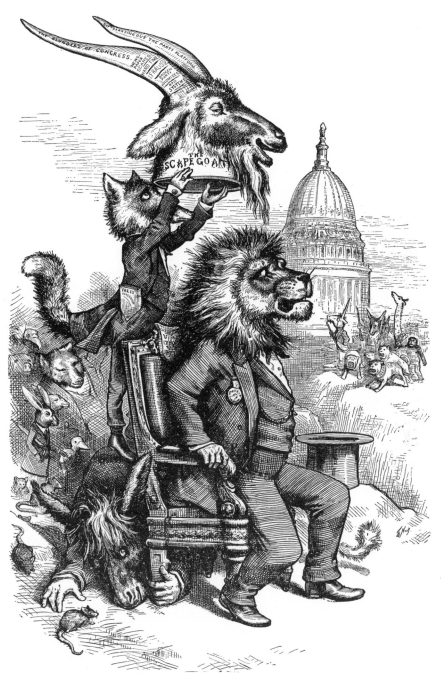

THE CROWNING INSULT TO HIM WHO OCCUPIES THE PRESIDENTIAL CHAIR

CHAPTER XXXVIII

During the early summer of 1876 the land was filled with preparation. Doubtless owing to the interest in the Centennial Exposition, political anticipation was somewhat less eager than during previous presidential years. Certainly there was less of bitterness than in 1872, and the pictures were drawn and the editorials written more in the spirit of entertainment than of determined warfare. Of the pictures by Nast, the illustrations of the eccentric progress of the now rudderless (tail-less) Tiger were perhaps the most amusing, though the Rag-baby refused to down in the halls of legislation and continued its ludicrous career in the pages of the Weekly.

THE "RAG" (BABY) AT THE MASTHEAD

Concerning the Presidential candidates, Mr. Tilden was the inevitable selection of the Democracy, while in the Republican ranks the crusade of Secretary Bristow against the Whisky Ring had made him a noteworthy antagonist of this New York Champion of Reform. Yet there were candidates more prominent than Bristow. Senator Conkling, who had led the Grant campaign in New York in 1872, was regarded as a great leader, and was, moreover, favored by the President. Blaine of Maine was perhaps foremost of all, while Morton of Indiana,

Governor Hayes of Ohio, and Marshall Jewell of Connecticut were all entitled to consideration. That Grant, even had he so desired, could become a candidate in the face of the accumulated disgrace of his appointed officials was out of the question.

The Republican National Convention of 1876 met at Cincinnati on June 14, and for a few days rivalled in public interest the Centennial Exhibition. The foremost men of the nation were among its delegates, including George F. Hoar of Massachusetts, George William Curtis of New York, and Robert G. Ingersoll of Illinois. The fact that its decision was wholly a matter of surmise lent to it a vastly added attraction.

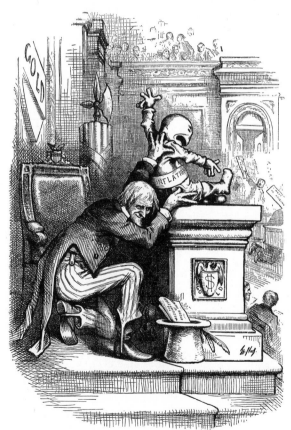

THE HAUNTED HOUSE; OR, THE "MURDERED" RAG-BABY WILL NOT BE STILL

In deference to the Centennial Celebration the Platform adopted was highly patriotic, containing a good deal of the Declaration of Independence, supplemented with recommendations as to the continued progress toward specie payment, protection of home industries, and monogamy in Utah.

The claims of the candidates were well considered. Mr. Thompson, of In-

diana, offered the name of Senator Morton, whose Inflation tendencies had made him acceptable to that wing of the party. Judge Harlan nominated Mr. Bristow, who was also the candidate of George William Curtis and Richard Henry Dana. The name of Roscoe Conkling was presented by Stewart L. Woodford; Governor Hayes of Ohio was advocated by ex-Governor Noyes and ex-Senator Wade, while Senator James G. Blaine was put in nomination by Colonel Robert G. Ingersoll, in that celebrated Plumed Knight speech which has never been equalled in the nominating speeches of any National Convention, and which at once placed Robert Ingersoll at the head and front of political oratory in America.

The fact that it was too late to begin balloting at the close of the speeches lost Blaine the nomination. The spell of Colonel Ingersoll's eloquence was upon the assembly. Had a vote been taken then the " Plumed Knight " would have been chosen on the first ballot. But the sunlight faded from the west windows, and with it died Blaine's moment of opportunity. " The gathering shades of evening compelled an adjournment," he says, in his book of recollections, and the sentence somehow has a pathetic sound.

Yet Blaine led in the balloting next morning, receiving two hundred and eighty-five on the first count, increasing the number to three hundred and fifty-one as against three hundred and eighty-four for Hayes of Ohio, who had begun the battle with the trifle of sixty-one.* Hayes's nomination was now made unanimous, and on the first ballot William A. Wheeler of New York was selected to complete the ticket.

Thomas Nast was particularly pleased with this ticket, for a day or two before the convention he had come out with a front

* On the first ballot Roscoe Conkling of New York obtained ninety-nine votes, which figure included sixty-nine of New York's seventy, that of George William Curtis having been given to Bristow. Conkling never forgave the defection, and retaliated in due time.

page caricature of himself "making a slate" upon which Secretary Fish led, with Governor Hayes as his running mate. Hayes's anti-inflation record appealed to Nast forcibly. The ticket made good one-half his prophecy—a fair percentage, in view of the numerous candidates. The week following the convention the cartoonist depicted himself again, this time rejoicing over the partial fulfilment of his forecast and approving the ticket in general. Hamilton Fish said, when he saw the picture:

"Well, I'm glad Nast had to scratch me off. I've got enough of politics."

Curtis, likewise, indorsed the nomination of Hayes, and once more the Harper editorials and pictures were as one. "Harper's Weekly emphatically indorses Hayes, and Curtis and Nast are again brethren together" was the comment of the Evening Post. Throughout the land "Third Term" and "Cæsarism" were laid aside and forgotten. The Republican forces were united for war.

The Democratic Convention met at

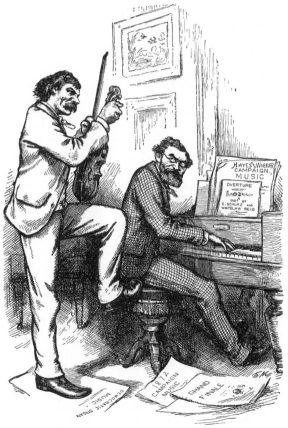

GETTING IN TUNE
(Mr. Reid and Mr. Schurz in the right key this time)

SAMUEL J. TILDEN

St. Louis (June 27) with many hopes of party success. Democracy was more nearly a unit than it had been since the days of Buchanan, and it was heartened by its victories of 1874. With Samuel J. Tilden, the most able political leader of the day, in absolute control of the party's fortunes, there was every reason for anticipating triumph. One of the articles of Democratic faith at this period was that Mr. Tilden could do no wrong. His signature to the notorious fraud circular of 1868 was declared a forgery.* That as a member of the " Barn-burners " wing of the Free-soil party

* The circular referred to was as follows:

Rooms of the Democratic State Committee, October 27, 1868.

MY DEAR SIR: Please at once to communicate with some reliable person, in three or four principal towns and in each city of your county, and request him (expenses duly arranged for at this end) to telegraph to William M. Tweed, Tammany Hall, at the minute of closing the polls, not waiting for the count, such person's estimate of the vote. Let the telegram be as follows: " This town will show a Democratic gain (or loss) over last year of ———." Or this one, if sufficiently certain: " This town will give a Republican (or Democratic) majority of ———." There is, of course, an important object to be attained by a simultaneous transmission at the hour of closing the polls, but not longer waiting. Opportunity can be taken of the usual half-hour lull in telegraphic communication over lines before actual results begin to be declared, and before the Associated Press absorb the telegraph with returns and interfere with individual messages, and give orders to watch carefully the count. Very truly yours, SAMUEL J. TILDEN, *Chairman.*

The object of this circular was to learn approximately at the earliest possible moment just how many votes the Ring would need to " raise " in New York City to overtop the Republican majority " beyond the Harlem."

" Mr. Tilden subsequently denied that he had signed the certificate, but the testimony he and Mr. A. Oakey Hall each gave on that subject, in December of the same year, before a Congressional committee, which sat on the election frauds of that year, in this city (New York) makes it apparent that he was well aware such a circular had been issued."—Hon John D. Townsend, in " New York in Bondage."

in 1848 he had been briefly an abolitionist, and later, during the Rebellion, a Seymour Democrat, were facts either forgotten or remembered, according to the exigencies of the argument for his support. His recent brilliant reform career had deified him with his admirers, while it had well-nigh silenced his enemies.

It is true he was opposed to some extent by " Honest " John Kelly, the head of Reformed Tammany, and an attempt was made to turn the tide to a Western candidate. Any such effort was of small avail.

When the St. Louis Convention assembled Henry Watterson was made temporary chairman, and John A. McClernand of Illinois was elected its Permanent President. The names of Governor Hendricks of Indiana, General Winfield Scott Hancock and others were then put in nomination—the name of Mr. Tilden being presented by Senator Francis Kernan of New York. Tilden led on the first ballot, with 404½ votes, and before a second ballot was declared to be the Convention's unanimous choice. Governor Hendricks, who had received the second largest vote, was now selected to complete the ticket. With the strongest man from each of the two most doubtful States, the Convention would seem to have redeemed the errors of 1872.

The platform, said to have been prepared by Manton Marble, was a most exhaustive treatise on the subject and necessity of Reform. As opposed to the Republican manifest, it declared for " tariff for revenue only," and denounced the existing schedule as " a masterpiece of injustice, inequality and false pretense." It also condemned the resumption clause of the Act of 1875 and demanded its repeal. Blaine referred to the document as being at once " an indictment and a stump speech." The Republican Platform was a sort of Fourth of July flag of patriotism. The Democratic document was a luminous banner of Reform.

But although the two foremost Democratic leaders of the East and West had been united in the St. Louis ticket, it was

THE DEFORMED TIGER SOLVES THE PROBLEM

unfortunate that they were unable to pull precisely in one direction. In fact, they pulled precisely in opposite directions on one very important issue—that of finance. Tilden of the East was for hard money. Hendricks of the West was for greenbacks. The golden calf and the Rag-baby had been yoked together.

Nast, however, did not use this figure. He supplemented his Tiger series with a cartoon of a tiger with two heads, pulling in opposite directions—the tiger of " Tilden and Deform."

The Democratic National Chairman did not have altogether an easy time in managing this two-headed exhibit.

" Talk soft money in the West and harden it as you go eastward " is reported to have been his counsel to Western speakers; while to those who were of the Atlantic States he said, " Talk hard money in the East and soften it as you travel toward the sunset." Nast's cartoons of Governor Hendricks as Mother Tilden, making Father Tilden nurse the Rag-baby, while she attends to the more active duties of the canvass, such as stirring the fire of Reform, were the amusing pictures of the campaign.

The cartoonist and his family, meanwhile, spent many days at the wonderful Philadelphia Exposition, where was displayed for the first time in America many of the rare things—sculpture,

bronze, pottery and antique curios—with which we have since become more familiar. Of these Nast, who was now out of debt and earning an income of twenty-five thousand dollars a year, bought a large and rather lavish selection. The Morristown home became the abode of a luxurious collector able and willing to gratify every taste and whim. His expenditures at the Exposition alone ran far into the thousands, and his purchases included some of the choice gems of that splendid exhibit.

As the campaign drew to an end it became evident that the results were to be very close. The cartoons came thicker and were somewhat more savage. Bellew, no longer on the other side, adopted Nast's Rag-baby to good purpose, while Nast, with the capabilities of fiercer warfare, was slashing about with more vigorous weapons. These political pictures and the Centennial displays well-nigh filled the Harper pictorial pages.

But just here developed one of those wholly unexpected events which make complete the great drama of human existence.

In view of the "Reform" policy of the Democratic Convention, Nast had published in the Weekly, at the time, a picture entitled "Tweed-le-dee and Tilden-dum." In this picture Tweed, in stripes, is demon-

HEN(DRICKS)PECKED

MRS. TILDEN—"Nurse the Baby, while I stir up the Fire."

strating his qualifications for the New York Governorship by his willingness to bring to justice any number of lesser thieves —the " thieves " being symbolized by two street arabs, whom he is dragging to punishment. The picture was of no special moment at the time, but being an excellent delineation of Tweed, who (as the Boss himself one confessed) had grown to look more and more like his caricatures, it was to result in a climax as far as possible from any purpose conceived by the artist.

It had become known that Tweed was somewhere hiding in Spanish territory. As early as September 30 Nast cartooned him as a Tiger, appearing from a cave marked Spain. Now suddenly came a report—a cable—that one " Twid " (Tweed) had been identified and captured at Vigo, Spain, on the charge of " kidnapping two American children."

This seemed a curious statement; for whatever may have been the Boss's sins, he had not been given to child-stealing. Then came further news, and the mystery was explained. Tweed had been identified and arrested at Vigo through the cartoon " Tweed-le-dee and Tilden-dum," drawn by Thomas Nast. The " street gamins "—to the Spanish officer, who did not read English—were two children being forcibly abducted by the big man of the stripes and club. The printing on the dead wall they judged to be the story of his crime. Perhaps they could even spell out the word " REWARD."

Absurd as it all was, the identification was flawless. Tweed, on board the steamer Franklin, came back to America to die,* When his baggage was examined, it was found that he had preserved every cartoon Nast had drawn of him, save the few final ones published after his escape, one of which had placed him again behind prison bars. On October 7 Harper's republished this picture with the story of the Boss's capture.

The pictorial drama was complete.

* In Ludlow Street Jail, April 12, 1878.

POLITICAL "CAPITAL"

THE "people are in a very puzzled and despondent state of mind about the political situation, and have got beyond the point at which they look for the appearance of the ideal statesman uniting the purest motives with the highest ability. They can get the pure motives, and they can get the high ability; but somehow, owing to no matter what circumstances, to get a man who unites both into a leading place in the government is a work of such difficulty that most people have given it up as (for the present at least) a bad job, and are willing to content themselves with any man who, for whatever motive, will do good work. It so happens, too, that the work to be done at this moment is not work which calls either for the highest order of genius or the highest aspirations. A man may do it very well without being a Moses or a Washington—without, in short, being either a prophet or a hero. He has neither to lead a race out of captivity nor call a nation into existence. The task before the American politician of to-day is the simple and somewhat homely one of preventing public officers from stealing and dividing the public money, and of preventing the government from cheating its creditors; and when a man offers himself for this work, there is no general disposition to ask whether he is a statesman of the first rank, or whether his political judgment has always been sure or his voice been always heard on the right side. In fact, they go so far as to say that to make capital in this way is a good thing to do, and they all all politicians to engage in it. They are ready to forbear all curious inquiries into the motives or antecedents of men who will undertake to put an end to cheating and stealing. In fact, the voters of the country are sticking notices up offering the highest offices in their gift, and "no questions asked," to any body who will bring in a few plunderers of the state. Mr. TILDEN has achieved his present success simply owing to his having, before any body of his class, understood the exact nature of the situation. He perceived sooner than his competitors that the time had come to stop preaching, and to begin making arrests and drawing up indictments. He now finds, and his competitors find, that his acuteness has rendered him the highest service, and his enemies actually play into his hands."—*The Nation*, October 7, 1875.

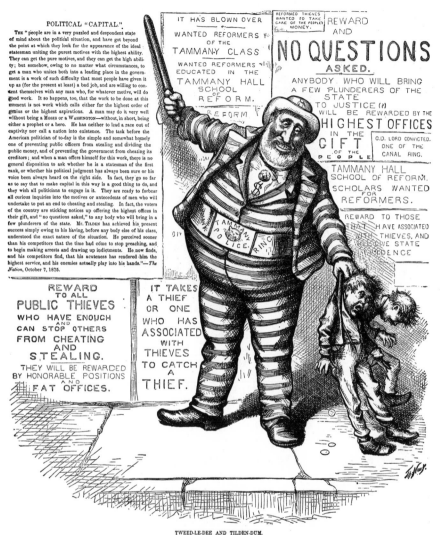

TWEED-LE-DEE AND TILDEN-DUM.

REFORM TWEED. "If all the people want is to have somebody arrested, I'll have you plunderers convicted. You will be allowed to escape; nobody will be hurt; and thou TILDEN will go to the White House, and I to Albany as Governor."

THE CARTOON THAT CAPTURED TWEED *

* Nast never fully credited the account of Tweed's capture until years after, when it was confirmed in a letter from Alvey A. Adee, who had been Secretary of the American Legation at Madrid. Mr. Adee in his letter (January 28, 1892) says:

I remember the incident well—in fact, it was I who found the picture among a lot of Harper's Weeklies on a top shelf in a dark closet in the house of a friend, Don Benigno S. Suarez, No. 3, Calle de la Flora. It made you famous in Madrid.

Very truly yours,

ALVEY A. ADEE.

BETWEEN TWO FIRES

SOLDIERS—"Whose side were you on?"
REFORMED USUFRUCT—"I—I was—busy in court with a *Railroad Case!*"

CHAPTER XXXIX

AN ELECTION AND A CONTEST

There were not many more pictures before election day. The
Northern and the Southern soldier asking in chorus of Tilden
" Whose side were you on? " and Mr. Tilden's reply, " I—I was
busy with a railroad case," was the subject matter for one of the
most effective. The Republican Elephant stepping on the two-
headed tiger was perhaps the best in the matter of drawing.
The so-called " Southern Claims " in the balance against bread;
the preparations to fire again on Fort Sumter; The Democratic
Wolf stripped of its lambskin of Reform; Tilden, as Eve, tempt-
ing Charles Francis Adams with the Democratic nomination for
the Massachusetts governorship—these were among the final
shots. The " Southern Claims " referred to consisted of a mat-

ter of something more than two billion dollars claimed as loss
and damage by war, for which bills of allowance were expected
to be passed in the event of Democratic victory. The feeling over
this possibility became sufficiently strong to induce Mr. Tilden to
write a letter, pledging himself to resist any such bills—a declara-
tion accepted by his Southern constituency with sufficient salt to
make it palatable. It was in reference to these Southern Claims,
in a small drawing entitled " The Solid South," that Nast first
used the dollar mark symbol in the spelling of financial issues.

The " bloody shirt " bannered
to the breeze in these final days.
Even Curtis, who had once pro-
tested against all reference to the
" bayonet," now filled his edi-
torial pages with allusions to this
fierce weapon.

CHANGE POLICY

"Jefferson Davis and the se-
cessionists merely endeavored to
enforce with bayonets the doc-
trines of Mr. Tilden," he says,
and in another place warmly
commends President Grant's order to General Sherman to use
all military force to protect citizens, " without distinction
of race, color or political opinion in the exercise of the right to
vote." Again, of South Carolina, " There is no doubt the Dem-
ocrats in that State mean to carry it for ' Tilden and Reform '
by means of the shot-gun," and he proceeds to denounce the
" Democratic derringer " means of winning elections, using
terms as severe as it was ever possible for Curtis to employ.

This volley was fired in the last issue of the Weekly previous
to the election, while in the same paper Nast's pictures were a
front page of Tilden emptying his " barrel " of money into the
ballot box, and a large double page of Columbia—the fine emble-

THE LION AND **THE LAMB.**
Growling about his Rights. When Duty Calls.

matic figure for which the artist's wife was most frequently the model—making ready to turn the political Wheel of Fortune.*

On the back page appeared the "Lion and the Lamb," an excellent satire on the citizen who is particularly fierce before election day, yet fails to go to the polls on account of bad weather. And thus closed the Centennial presidential campaign.

Yet the struggle was far from ended. Both parties were confident of triumph, and on the day following the election both claimed success. The party of Tilden was jubilant, for the telegraph on election night brought news favorable to their candidate. But early next morning Zachariah Chandler, Chairman of the Republican National Committee, obtained special information, or counsel,† concerning Florida, South Carolina and Louisiana which led him to make the public statement:

"Rutherford B. Hayes has received one hundred and eighty-five electoral votes, and is elected."

The Democrats jeered and reviled this report. They had been

* Once, during a visit to Washington, Mrs. Nast was presented to Chief Justice Drake. "Hail, Columbia!" he said by way of greeting. Judge Drake was of the tall Yankee type, and Mrs. Nast's prompt reply, "Why, how are you, Uncle Sam?" greatly amused the eminent jurist.

† Said to have been supplied by John C. Reid, editor of the New York Times.

too sure of the Solid South to calmly surrender any portion of it, though it was demonstrable that, in addition to the white Republican voters in each State, there were more colored voters (acknowledged Republicans) in the Southern States than of all the white suffragists combined. Both parties now vigorously claimed the victory and threats of violence became numerous.

THE CIRCULAR.

ROOMS OF THE DEMOCRATIC STATE COMMITTEE,
October 27, 1868.

MY DEAR SIR,—Please at once to communicate with some reliable person, in three or four principal towns and in each city of your county, and request him (expenses duly arranged for at this end) to telegraph to WILLIAM M. TWEED, Tammany Hall, at the minute of closing the polls, not waiting for the count, such person's estimate of the vote. Let the telegraph be as follows: "This town will show a Democratic gain [or loss] over last year of—[number];" or this one, if sufficiently certain: "This town will give a Republican [or Democratic] majority of ——." There is of course an important object to be attained by a simultaneous transmission at the hour of closing the polls, but not longer waiting. Opportunity can be taken of the usual half-hour lull in telegraphic communication over lines before actual results begin to be declared, and before the Associated Press absorb the telegraph with returns and interfere with individual messages, and give orders to watch carefully the count. Very truly yours,
(Signed) SAMUEL J. TILDEN, Chairman.

LETTER TO A POLITICIAN.

....Now, Mr. TILDEN, I call on *you* to put a stop to this business. You have but to walk into the Sheriff's, the Mayor's, and the Supervisors' offices in the City Hall Park, and say there must be no more of it—say it so that there shall be no doubt that you *mean* it—and we shall have a tolerably fair election once more. Probably a good part of the Fifty Thousand supplied last Fall with bogus Naturalization Certificates will offer to register and to vote—some of them pretending not to know that they are no more citizens of the United States than the King of Dahomey is—but very few will vote repeatedly unless paid for it; and we shall not be cheated more than Ten Thousand if you simply tell the boss-workmen that there must be no more Illegal Voting instigated and paid for.
Will you do it? Your reputation is at stake. The cowardly craft which

"would not play false,
And yet would wrongly win,"

will not avail. If we Republicans are swindled again as we were swindled last Fall, you, and such as you, will be responsible to God and man for the outrage. Prosecutors, magistrates, municipal authorities, are all in the pool; we have nothing to hope from the ministers of justice, and the villains have no fear of the terrors of the law. I appeal to you, and anxiously await the result. Yours,
NEW YORK, *October* 20, 1869 HORACE GREELEY.

THE PROSPECT IN NEW YORK.
"WHAT ARE YOU GOING TO DO ABOUT IT?"
UNCLE SAMMY'S BAR'L

" The Solid South has gone for Tilden and Hendricks, and by the God of Battles they shall be inaugurated! " was the expression of one fiery editor—a sentiment widely echoed by men whose knowledge of the facts was as nothing in comparison with their desire for results. Henry Watterson, in the Courier Journal, announced that 100,000 unarmed citizens should march to Washington to maintain the rights of Mr. Tilden. Foreign delegations that had lingered after the close of the Centennial were likely to witness something in American politics really worth while.

The situation did not improve. " Conspiracy " and " Fraud " were shouted at Zach. Chandler, and " Despot " was hurled at General Grant, who had quietly strengthened the military forces at the danger points.

A proposition was finally made and accepted that each party should send emissaries to the disputed States to recount the ballots. The President issued orders to General Sherman to preserve peace and good order, and to see that the proper and legal boards of canvassers were unmolested in the performance of their duties.

" Should there be any suspicion of a fraudulent count on either side," the order ran, " it should be reported and denounced at once. No man worthy of the office of President should be willing to hold it, if counted in or placed there by fraud. Either party can afford to be disappointed in the result. The country cannot afford to have the result tainted by suspicion of illegal or false returns."

In each state the " Returning Boards " gave the electoral votes to the Republican candidates, and a very large portion of the Democratic party refused to believe in the fairness of the count. Certain inflammatory journals declared that this fraud would not be permitted, and that an army of Democrats, armed with rifles, and with the war cry of " Tilden or Blood! " would march to Washington to take possession of the Government.

It was just here that the President's military training and quiet temperament came into play. Without demonstration he strengthened the forces about the capital; whereupon the editorial desire for war vanished. Whatever may have been the estimate of his capacity as President, there was no man with common sense who did not respect General Grant's honest desire for peace and order, as well as his peculiar genius for preserving these conditions.

Nast continued to caricature the situation from various points of view. The Ass in the Lion's Skin frightening the foreigners about to leave us, and the Ballot Box being kicked hither and thither, with little regard as to its uprightness, were the most

telling of these pictures. On December 14 he received a suggestion from the Chairman of the Republican National Committee.

A NATIONAL GAME THAT IS PLAYED OUT

My Dear Mr. Nast:
That " Elephant " is safe. Would it not be well to put him on his feet, with one foot on the Democratic Tiger, with Tilden upon one tusk and Hendricks upon the other?

Truly yours,
Z. Chandler.

But Nast did not follow the suggestion. He was opposed on principle to using any idea from the outside. Also this especial picture, under the conditions, may have seemed premature.

Congressional debates were now in order. Propositions and counter propositions, with a good deal of acrimony and noisy demonstration, ended at last in a bill for an Electoral Commission, which passed the Senate by a vote of forty-seven to seventeen, and the House by a vote of one hundred and ninety-one to eighty-six.

This bill provided for the selection of five members from the Senate, five from the House and five from the Supreme Bench. The bill was a Democratic measure, and passed by Democratic majorities—there having been in the two houses one hundred and eighty-six Democratic and fifty-two Republican votes in its favor, while eighty-five Republicans and eighteen Democrats voted against the bill.

In the selection of the commission thus provided for, three Republicans and two Democrats were chosen from the Senate; and three Democrats and two Republicans were selected from the House. From the Supreme Bench, it was ordered that the " Justices assigned to the First, Third, Eighth and Ninth circuits shall select, in such manner as the majority of them shall deem fit, another Associate Justice of said Court." Joseph P. Bradley was the fifth Justice finally chosen, all his associates agreeing.

A remarkable contest ensued between men skilled in the game and craft of politics. In New York City, Abram S. Hewitt, Chairman of the Democratic Committee, was most conspicuous of the Tilden contingent, and his face appears numerously in the caricatures of Nast.

Henry Watterson likewise continued " red hot " in his desire to win in this " Great American Game," and on Feb. 3 Murat Halstead of the Cincinnati Commercial is shown as pouring ice water on the head of the Courier Journal editor, from whose sleeves are dropping the cards still unplayed. The cards were, of course, purely figurative, but somewhat later, when Nast and Watterson met, the latter said:

" What in the world did you put those cards in my sleeve for, Nast? The boys all thought they were real, and I haven't been able to get into a game since."

It may be said here that though Watterson was often and severely caricatured by Nast, and while Nast was frequently and

"ONE TOUCH OF NATURE MAKES."—EVEN HENRY WATTERSON GIVE IN

"Let us have peace. I don't care who is the next President," cries our bold patriarch at the FIRST arrival.

"The Hon. HENRY WATTERSON has just been presented with a son—weight, 11 pounds."—*Washington Correspondence.*

FIRE AND WATER MAKE VAPOR

What a cooling off will be there, my countrymen!

(Personal sketch sent to Col. Watterson after a period of warfare)

firmly castigated by Watterson, the two were always the warm-
est of friends. "Baby Watterson" (March 10), a cartoon on
the advent of a new member in the Watterson household, the
only one of the 100,000 to arrive, was highly appreciated and
duly framed by the Kentucky editor.

The play for the great stake of the Presidency continued
through the entire month of February, and the day of inaugura-
tion was near at hand. The Democratic leaders fought with
startling boldness and amazing tactics. Putting aside the idea
of obtaining an elector from any one of the three disputed
Southern States, they sought out what appeared to be a weak
spot in the North, and attempted to disqualify and displace a
Republican elector from Oregon. The Electoral Commission,
however, regarded with disfavor this somewhat doubtful pro-
ceeding, and on March 2 brought in a verdict for Hayes and
Wheeler. Mr. Tilden had lost the Presidency by one electoral

vote, as claimed by Mr. Chandler. It was the first, and thus far has been the only case of a disputed Presidency in our history.

The effect of the decision upon the Democratic press of the country was extraordinary. On all hands was renewed the cry of " Fraud! " and Hayes was openly charged with being a usurper, profiting by dishonor. The outcry was continued until the Democratic party as a whole, as well as a large percentage of the Republican party, forgot that the Electoral Commission bill had been first re- ported from the Ju- diciary Committee by a Southern Dem- ocrat * in a Demo- cratic House, and had been supported by an overwhelming Democratic major- ity. Whatever may have been the rights in the beginning (and rights are not easily determined where purchase on one side and coer- cion on the other are regarded as legiti- mate methods†), all must concede that

A MODERN DON QUIXOTE
(Mr. Hewitt's predicament after making certain charges against the Post Office in connection with the election complications of 1876)

* Proctor Knott, of Kentucky. The bill is said to have originated with Mr. McCrary, of Iowa.

† Thomas Nelson Page, who may be accepted as authority on matters pertaining to the South, says:

" In some places the question was seriously debated whether it was worse to use force or fraud, the necessity for one or the other being simply assumed. In others, some negroes substantially auctioned off their votes."—" The Disfranchisement of the Negro," Scribner's Magazine, July, 1904.

with the verdict of
the Electoral Com-
mission the Presi-
dency belonged to
R u t h e r f o r d B.
Hayes. Yet there
are men to-day, of
both parties, who
have not read, and
who would not care
to read, a page of
the official reports
of the controversy—
who, with no actual
knowledge of the
facts, sincerely
maintain that Sam-
uel J. Tilden was
lawfully elected
President of the
United States, only
to be denied his "ANOTHER SUCH VICTORY AND I AM UNDONE."—PYRRHUS
seat through Republican legislative and military power.*

Nast closed the contest pictorially with a humorous caricature
of the much battered and bandaged Republican Elephant saying,
with Pyrrhus:

" Another such victory and I am undone."

We may fittingly end this chapter with a letter recently re-
ceived by the writer of these chronicles from a gentleman con-
nected with the National Republican Committee of 1876. Nast
himself never referred to the incident which this letter recalls.

* Mr. Tilden received a majority of the popular Presidential vote. In this sense
he was the "people's choice." Any other claim of his legal election is based upon
nothing more tangible than violent and prolonged assertion.

Perhaps it had passed from his memory. Perhaps he did not consider it worth recording:

Roseburg, Ore., July 6, 1904.

Dear Sir:

At the close of the Hayes-Tilden campaign I was sent to Morristown by the Republican National Committee with a check for $10,000 drawn in favor of Thomas Nast as a recognition of the great services he rendered the committee in that famous campaign, and he declined to receive it.

He said, " You may tell the committee that I am very grateful for the recognition, but as I have been paid by Harper Brothers I cannot accept it."

After spending a pleasant hour with Mr. Nast, I returned to Washington and reported to the committee. To say that Senator Chandler was surprised and disappointed is putting it but mildly. Mr. Hayes smiled and said, " He (Nast) was the most powerful single-handed aid we had."

Very respectfully,

R. W. Mitchell.

PART FIVE : THE STATESMAN

CHAPTER XL

A DISTINGUISHED GUEST, AND A GREAT LOSS

In the midst of the Tilden-Hayes controversy had come Grant's last Annual Message—a dignified, though rather sad, document of farewell. In it he referred to the mistakes he had made in political appointments. In part, he said:

History shows that no administration, from the time of Washington to the present, has been free from these mistakes; but I leave comparisons to History, claiming only that I have acted in every instance from a conscientious desire to do what was right, constitutional, within the law, and for the very best interests of the people. Failures have been errors of judgment, not of intent. . . . It is not probable that public affairs will ever again receive attention from me, further than as a citizen of the republic, always taking a deep interest in the honor, integrity and prosperity of the whole land.

Nast portrayed Columbia as sorrowfully contemplating the patriot's parting words. Later he presented Grant as " Ulysses " leaving official honors all behind—a dignified conception of the hero he had loved so long and defended so well. Only once had the artist criticised the soldier, and the soldier had long honored the artist with his friendship and his confidence.

The bond between them now ripened into intimacy. On May 3, just prior to the celebrated " Trip Around the World," the ex-

President, with Mrs. Grant and young Ulysses, made a family visit to the home at Morristown.

The Nasts gave a quiet dinner in honor of their guests. Josiah Fiske and General Corbin were there, and two of the Harper firm. Of course an effort was made to have the affair as perfect as possible. The table was artistically arranged and decorated, the courses had been carefully chosen and came in due sequence, the coffee appeared at last to complete the successful round of refreshment.

Then all at once the host was seized with a mortal agony of spirit. Not being a smoker himself, he had forgotten the cigars! With the most celebrated smoker in the nation at his table— the man whom he had depicted as puffing serenely when assailed by his enemies—with this great visitor at his board, he had forgotten the cigars! Pale, and with beads of perspiration on his brow, he glanced appealingly at the guest of honor, who smiled reassuringly.

"It's all right, Nast," he said. "I remembered that you don't smoke. Besides, I never go into action without ammunition," and he drew forth a handful of his favorite Havanas.

During the table talk that day the ex-President said: "I am tired of abuse, and of being a servant of the people. I am going to feel once more how it seems to be a sovereign, as every American citizen is."

General Grant was seized with a chill while still seated at the table, which made the visit end rather unhappily—all the more so as he was obliged to take the train that evening and the station platform was crowded with those who were anxious to do him honor. He rallied as best he could and his visit proved a notable event in the little city, long remembered by those who had an opportunity to see, and perhaps to shake the hand of, the foremost "American citizen." Two weeks later he had begun his long triumphal journey around the world.

The month of May was to end sadly enough. On the 29th, Fletcher Harper, who had been out of the office for several weeks, suddenly died. The stalwart, far-seeing man, who for fifteen years had been Nast's truest inspiration and firmest support, was no longer to be a part in the policy and guidance of the journal to which the artist had given his best years and thought, and whose success was so identified with his own. No more serious blow than the death of Fletcher Harper could have befallen Thomas. Nast. Friend, counsellor and champion he had been, with that unwavering faith which inspires courage and promotes immortal deeds. His successor, J. W. Harper, Jr. ('' Joe Brooklyn '') was no less a friend to Nast, but he was without the rugged fearlessness and initiative of his uncle. He was more likely to be swayed by the pacific policies and culture of Curtis, and to accord with the idea that the pictorial pages should reiterate the editorial columns. Disagreements were certain to arise, and without the intermediation of Fletcher Harper trouble was bound to ensue.

There was to be no delay in the beginning. Nast's satisfaction in the election of Hayes had been shortlived. The President's Southern policy, as declared in his Inaugural Address—that of pacifying the South by removing all military protection from the colored voter—he firmly opposed. When it further became known that Hayes was to recognize the Democratic candidate, Nicholls, as Governor of Louisiana, whereas the election of Packard, the Republican candidate, rested on a basis similar to that of the President, the cartoonist declined to introduce Hayes otherwise than unfavorably into the pictures.* Curtis, on the other hand, was enthusiastic over the pacification idea, which appealed to his own spirit of gentleness and avoidance of stringent measures. A break seemed imminent. Yet Nast remained good-natured, biding his time.

* It has been repeatedly asserted, though without proof, that Hayes was party to a " bargain " agreeing to seat Nicholls and remove the troops as the price of his Presidential seat.

He contented himself for the moment with social and international pictures, some of them being done in the old manner—drawn with wash instead of pencil. The Army and Navy cause he still espoused. Also he noted a final incident of A. Oakey Hall's metropolitan career, in a small picture bearing the very English legend, " H'all That's Left "—the cartoon being of Hall's glasses only—their owner having taken leave for England soon after Tweed's published statement that he was ready to bear witness against his old associates. Hall's arrival in England under the name of Sutliffe was reported March 31 from London, where, like Tweed, he had been speedily recognized by those familiar with the Ring cartoons. He was not disturbed, however, and lived

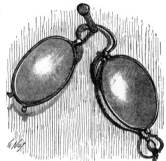

H'ALL THAT'S LEFT

in considerable respectability for a number of years. But the " Finger of Scorn " did not fail to follow him. Professor James Bryce published his book, " The American Commonwealth," which contained a chapter contributed by Professor Goodnow, of Columbia College, relating the Tammany scandals and Hall's connection therewith. Upon the appearance of the book, Hall sued Professor Bryce for libel, with damages laid at ten thousand pounds. Professor Bryce regarded the action as a blackmailing scheme and promptly prepared for trial, with depositions taken in New York and with files of Harper's Weekly supplied by Nast, whose cartoons had resulted in no libel suits on this side of the water.* Hall failed to press the suit, and in 1897 Professor Bryce had it dismissed " for want of prosecution," by which time Hall (1891) had returned to America. Nast promptly caricatured him again, whereupon

* It has been stated that Professor Bryce withdrew the edition of his book containing the Tweed chapter. This is not true. The edition was sold out. In a second edition while the suit was in court the chapter was omitted, and subsequently restored in its present form, written by Professor Bryce himself.

23

Hall, with the old spirit of bravado, sent him a late photograph, marked " Exhibit 32, for Identification," and with it a brief note:

Mr. Hall's compliments to Mr. Nast. Since the latter has again deemed it necessary to bring the former into pictorial prominence, he begs to enclose the last photograph, showing a change of appearance rendered necessary by a pending event.

What the " pending event " was cannot now be known. Nast replied that a change in appearance made no difference whatever, but that a " change in principles would." The letter and photograph were put in evidence by Professor Bryce to show that Hall's tendency was to court rather than to shun the notoriety incident to caricature. All this, of course, was long after the echoes of the Ring's downfall had died away, and we have gone far ahead of our narrative in following out " Elegant Oakey's " career. He died in New York City, October 7, 1898.

As the weeks went by and Nast made no pictorial comment on the presidential policy, despite the fact that the inside pages of the Weekly were filled with complimentary editorials from the pen of Curtis, the public began to wonder and to make surmises. The daily papers commented on the matter, at first lightly, then in serious editorials—favorable or otherwise to Nast, according to their lights and affiliations. Letters came both to the cartoonist and to the publishers, asking why the former contented himself with matters apart from those uppermost in the public mind, and apparently of foremost importance to Mr. Curtis.

" Give us a picture from Nast. Let us hear what Nast has to say on the subject," was the general demand from those who did not find complete satisfaction in the President's course.

" I'm ready to give them something when you say the word! " the artist said rather shortly to Mr. Harper, who had handed him one of these letters.

" But you want to attack the President, Nast. We want to give him a chance. We believe he means well."

" He means well but he doesn't do well," retorted Nast.

" But that's just your opinion. The general disposition seems to be to stand back and give the President's policy a chance."

" Will you let me put that in the form of a cartoon? "

" Yes, if you keep Hayes out of it."

So Nast caricatured himself as being in the " Blue " room of the White House, held down in the policy chair by Uncle Sam, who says, " Our artist must keep cool, and sit down, and see how it works." Above on the walls was the sign, " Watch and Pray. . . . Stand back and give the President's policy a chance," and this was signed " Gen. Disposition." The picture conveyed precisely the conditions in Franklin Square, and was widely commented upon.

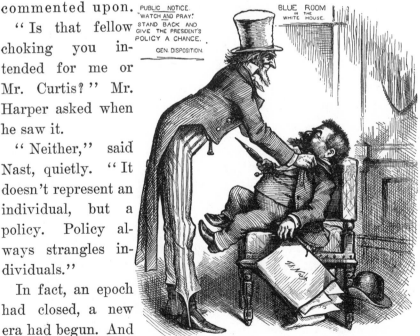

" Is that fellow choking you intended for me or Mr. Curtis? " Mr. Harper asked when he saw it.

" Neither," said Nast, quietly. " It doesn't represent an individual, but a policy. Policy always strangles individuals."

In fact, an epoch had closed, a new era had begun. And this was equally true in newspaper

" NAY, PATIENCE, OR WE BREAK THE SINEWS."—*Shakespeare*

U. S.—" Our artist must keep cool, and sit down, and see how it works."

and in national affairs. Issues were perhaps no less vital,
but they were less violent. Political differences were be-
coming academic rather than polemic. Parliamentary matters
were to be shaped in the committee rooms rather than in
the halls of eloquence and logic. In journalism the indi-
vidual would be merged more and more into the policy, and
policies would become less and less clearly defined. The man
was to be replaced by the machine, and the machine is not
a thing of inspired purpose or sublime convictions. The death
of Horace Greeley, of the elder Bennett and of Fletcher Harper
marked the decline of the old order and the beginning of the
new. Such men would not be replaced, for they were the result
of conditions that had passed, or were swiftly passing away.
The great mass of the American people, busy with their trades,
their farms and their ventures in commerce, were beginning
not to care. With the passing of the great military President
and the advent of Hayes, the change seems now to have been
clearly marked. Only during the heat of presidential campaign
would there be again a semblance of the old fierce strife. Even
then the bloody shirt would flap rather than wave, and oftener
in deference to some defunct and buried issue it would be draped
at half-mast.

To Nast the change which had already begun meant more
than to any other living man. More than any other he was a
knight in armor whose skill lay in dealing swift and heavy
blows, whose purpose was to avenge wrong. When the crusade
is over the paladin does not lightly put aside his battle-axe
and buckler to become a harlequin and entertain at the public
behest. Already there were plenty of such pictorial acrobats—
men with swift clever pencils, adapted to the new idea, willing
to draw what they were paid for and to use motives supplied
from any authoritative source. Puck had been started, and
Keppler, a man of great ability, and with few convictions beyond

those of line and color, had leaped into immediate public favor. The people who had ceased to care as in the old days were pleased with the skilful caricature, and laughed at the clever hits so unlike the penetrating thrusts and huge destructive blows of Nast. The day of his destiny was by no means over. He was to add other triumphs to his record of victories won. But the noon-tide of his glory had slipped by—the sun was already dropping down the west.

THE FIRST ISSUE OF PUCK. A CARICATURE BY KEPPLER OF
THE LEADERS IN JOURNALISM

(Whitelaw Reid, Ben. Wood, George Jones, Bennett Jr., Charles A. Dana, Wm. Cullen Bryant, Frank Leslie and others are in the group. In the lower right-hand corner, Nast appears, with Harper's Weekly "under his wing")

CHAPTER XLI

A DEFEAT AND A TRIUMPH

The caricature of himself was Nast's only reference to the
" surrender policy " of the Administration, and during the early
summer he continued to occupy his time with social and army
cartoons, and with pictorial observations on the Turko-Russian
War, then in progress. He did step aside to pay a negative com-
pliment to the Civil Service efforts of Hayes, by depicting the
service as it was under Andrew Jackson, whose administration
had established the precedent that " To the victor belongs the
spoils." * Hayes was making a sincere effort to further the
needed reform which Grant had favored, and Nast did not
hesitate to lend aid to the idea.

Perhaps Nast's friends decided that he needed recreation, for
we find evidence of a plan arranged by Henry Watterson, Murat
Halstead, and Samuel Bowles of the Springfield Republican, a
trio known as the " president makers," to take the artist to
Kentucky, thence to Nashville, where Watterson was to deliver
a Decoration Day address. Watterson wrote to Bowles, urging
the arrangement.

Why can't you and Tom Nast leave New York the
evening of the 28th, arrive here next night, spend the 30th

* A sentiment proclaimed in the Senate by William L. Marcy in 1832. In two
years President Jackson had made ten times as many removals as all his predeces-
sors had made in forty years.

here, go with me that night to Nashville, return the next night and then spend two or three days in the Blue Grass? Halstead will join you at Cincinnati, and we will make a week of it. I mean to make the most earnest, ungrudgingly national speech I am able to prepare, and, as it is the first instance of the kind since the war, I hope to do some good to both sides.

Nast, when consulted, declared that he could not make such a trip until later, which brought a protest from Bowles.

Wicked Boy! Behold!
I cannot wait till it gets summer hot. Cannot you arrange to meet us? Tell the great "Joseph" that it is necessary for your education in the new politics. We will pick up Halstead and we will not read the editorials, either of Harper's or the Springfield Republican all the while we are gone.

Let me have a word at the Brevoort House, where I may be on Tuesday. Yours very truly, Sam'l Bowles.

The "President makers" had their reunion in the land of Blue Grass, but this time Nast did not make one of the happy party. It may be that work was pressing just then, or the artist may have had reason to think that a little later there would be more time for recreative pleasures. In June he presented a pretty picture of Kate Claxton, whose

PEACE RUMORS
Let Us Have (A) Peace (Piece)
(*The Turk wishes he was a Christian*)

dramatic career in the " Two Orphans " had been marked by a number of disastrous fires. The press had made merry over the sorrowful circumstance, inventing jokes, incidents and interviews, much to Miss Claxton's annoyance and grief. The picture represented the mischievous reporters as a cloud of little donkeys armed with pens and torches, following the actress and disporting themselves at her expense. In heartfelt acknowledgment Miss Claxton wrote:

Thos. Nast—Dear Sir:

One evening, almost two weeks ago now, when feeling weary and depressed, Harper's Weekly containing your cartoon was handed me. One must have had an experience as sad as mine, and felt as keenly the stings of a thoughtless, and what has seemed to me a heartless, word-quibbling over it, to know how deeply and truly I appreciate your work. I take

OUR PRESENT ARMY—CAN IT BE CUT DOWN ?

this, the very first opportunity I have had since my return from the West, to thank you for your great and unexpected kindness to me. You have done me, with a touch of your wonderful pencil, a service no words I am clever enough to think of can describe. Accept, sir, the assurance of my lasting gratitude. I thank you. I thank you! Kate Claxton.

The picture was commented upon and approved by the better class of journals throughout the country, and the amusement at the expense of Miss Claxton ceased.

There was to be little more of Nast's work that summer. The standing army as the shadow of a skeleton was a final stroke in that worthy cause, and a double page, showing Grant being lionized and crowned by Britannia, recorded an episode in the march of the absent soldier. Following this, we find Tilden and Hendricks, who had been presidential possibilities

since 1864, embalmed as mummies to be kept " until 1880, or longer." In view of the " cipher disclosures " which were to occur more than a year later, there would seem to be some curious prescience in this picture with its occupants swathed in wrappings and cartonnage, and covered with cabalistic signs. It was that element of unconscious presage which is to be found again and again in the work of Nast, and was to continue with him to the last tragic touch that foretold the final scene. In the issue of July 14th, Britannia is shown as wiping the eyes of the Egyptian Sphinx, assuring it of protection. Then for nearly four months not a line of Nast's appears.

The Weekly made no explanation of this silence and everybody was curious. The Harpers and Nast were alternately interviewed by reporters from the Sun, World and other journals, but little satisfaction was obtained. All sorts of rumors were started. It was claimed that Nast used a coating for his engraving blocks that had poisoned his hand. Journals whose hope inspired the prophecy, declared that he would never

THE CHIVALROUS PRESS. ONE MIGHT ESCAPE FIRE, BUT—
(Miss Claxton and the Reporters)

draw again. Others recalled the "Gen. Disposition" caricature and announced with an air of authority that there had been trouble in Franklin Square over the President's Southern policy, and that Nast had left Harper's for good. The fact that the Weekly now published several pictures complimentary to Hayes was accepted as proof of this conclusion, though the cartoons themselves were compared rather unfavorably with the more strenuous work of Nast. The following sequence from the Inter Ocean will serve as a brief summary of many artistic conclusions.

Oh, give us back Nast! We prefer malignant cartoons to idiotic ones. Boston Post.

Amen! Springfield Republican.

And so say a thousand papers. The original article is wanted, not an imitation. Rochester Democrat.

To this the Inter Ocean adds:

But Nast never agreed with the editorial page. Must we not "consist" in these perilous times?

As a matter of fact, the cause of the rupture between the artist and his publishers had nothing whatever to do with the political situation. Indeed, the incident had less of public importance than interest, and perhaps in itself seemed too personal and too trivial to be given to the press.

A brief poem written by James Russell Lowell in 1876 had been the start of the whole matter. Lowell was now Min-

A CARICATURE PAINTING OF NAPOLEON
SARONY
(Sarony and Nast were friends for many years)

THE UNPUBLISHED CARTOON OF MINISTER LOWELL (From a proof)

ister to Spain, and to Nast it seemed that his poetic strictures on
his own country * might, with propriety, be repeated to certain

* THE WORLD'S FAIR, 1876.

Columbia, puzzled what she should display
Of true home make on her Centennial Day,
Asked Brother Jonathan; he scratched his head
Whittled awhile reflectively and said,
"Your own invention and own making, too?
Why any child could tell ye what to do—
Show 'em your Civil Service and explain
How all men's loss is everybody's gain;
Show your new patent to increase your rents
By paying quarters for collecting cents;
Show your short cut to cure financial ills
By making paper dollars current bills;
Show your new bleaching process, cheap and brief,
To wit, a jury chosen by the thief;
Show your State Legislature; show your Rings,
And challenge Europe to produce such things
As high officials sitting half in sight
To share the plunder and to fix things right.
If that don't fetch her, why you only need
To show your latest style in martyrs—TWEED
She'll find it hard to hide her spiteful tears
At such advance in one poor hundred years.
From the "Nation." —J. R. L.

European nations. The poet-minister was depicted as reading his lines to drowsy listeners, themselves laden with bigotry and debt. The poem seems a commonplace production, and the picture is of no special merit. Certainly, from an international standpoint it seems inoffensive enough, compared with many of those which had preceded it, and was hardly a deadly thrust at Lowell, who was quite able to laugh at a satire much more severe. If Mr. Curtis had objected to the feature as not being worth the space, we could think him justified, but the fact that the block was engraved, the page numbered and the paper ready for the press would preclude this assumption. It must have been, therefore, his old scruples against admitting a man of parts, like Lowell, into any cartoon. At all events, he besought Mr. Harper to leave out both poem and picture, and in spite of the fact that Secretary Evarts, who was asked to testify, could see no harm in the feature, it did not appear in the issue for July 14th, for which

JAMES PARTON

it had been intended, nor ever after. This was a triumph for Curtis, and we may assume that it was the principle involved rather than the loss of the picture itself that resulted in Nast's voluntary retirement from the paper.

Among those who sought information on the subject was James Parton, in a letter addressed to Mrs. Nast:

Newburyport, Mass., Sept. 19, 1877.
My Dear Sally:
In common with the people of the United States generally, I miss a certain hand from Harper's Weekly. Please write me one line to let me know if anything serious is the matter. At first I hoped he had been wise enough to take a holiday, and read with pleasure of your being at Long Branch. But many weeks have now passed and I can yet see no trace of him. Meanwhile iniquity abounds, the incom-

THOMAS NAST, 1877

petent masters who drive the men to strike by their insolence and inhumanity still live. The Avenger stirs not. What is the matter with our Achilles of the pencil?

Perhaps you are in Europe!

Sally, we have the nicest, plumpest, merriest baby ever seen out of Morristown. She is gifted beyond her months. She is seven months, but she knows how to bump heads, play bo-peep, laugh out loud and put everything into her mouth. Her eyes are the brightest blue, and her hair is of the color of tow. She is a perpetual delight and weighs eighteen pounds.

Send me one word if you are in this hemisphere, and give my love to the Avenger and the children. Your affectionate cousin,

James Parton.

To this Mrs. Nast replied quite fully, enclosing a proof of the rejected cartoon.

At the risk of dwelling too long on what would seem no great matter, but which, after all, was the beginning of those trying conditions which ten years later were to end in the close of a great career—the historic combination of a man and a paper—we may consider in full Parton's second letter:

Newburyport, Mass.,
Sept. 25, 1877.
My dear Sally and Tommy:
I have read your letter with

MRS. NAST, 1877

great interest, and inspected closely the picture, wondering where the treason lies in the latter. If that picture is to be rejected for any reason, it is plain that Thomas Nast and the rejector thereof cannot work in concert. You could never be sure of having anything accepted, and that feeling of doubt would paralyze your arm in another than the physical sense.

On the other hand there cannot be two captains to one ship, nor two editors to one paper. If Mr. Curtis is to be the editor, he must possess all the power of an editor, and in that case you could never work under him. I hold him in very high esteem, and always have, but between him and you there could never be any harmony, no more than there could between a nightingale and a falcon.

My impression is that he mistakes his ground. He probably will never be the editor. Keep quiet and enjoy existence. Rest, spirit, rest. Do nothing with great assiduity, and all will be well. The country needs and desires you both. Amuse yourself by writing long letters to me.

<div style="text-align:right">Affectionately yours,
James Parton.</div>

Parton's advice was taken, at least in one particular. Nast did nothing but enjoy himself, or give enjoyment to his family. He was a rich man now, with horses and vehicles of many kinds. The children had ponies to ride, and there was always spending money in a drawer, into which fifty dollars weekly was put for no other purpose. The big house and grounds of the Morristown home were usually filled with a crowd of merry boys and girls, and the artist was a boy among them, often on his own saddle-horse accompanying them through the Jersey Hills.

At other times he made little trips and paid brief visits here and there, a privilege he had been obliged to forego during busier days. The preserved correspondence shows that one such journey was made to Philadelphia, to visit George W. Childs— always one of Nast's most loyal admirers—and that many other valued friendships were renewed or kept warm during this period of rest. Certainly he need not be in haste to resume his labors, and could afford to wait for happier conditions.

Meantime, letters continued to come, some of them with offers

of positions—two of these being from the Daily Graphic and Leslie's Weekly; many with offers of elaborate entertainment—buffalo hunts, camping trips, junketing tours and the like—while from Major Pond came frequent and urgent invitations to go out once more and harvest in the field of the public lecture.

In one letter Pond offers a guarantee of twenty thousand dollars for the season. In another he promises a thousand dollars a week and all expenses paid, this arrangement to continue for one week, or as many as the artist will agree upon.

" Why can't you send us just one word? " he wrote, in a final appeal. Just the word " yes " will do. Our Lyceums all want you. The cry is " Nast! Nast! " and we can give them no Nast. Can't you put in about ten weeks and take ten thousand dollars for it? I have tried to get to see you, but have been called home both times. Hoping you are well and in good spirits, with kind regards, Yours truly, J. B. Pond.

Mark Twain, who was planning a personally conducted tour of his own, made what would seem to have been a still more alluring proposition.

My dear Nast:
I did not think I should ever stand on a platform again until the time was come for me to say " I die innocent." But the same old offers keep arriving. I have declined them all, just as usual, though sorely tempted, as usual.

Now, I do not decline because I mind talking to an audience, but because (1) travelling alone is so heart-breakingly dreary,

G. W. C.: "No, thank you, I must keep my *Ledger*."

(Personal drawing sent to George W. Childs. Mr. Childs declining political honors)

and (2) shouldering the whole show is such a cheer-killing responsibility.

Therefore, I now propose to you what you proposed to me in November, 1867, ten years ago (when I was unknown), viz., that you stand on the platform and make pictures, and I stand by you and blackguard the audience. I should enormously enjoy meandering around (to big towns—don't want to go to the little ones)—with you for company.

My idea is not to fatten the lecture agents and lyceums on the spoils, but put all the ducats religiously into two equal piles, and say to the artist and lecturer, '' Absorb these.''

For instance—(here follows a plan and a possible list of cities to be visited). The letter continues:

Call the gross receipts $100,000 for four months and a half, and the profit from $60,000 to $75,000 (I try to make the figures large enough, and leave it to the public to reduce them).

I did not put in Philadelphia because P—— owns that town, and last winter when I made a little reading-trip he only paid me $300 and pretended his concert (I read fifteen minutes in the midst of a concert) cost him a vast sum, and so he couldn't afford any more. I could get up a better concert with a barrel of cats.

I have imagined two or three pictures and concocted the accompanying remarks to see how the thing would go. I was charmed.

Well, you think it over, Nast, and drop me a line. We should have some fun. Yours truly,
 Samuel L. Clemens.

Certainly this would seem to have been a fascinating plan. But Nast had no inclination for the lecture field at this period, at least he did not wish to close an engagement to travel, unless the Harper problem remained too long unsolved.

The solution came soon after the Republican State Convention at Rochester, where a specific endorsement of President Hayes was urged by George William Curtis and opposed by Roscoe Conkling. Conkling had not forgotten that Curtis had fought him in the National Convention of the year before, and had been biding his time for punishment. He went into the fight with all the energy of purpose and bitterness of spirit of which he was capable, his head high in air, his nostrils dilating,

his chest thrown out in splendid and proud defiance of his adversary. Yet he might not have descended to personalities if Curtis in his opening address had not referred—looking directly at Conkling—to those " blinded by the flattery of parasites, or their own ambition."

When Curtis closed and Conkling rose to reply, the Convention forgot the issue of the moment in listening to one of the most deadly personal attacks in the history of American politics. No man was better suited to such an undertaking than Roscoe Conkling. His powerful frame seemed to thrill with delight in the thought that the time had come to repair ancient injuries and redress recent wrongs. He spoke to Curtis, he pointed at him, he held him up to ridicule as a " man-milliner," a " dilettante," a " carpet-knight of politics." When he referred to Mr. Curtis's " unique and delicate vote," he leaned forward and shouted out his sentence with a look and a gesture that carried it straight to its mark. He would even bend to one side where he could get a full view of Curtis and hurl his words at him with the help of his index finger as straight as a boy would fling a stone.

But the sublime touch was still to come. He referred presently to Harper's Weekly, " —that journal," he said, " made famous—"

He paused and looked straight at Curtis, that his words might sink deeply, and then, with great and fierce deliberation added, " by the pencil—of Thomas Nast! "

" His (Conkling's) friends were in ecstacy," says the New York Tribune, " and even some of Mr. Curtis's friends could not refrain from enjoying the skilfulness of the thrust."

The amendment which had been offered by Curtis was lost, and the Convention closed with triumph for Conkling; also, incidentally, for Nast. Even if the publishers did not altogether approve of Senator Conkling's statement, its effect on the public mind was not to be gainsaid. In a few days Nast was at work

24

again, following his own ideas, and the " Millennium," a comment on the President's policy, which had tended to solidify the South without pacifying it in any noticeable degree, showed the Lamb and the Tiger lying down together. The Lamb does not appear, but around the neck of the Tiger is a conspicuous sign which says, " For Republican Lamb Inquire Within." It was a cartoon which would have made an unknown man famous. There was a general round of applause from the press; and Nast's return to work was greeted with a universal hurrah and many letters from his admirers. The National Republican took occasion to recall his past achievements.

We had fears that Harper's Weekly had degenerated into a mere picture paper, it said, an every Saturday ladies' magazine. . . . Harper's has been a great power in the past. No man ever so nearly made himself a third estate in this country as Thomas Nast. Every line he drew during the dark days of war was a line of battle. He was the Grant of the easel. His cartoons aroused lagging zeal into fresh enthusiasm. The secret of his vast influence was his thorough honesty and his earnest purpose. No man except Lincoln ever swayed such political power. There is a fly on the chariot wheel. It is called Curtis. We feared that the fly had become the charioteer. We are glad to see that we were mistaken. Nast is at work again. Shoo! Fly!

It was triumph for Nast, though none realized more clearly than himself that, with Fletcher Harper dead, it could not be enduring. An idea for a paper of his own—a journal which would be absolutely free of clique and independent of clan— began to take form, and as the years passed and the situation grew always more difficult, this was to become the one great ambition of his life. It was for this, and for this only, that as years passed he strove to add to his means through business investments of which his knowledge was as nothing, and which proved always unprofitable in the end.

As yet, however, he was in the height of his prosperity and in the heyday of his fame. He closed the year 1877 with a

number of fine cartoons, of which the Republican Elephant trying to cross the broken " Ohio Bridge " (the President's own State having been carried by the Democrats in October), and the same Elephant suspended over a precipice, hanging by the tip of his trunk to a scrubby bush, unsafely rooted in Republican successes barely gained, appear to have been the most effective. In

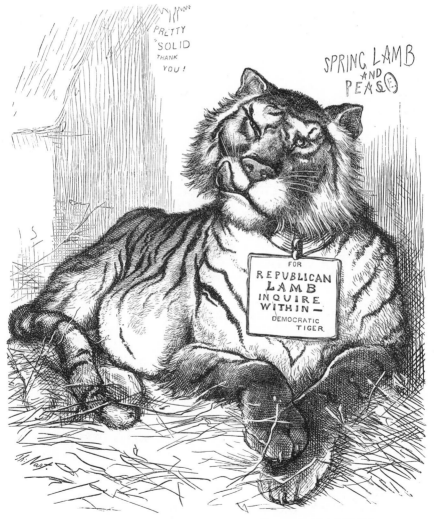

THE MILLENNIUM. THE TIGER AND THE LAMB LIE TOGETHER

"Thanksgiving on the Other Side," the powers are getting ready for the Turkey which the Russian cook is still pursuing, while in "Exhumed" Nast fired the final shot of the year in the cause of the Army and Navy, "who bled and died for something, but it is of no consequence now."

If Harper Brothers needed any additional proof of the honor and affection with which Nast was regarded by a very important element of the nation at this time, it came now at the end of December, in the form of a letter and enclosure from Col. Guy V. Henry, one of the "bravest of the brave," then at Fort Sanders, trying to get well of injuries received in the campaign against Crazy Horse, under General Crook. The letter ran:

TESTIMONIAL TO THOMAS NAST.

To the Editor of the Army and Navy Journal:

SIR:—The Army feel that Mr. THOMAS NAST, of *Harper's Weekly*, has, by his vivid caricatures, in said paper, exhibited to the country how the Army has been and is being treated, and by such action on his part he is entitled to the gratitude of both officers and soldiers. It is proposed to express our thankfulness and appreciation of his skillful efforts in our behalf, by opening a subscription list, open to all the Army and Navy, and limited to twenty-five cents for each individual. The money so subscribed to be sent to Col. CHURCH, of the *Army and Navy Journal*, who is requested to act as treasurer of same. When the amount is sufficient a suitable testimonial will be purchased and presented to Mr. THOMAS NAST, of *Harper's Weekly*.

"CAVALRY."

We heartily sympathize with the purpose of this subscription, and shall be glad to forward it in any way we can. Mr. NAST has done yeoman's service for the Army by his caricatures in *Harper's Weekly*, showing in a popular way the injustice and the criminal folly of those who have sought to destroy our military establishment by depriving it of the pecuniary support to which it is entitled by law as well as in justice. We will take charge of the subscriptions sent to us with pleasure, and would suggest that a consolidation of amounts contributed at different posts would greatly hasten and simplify the collection of the amount required to provide a suitable testimonial.—*Ed. Army and Navy Journal.*

In order the above may be a success creditable to the Army, will you please forward the subscriptions of your officers and men as soon as possible?

FT. SANDERS, W. T., Dec. 1877.

These circulars have been sent to every post in the army. Guy V. Henry

THE CIRCULAR SENT TO THE ARMY AND NAVY BY COL. HENRY

Ft. Sanders, W. T., Dec. 28, 1877.

Editor Harper's Weekly, New York City.

Sir: I enclose a circular which was started at this post by myself and assisted by the officers of the same. The Army as a mass feels most gratefully toward Mr. Nast for his efforts

Thanksgiving on the other side—No. 1

Thanksgiving on the other side—No. 2

THE POWERS WAITING TO DIVIDE THE TURKEY WHICH RUSSIA IS STILL PURSUING

in our behalf, and a failure of this scheme can only arise from thoughtless inattention to the matter.

<div align="center">

Yours respectfully,

Guy V. Henry, Bvt-Col. U. S. A.*

</div>

The circular enclosed was entitled "A Testimonial to Thomas Nast," and was a notice to the Army and Navy that a subscription list had been opened for the purpose of raising money to purchase a "suitable testimonial," which should express the gratitude of soldiers and sailors toward the man who had been battling so long for their welfare. The amount of each subscription was limited to twenty-five cents, so that none might feel that he could not afford to share in the undertaking. "These circulars," said Colonel Henry, in a note of comment, "have been sent to every post in the army."

SAVED (?)

* Scribner's Magazine for October, 1903, contains a graphic sketch by Cyrus Townsend Brady of this fearless and splendid soldier, whose almost incredible deeds of warfare gave him the name of "Fighting Guy." He died in Porto Rico, literally in the harness. Brady in his article says:

"He was the knightliest soldier I have ever met, and I have met many. He was one of the humblest Christians I have ever known, and I have known not a few. . . . So, his memory enshrined in the hearts that loved him, his heroic deeds the inspiration of his fellow-soldiers, passed to his brighter home, Guy V. Henry —a Captain of the Strong!"

CHAPTER XLII

THE FIRST BATTLE FOR GOLD

WAKING UP—1878.
J. Bull. "Who said I was to be taken by the Horns?"

With the beginning of 1878 the Turko-Russian War was still in progress, and in January we find John Bull suddenly waking up and asking, " Who is eating up My Turkey? " This was followed by a grewsome double skull, labelled " The Temple of Janus," and entitled the " Jaws of Death," into which the opposing armies are steadily marching.

Criticism of the President's Southern policy was allowed to continue in the pictorial pages of the Weekly, and even the editorial columns began to waver in their allegiance to the Hayes idea.

" Unfortunately," says Curtis (Jan. 12), " the course of the administration has been hesitating, and the consequence is that the party opposition is organized, bold, defiant, while the tone of the hostile Republican leaders is contemptuous."

The fact that the fall elections of 1877 had been danger signals, doubtless had something to do with Mr. Curtis's gradual leaning toward the attitude which Nast had assumed in the beginning.

But whatever may have been their differences and debates concerning the President's pacification policy, editor and artist were as one in their financial views. The restoration of silver coinage had become the most important public issue, and both Curtis and Nast, in common with President Hayes, were uncompromisingly for gold.

There had been no stir when the silver dollar had vanished. Indeed, nobody seemed to know that it was officially gone until with a sudden influx of the metal, as a result of the discovery of new and almost fabulous lodes, the nation awoke to the fact that there was no longer any provision for its coinage. Nobody seems to have noticed a piece of legislation that in February, 1873, had made the silver dollar no longer a legal issue, with a debt-paying power like that of gold. The scarcity of silver at that time had made the intrinsic value of the coin greater than its face denomination, with the result that silver money had been melted up or laid away. Not foreseeing the abundant supply of this precious white metal which the future would produce, a measure was passed discontinuing its coinage. The act was regarded at the time as being of slight moment. Yet in the years to come, this seemingly unimportant detail in a day's legislative work was to become exalted into an event of gigantic political proportions, for it was this unnoticed and quickly forgotten act, or the effort to obliterate it, that was to put the most important plank into more than one Presidential Platform; that was to become almost the single issue of more than one national campaign; that was to result in the formation of a new national party, with a war-cry " 16 to 1," and with a fierce demand that the American people should rise up and repeal the " Crime of Seventy-three! " It seems curious now that any piece of legislation providing for such enormous possibilities should have gone unheeded at the time of its enactment. Yet so it did, and not even the slightest mention of it was made, either editorially or pictorially, in the

pages of Harper's Weekly, nor, so far as the writer has been able to discover, in any of the important journals of that day.

It was when the great Comstock Lode had begun to pour its shining precious stream into the marts of men, that the price of silver again went down and the " Crime " began to be suspected. It was then that mine owners discovered that one of the most

INTO THE JAWS OF DEATH

important uses of their metal was gone. Men like General Butler, whose desire to increase the circulating finance of the country had carried them to any length of proposed fiat legislation, promptly rallied to the support of silver, which at least had a basis of substantial value. Nor were the inflationists the only champions of the white metal. Many of the foremost legislators in both Houses favored a return to the traditional " double standard of the Constitution," denouncing gold as the " money of monarchs, the prerogative of tyrants and of kings."

During 1877 the financial question had been freely discussed in Congress, and various measures had been suggested with a view to restoring silver to its old place of honor. But in his annual Message in December the President had recommended that it be used only on a basis of its intrinsic value, at that time about ten per cent. less than the face value of the coin. Secretary Sherman, of Ohio, concorded with this opinion. It remained for Stanley Matthews, a newly elected senator from the same state, to secure the passage of a resolution providing for the payment of all public debts, including bonds, in silver dollars of $412\frac{1}{2}$ grains each. Richard P. Bland, of Missouri, had already secured in the House the passage of a bill providing for a return to free coinage, but this measure was for the time superseded by the Matthews resolution.

During the Presidential controversy, early in 1877, at the " Compromise Dinner " Matthews and Nast had met. The Ohio man had regarded the artist with a good deal of curiosity, and finally said:

" I don't suppose you could caricature a man with regular features like mine."

Nast regarded the rather good-humored countenance, with its projecting moustache that shut down on the round beard below like a box cover. Then he laughed.

" Don't give me too good a chance to try," he said.

The chance had now come. In a caricature of Matthews as a pawnbroker, returning a silver watch for a gold one, there was a suggestion of what might be done with that mustache and beard. But when on the 28th of January, 1878, Matthews's Resolution was adopted both in the Senate and the House, by large majorities, the bearded mouth of Matthews became all at

THE FIRST STEP TOWARD NATIONAL BANKRUPTCY

(Uncle Sam puts his foot into the Stanley Matthews silver trap)

once the jaws of a steel-trap, fastened to the leg of Uncle Sam. The trap was labelled " St. Matthews' Resolution " and the picture entitled, " The First Step Toward National Bankruptcy."

It was a remarkable cartoon, showing as it did the artist's ability to give human character to an inanimate thing, and this, too, without gross caricature. It also exemplified the fact that for those who have eyes to see there is a psychological relation between the character of any human face and the peculiar deeds of its owner. Matthews's face distinctly suggested a trap. His Resolution was a political trap, skilfully set and sprung. A proposition by Conkling to make the Resolution " joint " instead of " concurrent," in order that it should require the President's signature, did not meet with success. The wily Matthews had constructed his trap with such care as to avoid this necessity. The play upon the Ohio Senator's name, by which it was made to conform to the cartoon idea, was one of those added touches which proved Nast great among his kind. The much abused pun, so frequently the cheap resort of a shallow wit, was a favorite adjunct with Nast, and in his hands was likely to become a stroke of genius. The trap of St. Matthews, which so resolutely closed on the leg of Uncle Sam, is an excellent example of the less violent caricature of Nast. The features disappeared presently, but the trap, a trap pure and simple, remained, and the memory of its first appearance remained so clearly established that, to those who had seen it, the trap was still Matthews and Matthews was always the trap. Clearly it is not good policy to challenge the possibilities of caricature.

Matthews was not alone in his distinction. Henry Watterson, who had declared that universal suffrage could " decree soft soap to be money," if it chose to do so, and Murat Halstead, who had announced that what the American people wanted was a dollar so big that the eagle on it could, with his right wing, fan Washington City, and with his left, waft the dust along the

"We do not want a Wall Street silver dollar coined, but a people's silver dollar—a Mississippi Valley dollar—a dollar with an eagle on it, whose right wing shall fan Washington city, while his left wafts the dust along the streets of San Francisco, and his tail spreading over Hudson's Bay, while his beak is dredging the mud islands from the stream between the jetties at South Pass."—*Cincinnati Commercial.*

"Universal suffrage can, if it likes, repudiate the whole debt; it can, if it likes, decree soft soap to be currency."—*Louisville Courier-Journal.*

THAT DOLLAR

AQUARIUS—"Now don't you think Soft Soap would not have been quite so heavy, after all!"

(Col. Watterson cools the brow of Murat Halstead)

streets of San Francisco, while his tail was spread out over Hudson Bay—his beak dredging the jetties at the Gulf—came in for a full share of pleasant satire. On March 9th, we find Halstead crushed under his big dollar, while his friend Watterson—the tables reversed, this time—is bathing the Commercial man's head with ice-water, and asking him if he doesn't think, after all, that a soft soap dollar would be better.

The disposition toward silver legislation was very general. The Republicans who opposed it were not over zealous. In fact, such Democrats as fought the Bland bill, which now came up for further consideration, were far more vigorous in their attempts to defeat what was to them, in a sense, a party measure than most of those who opposed it on the other side of the House. Lucius Quintus Cincinnatus Lamar, of Mississippi, the noblest Roman of them all, battled with all his heart and soul against the silver measure, and this in the face of the fact that his action

was repudiated by his State, whose legislature forwarded reso-
lutions demanding that he change his views or resign his seat.
In refusing to obey he said:

"I cannot vote as these resolutions direct. I cannot and
will not shrink from the responsibility which my position im-

poses. My duty as I see it
I will do, and I will vote
against this bill." *

Nast's efforts on the sil-
ver question did not go un-
recognized. Many letters
came to him, both of praise
and condemnation. Colonel
Robert G. Ingersoll sent an
appreciative letter (Febru-
ary 4, 1878), in which he
said:

THE MANDARIN IN THE SENATE
(Senator David Davis)

I have long wished to make
your acquaintance, and shall
avail myself of the first opportunity. I want to know the man
who writes such wonderful essays and speeches without words.

But letters of another sort were more plentiful, for the silver
sentiment was strong throughout the land. Papers condemned
him as a fool or a knave. The Graphic having failed to secure
his services, now cartooned him on the front page of nearly every
issue. Its favorite plan was to reproduce by a new process-
engraving certain of his former cartoons, done in the old "In-
flation" days—at a time when silver, like gold, had been worth
intrinsically its face value—and to present Uncle Sam as pointing
them out to him and taunting him with his present sinfulness in
rejecting the metal he had once deemed so worthy.

* In spite of Senator Lamar's disregard of his constituency he was reëlected to
the Senate in 1882 by a much larger majority than he had received six years before.
In 1885 he was appointed Secretary of the Interior, and in 1887 an Associate Jus-
tice of the Supreme Bench. He died in 1893.

As a matter of fact Nast did not know that silver had been demonetized when he drew those first " specie " cartoons. It has been said that Grant himself did not know it, and that those who did were very few indeed. In one issue, the Graphic portrayed Uncle Sam as spanking Nast for his persistent wickedness. When the bill was finally passed, and vetoed by the President, and was passed again over his head, the Graphic rejoiced in its victory over the " pencil of Nast," and emphasized it with a quotation from the Chicago Tribune, which said:

The Graphic had the wisdom and sagacity to espouse the remonetizing of the old national money. When the caricaturing pencil of Nast was purchased to traduce the advocates of silver, the Graphic portrayed Mr. Tom Nast in cartoons that made him wince and his employers squirm.

The passage of the silver bill was in truth a humiliation. The cartoonist cared nothing for the Graphic's caricatures, or the fact that a hundred other papers denounced him and rode him down. He grieved only in the reflection that he had fought what seemed a great wrong and had failed. His first comment on the matter was a picture of the discarded and half-forgotten Rag-baby,

GIVING U. S. HAIL COLUMBIA
(Columbia abusing Uncle Sam for his doubtful financial policy, resulting from the Bland silver bill)

who having swallowed the silver dollar seemed to be reviving. In the same issue he relieved his spirit in a good cause with a full-page plea for the skeleton Army and Navy, against which new bills of reduction and retrenchment had been devised.

Uncle Sam, the trap still on his leg, now became a sort of a dissolute person who was inclined to disregard his obligations. The Fisheries Award of $5,500,000, allowed to England in settlement of a dispute which had been going on for the better part of a century, our National Uncle seemed willing to repudiate, or at most to settle in depreciated coin. We find him whittling a good deal at this stage, and sitting about the house and being abused by Columbia for his shiftlessness.

But in sections of the country large masses of the people rejoiced greatly, and from the tone of the " silver " press it would seem that the time of the millennium drew near. Naturally President Hayes fell more and more into disfavor. The few who approved his financial policy were likely to condemn his attitude toward the South, while the South, whose friendship he had hoped to win, regarded him as a usurper and rejected him accordingly. Yet it is probable that no man has ever tried more faithfully to be a good President than did Rutherford B. Hayes.

DANCE TO YOUR DADDY.
The Dear has Swallowed the Silver Dollar (412½ Grains) and is Reviving.

HARD TO PLEASE THE "WHITE TRASH"
U. S.—"I hate the 'nigger' because he is a citizen, and
I hate the 'yellow dog' because he will not become one."

AMERICA ALWAYS PUTS HER OAR IN
(Columbia wins at Henley)

CHAPTER XLIII

A DULL SPRING AND TRIP ABROAD

At frequent intervals Major Pond renewed his endeavors to induce Nast to return to the lecture platform. Hathaway and Pond was the style of the lecture firm at this time, successors to the Redpath Lyceum Bureau. A single letter will convey an idea of the temptations in this direction with which the artist was still beset:

<div style="text-align: right">Boston, June 6, 1878.</div>

My Dear Mr. Nast:

Beecher said the other day, " Nast is a statesman." We want just such a statesman as you to lecture next season. Can't you be prevailed upon to give us a month—a week—a day? We will give you $300 a night for four or six weeks, and if you can give us the season we will make it as much of an object as possible. We will do everything that can be done to make your travels easy, and we will make no more nights a week than you can comfortably fill. I will go with you and take all the care of you that can be taken, will make your yoke easy and your burden light for you; and heavy for me as you like. Please reply yes.

Kind regards to Mrs. Nast and the little folks.

<div style="text-align: right">Faithfully yours,</div>

<div style="text-align: right">J. B. Pond.</div>

It would seem hard to have resisted such offers as these,

25

DEATH IN THE TUNNEL
(The features of the skull formed by the wreckage)

OUR ARMY AND NAVY—AS IT WILL BE

especially as the cartoonist could have continued his work in the Weekly, the publishers being more than willing that he should be thus brought in personal contact with their public.

Yet he did not go. Money matters were easy with him, and the long travel and broken sleep were not to his taste. More than all, he was unhappy away from his home and family, in which he found ever his greatest comfort.

The anti-Chinese prejudice feeling began to manifest itself again during the early part of 1878. Uncle Sam still wearing the trap, as well as an expression of general disgust at his own decline, is made to say, " I hate the nigger because he is a citizen, and I hate the yellow dog because he will not become one,"

Nast never had the slightest sympathy with any sort of organization or movement that did not mean the complete and absolute right of property ownership, as well as the permission to labor, accorded to every human being of whatsoever color or race. His first real antagonism to James G. Blaine began with the latter's advocacy of Chinese Exclusion.

Cartoons on Communism and on certain evil results of the silver legislation continued through a quiet spring, with here and there a comment on European affairs, a stroke for the Army,

or a slap at the Income Tax, a measure which Nast bitterly opposed.

The victory of America over Great Britain, achieved by the Columbia College crew in the regatta at Henley, July 4 and 5, was duly recorded in three cartoons, published July 27. It had been a great international event, and Columbia's triumph occurring so opportunely, added vast joy to the celebrations of American independence.

Turkey as a bone of contention, with Bismarck holding a lean hound in the leash, and the same soldier-statesman presiding at the International Table and observing, to a line of empty plates, " Gentlemen, there is *really* no more Turkey," completed the European war pictures, and Nast's summer's work. Already with his family he had sailed for Europe when these appeared, and for three months gave little thought to the mischief of politics or the making of pictures.

It was the year of the Paris Exposition, where the Nasts added a number of art objects to their Centennial purchases. While there Nast received through his old friend John Russell Young, then in Paris, a request from the

IT IS EVER THUS WITH ARBITRATORS
"Turkey, Turkey, everywhere, and not a bit for us."

American Minister, Mr. Noyes, that he (Mr. Noyes) be allowed to give the artist a dinner at the Legation. In closing his note Young says:

Halstead sends you all kinds of pleasant messages. Fenton says you used to make wonderful drawings of his nose and shirt collar.

Halstead and Fenton were both in Paris at the time, the latter as chairman of the International Monetary Conference. The pleasantries of the Greeley campaign had lost their sting, and the happiness of the Legation dinner was unmarred.

During this trip abroad, the Nast family journeyed through Scotland, Ireland and England, to the chief points of interest, including Stratford and old Chester, and down into Cornwall for a stay at the home of Colonel Peard. At Chester they added a number of valuable old relics to their collection of antiques.

BISMARCK'S "AFTER-DINNER" SPEECH
"Gentlemen, there is *really* no more Turkey."

While in London they visited Banbury, of "Banbury Cross" fame, where dwelt Thomas Butler Gunn, of the old merry crowd which twenty years before had gathered at the "Théâtre des Edwards." It was a needed vacation, and the publishers in America were careful to see that the facts of the cartoonist's absence were duly made known to the public.

CHAPTER XLIV

THE TRIBUNE'S CIPHER DISCLOSURES

LIGHT SUMMER READING

During Nast's absence in 1878 a Congressional committee had begun investigations in Louisiana, with a view of settling the many charges of electoral fraud, preferred by Manton Marble and other friends and advisers of Mr. Tilden. Ever since the presidential decision of 1876 a number of men and papers had kept up an unceasing cry of " Fraud " and " Corruption " as against the Republican Managers, with an equally persistent claim of " Morality " on the part of Mr. Tilden's cause. Never for a moment had the dissatisfaction been allowed to become quiescent. On his return from abroad, October, 1877, Mr. Tilden had been serenaded, and from the front stoop of his Gramercy Park residence had made an address to the Young Democrats on his favorite doctrine, Reform, strenuously denouncing the methods by which the accession of President Hayes had been obtained. His words were widely repeated and kept the fires of indignation bright.

Mr. Marble became especially unsparing in his accusations and rhetoric, until at last, considerably more than a year after the electoral decision, a resolution had been offered by Clarkson N. Potter to make still further inquiries into the alleged fraudulent returns from the three disputed States. It proved to be one of the most disastrous political boomerangs ever launched.

A NEAT DESIGN

A Bit of Work just from the Potter

Mr. Tilden had the sympathy of his entire party at this period, and of many who had opposed him in 1876. He was the one Democratic candidate for 1880, and would almost certainly have been chosen had the Louisiana matter been left undisturbed.

The organization of the Potter Committee had occurred before Nast sailed for Europe, and had been recorded by him in two cartoons. The first of these was "A 'jar' from the Potter," which was to "turn the White House upside down"; the other, a caricature of Henry Watterson, sharpening his pen in readiness for the results. Nast then sailed away, little dreaming what those results would be. Certainly he expected nothing of very great importance.

What the friends of Mr. Tilden expected it would be difficult to say. As the weeks passed, Mr. Marble became particularly bitter in his denunciations of the methods used to seat Hayes and Wheeler, and still more persistent in his assertion that Mr. Tilden and his friends had relied wholly upon moral forces to achieve victory.

The situation was therefore somewhat ludicrous, and certainly dramatic, when a quantity of Democratic cipher telegrams of 1876, which had passed into the hands of a Senate Committee,

were translated by the combined efforts of Colonel W. M. Grosvenor and Mr. J. R. G. Hassard, of the New York Tribune, and established apparently beyond question that the voluble and vindictive reformer, Marble, with C. W. Wooley, Smith M. Weed, John F. Coyle, Colonel W. T. Pelton, and others, had been engaged, during the weeks following the election of 1876, in a direct effort to purchase the Presidency with money.

In the beginning, the Potter Committee had reported certain Republican irregularities and there had been great rejoicing in and about the neighborhood of Mr. Tilden's residence in Gramercy Park. Early in August Mr. Marble had taken occasion to put forth a letter more direct, more bitter and more specific in its charges, as well as more exhaustive in its peculiar rhetoric than any preceding document. This remarkable manifesto appeared at a singularly unfortunate time, for the ink with which it was printed was hardly dry when there began to appear, in the pages of the Tribune, selections from the mass of cipher despatches which had passed between Mr. Tilden's residence and those friends who had looked after his interests in the South during the Returning Board period.

The despatches, as they first appeared, were still in cipher, but even in their cryptographic form there was something strangely suggestive in certain of the phraseology, and day by day as they appeared the interest of the public became ever more intense, especially as the Tribune here and there hinted at possible meanings and word arrangements—a fact which would suggest to-day that the cipher experts were already far on their way toward actual solutions, and that the Tribune was merely preparing the public for one of the greatest newspaper beats on record.

Indeed, the gradual development of the Tribune's "Cipher Disclosures" resembles nothing so much as a cat playing with a mouse, or with a number of mice, which, when it is ready for the feast, it will slay with great gusto and intense torture. The

Tribune prolonged its playful enjoyment by quoting despatches and parts of despatches having a humorous sound. Such words as " geodesy " and " incremable " gave special delight to the writer, who declared that no one but Mr. Marble could have employed these verbal curiosities. Presently there began to appear half-translated cryptograms, such as the following:

" To Colonel W. T. Pelton, 15 Gramercy Park, N. Y.
(15 Gramercy Park was Mr. Tilden's home. Colonel Pelton was his nephew and private secretary.)
" Bolivia Laura. Finished yesterday afternoon responsibility Moses. Last night Fox found me and said he had nothing which I knew already. Tell Russia saddle Blackstone. M. M."

It became evident, not only to the conspirators, but to the public, that if the paper had not already found the key to these communications, it would speedily do so, and that a great exposure of inside history was about to be made.*

The Tribune now gave Mr. Marble and his associates an opportunity to publish, of their own accord, the key to the ciphers, and thus clear Mr. Tilden of the suspicion that was rapidly growing in the public mind.† Republican ciphers had been translated and found to be harmless. If the Democratic despatches were of the same sort, it was time that the reputation of the party, and especially the good name of Mr. Tilden, should be protected.

For, says the Tribune, there is no man outside of an asylum of idiots who will believe that Mr. Tilden did not know anything of the despatches in cipher, passing between his house and his confidential friend, Manton Marble.

* In a recent letter to the writer Mr. Whitelaw Reid says:

My recollection is that Mr. Hassard and Colonel Grosvenor worked independently of each other for some time on the ciphers, occasionally consulting and comparing notes; and that when the clue was finally detected Mr. Hassard gave me his discovery in the afternoon, and a little later, on the same day, a despatch was received from Colonel Grosvenor at Englewood, reporting the same discovery. Practically it was simultaneous.

† Copies of the cipher despatches were also privately offered to Mr. Tilden by Mr. Reid during an interview at the United States Hotel in Saratoga. Mr. Tilden declined them, which might be taken to indicate that he was already familiar with their contents.

The Tribune adds:

If they (the despatches) have an innocent meaning, why is it that of at least a dozen friends of Mr. Tilden who were found using the same cipher, not a single one dares to come forward with the key. Plain people know what such silence means. Dare Samuel J. Tilden make known the key of the secret despatches to and from Gramercy Park?

The curiosity of the public was now at fever heat and there had been awakened a feeling of indignation which had resulted in a suggestion that the returned Potter Committee should put Mr. Tilden and his friends on the stand to explain the secret correspondence. Of course, from the newspaper standpoint, this would not do—not yet. The cat must kill its own mice, and the time for the killing was close at hand.

On Saturday, October 5, the Tribune gave notice that the first execution would take place in the Monday morning issue. It said:

We shall show not only what the cipher despatches mean, but how they were made, who wrote them, who received them, and how we discovered the interpretation of

VERY SOCIAL

First D. H. Conspirator—"After we have killed all kings and rulers, *we shall be the sovereigns.*"

Second D. H. Conspirator—"And then we will kill each other. What sport."

them. We shall print the despatches themselves, as well as the translations, and we shall give the keys so that anybody can test the accuracy of the versions.

What happened in Gramercy Park over that fateful Sunday has not been recorded, but bright and early on Monday morning the Tribune made good its promise. In extra pages and in bold type a goodly portion of the Florida despatches were set forth, with the keys necessary to their solution. Also the explanation of how the ingenious " Dictionary Ciphers " had been gradually and surely worked out until the whole miserable story was clear for all the world to read.

And the world did read, absorbing the strange marvel of the tale. The Florida despatches which had passed between Mr. Tilden's residence and Tallahassee showed that one proposition from Mr. Marble to pay $200,000 for a favorable decision had been held " too high " because another despatch from another agent had promised a cheaper bargain. Mr. Marble's despatch was as follows:

" Tallahassee, Dec. 2.
" Colonel Pelton, 15 Gramercy Park:
" Have just received a proposition to hand over at any hour required Tilden decision of board and certificate of Governor for $200,000. Marble."

The " cheaper bargain " had been offered by C. W. Wooley, whose cryptographic name was " Fox," and had been addressed to H. Havemeyer, who would appear to have been in some way related to the enterprise. It bore the date of Tallahassee, December 1.

" Board may make necessary expense of half a hundred thousand dollars. Can you say will deposit in bank immediately if agreed? "

The reply to this was:

" Telegram received. Will deposit dollars agreed. (You) cannot however draw before vote (of) member (is) received."

The wary financial end of the enterprise did not wish to

pay for a vote without the goods in hand. To this Wooley replied:

" Select some one in whom you have more confidence."

Answer:

" All here have perfect confidence in you. No other has power and all applications declined. Stay and do what you telegraphed you could do."

This was signed " W," and is supposed to have been sent by Colonel W. T. Pelton. Three days later Mr. Marble, who was cryptographically " Moses," and who even in cipher could not avoid rhetorical exercise, sent this interesting word:

" Tallahassee, Dec. 4.

" Col. W. T. Pelton, 15 Gramercy Park:

" Proposition received here giving vote of Republican of Board, or his concurrence in court action preventing electoral votes from being cast, for half a hundred best U. S. documents. Marble."

" Best U. S. documents " were one thousand dollar bills—half a hundred of which would be $50,000, the amount already proposed by Mr. Wooley. Here was a dilemma. Gramercy Park could not be certain that the agents were acting in concert and ordered them to get together at once. Doubtless this was accompished, for presently from " Moses " came a second cipher which, translated, read:

" May Wooley give one hundred thousand dollars less half for Tilden additional Board member? "

No reply came to this, and in Tallahassee feverish hours went by. The time for action was getting brief. Gramercy Park was uncertain, economical and hesitating. It was not altogether clear that the same vote was not being twice paid for. With a business thrift perhaps inherited from his prudent uncle, Colonel Pelton did not care to waste money. Finally he telegraphed:

" Proposition accepted if only done once."

But there was some mistake in the transmission of this message and it was unintelligible in Tallahassee. " Moses " and

" Fox " wired again and more precious hours were lost. Then, at last, came the long-waited for authority in proper form. The order to buy one Presidency for " half a hundred best U. S. documents " was in their hands. The purchasers rushed out and—it was too late. It was then that " Moses " had sent the " Blackstone " telegram, which, fully elucidated, ran:

" Col. W. T. Pelton, 15 Gramercy Park:
" Proposition failed. Finished yesterday afternoon responsibility as Moses. Last night Wooley found me and said he had nothing, which I knew already. Tell Tilden to saddle Blackstone. Marble."

That is, Mr. Tilden was to resort to legal proceedings.

Never since the Times exposure of the Tweed accounts had there been such a newspaper triumph. From end to end the nation was in a mixed state of sorrow and ridicule. Every journal of whatever party was full of the matter—every Hayes organ and a goodly number of those which had hitherto supported Tilden promptly accepting the disclosures as genuine, and as proof of Mr. Tilden's complicity.

That Thomas Nast would make the most of the Florida revelations goes without saying. His faith in Tilden had never been more than momentary, while Manton Marble had even more rarely commanded his admiration. He removed Mr. Tilden's mummy from the company of that of Mr. Hendricks, covered the casing with cryptograms, and inscribed upon it, " Tilden and Reform," with the pseudonyms, " Moses " and " Fox." Upon the brow of the occupant he branded the word " Fraud "—the whole " Exhumed by the New York Tribune." Marble he depicted as a statue with a scroll of ciphers in his hand. The issues of the Weekly containing these pictures complimented the Tribune's great achievement and gave translations of the ciphers on Mr. Tilden's casing.

It seems hardly necessary to enter into the full details of the South Carolina and Oregon attempts to buy or control

electors. Those who care to dig more deeply into these political methods of a bygone day may follow the entire proceedings in the files of the New York Tribune during the final months of 1878 and the early months of 1879, and learn therefrom the whole curious and remarkable story.

The transactions of Smith M. Weed in South Carolina would seem to have been even more open than those in Florida. He did not use a pseudonym, but wired over his own initials that he could control the Returning Board for $80,000. This proposition

being accepted, he set out for Baltimore, where a messenger was to meet him with the money, which he had requested should be conveniently divided into three packages of $65,000, $10,000, and $5,000, respectively, all in bills of large denominations. But, alas, there was the usual delay and uncertainty of all Gramercy Park transactions, and before the necessary funds arrived the Canvassing Board had declared for Hayes.

AN APPEAL TO MARBLE
" 'Tis time; descend; be stone no more."—*Shakespeare*

In Oregon, as previously noted (page 346), an attempt was made to disqualify a Republican elector on the ground of ineligibility. It was necessary, however, to purchase another elector to act with Cronin (the Democrat selected) and negotiations to this end were conducted through one J. N. H. Patrick and others. The Oregon episode is chiefly notable for the celebrated "Gobble" or "Gabble" cipher sent by the Democratic Governor of Oregon, Grover, directly to Mr. Tilden himself. Patrick had already telegraphed to Pelton, November 30:

"Governor all right without reward. Will issue certificate Tuesday. One elector must be paid to recognize Democrat to secure majority. Will take $5,000 for Republican elector."

The Governor's cipher despatch to Mr. Tilden next morning confirmed the above, at least so far as his own intentions were concerned. Translated, it ran:

"Portland, Ore., Dec. 1, 1870.
"To Samuel J. Tilden, 15 Gramercy Park, N. Y.:
"I shall decide every point in the case of post-office elector (the disqualified Republican) in favor of the highest Democratic elector, and grant the certificate accordingly on morning of 6th instant. Confidential.
' Gabble ' " (Governor).

It is presumed that a telegram addressed to Mr. Tilden personally at his home would be delivered to him, and that at least he received this particular message. Yet the Oregon negotiations continued and were still in progress on December 6th, five days later. The money was sent to purchase the elector, who "must be paid," but with that curious fatality which followed at the heels of each of these attempts it arrived one day too late.

And it seems a destiny still more strange that the Potter Committee should now turn to rend those who had prodded it into existence. It held an inquisition at Washington, where it wrung confession from Colonel Pelton; also from Mr. Weed, who justified his offence by declaring it was "only paying money for stolen property." Then, when it had secured a statement from Mr.

Marble that such telegrams as he had sent had been merely " danger signals," it came to New York to allow Mr. Tilden to testify in his own behalf. The examination took place in February, 1879, at the Fifth Avenue Hotel, and was of dramatic interest. The witness was feeble and broken. The sorrow of his defeat, the obloquy incident to the exposure, the months of suspense had told. Commenting editorially on this " last scene of all," the Tribune said:

In a low dark room, excessively hot and densely packed, the whole world sat at the reporters' tables, or crowded close with note-book in hand to catch the faint whispers that fell from a worn and haggard old man.

The " Sage of Gramercy Park " had become a pitiful and shrunken figure. His hands shook, his words were almost inaudible. The cross-examination of Frank Hiscock of New York and Thomas B. Reed of Maine was unusually trying and severe, and, shrewd lawyer that he was, Mr. Tilden fared badly in their hands. Again, as in 1868, he denied that he had ever taken any part in the attempted bribery. He avowed that he would have scorned to defend his title by any such means. He referred to the " futile dalliance " of Colonel Pelton, whose sole offence, he said, was to offer to bribe men to do their lawful duty. Once, when a sharp sally from Mr. Reed provoked laughter among the spectators, Mr. Tilden made an effort to join in the mirth.

He was allowed to go at last, and in the hearts of men censure began to give way to a feeling of sympathy for one who so recently had been his party's idol and the " people's choice," but who now was but an added wreck among the rocks and shifting sands of politics. For, innocent or guilty, with the first publication of the cipher disclosures, his career had met death at his very threshold, his pennant of Reform had become a rag of mockery in his hands.

———

While the evidence adduced against Mr. Tilden by the Tribune

exposures and the subsequent examinations was of a kind purely relative and inferential, it was nevertheless of a nature sufficiently startling. Nor have more recent developments been favorable to the assumption of his entire innocence.

In a recent article in McClure's Magazine (May, 1904) the writer, a friend of the late Abram S. Hewitt, in reference to Mr. Tilden's conduct during the days of the Electoral Commission (January and February, 1877), says:

Throughout the controversy there was a continual uncertainty as to who was Mr. Tilden's spokesman. Mr. Hewitt naturally thought he ought to be, but was often as much in doubt as any one. Colonel Pelton, Mr. Tilden's nephew and private secretary, sometimes seemed to be the man, sometimes Speaker Randall, sometimes Colonel Watterson, who accepted election to vacancy at Mr. Tilden's urgent request, and again David Dudley Field. In fact this writer is assured that there never was a time when any man had the complete confidence of Mr. Tilden, whose frequent telegrams were often unsigned, and though in general there was a perfect understanding as to what should be done, progress in a matter in which Mr. Tilden was most concerned was much interrupted by his occasional utter refusal to give orders, or by the order being sent to the wrong person.

The reader must see that this coincides exactly with the hesitations and delays which brought to naught the purchase proceedings in the several States where negotiations had been actually begun. Many of the cipher telegrams were unsigned, while the tendency to dally, to hesitate and to distrust was constantly made manifest. If we assume that Mr. Tilden himself was behind Colonel Pelton, the reason for the peculiar economies and delays—the " futile dalliance "—becomes immediately apparent.

That Colonel Pelton did so act for his uncle was the prompt conclusion, not only of the Republican Party, but of a sufficiently large number of Democrats, to destroy utterly the possibility of his ever obtaining another presidential nomination. Most of these did not hesitate to declare that the fact of the telegrams having been sent and received at 15 Gramercy Park

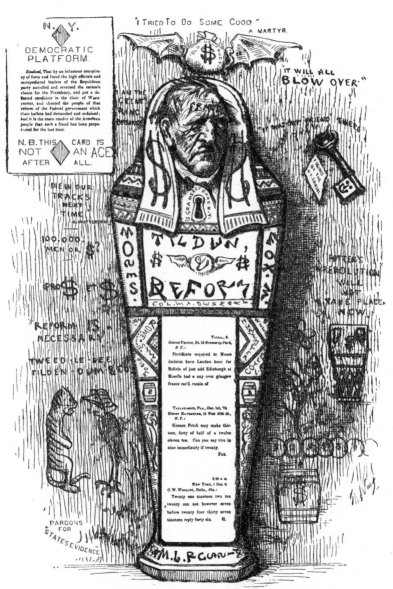

CIPHER MUMM(ER)Y

(Exhumed by the New York Tribune)

was sufficient evidence that Mr. Tilden knew what was in prog-
ress—it being his habit and very nature to give extraordinary
attention to the details of political contests. It developed further
that the cipher used was one which Mr. Tilden had long em-
ployed in his business transactions and continued to do up to
the very time of the Tribune exposure. Also, it may be added,
a number of the telegrams, like the " Blackstone " cipher,
would seem to have been intended for " Russia " (Mr. Tilden's
cryptographic title), such messages having been sent by his
intimate friends with a full knowledge of all the conditions and
possibilities, while the " Gabble " cipher was sent directly to Mr.
Tilden himself, and could hardly have passed unnoticed. More-
over, there is recorded evidence that Mr. Tilden was apprised of
Colonel Pelton's doings while the attempts were still in progress,
for Colonel Pelton himself, before the Potter Committee, testi-
fied that he had been censured by his uncle for the South Caro-
lina attempt in November, which reproof had not prevented him
from undertaking, through " Moses " and " Fox," the Florida
enterprise, ending with the " Tell Russia to saddle Blackstone "
cipher. He added that throughout all he had been recognized
by the others as his uncle's accredited agent and that any request
from Pelton had been virtually a request from Tilden. That
Mr. Tilden should have retained as friends and intimates of his
household not only his nephew but those associated with him in
the undertaking, and had still proclaimed the creed of Reform
from his doorstep long after he had acquired a full knowledge of
their misdeeds, was a condition which even his warmest admir-
ers could not overlook.

Finally, it may be added that as Mr. Tilden's nephew, Colonel
Pelton, was believed to have no amount of funds that were not
provided by his uncle, the conclusion was naturally reached that
the " Eighty thousand dollars in three convenient packages "
and the " Half a hundred best U. S. Documents " were to be sup-

plied in some manner from " Uncle Sammy's celebrated barrel," which had figured so largely during the campaign.

Concerning the evidence in Mr. Tilden's favor, it may be said that all of those examined by the Potter Committee declared for his innocence. Their testimony may be accepted for what it is worth. If we do not highly regard it as evidence, we may respect in it a certain honor and sense of chivalry. That conspiracy and fraud could spring up and thrive not only at Mr. Tilden's threshold, but by his very fireside—all unknown and unsuspected by that astute lawyer—was not conceded for an instant by his enemies, and was admitted with reluctance by his friends. Even those who remained loyal and honored him were obliged to confess that one so easily hoodwinked could not properly become the nation's chief executive.

Time has softened and forgetfulness destroyed many of the old impressions and the old asperities. Sympathy with a feeble and disappointed man is characteristic of the American people, and in the case of Mr. Tilden the general unpopularity of his successful opponent, President Hayes, told largely in his favor. Mr. Tilden to-day is almost universally regarded as a hero and a martyr—a great statesman defrauded of his rights—the victim not only of his enemies but of his friends.

THE OPENING OF CONGRESS

CHAPTER XLV

The autumn elections of 1878 were directly influenced by the cipher exposures. Much of the ground which the Republicans had lost the year before was regained, while Democratic possibility of a President in 1880, which had become clearly defined since the inauguration of Hayes, now became daily more remote. Nast pictured the Lamb as emerging from the interior of the Democratic Tiger, and Henry Watterson as chaining up the devil who was not to be turned loose just yet. He closed his important work of the year with a companion piece to his " Gen-Disposition " caricature of himself, printed more than a year before. In this second picture Uncle Sam is shown as fleeing, while the bottom has dropped out of the policy chair, and " our patient artist " has fallen through, though he still extends high in air the traditional " scissors," significant of defiance to the last.

Nast's position on the President's Southern policy had been vindicated by events. The conciliation overtures made by Hayes had resulted in making the South scarcely less bitter and certainly more solid than at any time since the war. That the Harpers permitted the publication of this second picture was sufficient notice to the public that their surrender on this point was complete.

OUR PATIENT ARTIST

The Christmas picture of 1878 was copied by the Pictorial World of London, without credit, and used as a color supplement —the only change being that the American Flag of Nast's picture was altered by the English periodical into the flag of Great Britain. This reproduction and adaptation of Nast's work on the other side was now the rule with many of the London papers, especially with the holiday editions. A single Christmas number of " Yule Tide " contained both front and double page reproductions of his pictures.

January 1, 1879, was marked by the resumption in the United States of specie payment. There had been considerable doubt as to the ability of the Government to maintain its promises, even up to the final months, but the prices of coin and currency drew nearer and nearer together, until, when the final day arrived, they had merged into one, and those who had been hoarding greenbacks with the idea of converting them into gold found that they did not really want it, after all.* The great change

* There had been uneasiness at Washington, owing to rumors of a gold " corner " and a possible run on the Sub-Treasury in New York, but at the close of business on the first " resumption " day it was found that $400,000 in gold had been paid into the Sub-Treasury and but $135,000 withdrawn.

took place without a flutter of disturbance. Confidence in our national integrity was complete. The chief evil resulting from the war had been overcome.

Perhaps Nast's disgust with the silver situation prevented him from taking any pictorial notice of this great financial event. Instead he presented " A Christmas Box " to the Solid South—the box containing a new, clean shirt, to be donned in place of the old " bloody one " which is suspended on the wall. The artist realized that the day of this emblem was about over. The tendering to his ancient enemy of the new and speckless garment was like holding out the Olive Branch, or, more exactly, the Flag of Truce.

The new year also introduced General Butler—who was neither Republican nor Democrat—as " The Lone Fisherman, from Mass.," angling for a new party in stormy political seas. Secretary Schurz, as a carpenter, having reconstructed his " Indian Bureau " in a somewhat heterogeneous fashion, calmly invites public inspection to his work. " The Ass and the Charger," one of Nast's telling army pictures, came the last week in January, and, as if in immediate acknowl-

THE LONE FISHERMAN (FROM MASS.); OR, THE BULLDOZED OLD MAN
"The friends of General BUTLER credit him with an intention of organizing a new Democratic party, which shall be made 'the especial champion of human rights.' " —*Washington correspondence of the Tribune*

edgment, there followed the presentation of the Army and Navy testimonial—the consummation of the plan which "Fighting Guy" V. Henry had inaugurated the year before.

This testimonial, like that of the Union League Club, in 1869, was in the form of a beautiful silver vase, its pattern being that of a large army canteen, handsomely chased

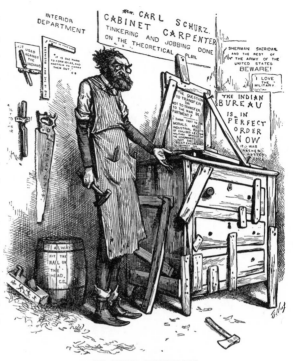

NO MORE OUTBREAKS

C. SCHURZ—"I do not repel, but invite, inspection and observation on the part of military officers."

and mounted. On one side Columbia is shown as decorating the artist in token of his services. On the other is the inscription:

Presented to Thomas Nast by his friends in the Army and Navy of the United States, in recognition of the patriotic use he has made of his rare abilities as the artist of the people. The gift of 3,500 officers and enlisted men of the Army and Navy of the United States.

The ceremony took place at the home of Colonel William C. Church, editor of the Army and Navy Journal, 51 Irving Place, New York City. General Hancock was to have made the presentation address, but being ill could not attend, and General Crittenden acted in his stead. The event was unique in military history. Never before had the Army and Navy made public recognition of the services of a private citizen. General Crittenden said:

At a time when the Army and Navy were in their utmost straits you were a friend. When the Army and Navy were assailed in the rear, when men who had been comrades and had got to be politicians, were assailing the army, when its best friends were timid or silent, you with a matchless, magic pencil spread the truth abroad in the land and filled the minds of people with truth, and their hearts with generous sentiments. What wonder that all those officers and soldiers should now turn to you as their steadfast friend, and one most deserving to be honored at their hands. . . . Your little finger was stronger on our side than the pens and voices of the ablest and loudest orators who were against us. What wonder that these people should consider you as their friend. In their name I tender you this as a token of their admiration, their gratitude and their friendship.

Nast could say but little in reply. He managed to tell them that the pencil was the only instrument he could play upon, and complimented the bravery and steadfastness of soldier and sailor. He added a tribute to the paper which had permitted him to champion a worthy cause. Ten years before, at the Union League, he had spoken of himself as " standing just beyond the threshold " of his career. Had he referred to his progress now, he might have said that not only had he entered the house of his inheritance, but had mounted to its highest dome and pinnacle.

Many of the country's bravest defenders were gathered to see honor done to the man who had labored in their cause. General Sherman could not be there, but sent Nast a long letter of congratulation. He closed by saying:

In 1864, when the existence of our nation, with all its cherished memories, and all its promises for the future were in great peril, both political parties in asking the votes of the people proclaimed their devotion and eternal gratitude to the Army and Navy, then struggling for victory and national perpetuity. But we have been made to realize that such promises are easily forgotten when the danger is past, and peace reigns supreme. We are more dependent on the heart of our people than any other class of public servants, and your illustrations reach direct to the heart of those who look upon them; and therefore our deep obligation to you. Should your interest ever

carry you to our frontiers, you will realize that you have a place in every heart, and a welcome to every military post or camp.

Truly yours,

W. T. Sherman.

Colonel Henry himself was too modest to be present, and Nast wrote him a heartfelt letter of thanks, to which the brave soldier made a brief and characteristic reply:

Thomas Nast, Morristown, N. J.:

Dear Sir: Yours at hand. You have no reason to feel in debt to the Army. They owe you one they can never repay. Your one picture of a skeleton soldier, standing at present arms, to dismounted cannons, demolished fortifications, etc., did more to mould public opinion in our favor than bushels of letters. I am both glad and proud to have been the one to suggest to my brother officers what their hearts already prompted them to do.

I am, sir,

Very truly yours,

Guy V. Henry,

Bvt.-Colonel, U. S. Army.

THE ARMY AND NAVY TESTIMONIAL

There are perhaps not a hundred people alive in the United States to-day who recall this tribute of the nation's defenders to Thomas Nast or the pictures which inspired it. We are a vast and busy nation. The curtain of the present shuts closely on the spectacle of the past. The heroes of yesterday fade back into shadow land. Their bodies are dust, and their deeds, in the words of Sherman, are " easily forgotten."

CHAPTER XLVI

QUIET ISSUES AND A NOTABLE RETURN

DIFFICULT PROBLEMS SOLVING THEMSELVES

General Grant's march of triumph around the world was recorded here and there by Nast, as news came of royal welcomes, occidental and oriental, and of the consideration everywhere accorded to the Ex-President, not only because of his nation, his former rank and his military genius, but as a tribute to his own simple personality and modest greatness. It is no wonder that with such recognition from those abroad, and with a period of freedom from care, there should awake in the bosom of the soldier a wish to crown his homecoming with a renewal of the highest honor which his own nation had to bestow. He knew that his triumph abroad had in a great measure vindicated him in his own land; that the charges and slanders which had blighted his last administration had well-nigh died away, and that the priceless achievements of his long term of public service were once more foremost in the public mind. With experience he could avoid many political snares and pitfalls. He longed to

redeem old errors by becoming once more the " people's serv-
ant "—to give his nation a final term—not only of loyal and
faithful, but of veteran service.

John Russell Young, who had joined him in his journey, wrote
to Nast concerning the General's welfare, and of these aspira-
tions. In a letter dated " On
the Red Sea, February 6,
1879," he said:

The General, Mr. Borie * and
I spent most of our time look-
ing at the waves and scheming
for a third term! ! ! !
You never saw such a
schemer as the General is. He
sits up hours and hours, late,
and schemes. Don't tell Mr.
Harper about this—it will dis-
tress him. . . .
Tell J. " Brooklyn " that
when I reach India I will write

EDUCATION. IS THERE NO MIDDLE COURSE?

him the sweetest letter he ever read, praising every one around
Franklin Square, and telling him of a charming dinner (Wil-
liam) Black, Brunton and I had the night before I left London,
and how kindly Black talked of him.
I left General Grant on deck talking to his wife. He was
scheming for a third term. I told him I was coming down
stairs to write to some people—you among them. The General
sent you his kindest wishes, and his regards to J. W. H. Mrs.
Grant sent you her love. Please do not tell Mrs. N. of this
message.
We think of returning home in October.
Yours sincerely,
John Russell Young.

It is likely that Nast was willing to regard this letter through-
out more as jest than earnest. Seeing the situation as it was, he
preferred to believe that Grant did not really want a third term,
or that at least he would change his mind upon his return; and
this, in fact, Grant was to do, as we shall see later.

* A. E. Borie, first Secretary of the Navy under Grant.

The labor question was often uppermost in the public mind
during the later seventies. Communism laid its blight upon in-
dustry, the anti-Chinese movement in California was accom-
panied with riot and bloodshed. Meetings begun by Dennis
Kearney in 1877, on the open sand lot fronting the new City Hall
in San Francisco, had started a general war-cry, "The Chinese
Must Go!" with the result of a combination of riotous foreign
elements against the most peaceful and industrous of them all.
Nast, whose sympathies were always with the oppressed, fought
hard and fiercely for the Celestial and, as well, for the red man.
In a cartoon published in February, 1879, he has them together.

"Pale-face 'fraid you crowd him out, as he did me," says the
Indian, and on the dead wall behind is a caricature of the red

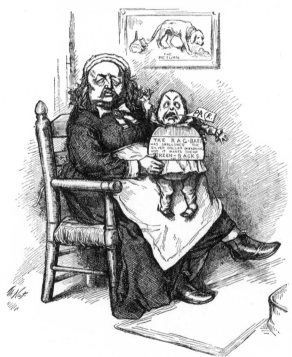

man being driven
westward by the
locomotive, and an-
other of the yellow
man trying to catch
the locomotive that
will bear him to the
east. Of course the
question at once be-
came political, and
those statesmen
who were willing to
abrogate the terms
of the Burlingame
treaty in order to
secure a Chinese
Exclusion measure
were severely and
justly handled by

IN THE MATRIMONIAL MARKET AGAIN
(General Butler as the widow of many parties)

Nast. Blaine was

foremost of these, and was portrayed in a manner that made the man from Maine heartsick, remembering that so soon he might be before the people as a national candidate, and that Nast, who never yet in a campaign had been on the losing side, might refuse him his support. He attempted to explain and to justify his position, but the artist could see in the Chinese immigrant only a man and a brother, trying to make a living in a quiet and peaceful manner in a country that was big enough for all. The Chinese Exclusion bill, introduced by Mr. Wren of Nevada, passed both Houses, but was firmly and bravely vetoed by President Hayes, who declined to abrogate a treaty fairly made. Eventually a new treaty was concluded and Celestial immigration restricted. This was defeat for Nast, but Blaine's political bid for California was one of the things that cost him the presidency of the United States.

Mr. Tilden still in his cryptographic casing and Mr. Thurman pointing out the financial graveyard through which the nation had passed to reach specie resumption were the first indications of usual autumn stirring of the political pulse. In New York State both parties were badly divided, many Republicans having

THE CIVILIZATION OF BLAINE

JOHN CONFUCIUS—" Am I not a Man and a Brother ?"

THE QUESTION AFTER THE NEW YORK ELECTION—WHAT KIND OF A TIME DID YOU HAVE?

deserted the " machine " controlled by Conkling, while " Honest " John Kelly had revolted from the element known as the Tilden Democracy, preferring to throw his influence to the Republican candidate for Governor, A. B. Cornell, than to support Robinson, who represented those still loyal to the " Sage of Gramercy."

It is doubtful whether Mr. Tilden himself took any very deep interest in the result. Nast depicted him as smiling at the " monkey-and-parrot " fight of Kelly and Robinson, and as still smiling and saying " Bless you, my children," when the election was over and both Tammany and Tilden Democracy had met defeat. Curtis, in the Saratoga Convention, still at war with Conkling, had opposed the nomination of Cornell, and had continued to depreciate him in his editorials, to the discontent of many readers. As a result, in the issue of October 25th, the publishers explained the paper's position. It declared that, as energetically as it had condemned unwise and unpatriotic practices in

the Democratic ranks, so with equal force would it resist the evils developed by his own party. " Only by silence and the slavish following of unwise and corrupt policies can any journal purchase place," it said. " If the success of the Weekly must depend upon such a sacrifice, we would rather discontinue its publication." In the same number Mr. Curtis tendered his resignation as Chairman of the Richmond County Convention. These incidents, in themselves of no great national importance, were among the early beginnings of a dissatisfaction which culminated in the great Mugwump defection of 1884. Nast had taken less

than usual interest in the four-cornered fight, in which there had appeared little principle beyond that of office-seeking. Such sympathy as he had was against the " machine " controlled by Conkling, whom he caricatured with considerable severity, notwithstanding the personal friendship between them. Conkling as a jackdaw with borrowed plumes was the most notable of these, and was widely remarked.

" COME INTO MY PARLOR," SAID THE " BOSS " SPIDER TO
THE NEW YORK FLY

But by far the

BORROWED PLUMES—MR. JACKDAW CONKLING
Eagle—" Perhaps you would like to pluck me."

chief event of the autumn of 1879 was the return of General Grant from his trip around the world. He had been absent for more than two years, during which he had received an almost continuous ovation from foreign nations and their sovereigns. No American abroad ever has been so honored as General Grant, and no returning American, except Admiral Dewey, was ever so extravagantly welcomed. On September 20, 1879, on the " City of Tokio," the Ex-President arrived in San Francisco Bay.

The entire city was decorated with bunting and flowers, while the wild ringing of bells, the blowing of whistles and the firing of cannons welcomed the hero to his native land. " The Return of Ulysses," was Nast's allegorical presentation of this episode.

There had been nothing partisan in Grant's welcome home. The feeling with which he was greeted was one of universal pride, and a patriotic desire to pay tribute to a great commander. It was as an echo from the closing days of the war, when all that we knew of Grant was that he had given us victory.

CHAPTER XLVII

" Another stocking to fill " was the Christmas greeting of 1879-80. The picture showed Santa Claus bending over the crib of the " new baby "—the new baby being a late arrival in the Nast household, the first for eight years. It was a boy this time, Cyril, born August 28, 1879, and it is said that the baby in the crib is a true likeness, while the features of Santa Claus are not unlike those of the proud and happy father.

The new baby completed the family, and with the beginning of 1880 the fortunes of the Nast household had reached their highest point. The artist still owned the Harlem property, which had a valuation of thirty thousand dollars, the price for which it was eventually sold. He had accumulated another sixty thousand dollars in Government securities, while the beautiful Morristown home and its rare contents were all his own. Solely by the combined work of head and hands, the young man who less than twenty years before had begun married life with an unpaid-for piano, had acquired no less a fortune than one hundred and twenty-five thousand dollars—an amount considered rather large in that day. Well for him if he had remained content with his success, doing such work as agreed with his convictions, living on such income, whatever it might be, as his work and investments provided. Not that his income had

27

appreciably decreased, for it still averaged considerably more than twenty thousand dollars a year—five thousand of which was the annual retainer from Harper Brothers, while something more than an equal amount came from his securities. The remainder was the additional received for drawings, and while it had become somewhat less than it had been prior to the death of Fletcher Harper, it was still a very considerable sum, and sufficient to many needs.

But the artist grew ever more restive as he found it more difficult to express himself fully in the pages so long identified with his individual utterances; and the idea of a paper of his own—an endowed journal in which every man who had something to say, and the ability and courage to say it—a paper uncontrolled by any party or policy—became more and more a dream which he resolved to make real.

But those to whom he spoke of an endowed paper, while they frequently expressed enthusiasm, were reluctant to invest in such an enterprise. Theoretically it seemed a good idea. Commercially it did not appear promising. With a total lack of business judgment himself, the artist was impatient with these kindly but financially reluctant friends, and resolved to acquire through speculative investments sufficient capital eventually to start the paper on his own account. For the money itself he did not care, beyond the comforts that it would buy. His sole desire for increased fortune was that he might undertake the publication of a journal wherein he could do battle for those social and political reforms which seemed to him so needful in the city and nation of his adoption. Two things he did not realize. First, that the public—so much larger, wealthier and less primitive than in those days following the Civil War—had grown careless of reform and preferred to be entertained—that the time for a paper of the sort he dreamed, if it had not gone by, was at least rapidly waning. Second, he did not understand that

men in the guise of friendship could seek, for their own petty profit, to divest him of his hard-earned savings. Like his old hero, Garibaldi, he was a master in his own field—a field of action and of honor. Also like Garibaldi, he was guileless and easily played upon by those who through friendship won their way to his confidence or appealed to his moral and patriotic impulses. The lesson of his childhood—learned of the pet lamb in the field back of Landau—he had long since forgotten. He remembered only that once, through a friend's advice, he had bought the Harlem lot, which as an investment had turned out well. Other friends—some of them men whom he had known for years—learning that he wished other profitable investments, now brought him this and that opportunity — a mine, perhaps, a patent, or a railroad undertaking — until within a single year he had distributed a large part of his savings—those precious Government securities—into various channels, alluring streams of

STRANGER THINGS HAVE HAPPENED

SENATOR BAYARD—"Hold on, and you may walk over the sluggish animal up there yet."

(In this cartoon the Donkey and Elephant symbols first appear together, bearing their respective labels)

Pactolus that sparkled by and brought no returning tide.
He did not lament over these earlier losses. He had earned
the money once—he could do so again. Neither did he learn wis-
dom, or become distrustful of mankind in general. It was only
at last in his final years, when the day of his power and for-
tunes had passed by, that he ever became suspicious—and, some-
times, as may be readily supposed, even of those who wished
his welfare and were his friends in truth. It is one of the curious
phases of human perception that this man, whose eyes rarely
failed to penetrate a public sham, was likely to be sadly lacking
in his estimate of personal friends.

In Harper's Weekly the presidential year opened with the
attempted adjustment of an election complication in Maine.
The matter is of no general importance now, but it resulted then
in a personal protest to Nast from Senator Blaine, who had been
caricatured as a "plumed" Indian, seeking to straighten out
matters with a war-club. As already mentioned, Blaine had been
deeply humiliated by the Chinese cartoons, to which he could
make no satisfactory answer. Now, it seemed to him, he might
protest with reason, for he had gone to Maine in an attitude of
peace rather than of war.

> Washington, D. C., Jan. 31, 1880.
>
> My Dear Mr. Nast:
> I am perhaps as willing a victim as ever was caricatured
> for the entertainment of the public. But, of course, I do not like
> to be totally and inexcusably misrepresented on an important
> issue. Having spent seventy anxious days and nights in Maine,
> for the express purpose of settling all our troubles, without
> violence or the slightest infractions of the law, I do not quite
> see the justice of painting me as an Indian with a war-club,
> anxious to strike and only prevented by the interposition of
> George Chamberlain. I would be glad as a matter of mere per-
> sonal curiosity to learn any fact or rumor or hearsay that justi-
> fied you in thus presenting me. If I was ever widely known for
> any public act or policy, it was for precisely the reverse of that
> which you present.

I have always had a strong belief in your sense of right and justice, and I leave you to do what seems meet and proper in your eyes. Very sincerely,

J. G. Blaine.

What reply Nast made is not recorded, but concerning the cartoon it may be said that it was less effective and individual than any preceding work, very unlike Nast in idea, and it is possible that Blaine did not complain without reason.

Senator Daniel W. Voorhees, of Indiana, the " Tall Sycamore of the Wabash," began to make his appearance in the cartoons of '79 and '80 as a silver statesman, and later we find him repelling the exodus from the South of colored laundresses who have advanced upon the " great unwashed " Democracy of his own state.

It was about this time that Henry H. Lamb, Acting Bank Superintendent, began to look into the matter of savings-banks voting large gifts and salaries to trustees, and making other illegal and unnecessary use of funds. In the course of his investigations Superintendent Lamb found a copy of Nast's letter of resignation, written in 1869, and applied to him for further particulars. Nast replied, giving additional details. With

THE INVASION OF INDIANA

GREENBACK THE WEAVER

this letter and such other " inside " information as he could get hold of Mr. Lamb began his crusade for Savings Bank Reform.

The result was a decided upheaval in this particular financial quarter. Nast's letter of ten years before was printed, and presently supplemented with another, which was likewise given to the press. In the Weekly of March 6, 1880, Nast further helped the cause with a cartoon, which showed the persistent and imperturbable " Lamb " mounted on a large Bank safe with a pack of angry wolves leaping up from below in an effort to destroy the official. It was one of the many curious coincidences of Nast's life that the letter, written out of a heart's conviction so long ago, should have sent a voice down through the years to awake at last an echo of reform.

Perhaps one of the best of the early pictures of this political year was a caricature of Congressman J. B. Weaver, of Iowa, who several months later was to become the Greenback Party candidate for the presidency. Mr. Weaver had prepared certain inflation resolutions which he wished to introduce to the House,

and which Speaker Randall persistently refused to note. He declined to " recognize " Mr. Weaver, who as persistently arose in his place to obtain a hearing. Nast cartooned him in the impersonation he had applied to so many (that of " Bottom ") and " Greenback, the Weaver," appeared as an imposingly ludicrous figure, upon which the back of the Speaker was turned.

When the paper came out, Weaver folded a copy of it with his resolutions, and appeared in his place as usual. He explained good-naturedly to the Speaker that he did not object to being cast for the part of a donkey, but pointed out the fact that the cartoon offended in that the Speaker had never yet turned his back on him. Speaker Randall smiled. He was quite willing to converse with the Gentleman from Iowa, while declining to recognize him in the parliamentary sense.

" The chair in discharging its duty is unmindful of any criticism of that sort," he said.

The antics of joy displayed by " Greenback, the Weaver," when finally he was recognized, was the sequel to this bit of national comedy.

WHOA!—GREENBACK THE WEAVER.
His frantic delight at being recognized by the Speaker and the inflated Democratic House

CHAPTER XLVIII

THE GREAT CONVENTION OF 1880

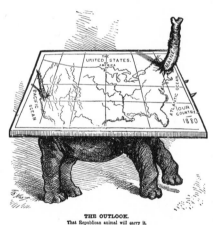

THE OUTLOOK.
That Republican animal will carry it.

As the national conventions drew on, the political situation became more clearly defined. On the Republican side there was a very large element, led by Roscoe Conkling, John A. Logan, and Senator J. D. Cameron of Pennsylvania, who were eager in their desire to elect General Grant to the Presidency for a third term. The St. Louis Globe-Democrat had long printed a daily column headed, "Grant in 1880," and a number of other leading journals East and West had accorded with the idea. Another important element, of which George William Curtis was a factor, opposed such a nomination on the ground that the possibility of a third term for any man would alienate many voters. They argued that there were many other "strong" men, of whom Secretary John Sherman of Ohio was by no means the least desirable. Nast, being loyal to Grant, refused to support any editorial expression against him—a fact which aroused comment and inspired poetry. He also declined to support Blaine

in event of his nomination, and in order that this might be fully recorded he proceeded to caricature most severely the " Plumed Knight " on the eve of the Convention, portraying him as the "magnetic man " who had attracted many undesirable political features; also as being decorated with many objectionable plumes. Nast was not, however, an ardent advocate of the third term idea, believing it to be better on the part of Grant to let well enough alone. Grant himself, in 1875, had said:

I would not accept a nomination unless it should come under such circumstances as to make it an imperative duty, circumstances not likely to arise.

That such circumstances had not arisen, he must have realized, for under date of May 2d he wrote Conkling a long personal letter in which he said:

I fear that the presentation of my name at the convention would not only assist in the defeat of Mr. Blaine, but seriously affect your future, besides warping my career. Even should I be nominated, it could only come after a spirited contest into which much bitterness would be injected; and then I doubt if I could be elected.

The letter contained a plea for reconciliation between Conkling and Blaine, and closed as follows:

I am generous enough to suffer myself rather than to have my friends suffer, if I am convinced that any action of mine would cause them to suffer.

This indicated an entirely changed sentiment from that suggested in the letter written to Nast by John Russell Young, " On the Red Sea," a year earlier. Evidently General Grant had awakened to the insubstantiality of his dream and the unwisdom of attempting to make it real. That he allowed himself to be re-convinced, or at least re-persuaded, resulted in one of the regrettable chapters of our political history.

The Republican National Assembly convened at Chicago, June 2d, though for many days the clans and their leaders had

been gathering and conspiring for their various candidates. Some of the greatest men of the nation were present at this historic meeting—the foremost orators and politicians, the most eminent leaders in parliamentary tactics. No other national convention has ever shown a more brilliant display of history makers than the one which gathered at Chicago during those early days of that memorable June.

Conkling of New York and Garfield of Ohio were the recognized leaders of the two great opposing forces. Senator Conkling led those who were united for Grant, the " stalwart three hundred " who unwaveringly supported their hero to the end. General Garfield had come to Chicago merely as leader of the Ohio delegation for Sherman, but was promptly recognized as being the ablest of those who opposed Grant, and his victory over Conkling in a brief debate on the third day of the convention won him the favor of the assemblage.

Never in the history of American politics has there been a struggle to compare with that which took place at the National Convention of 1880. The Grant organization, under the lead of Roscoe Conkling, fought every move and contested every

THE STATESMAN AT HOME

inch of ground that promised a possible loss to their candidate. The work of the Committee on Credentials was a long and arduous labor. A full four days were spent in the various preliminaries of organization, and it was not until the afternoon of the fifth, which fell on Saturday, that the platform was reported, and it was Saturday night that nominating speeches were made.

The night session was an occasion to stir even the oldest veteran of politics. Men who had been through every national battle of our fiercest political period were aroused and eager for the onset. The vast convention hall aflare with lights was crowded with spectators, and enthusiasm had reached a pitch where outbreak was akin to madness.

James G. Blaine, once more a candidate for national favor, was the first to be placed in nomination by Mr. Joy of Michigan. Thousands in that convention wanted an opportunity to vote for Blaine, and they welcomed his name with a mighty demonstration. Then Roscoe Conkling arose to offer the name of Grant.

In an instant the New York statesman was caught as in a very cyclone of applause. For several minutes he stood there, while it whirled and rioted and tossed up and down that vast multitude which without regard to policy or candidate, remembered only that he was about to present America's foremost citizen and soldier, Ulysses S. Grant. It seemed indeed, as Conkling had predicted, that the name of Grant would carry the convention by storm. The handsome, brilliant senator from New York smiled approval and waited for the lull. It came, at last, and he said:

> When asked what state he hails from,
> Our sole reply shall be
> " He came from Appomattox
> And its famous apple-tree! "

Again he was lifted and silenced by a great outbreak of emotion. Then followed one of Conkling's splendid oratorical

efforts, and had the balloting begun at its close Grant might indeed have been borne in on the high tide of patriotism that swept and billowed over the great assembly.

But General Garfield, with calm and logical mind, rose and quelled the seething waters. Somewhere between storm tide and low ebb, he said, there was a quiet level of safety. Then having allowed the great throng to subside a little, he nominated John Sherman in a masterly speech which made a deeper and more lasting impression than Conkling's magnificent flight of oratory.

The speeches that followed were less notable. The names of Senator Edmunds, Elihu B. Washburn, and William Windom were all presented, and it was close upon midnight when the session adjourned.

The balloting, which began on Monday morning, showed 304 votes for Grant; 284 for Blaine, and 93 for Sherman. Other candidates were honored in lesser measure, and one vote was recorded for Garfield. In spite of Conkling, the New York delegation was divided, nineteen members under the lead of William H. Robertson having voted for Blaine. Then followed twenty-seven ballots, during which the " three hundred " rallied again and again about their old commander, and it was not until Tuesday morning, on the thirty-fourth ballot, that sixteen votes from Wisconsin for Garfield showed the break in the opposing forces, the end of which would be defeat for Grant.

On the announcement of the result of this ballot, General Garfield promptly rose and addressed President Hoar, who regarded him with some trepidation and considerable sternness.

" For what purpose does the gentleman rise? " he asked.

" I rise to a question of order," replied Garfield.

" The gentleman from Ohio rises to a question of order."

General Garfield then challenged the correctness of the announcement.

" No man," he said, " has a right, without consent of the

person voted for, to announce that person's name and vote for him in this convention. Such consent I have not given——"

President Hoar promptly interrupted him at this point.

" The gentleman from Ohio is not stating a question of order," he said. " He will resume his seat. No person having received a majority of the votes cast, another ballot will be taken. The clerk will call the roll."

There was now a general break of the anti-Grant delegates for Garfield, who received 399 votes on the thirty-sixth ballot, the stalwarts, their number increased to 306, remaining loyal to Grant.

A wave of Garfield enthusiasm now rolled over the assembly. Banners were seized and waved above the head of the successful candidate, who pale and dazed sat as one half stupefied.

On motion of Senator Conkling the nomination of General Garfield was made unanimous, and on the first ballot for Vice-President, as a concession to Conkling and his stalwarts, Chester A. Arthur, of New York, was chosen. The greatest of conventions had ended. At last General Grant had met defeat.

NOTE: In his " Autobiography of Seventy Years " Senator Hoar confesses his great admiration for General Garfield, and in relating the incident of the latter's protest in the convention, states that he (Hoar) purposely interrupted him for fear Garfield might say something which would " make his nomination impossible." To Senator Hoar, therefore, is due the honor of having " made a President." It may be for these reasons that the good senator in his chapter on the Credit Mobilier fails to mention Garfield, except to include his name on Ames's list of those to whom the stock was to be offered. Yet General Garfield's relation to this unfortunate episode was identical with that of Schuyler Colfax whose " disingenuousness " and " untruthful story of the transaction " Mr. Hoar does not fail to point out. Both Colfax and Garfield owned Credit Mobilier stock, and both failed to confess the fact before the Committee of Investigation. The single difference seems to have been that Garfield made a statement of general denial and then remained silent, while Colfax continued to protest his innocence. Senator Hoar still further states that Colfax died soon after his term of office had expired, and suggests, at least by implication, that this event, like the death of Ames and Brooks, was hastened by disgrace. As a matter of fact, Ames and Brooks, as we have seen, died immediately after the investigation in 1873. Schuyler Colfax did not die until twelve years later (January 13, 1885), and was no less honored than General Garfield in private life.

CHAPTER XLIX

The Democratic situation in 1880 was complicated by the fact that Mr. Tilden had to be disposed of; for while no one believed that he could be elected, a failure to nominate him would be an acquiescence in the electoral decision of 1876, or, what was worse, a confession that he had been unduly associated with the attempted purchase of the Returning Boards. The cipher disclosures had alienated almost the entire body of independents, who had supported the Democratic ticket in 1876, as well as the Tammany legion under the lead of John Kelly, who still avowed that he preferred the election of a Republican candidate to that of Mr. Tilden. The " Sage of Gramercy Park " had preserved no standing whatever as a Reform candidate. Indeed, in 1880, to have coupled his name with Reform would have excited only derision. It will be seen, therefore, that even had Tilden in some manner obtained the nomination, the possibility of his election would have been exceedingly remote.

Rumors of Mr. Tilden's intended withdrawal came from time to time, to the great joy of Tammany, and Nast depicted Kelly with an ear trumpet to the lips of the " Mummy," calling upon him to declare it " Louder! Louder! *Louder!* "

Mr. Tilden did so declare it, a few days prior to the convention in a letter declining the nomination, much to the relief

of the entire party. Samuel J. Randall, of Pennsylvania; Senator Bayard, of Delaware, and General Winfield Scott Hancock, of Governor's Island, were the foremost remaining candidates.

The Democratic National Convention met at Cincinnati, June 22, and reached a decision without delay. Its platform was a declaration of "Tariff for Revenue Only," and contained a severe denunciation of the decision against Mr. Tilden in 1876, though the convention carefully failed to disregard his letter of withdrawal and nominate him by acclaim.

On the first ballot General Hancock, who had been a presidential candidate as far back as 1868, when he had been used as a stalking horse for the capture of Seymour, received 171 votes; Bayard 153½, and so down the list to Mr. Tilden, whose number was 38. The convention adjourned to combine next day on General Hancock, with William H. English, of Indiana, for second place. It had been an orderly and uneventful episode, and the choice of General Hancock was regarded as wise.

The result of the Republican Convention had been a disappointment to Thomas Nast. He had hoped, of course, for the success of Grant. He had feared for the

"IT IS WHISPERED AGAIN THAT TILDEN HAS GIVEN IN"
THE HON. JOHN KELLY—"*Louder!* LOUDER!! LOUDER!!!"

success of Blaine. He would have been satisfied with any one
of several other candidates, but he had not counted on the
success of Garfield. His " Credit Mobilier " cartoon of May
15, 1873, had expressed his sentiments concerning those impli-
cated in that disastrous exposure, and he had seen no reason
for a change of convictions. He greatly admired General Gar-
field's ability and statesmanship, and he was loyal to the
party represented by the Ohio nominee. He would work for
that party, as hitherto, but he declined to introduce the Repub-
lican candidate into any of the pictures.

With the nomination of Hancock, his difficulties were more
complicated than before. General Hancock was one of his friends
and heroes. He had fought bravely through two wars, and had
distinguished himself on many fields of conquest. His record
was that of a splendid soldier, a thorough gentleman, an upright
and lovable man.*

" I hear you are very fond of General Hancock? " was said to
Nast, when the news came that the hero of Churubusco, Antietam
and Gettysburg was likely to be the convention's choice

" The man, yes; his party, no," the cartoonist replied with
some feeling.

He wrote his troubles to Grant, congratulating him on being
out of it all, urging him to come to New York to review the
situation. But Grant had had enough of politics. He replied
from Galena, June 26th:

Dear Mr. Nast:
I have your letter of the 23d. You had better devour the
proposed luncheon and get another ready sometime in November.
I start next Thursday for the Rocky Mountains, and may remain
all summer. At all events, I have no intention of going East
until after the November election. As you say, I am " out of
the Wilderness," and I feel much relieved thereat. But I don't

* General Sherman once said of Hancock, " If you will sit down and write the
best thing that can be put into language about General Hancock as an officer and a
gentleman, I will sign it without hesitation."

see how you are there. I would like very much to see you, but unless you take a run to Colorado, or come out here after my return, I do not see how this is to be before fall. If you come here bring Mrs. Nast with you. Mrs. Grant would be glad to see you both. Give her and the children my love. Mrs. Grant would return hers, but she is not yet up.

Very truly yours,
U. S. Grant.

Perhaps to relieve himself, Nast opened the campaign with

BOOM !!!—SO NEAR, AND YET SO FAR

S. J. T.—"By Jupiter! can't they understand a joke? Catch me believing in lightning-rods again!"

another caricature of James B. Weaver, who with B. J. Chambers, of Texas, had received the "Greenback" nomination. "Greenback the Weaver" seemed fair game, and one could at least laugh at the vagaries of this midsummer night's dream. Tilden's letter of withdrawal, a "lightning rod" that had failed to attract the nomination, was likewise a mental explosion which helped to clear the air and harmed nobody.

But at this point trouble began. A cartoon showing a general surrender of the various Democratic elements to the brave and soldierly General Hancock was rejected at the Harper office, and briefly strained relations were the result. There was to be no continued break, however. A compromise was effected whereby Nast was to attack party principles without severe caricature of the Democratic leader, and to leave Garfield out of the car-

28

toons altogether. It was upon this basis that the campaign was conducted—an arrangement requiring skill on the part of the artist, with the result that most of the pictures were notable rather for their delicacy than for the customary fierce vigor.

As the campaign proceeded, the Harpers were not altogether satisfied with this idea, and engaged other illustrators to help out with the cartoons. Gillam, Worth, Thulstrup, Woolf and Rogers were tried with varying results. They were all young capable men, but Nast had been so long the political cartoonist of Harper's that the public did not then receive their work kindly, and the press began to comment on the fact that Nast was " no longer allowed full swing." General Garfield's Credit Mobilier association had, of course, been recalled, and the papers did not fail to remember Nast's cartoon on the subject. Neither did they fail to explain at great length just why the Republican candidate failed to appear in Nast's present drawings. Then half of the big Credit Mobilier cartoon—the end which showed the victims of that conspiracy—was reprinted by the Democratic managers, with names carefully put under each figure, and this, with a fac-simile of the Harper title-head and columns of newspaper comments on the investigation, was universally circulated

SHIRKING THE FEAT.

NAST CARTOONED BY PUCK IN 1880

NAST—"I went through that Ring in 1873; but I can't go through it again. I am not that kind of a Jim Nast."

as a campaign document. The stir that this made was such that for a time it would seem as if the situation in Franklin Square was of more importance than the national contest. The Harper's Weekly candidate being destroyed by one of its own pictures, was something to make its enemies rejoice and temporarily forget the larger issue. The added fact that Nast continued to ignore the Republican candidate was an added source of

GENERAL INSPECTION. GENERAL HANCOCK AND GENERAL VACANCY

gratification. Puck cartooned the situation, caricaturing Nast as a bare-back rider on a rocking-horse, blanketed with Harper's Weekly. He points to the Republican " Ring," which he is expected to leap through, and says:

" I went through that ring in 1873, but I can't go through it again. I am not that kind of a Jim Nast."

Eventually Mr. Curtis found it necessary to explain the paper's position, and to announce as he had done six years before, that its real views were to be found in its editorial columns. Some of the Republican papers that had been devoted admirers of Nast, now

took occasion to announce that he never had been much of an artist any way. One excited adherent of Garfield declared that there were at least a " thousand better cartoonists than Tom Nast," a statement which would seem to have been unnecessarily large.

Yet Nast by no means failed to strike blows for his party. On August 28 appeared a double page of General Hancock, regarding sadly the burial field of the Confederate dead at Gettysburg, " The silent (Democratic) Majority," whose " votes he would miss on election day." It was a striking picture, showing as it did the fine dignity of the Northern general who had fought so well, now thoughtfully considering the section where he must look for his chief support. Hancock, perhaps not grasping it fully at first sight, said, " That picture will elect me." But men studying it carefully did not regard it as an argument in his favor, while Wade Hampton's declaration in a speech at Staunton, Virginia, that General Hancock represented the principle for which Lee and Jackson had battled four years, proved so unfortunate that a denial was considered necessary. The tiger during the campaign of 1880 was represented as an emaciated beast starving for office.

THE EMPTY PAIL

Pat—" Where's the dinner ? "

Wife—" Ah! since ye've had stiddy wurrk, haven't ye had splindid dinners ? and now yer always talking about change, change, change, and sure I thought I'd give ye wan."

The September election in Maine was discouraging to the Republicans. Though by a very slight majority, the State went Democratic, which was thought to foreshadow the national result. Both parties now brought every resource into play. That tariff was fully discussed—more fully discussed than understood—and became almost the single issue of the campaign. Democratic speakers declared that high-tariff meant fortunes for the rich at the expense of the workingmen, while Republican orators avowed that "Tariff for Revenue only" meant destruction to home industries and ruin to labor. Democracy insisted that a "change" was necessary, while its opponents held that experiments were dangerous and that no "change" was needed. On October 16 the "Workman's Empty Dinner Pail" was introduced by Nast, to show a possible change which the laborer

would not be likely to relish. It has been said that this picture was the most effective Republican argument put forward during the campaign.

As election day drew near the battle in Ohio and Indiana became very fierce. General Grant forgot that he had gone to the Rocky Mountains until November, and Senators Conkling and Platt of New York, who

THE REPUBLICAN PACHYDERM ALIVE AND KICKING

had hitherto remained inactive, were conciliated through Arthur in a manner which will develop later. Accompanied by Grant, Conkling made a personal canvass of the doubtful territory. The result was marked by Republican victories at the State elections, and the tide had turned.

General Hancock, alas, proved as unskilled at politics as he had been great in battle. Tariff arguments bored him. When he discussed the question he declared it to be a " local issue " and made otherwise so disastrous an attempt that Senator Randolph,

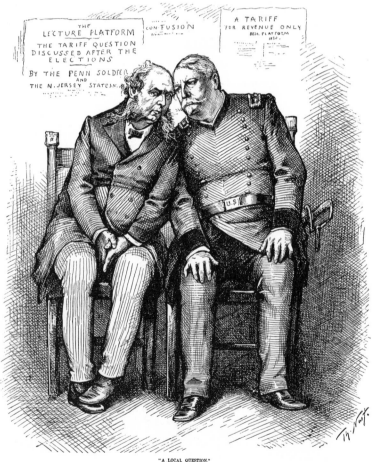

"A LOCAL QUESTION."
"WHO IS *TARIFF*, AND WHY IS *HE* FOR REVENUE *ONLY*?"

of New Jersey, wrote to know if he had not been incorrectly reported. Nast's cartoon of General Hancock asking Randolph, " Who is Tariff and why is he for Revenue Only ? " expressed so exactly the unfortunate soldier's difficulties that everybody, regardless of party, laughed.

Democracy was now reduced to desperate measures. Conspirators, one of whom was afterwards sentenced to a term of imprisonment, concocted the celebrated " Morey Letter," a document purporting to have been written by General Garfield to one mythical H. L. Morey, of Lynn, Massachusetts. In it the writer declared in favor of cheap labor, and assumed an attitude entirely at variance with the party doctrines.

THE DEMOCRATIC PARTY SHOULD RETAIN ITS ORGANIZATION

This letter, though a rather clever forgery, was instantly exposed, but not before it had obtained universal circulation as a campaign document, and the sanction of the Democratic managers and press. Coming at so late a date, it is said to have cost the Republican candidate a number of electoral votes, though not enough to result in his defeat.

The returns gave 214 electors to Garfield as against 155 secured for the Democratic candidate. Well for Hancock that he had failed. Like Grant he would have found the hordes at Washington harder to combat than had been those at Gettysburg. Nast closed this political episode with a fine tribute. The defeated candidate sits bowed and gazing into the fire, while the spirit of Columbia, her hand laid lightly on his shoulder is saying:

" No change is necessary, General Hancock; we are too well satisfied with your brave record as a Union soldier."

"NO CHANGE IS NECESSARY, GENERAL HANCOCK; WE ARE TOO WELL SATISFIED WITH YOUR BRAVE RECORD AS A UNION SOLDIER."

CHAPTER L

A NATIONAL FEUD AND A TRAGEDY

During the campaign of 1880, process reproduction had largely taken the place of the old hand-engraved block. Drawings were now made on paper and reproduced by a photo-chemical process. Nast's hand did not immediately accommodate itself to the change from the soft pencil and smooth hard surface of the box-wood to the pen, ink and yielding paper of the new way. Also, there was the idea of reduction to be considered—of drawing larger than the picture was to appear when published—and the chemical engraving process was still far from perfect. Often the acid bit into the lines, leaving them hard and harsh, some-times altogether destroying the more delicate touches. For a time there was what seemed to be a falling off in the quality of the cartoonist's work. Journals that had opposed his views did not fail to wax critical, to assert that Nast's hand had degen-erated, that he could no longer draw, that his day was, in fact, over.

But whatever grounds there may have been for these adverse opinions would seem to have vanished by the beginning of the new year, for the holiday drawings were never so good—not only in spirit but in technique—and were reproduced by the London papers, who realized that English as well as American

children had a special affection for the merry Santa Clauses of Thomas Nast.

Politically, the opening months of 1881 were not especially interesting, at least not from the pictorial point of view. Foreign complications over the Suez Canal and the anti-Jewish agitation in Germany were matters only slightly noted by the great American multitude. At home there were the usual complaints against public officials, who may never hope to please while human nature is embodied in human clay.

PEACEFUL-NEUTRALITY.
The Position of England and France on the Suez Canal

But if there prevailed a general quiet among the public at large, there was also a mighty quiver of expectation amid the hordes of office-seekers who had flocked to Washington in readiness for the presidential change. Four years of Hayes and Civil Service had proved a severe trial to the great unqualified, who were now ravenous for place and rabid in their demands.

There existed a belief that Garfield would dispense patronage somewhat after the ancient fashion—that to those who had helped to reap the victory would be allotted a share of its fruits, not to say spoil. It was understood that certain pledges had been given—it was taken for granted that assurances more or less positive had been distributed with a liberal hand. The Stalwarts, under Conkling and Platt, with the aid of Grant, had rendered incalculable service in the doubtful states, and while

HOW THEY EXPECT TO GET ON A SOUND
FOOTING

GIVE THE RED MAN A CHANCE

the terms of the bargain were not known, it was assumed that nothing short of the New York state patronage would be accepted by its senators as their reward.

On the other hand, the so-called Half-Breeds, who had been responsible for Garfield's nomination and formed the larger portion of his following, were not to be gainsaid in their claims or put off in their demands. The circumstances of his election made the new President's position difficult—more difficult than was generally realized—and whatever may have been his higher qualifications, and doubtless they were many, he lacked that breadth of political understanding and diplomacy without which the conditions were certain to result in embroilments and did lead to tragedy.

The friends of Garfield were early concerned for his welfare. Knowing the man, and the bitterness of the factions with which he must deal, they advised extreme caution. An old classmate—a man in the foremost rank of American letters—wrote, urging him to make Civil Service Reform his safeguard. Garfield replied that he believed in the Civil Service idea, but that

NEW YORK IN A FEW YEARS FROM NOW
(A prophecy of 1881)

"DAS DEUTSCHE VATERLAND" IS ABOVE CRITICISM.
FROTH—" I will cut you into small pieces if you say dem mean tings again!"

certain things seemed to him " expedient " and therefore necessary. Yet Garfield would appear to have been the last man to carry out a policy of expediency. From the beginning it seemed his purpose to humiliate the men who had saved him the doubtful States. His appointment of Blaine as Secretary of State was a mortal offence to Conkling, and was regarded with disfavor even by friends of both the President and the Maine Senator. Senator Dawes warned Blaine that his position in the Cabinet would be a detriment to the Administration and to his own career.

The selection of Charles J. Folger of New York for the Treasury portfolio in opposition to Conkling's earnest advocacy of Levi P. Morton did not improve matters, and though Folger declined the appointment the New York senators were not appeased. When it became known that Thomas L. James, formerly postmaster in New York City, had been chosen for the position of Postmaster General, Conkling and Platt, in company with Vice-President Arthur, called at Garfield's apartment in the Riggs House, where Conkling, in a furious burst of anger, charged the President with unfaithfulness to his word and dis-

loyalty to his party. That the President's course had been directed by Conkling's deadly enemy, Blaine, cannot be doubted. That the President had opened the way to a charge of bad faith is equally certain. The four men in that room knew precisely what the terms with the Stalwarts had been, and Conkling spoke by the card. His rage, violent and unseemly as it must have appeared, was politically just. To one of those who listened—Chester A. Arthur—the President's repudiation of contract meant a sorrow and a humiliation which would go with him to his grave; and of this, later, we shall learn as from his own lips.

Conkling's wild outbreak did not advance his cause. He stormed and threatened, while Garfield sat stubborn and unyielding, though filled (as were all present) with gloomy foreboding as to the outcome.

The feud grew and alarm spread through the party. It began to look as if the old Republican organization, which had been the outgrowth of a great national issue, was itself to go to wreck in a tempest of civil strife. When the President named, as Collector of the Port of New York, William H. Robertson, leader of the nineteen delegates who had opposed Grant at Chicago, the fury of Conkling rose to heights that were really appalling.

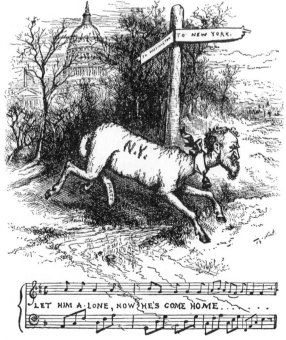

LET HIM A·LONE, NOW HE'S COME HOME. . .

A committee of five was appointed to meet and discuss the matter with him. Conkling appeared before this committee and in his own marvellous manner recited his wrongs. Later, the chairman, Senator Dawes, said: " He surpassed himself in all those elements of oratorical power for which he was so distinguished. . . . He continued for two hours and a half to play with consummate skill upon all the strings known to the orator, and through all the notes, from the lowest to the highest, which the great masters command."

Conkling ended by declaring that he had in his pocket a letter written by the President which he prayed to God he might never be compelled in self-defence to make public. " But," he cried, " if that time shall ever come I declare to you, his friends, he will bite the dust! "

The letter in question was one addressed by Garfield to the Chairman of the Congressional Committee, Hubbell. It began, " My Dear Hubbell," and contained an inquiry as to the progress of the campaign assessments, including those from government employees. From a political point of view it was not, at this period, thought especially reprehensible, and Garfield's friends urged him to forestall Conkling with its publication. This he did not do, though its appearance later added little to the disorder and scandal which already prevailed. Further efforts were made to reconcile Conkling and the President, but without success. General Grant undertook to mediate, but to no purpose. Conkling would agree to nothing short of complete surrender and the fulfillment of what he held to be the terms of agreement. Arrogant, brilliant and vainglorious, he believed he could rule or ruin his party, and it is maintained by those most nearly related to him that Senator Platt encouraged him in this belief. On May 16, as a final dramatic coup, he resigned his seat in the Senate, believing his state would indorse his action, and rebuke the Administration by triumphantly restoring his seat. Senator

Platt also resigned, thus earning the sobriquet of " Me too," which he was to bear through life. Neither was returned. Two Half-Breeds, Warner Miller and E. C. Lapham, were chosen, and Conkling retired to private life. Platt, patient, suave and skilled at intrigue, bided his time—making and unmaking public officials—to be returned to the Senate in 1896.*

During the beginning of the party difficulties Nast had said but little. Factional quarrels seldom appealed to him.

In May, however, while the fight over Robertson was still on, he gave vent to his feelings in a picture of Conkling and Blaine tugging in opposite directions at the Presidential Chair. A little later, Conkling as a bell-weather, with Platt as the tail, comes galloping back to New York, with this line of advice below, " Let him alone, now he's come home."

For whatever may have been Nast's disgust with the situation as a

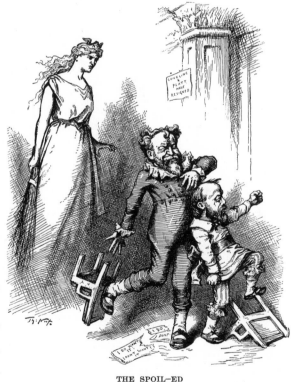

THE SPOIL—ED

New York (*meaning business*) : " I know what you DO want ! "

* Roscoe Conkling was a great lawyer, and President Arthur, in 1882, offered him a place on the Supreme Bench, which he declined. He was a talented, spectacular strong-headed man. He was also a patriot, and it is to his credit that he made no money out of politics. He died in the great blizzard of 1888, and his statue stands to-day in Madison Square.

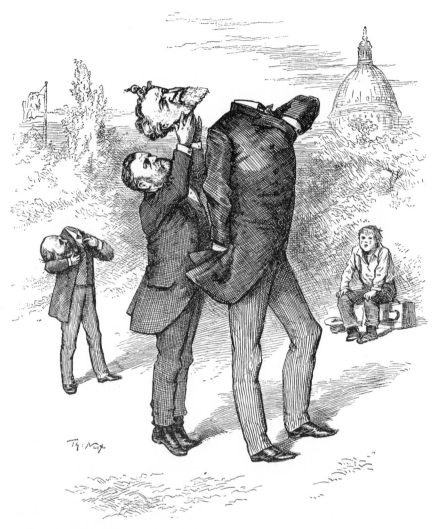

whole, he could not but disapprove of the Conkling-Platt
determination to control or destroy the party because of a per-
sonal grievance. Conkling and Platt as two unruly boys about
to be chastised significantly follows this, and then that great
cartoon series, so often used since in idea, the " Lost Head."
The first of these was a small picture, showing Conkling walking
proudly away from the Capitol, his head lying behind him in the

road—a street gamin trying to attract the Senator's attention to his loss. In the next picture, General Grant, who had returned from Mexico for the purpose, is making a futile effort to set the lost head in its proper place. The body of Conkling stands stiffly erect, and Grant cannot reach high enough to put the head in place. No line was put under this picture, but immediately after its publication, an up-state editor wrote to the artist that his little girl, seeing the picture over his shoulder, had remarked:

" Papa, why doesn't he stoop a little? "

Certainly no title could have been more appropriate, and this childish comprehension of his idea pleased the cartoonist more than all the notice which the picture had attracted.

But far more attention and vastly more condemnation was aroused by a picture which appeared on the first of July. Matters by this time had become sufficiently disturbing. The breach in the party was widening every moment and the hope of reconciliation was waning dim. It became known that Vice-President Arthur had recently made a trip to Albany to see Conkling and Platt, sup-

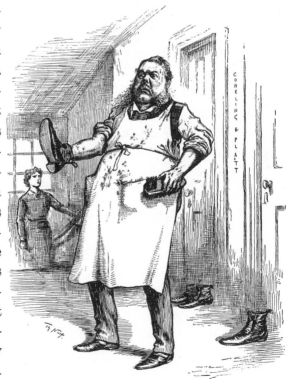

OUT-" SHINING " EVERYBODY IN HUMILIATION AT ALBANY

" I did not engage you, Vice-President ARTHUR, to do this kind of work."

(See also reference, page 486)

29

posedly for the purpose of winning them back to the Administration. Nast launched a protest in one of his severest cartoons. " Out-'shining' Everybody in Humiliation at Albany " showed the Vice-President polishing the shoes of Conkling and Platt. It naturally awoke a storm of denunciation from such journals as had a grievance against Nast, regardless of party. Yet the picture was eminently true. Arthur had been humiliated to a degree which Nast, then, did not even guess. As had happened so many times, he had pictured better than he knew.

The picture was the more disturbing because of what immediately followed its appearance, for on Saturday, July 2, came the tragic end—the assassination of President Garfield by Charles J. Guiteau, a crack-brained office-seeker, whose disordered intelligence had been over-wrought by party difficulties and dissensions. Doubtless he began by believing that the life of Garfield stood between him and political appointment. His statements indicated that he had persuaded himself that Garfield's removal was necessary to the preservation of the party. Later he claimed that the Lord had commanded him to commit the deed. He professed to be a " Stalwart of Stalwarts."

" I am a Stalwart and want Arthur for President," he said when arrested.

He was, in fact, a wretched human creature of debased and deformed intellect.

Nast had been none too friendly to Garfield, but the tragedy appalled him and filled him with sorrow. He portrayed Liberty with two stains at her threshold. A smaller picture was entitled, " The Biggest Blot on Our Spoils System—Office or Death."

Anxious days followed. A whole nation forgot all feuds and bickerings in waiting for bulletins that told of a strong man's battle for life.

As the summer waned it became evident that the President could not survive. Nast's cartoon, a fine double page, entitled,

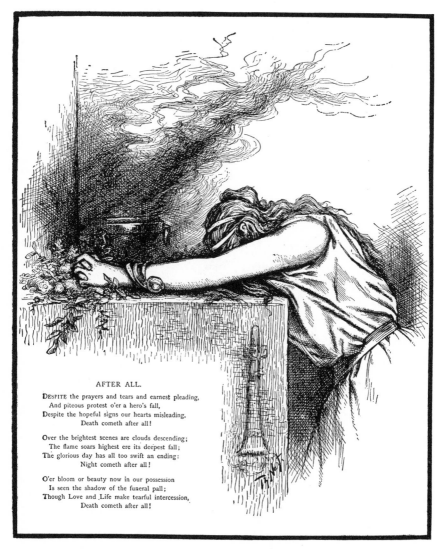

AFTER ALL.

DESPITE the prayers and tears and earnest pleading,
 And piteous protest o'er a hero's fall,
Despite the hopeful signs our hearts misleading,
 Death cometh after all!

Over the brightest scenes are clouds descending;
 The flame soars highest ere its deepest fall;
The glorious day has all too swift an ending:
 Night cometh after all!

O'er bloom or beauty now in our possession
 Is seen the shadow of the funeral pall;
Though Love and Life make tearful intercession,
 Death cometh after all!

"God Save the President," was published but a few days before the end, which came September 19. A front page, entitled, "After All," was a noble expression of the nation's grief.

George William Curtis in his editorial estimate of Garfield says, "He was a statesman much more than he was a party leader"—a conclusion which is likely to stand the test of time.

LIVE AND LET LIVE IN RUSSIA

MUTUAL ADMIRATION
(Barnum and Jumbo)

CHAPTER LI

THE DAWN OF REFORM

The administration of President Arthur did not begin auspiciously. The circumstances of his nomination and of his succession were against him in the hour of his inheritance. Nor were his record and his affiliations regarded with favor. Under Hayes he had been removed from the office of Collector of the Port of New York on the grounds that his methods in the Custom House had been political rather than businesslike. He was regarded as an excellent gentleman, with a weakness for his friends. Reckoned as an ally of Conkling, then in deep disfavor, he had been fiercely caricatured and criticised, as we have seen. Curtis, in an editorial more or less sympathetic, referred to him as " an amiable gentleman, long engaged in practical politics, with no administrative experience except such as he acquired as Collector of the Port." The fact that he had maintained a demeanor that was at once discreet, dignified and delicate, through all the trying weeks of Garfield's illness, was the one thing which the majority of the press had to say in his

behalf. Nast greeted him with an emblematic cartoon, in which Justice confers on him the sword of power, with the admonition that he

> " Use the same
> With the like bold, just and impartial spirit
> As you have done against me."

To which Arthur replies:

> " The tide of blood in me
> Hath proudly flowed in vanity till now;
> Now doth it turn and ebb back to the sea."

The new President's brief inaugural address made a good impression. It was modest and sympathetic and awakened in the American people that responsive sympathy which is the first step toward confidence. Nast never again found cause to criticise Arthur, and eventually became his loyal admirer and friend.

The administration of President Arthur proved to be one of the most dignified, careful and upright in our history. Fairness, firmness and calmness were his executive attributes. The men who had scoffed and railed at him learned to honor his

THE QUEEN OF INDUSTRY; OR, THE NEW SOUTH

integrity and to respect his attainments. We have only to recall the succession of Andrew Johnson—under conditions somewhat different, it is true, though scarcely less trying—to realize the debt of gratitude this nation owes to Chester A. Arthur.

Yet the autumn elections of 1881 did not bespeak favorable conditions. There was a general " scratching " and " bolting " —a shattering of old idols, the upbuilding of new. Every word and act of the President were regarded as significant. It was prophesied that the usual fate of Vice-Presidents who succeed the Chief Magistrate would overtake him. It was not until his annual message in December that the tide really turned in his favor. It was a moderate document, full and clear, and distinguished for its elegance of diction. Feuds and factions which had threatened to wreck a party and disgrace a nation were—for the time at least—relegated to the background. The new year opened with the public eye directed at Congress rather than toward the President.

During 1882 the work of Nast became somewhat less positive than heretofore. It became more the semi-critical pictorial comment of to-day than a distinct and dominating force. More and more the policy was absorbing the individual, and with an outreach that was circumscribed, and an uncertainty as to the acceptance of his work, which now, as in the days of his earliest employment, was critically considered and debated upon, the time had come which five years before Parton had foreseen, when he wrote, " That feeling of doubt would paralyze your arm in another than the physical sense."

It was not that his work was less appreciated by his publishers, or that the relations betwen them were less cordial. A connection which had endured for twenty years had become something more than a mere matter of business. The younger Harper families and the family of Nast had grown up almost as one. They constantly visited back and forth and the intimacy

between them was that of blood relationship and genuine affection. The difficulty lay in the fact that, as the new times were not the old times, so the new conditions were not the old conditions; the new publishers were not the old publishers; the new cartoonist must become part of a policy where the old cartoonist had been an individual and a leader of men. His career had begun so early in life that he had lived to see the old order change while he was yet in the full bloom of manhood and power. It was difficult for him to comprehend the situation or to consider it fairly. He grew ever more restive under the restraints, and dreamed more continuously of the newspaper which was to be his own, and free. He had been an autocrat and a leader so long—so firmly sustained and so surely vindicated— that he had no doubt of his ability to continue his success on the old lines. He yielded with poor grace to this new order of things which was to make him but a part of a vast complex mechanism, the whole kept in motion and whirled and driven by a resistless tide of events. Neither did he doubt that eventually some of the money which he had invested, and continued to invest as fast as it accumulated, would return to him in great increase, when all would be well again.

THE "TALL SYCAMORE" HANDLING THE BRITISH LION

The Star Route investigations and prosecutions which had been dragging through courts and committee rooms came prominently to the fore in 1882. These Routes were mail lines, indicated on the postal maps by a star, leading to points not reached by the railways. Mail to these points was carried by vehicle or on horse-back. A ring of officials controlled the contracts for payment of the carriers, and, somewhat after the manner of the old Tweed transactions, arranged to have such contracts drawn for amounts from five to ten times the cost of service. The bills were allowed and the profits, which ran into millions, were divided—just as the bills of every ring have been allowed and allotted and will continue so to be until the millennium's dawn.

These frauds had been known for some time and when Postmaster General James took charge of his department he declared that he would push the prosecutions regardless of whom they might involve. Thomas W. Brady, Second Assistant Postmaster General, was charged with being party to the Star Route transactions. He was defiant, and announced that he would publish a " Hubbell " letter written by Garfield unless the prosecution was brought to a close. Brady declared Garfield had meant that besides obtaining " voluntary contributions " from the Government employees he was to get funds from the Star Route contractors. Brady's trial was postponed and he was not convicted. Ex-Senator Stephen W. Dorsey of Arkansas was likewise supposed to be a prominent offender, and, among others, was indicted for conspiracy. Colonel Robert G. Ingersoll believed Dorsey innocent of the charge and became his counsel. It has been claimed that Colonel Ingersoll received large sums for his services. On the contrary, he received nothing whatever, but lost a very considerable amount through indorsing the notes of the men he defended. He was severely criticised, however, and the caricaturists, Nast among them, had their way with him. In one of Nast's pictures

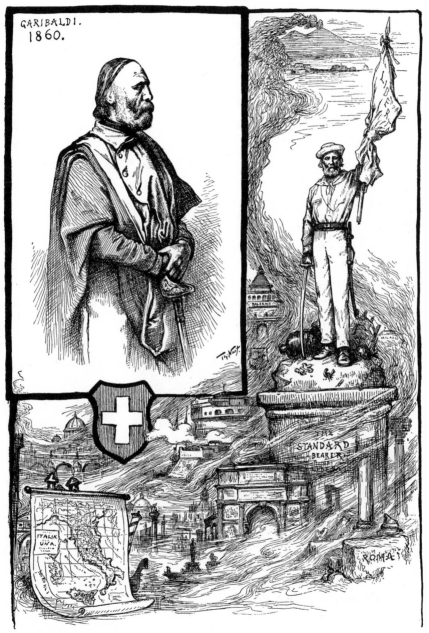

GIUSEPPE GARIBALDI: DIED AT CAPRERA, JUNE 2, 1882

the " Stars " are asking: " What shall we do to be saved? " and Colonel Ingersoll, with a copy of a book entitled " There Is No Hell," replies, " Read This." " But I fear it may be made hot enough for us here," answers the " Star," looking toward the penitentiary. Whatever the truth may have been, the verdict finally rendered, June, 1883, was not guilty as indicted.

Perhaps the most important picture of 1882 was a page in commemoration of the life and career of Garibaldi. At his island home, Caprera, on June 2, the boy artist's first great hero, Garibaldi the Liberator, reached the end of his tumultuous journey. He had lived to see his great work accomplished, and died beloved and honored of all men. He had made mistakes, but they were errors of judgment, never of intent. During his final years, his rock-bound retreat had been the shrine of those devoted to the cause of liberty. Gracious, charitable, pure-hearted and brave, he died as he had lived, a man of and for the people, one of the world's foremost heroes, one of the noblest benefactors of mankind.

In his picture, Nast showed Garibaldi as he had sketched him

NOTHING SUCCEEDS LIKE SUCCESS.

MIGHT MAKES RIGHT.
Q. "Upon what meat doth this our Cæsar feed, that he is grown so great?"
A. "Small game—blackbirds."

from life on that day at Caserta, twenty-two years before. No picture of Garibaldi has more of the man's simple dignity than this one by Nast, and no one recalled the hero of Marsala and Palermo with greater honor and deeper affection than the boy who had followed with the red shirts in their march of triumph so long before.

It was during the summer of 1882 that European difficulties

AN INSIDE VIEW.

EXPECTED NEWS: THEY WILL BOTH BE SO SORRY.

with Egypt, in which France and England were chiefly concerned, began to assume a serious aspect. The bombardment and partial destruction of Alexandria by English ships of war, on July 11, was the result. Nast took a rather vigorous interest in this embroglio, and did not miss the occasion to point out the inefficiency of our own navy, which President Arthur, through Secretary William E. Chandler, was already making an effort to rebuild.

Those "voluntary contributions" to campaign funds, requested by Mr. Hubbell again became a matter of public interest at this time, and a number of the solicitous letters were printed. One of them will be sufficient to show the character of these invitations. The following is a copy of the form sent to Pennsylvania employees:

Dear Sir: Our books show that you have paid no heed to either of the requests of the committee for funds. The time for action is short. I need not say to you that an important canvass like the one now being made in an important State like Pennsylvania requires a great outlay of money, and we look to you as one of the Federal beneficiaries to help bear the burden. Two per cent. of your salary is ——. Please remit promptly.

At the close of the campaign we shall place a list of those who have not paid in the hands of the head of the department you are in.

It was such insolent demands as this, and the conditions which had resulted in the tragic fate of Garfield, that awoke at last a genuine response to President Arthur's appeal for Civil Service Reform. The bill introduced under Hayes, by Senator Pendleton, an Ohio Democrat, was promptly forwarded and received President Arthur's signature, in January, 1883. It provided for competitive examinations and classification of employees, and declared that no official could be removed for failing to contribute " voluntary " assessments. It further provided that any Government official convicted of soliciting or receiving such contributions should be subject to a fine of $5,000, or three years' imprisonment, or both. This effectually put a stop to most of the transactions of the " Hubbell " nature, and was accounted a very long step toward the better conditions which have since prevailed.

THE NEW ANGELIC FLYING MACHINE—(PATENT APPLIED FOR)

GROVER CLEVELAND (*head angel*)—" Be careful in adjusting the wings. See that they *do not clash.*"

The veto by President Arthur of the River and Harbor Bill, a vast aggregation of jobs and steals, was another act which brought him the applause even of those who opposed him politically. It would seem the President was in a fair way to become his party's leader during the next cam-

paign. Yet certain party elements which had gradually crystallized during this quiet political summer, refused to assimilate for any purpose, however good.

The Gubernatorial election in New York found Judge Folger, who could count on nothing but his own individual wing of the party, matched against Grover Cleveland, a Democrat who, as Sheriff

DEEP DIPLOMACY

JOHN KELLY: " I'll let them have their way *before* election, but—

and Mayor of Buffalo, had placed himself on record as an upright official, and who could count, not only on a reasonably full Democratic support, but also on a very large portion of the variously disaffected Republican elements.

In Nast's first picture of Cleveland, October 14, 1882, we find the Democratic candidate standing before the mirror, regarding with some complaisancy his robe of spotlessness, while the two wings of Democracy are being adjusted to his shoulders. That Cleveland was getting ready to fly Nast foresaw. In a second cartoon, October 28, he is shown as Governor of New York, taking a flyer for the White House—another instance of Nast's absolute clearness of insight into political conditions. Cleveland was not even Governor as yet, and as a Presidential possibility had not been named.

THE CURIOUS EFFECT OF CLEAN LINEN UPON
THE DEMOCRATIC PARTY

That Cleveland's notions of reform had caused his Democratic wings to be turned upside down, as shown in Nast's pictures, in no way impeded his flight. He carried the State by one hundred and ninety thousand votes, a plurality greater than ever had been known in a contested State election. In Massachusetts, General Butler was likewise rewarded with the governorship, and at Washington the House of Representatives once more passed into the control of Democracy. Truly the Republican Party had been taught that a house divided against itself is in imminent danger.

Yet the result was not so much an approval of Democratic principles, or policies, or measures as a tremendous rebuke from the people, administered to bosses and rings and corrupt political methods. The Grand Old Party which had put down rebellion and abolished slavery had become as a rendezvous of spoilsmen—a harbor of rascality. Like an army that has been mustered out, yet remains in the field, it lacked organization and its chief purpose was plunder. Men not blinded by partisanship realized this, and that the time had come when it was not a question of party, but of a leader—the man who would oppose and defeat the spoilsmen and keep his own record clean.

EGYPT, A PRESENT FROM GLADSTONE

JOHN BULL: "Dear me! who could have put that in my stocking? It must have been that grand old man—Santa Claus."

CHAPTER LII

NEW YEAR'S JUMP WITH HOPE WINS AGAIN

With the opening months of 1883 Nast began investing money with the firm of Grant and Ward. This firm was originally composed of Ferdinand Ward and U. S. Grant, Jr., with J. D. Fish, President of the Marine Bank as a special partner. The business of the firm was supposed to consist in supplying money for carrying out railway contracts, and was believed to be profitable. It was "boom" times in railway building. Fortunes were made easily and with great expedition. The firm of Grant and Ward was presently rated "gilt edge," and eventually was regarded as being worth no less than fifteen millions of dollars.

In 1880, General Grant, knowing nothing of the real nature of the business, as indeed no one knew except Ward himself, whose influence is said to have been little short of hypnotic, invested all his savings, $100,000, with the firm, there being an understanding that he was to be liable only for the money put in.

There were many such investors, and among them, in 1883, was Thomas Nast, who sold the Harlem lot for that purpose, believing that the profits on this last $30,000 would replace all that he had lost through former investments. Bad judgment can hardly be charged against him in this instance. He knew that many of his nearest friends, including General Grant, were receiving fine dividends on their money. The firm had existed for a number of years, and there had been no hint that would suggest even a suspicion as to its integrity, or that the nature of its transactions was not wholly legitimate. Some of the greatest

PLUCKED TURKEY

business firms in New York trusted themselves completely in Ward's hands, while to be permitted to invest in the firm's undertakings was a privilege accorded only to a favored few.

In fact Nast's dividends presently became so liberal that it seemed to him he might now afford to give up the old Harper arrangement, which had become less satisfactory as each year the publishers regarded rather more doubtfully his tendency to startling reforms and radical political views. It is true the political situation was very delicate at this time, but delicate situations are rarely improved by being avoided, and if it was the paper's purpose to be right at whatsoever cost—a conclusion which may be assumed from the developments of a year later—it would seem that the keen prophetic insight of Nast might have been safely trusted in the subject matter of his cartoons.

Comparing the Weekly of this period with the files of ten years before the difference is very marked. It would appear to have become less a paper for the man than for his family, more

social and domestic than political in its pictures, partaking somewhat of the nature of the Bazaar. In the issue of February 17, 1883, a girl's valentine story, with an appropriate picture, begins on the front page. Certainly this was a different journal from the one which had been instrumental in destroying Tweed, and Nast felt that such work as he could do best had little place in its pages. On March 16 he expressed himself on this subject in a letter to Mr. John W. Harper, then in charge:

My dear Mr. Harper:
Since you have taken exclusive charge of my drawings, they have appeared less and less frequently in the Weekly, and I think I have observed faithfully the letter of the agreement. For some years past my work has been refused at times, but some reason has been assigned for it, generally that the subjects were adverse to the interests of the house.

Of late, however, no such motive could apply, for noticing how often they were suppressed I have been careful to avoid doubtful subjects. Still they have met the same fate persistently, and whenever you have selected any for publication you have invariably chosen the smallest.

Hence, I am forced to the conclusion that for some reason unknown to me, my drawings are no longer of use to you, and that under those circumstances you certainly cannot care to continue the arrangement with me. . . .

Of course, nothing having been said up to January 1, I naturally considered the agreement binding for another year, and have refused good offers. But as it is, I have decided that it would be best for both parties to bring it to a close at the end of the first quarter, April 1.

The agreement as to the retainer, made ten years ago, may also expire at the same date. Yours truly,
 Th. Nast.

The reply to this proposed resignation came promptly:

My dear Nast:
Your dynamite communication of the 16th inst., in which you decide to exchange old friends and long friendships for new, came to hand, very singularly, on St. Patrick's Day. The conduct which you criticise has not been that of any one member of our firm exclusively, but we have advised with one another, as is our habit in other business questions. Whenever your work

has been omitted, there have been good reasons, in our judg-
ment, for such omissions, and explanations have been made
frankly when you have given us an opportunity to do so by your
presence. In many instances, I think, you have agreed with us.
Recently you have avoided me altogether, but I did not suspect
it was from any unfriendly feelings; I supposed it merely acci-
dental. From your point of view, I am not surprised at your ex-
pressions; but you ought to remember that we have to consider
these matters from a business standpoint, as well as from their
artistic merits.

I shall submit your letter to the firm, for whom it is in-
tended, and in any event I shall hope that our friendly inter-
course of so many years may not be interrupted because we differ
in questions relating wholly to business.

<div style="text-align:right">Yours very truly,
John W. Harper.</div>

P. S.—Perhaps you had better not disturb the retainer feature
just now, but take more time to consider before cutting loose
from Your Franklin Square Friends,

<div style="text-align:right">H. B.</div>

This was friendly enough, but it did not adjust the matter.
Nast chafed under the policy of discussing the pictures to find
possible flaws. He recalled with fondness the old days when one
man, Fletcher Harper, had been supreme. " Too many cooks
spoil the broth," he declared, which old adage differs but little
from the more recent saying of one of America's foremost news-
paper owners, " There's no paper big enough to stand the mis-
takes of more than one man." The retainer feature, which pre-
vented Nast from contributing elsewhere, was allowed to remain
undisturbed, but his drawings for that year ceased with the
end of March.

In May he sailed for England, partly on business, but
chiefly for recreation. General Grant gave him a letter to
friends in Europe, who eagerly made him welcome. It proved
a pleasant if not a profitable trip. In London he was variously
invited and entertained by painters, politicians and men of
letters. Edwin A. Abbey, already settled abroad, gave him a

dinner, to which a number of well-known artists and literary men were invited. William Black, and Mr. Laffan, now of the New York Sun, were present. Sambourne of Punch sent characteristic regrets in picture and rhyme.

" E. Abbey, Esq.,
 Poet Laureate,
 54 Bedford Gardens:
My dearest Abbey,
Don't think me shabby,
Your festive kabby,
Poor me can't nabby,
I dine with Labby,
M. P., North Abbey,
Who sleek as Tabby,
Black, white or drabby,
This mouse does grabby,
That's all my blabby,
I'm awfully sorry but can't be helped.
 Ever thine."

During his stay in London Nast attended a State concert, given at Buckingham Palace, " By Command of the Queen," and the pretty, lace-edged, purple-printed programme already seems curious and quaint in this day of different printing. Literary men, painters and members of the nobility entertained him at their clubs and homes, honors which gratified him, no doubt, but tired him rather more, while the high-living incident to his gay life made him bilious. He sailed for America rather early in the summer, and with Mrs. Nast spent some weeks at Saratoga, drinking of the beneficial waters.

Returning to Morristown for a period, they were once more visited by General and Mrs. Grant, accompanied this time by Colonel and Mrs. Frederick D. Grant, then living in Morristown. After their trip around the world, General Grant and wife had presented the Nast household with a pair of rare cloisonné vases, bought for that purpose in Japan; but various travels and duties had prevented their meeting since the Nast dinner

given on the eve of departure, six years before. Many changes had taken place. Fortune and misfortune had befallen them all. Now, once more, with continued and increasing returns from the Grant and Ward investments, in which all were interested, prosperity seemed to smile and the family dinner was a cheerful reunion.

There was no elaborate service this time.

" What would you like for dinner, General? " Nast inquired, when he gave the invitation.

" Well," said Grant, " if you knew how tired I am of little birds, you would give me corned beef and cabbage."

So this was what they had, and all formality was forgotten in the old-fashioned home dinner. Grant has been called a silent man, but he was not so on such an occasion as this. He talked continuously of his travels and in a most interesting manner. When asked what had most impressed him on his trip, he said:

" The decay of the Latin races. They are doomed—doomed! "

A few days later, during the General's visit, Colonel Grant and wife gave the Nasts a return dinner, a similar and no less happy housewarming.

In October, 1883, the Nasts resolved to fulfil an old promise to themselves to go over their wedding trip again. They journeyed to Albany and Buffalo, thence to Niagara, stopping at the same old hotel, the Cataract House, where all day and night may be heard the thunder of the Falls.

Twenty-two years had passed, but the old romance grew young again. Other guests believed them lately wed, and when told of the four children at home—one of them half as old as her mother, and already a young lady—they listened with incredulous ears. Thomas Nast, even to his last days, had the air and step of youth, and the Nasts were a couple young for their years.

They continued their journey into Canada, where, at Montreal, Mr. Nast contracted a severe cold. They had intended visiting

Quebec, but re-
turned home in-
stead, and none too
soon, for pneumonia
developed, and
though promptly
taken in hand and
combatted, the art-
ist was left weak
and prostrated. It
was not until he
made a trip to Flor-
ida during the win-
ter—a journey made
with the Earl of
Huntington (Chair-
man of a Florida
Land and Mortgage
Company), his son,
Lord Hastings, and
a pleasant party of
investors and pleas-

A CORNER IN THE NAST PARLOR

sure seekers—that he recovered his health and was in a condition
to renew his work. While on this trip he was constantly inter-
viewed as to his plans and political views, for his absence from
the Weekly had not failed to arouse the usual curiosity and
surmises, while the fact that it was longer than ever before led to
the belief that the separation was final.

Such, however, was not the case. The letters which had flowed
into Franklin Square, calling for the old artist and the old pic-
tures, had not been without their result. As usual, a number
of good men had been tried—some of them our foremost car-
toonists of to-day—but the readers of the Weekly demanded the

old favorite and would not be gainsaid. Perhaps they did not recognize so easily the familiar political faces when portrayed by new hands, for it was during this period that we first find adopted by the Weekly the practice so prevalent to-day of labelling the different cartoon figures with their names.

As early as September we find a letter from J. Henry Harper, one of the third generation of this remarkable family and afterwards head of the firm, in which he urges the wandering artist to return. He had been always fond of Nast, who seemed to him almost as a father, or as an elder brother, and he wrote to him with the spirit of youth.

Dear Nast:
I have thought and worried over what you told me when we separated last night.
I then understood you to say, but I hope my inference is incorrect, that you have concluded to sever your connection with us. I have not since mentioned the matter to any member of the firm, but I think I ought to know what your determination is, for they have now apparently given me charge of the Weekly. Nothing has been done as yet to fill the void in that journal which your absence has created, and I consequently feel that if you have irrevocably made up your mind to leave us that we must make some attempt to fill that vacancy. I can't add anything to what I have already said to persuade you again to take up your pencil for us, but the Weekly must endeavor to forge on again, and if we fail to secure the services of the old-experienced and well-beloved staff who have fought with us through so many successful campaigns, we will, alas, be compelled to hunt around among the untried and uncongenial lesser lights to prepare for the fight which is hard upon us.
I write without consulting anyone, and will look for your answer, I must own, with sad misgivings. I know, however, that whatever decision you may make will be from a conscientious sense of duty, and I remain as ever,
Faithfully yours,
J. Henry.

It was not in Nast's nature to resist a letter of this sort, though he could not, at the time, give a positive answer, leaving the firm free to replace him, should this become necessary. Nothing

definite was done, and on October 30 his old friend, Joseph W. Harper, Jr. (" Joe Brooklyn "), wrote, enclosing a letter—an example of the very many received at this time. It ran:

" Will you please answer, either by letter or in your personal column, what has become of Mr. Thomas Nast? I, as well as many others, have missed his pictures in Harper's Weekly very much for the last six months. If you have made any explanation in regard to him, it has escaped my notice."

In his note accompanying this, Mr. Harper wrote:

My Dear Nast:
I find on my desk the enclosed letter from Illinois, which gives me the opportunity of saying frankly and sincerely that I wish you would resume work on the Weekly, and of assuring you that should you do so we would all of us try to make it in every way pleasant for you.

A CORNER IN THE NAST DRAWING-ROOM

Mrs. Nast writes that though you are suffering from a severe Montreal cold, you will endeavor to be with us at the Henry Irving breakfast on Friday, and I hope you will come. But don't expose yourself, and if you're seriously housed or limited to gruel, I will roll down to Morristown to see how you like it and to share your bowl of gruel.

Yours always, J. W. Harper, Jr.

This was followed by Nast's illness and some intimate personal letters and visits, during which the old arrangement and ties were renewed for another term. On December 27 the Weekly published a small Christmas " comic," left over from the year before, and printed the following announcement:

In answer to many inquiries from subscribers, we regret to say that Mr. Thomas Nast, who still maintains his connection with Messrs. Harper & Brothers, has not yet sufficiently recovered from the severe attack of pneumonia by which he was recently prostrated to give the public the benefit of his genius. We hope, however, that before many months have passed he will be able to resume the pencil with which he has done such vigorous and noble work in the cause of the Union and in support of an honest and enlightened administration of National, State, and Municipal government. The public will be glad to learn that, should his health permit, Mr. Nast will deliver some lectures during the winter.

They had hoped to have one of his customary Santa Claus pictures, and Mr. S. S. Conant, who then had charge of " making " the paper, had written, December 3:

My dear Mr. Nast:
The approach of Christmas time reminds me that for many years our readers have been favored with delightful holiday pictures from your pencil. They, as well as ourselves, would be very sorry to miss your contributions this season, and I write to ask whether you would feel inclined to favor us with Xmas illustrations, either for the Weekly or for each of the three periodicals?

But the artist was not yet equal to the task in the brief time allowed, and the young Harper readers missed his jolly St. Nicholas that season.

CHAPTER LIII

It was not until March 1, 1884, that Nast made his reappearance in the Weekly. He had lingered in the South to acquire strength for the Presidential campaign, which bade fair to be—what it in good sooth became—one of the fiercest and most closely contested political battles in history. When in February the press reported his return to Morristown, he received from Franklin Square a word of greeting and suggestion:

My dear Nast:
Have you returned?
Did you buy ten thousand acres or so?
And where's my alligator?
And when are you to begin in the Weekly?
The first picture ought to be strong and incisive, for we must remember that while your hosts of friends and the friends of the Weekly are ready to welcome you, there are also hosts of enemies who will be unfriendly critics, and who will be eager to claim that your eye is dimmed and that your hand has lost its cunning.
The boys join me in kind regards to you and Mrs. Nast. I hope you have brought back no fever and ague.
Yours faithfully,
J. W. Harper, Jr.

The first picture was one to disarm criticism. It depicted the dire need of Cincinnati, where terrible winter floods had wrought ruin and desolation. The cartoon was a powerful cry for "Help!" It was not until a week later that he presented the

political situation—simply a great, white " Sacred Elephant," labeled the Republican Party, carrying the Presidential Chair, and wearing the belt of Civil Service Reform. A small caricature of Nast himself introduces the exhibit, beneath which are the words:

" This animal is sure to win, if it is only kept pure and clean, and has not too heavy a load to carry."

It was a striking picture, and precisely summarized the situation; also the position of Harper's Weekly and of Nast himself. With respectability and a proper burden the Republican Party could win. Otherwise its case was doubtful and the support of Franklin Square most uncertain.

In this issue of the Weekly, at the head of the editorial column, the attention of the public was directed to the fact of Nast's return. The notice closed significantly:

Our readers will recognize the familiar figure of the Republican Elephant treated in a manner at once retrospective and suggestive, recalling the principles by which the Republican Party has won the confidence of the country, and by strict adherence to which alone it can hope to retain that confidence in the future.

The cartoonist's welcome back to the old journal was general and enthusiastic. The newspapers which had been asking, as did the Herald, " Why is the public no longer instructed by the work of this historic caricaturist in the ' journal made famous by Thomas Nast? ' " now accorded him a notice that was, if possible, more universal than ever before. The following is a fair sample of the comment; also of the frequent misstatements which have led to so many false impressions concerning his relations and difficulties with the Harper firm:

The reappearance of the familiar bold signature of Th. Nast on a cartoon in Harper's Weekly has produced more of a sensation than either Nast or the Harpers could have dreamed of. That was a peculiar quarrel, or rather its consequences were peculiar. Two years ago the artist's vigorous pictures disappeared. He was under contract not to draw for any other periodical, and

so every week he sent in a sketch to Harpers, and they in return continued to pay him five thousand dollars a year. During the two years in his cosy home at Morristown he has drawn the best work of his life, as all the friends who have seen the many ambitious pictures stored there unite in declaring, etc., etc.

Perhaps this is accurate enough for the daily newspaper reader, but from a historical standpoint its errors seem important. Nast's absence from the Weekly had been less than one year, during which he had remained very little in his " cosy

THE SACRED ELEPHANT

THIS ANIMAL IS SURE TO WIN, IF IT IS ONLY KEPT PURE AND CLEAN, AND HAS NOT
TOO HEAVY A LOAD TO CARRY

home at Morristown '' and had drawn no pictures whatever. He had received the $5,000 in the stipulated payments, but this had been merely a retainer, work or play. Had the writer doubled the amount of this annual payment, as many papers did, he would have crowded as many misstatements as would seem possible into a brief paragraph, which after all contained the elements of news. The story that Nast ever went on supplying pictures to Harper's Weekly during any period of absence from its pages may properly be denied here. It was, as we have seen, the occasional refusal of his drawings, more or less frequent, which resulted in these hiatuses; but during such weeks or months he supplied no work and was not expected to do so. His retainer merely provided against his contributing to other journals. His drawings were always additionally paid for. It is probable that altogether, during the twenty-five years of his connection with the Harper firm, not more than twenty-five of his pictures remained unused.

The letters of welcome were as kindly and almost as numerous as the press notices. From John G. Borden, the great dispenser of milk, came this measure of human kindness:

Good morning! I too want to shake hands! Glad to see you back! Certainly! Come to stay, we all hope!　　　　Borden.

From the office all sent greetings. S. S. Conant wrote: '' I am glad to welcome you back. Will you kindly let us know by telegraph what you intend doing for next week? When you come in won't you shed the light of your countenance on yours truly? ''

His old companion in arms forgot all disagreements and held out the right hand of fellowship:

Dear Nast:
I am sincerely glad to know that you are better, or what is better still, quite well, and that we are to go into the old and ever new fight again, side by side. With every good wish, I am,
　　　　　　　Very truly yours,
　　　　　　　　　George William Curtis.

"'TIS TRUE, 'TIS PITY, AND PITY 'TIS, 'TIS TRUE"

DEMOCRATIC WOLF—"There are some black sheep in your fold; therefore you had better let me take care of your flock. Having been so long without food has made me very kind and gentle, and has changed my nature so completely that I am an excellent shepherd's dog now."

That the " old and ever new fight " was to begin by opposing Blaine is shown by consulting the Weekly's editorial and pictorial pages, now in perfect unison. Early in March " Blaine Leans Toward Logan " was the subject of a cartoon showing Logan, bound hand and foot, and being pushed from the steps of the White House by the " leaning " Senator. The grouping of these two is subject to another interpretation of that unconsciously prophetic kind which made the genius of Nast something almost uncanny.

Again, in April, Blaine appears as a book agent, canvassing with his new work, the " Twenty Years " record, while a week later Grover Cleveland is significantly complimented for his excellent work in New York City, carried on with Theodore Roosevelt, who now, for the first time, appears in the cartoons.

It was not that Harper's Weekly seriously contemplated a bolt from the Republican party. Yet there were constant insurrections in the ranks, and anything was likely to occur. Those who called themselves Independents were for reform before party,

and it was to this element that Harper's Weekly, in common with most of the better class of journals, belonged. Curtis and Nast did not hesitate therefore to applaud the work of Cleveland in city and state, especially as Cleveland himself willingly united with a strong-hearted young Republican like Theodore Roosevelt

"BLAINE LEANS TOWARDS LOGAN"

in certain legislation for reform. Democracy, as a whole, Curtis still freely denounced. He declared that, as a party, it had ceased to represent anything whatever but opposition—not opposition to principle or policy, but merely to Republican measures because they were such.

Yet he did not hesitate to praise such Democrats as Mr. Hewitt, who supported the bill for an increased navy against the opposition of Samuel J. Randall and the party as a whole. Each day it became less a question of party than of men, and as the Independent journals pointed out, the man selected must be one whose record, long or short, would show a tendency toward progress, especially in the direction of impartial allotment of public office as a reward of merit and not as the fruits of victory. In the editorial above mentioned, Curtis adds: " The interest of Grover Cleveland in the cause (Civil Service) has been signal and effective." Curtis did not advocate a new party under the lead of the Independents. The administration of Arthur he pronounced good. It was his chief concern that the integrity of the party should be maintained, with a policy and a candidate in accord with the better doctrines which the Independent wing was seeking to establish and hoped to make permanent. It was his belief, as it was that of Nast—and we are dwelling upon the opinions

of these two because they were in the foremost rank and were presently to become conspicuous in a great party upheaval—that the nomination of Blaine would mean simply a continuation of the old system of party rewards and a renewal of the feuds and wretchedness of 1881. There was a widespread conviction that Blaine, who had begun as a patriot and a statesman, had become a politician and a spoilsman. It was Blaine who was considered the " too heavy a load " for the " Sacred Elephant " to carry.

Yet Blaine was a magnetic man—a pillar of wisdom and oratory, and his following was mighty in the nation. With the legitimate support of Republican press and patriot, his success was assured. Doubtless he believed, and his friends believed, that with the nomination most of those who had been his critics would swing into the old line, and if they did not strenuously uphold his cause, they would at least not cry it down. They remembered that such papers as the Herald and the Post, which had been most critical of Grant, had, upon his renomina-

REFORM WITHOUT BLOODSHED. GOVERNOR CLEVELAND AND THEODORE ROOSEVELT AT THEIR GOOD WORK

tion, wheeled back into the ranks and fought his battle. Perhaps they forgot, or refused to remember, an important thing. Grant's personal integrity was never for a moment really doubted by intelligent men. Whatever may have been the criticism of his methods, or the slanders inspired by malice, no impartial and thinking individual ever suggested that Grant was not the soul of honor, that he ever even considered the possibility of using his public office for personal gain. On the other hand, Blaine had been involved in more than one affair of doubtful aspect, and once, in 1876, had been the subject of a Congressional inquiry relative to a questionable connection with the Little Rock and Ft. Smith Railroad. True, his dramatic vindication at this time had appeared sufficiently complete to inspire the famous " Plumed Knight " speech of Colonel Ingersoll, but certain facts connected with the denouement, and calmer reflection, had left the public mind by no means clear as to his entire innocence. The matter would be sifted to the final dust if he became a presidential candidate. Blaine of Maine could show much that was noble in his record, but a man who could show less, even one with no record at all, would have been a safer nominee.

In every issue of the Weekly, Curtis protested with force and skill against the nomination of Blaine. He pointed out that it would divide the party, that it would debase it by committing it to the old creed of spoil and high tariff; that, furthermore, a campaign under Blaine must necessarily become one of explanation and defence. The friendliness of the Democratic papers to Blaine he regarded as " one of the most suspicious signs of the situation." When finally the old railroad scandal was raked over, as it began to be, even before the convention, and William Walter Phelps rushed to the fore with a letter of defence, Curtis did not hesitate to speak his mind fully:

" The one fact in this controversy which remains undis-

turbed," he said, " and which the honest voter everywhere will plainly comprehend, is this:

" In the spring of 1869, Mr. Blaine, as Speaker, made a ruling in favor of the Little Rock railroad, securing to it a government land grant which passed on April 9. Soon afterward it appeared that Mr. Blaine was very desirous of obtaining an interest in building the road, and on June 29 he wrote to his friend Mr. (Warren) Fisher, the contractor, who had made him some offer, asking that Mr. Caldwell, who then controlled the enterprise, should make him (Mr. Blaine) a definite proposition to enable him to acquire the interest he desired. On the 2d of July he renewed the suggestion. Mr. Caldwell apparently not responding, Mr. Blaine writes again on the 4th of October to his intermediary, Mr. Fisher, and tells the story of his ruling, showing that he, as Speaker, saved the road, and authorizing Mr. Fisher to tell Mr. Caldwell that thus, without his knowledge, that he (Mr. Blaine) had done him a great favor. On the same day he writes another letter to Mr. Fisher, urging him to read the Globe, which he sends him, and see how narrowly, by means of his ruling, the bill aiding the road escaped defeat. In the same letter Mr. Blaine expresses his natural anxiety to make the most of the arrangement which he had already completed with Mr. Fisher, but states that he is bothered by Mr. Caldwell's delay. This repeated reference to his official action was apparently intended to bring Mr. Caldwell to the point. . . . Could the party venture upon a campaign which would inevitably turn upon the question whether its presidential candidate had made his official action serve his personal advantage? " *

It seems proper to explain here that the letters referred to by Curtis in the above extract were the celebrated " Mulligan letters," which were destined to become a most disturbing quantity during the campaign. These letters had fallen into the hands of one James Mulligan, who had been a clerk of the Warren Fisher mentioned. In the investigation of 1876 Blaine had pleaded with Mulligan to surrender these letters. Mulligan at first declined, but at length yielded them on condition that they were to be returned. Blaine did not return the letters, but on June 5, 1876, read from them himself before the Judiciary Committee. A letter from Warren Fisher had been forwarded to this com-

* Harper's Weekly, May 10, 1884.

mittee for the purpose of exonerating Blaine; also a cable dispatch, from Josiah Caldwell. This testimony, for some reason, the committee had withheld—perhaps to test its genuineness—and Blaine had a moment of splendid triumph, when he strode down the aisle, or, as Colonel Ingersoll expressed it, "Like an armed warrior, like a plumed knight, James G. Blaine marched down the halls of the American Congress and threw his shining lance full and fair against the brazen foreheads of every traitor to his country and every maligner of his fair reputation."

Blaine on that day had flourished in his hand a copy of the suppressed cable message, and the sensation had been so great when he flung it in the faces of the committee and charged them with false dealing that the nation was startled into forgetfulness of the fact that, after all, the letters he had himself written remained unexplained and unjustified, though neither this moment of triumph nor Colonel Ingersoll's eloquence had obtained for him the nomination. Now, eight years later, the explanation which did not explain must be made all over, while the fact that he had broken faith with Mulligan in not returning the letters, and that the press and American people would handle his reputation in the unsympathetic manner of campaign debate could not have been a gratifying reflection to the "Magnetic Man from Maine."

FROM BAD TO WORSE.
82 cents for 100 cents.

INDIAN OUTRAGES.

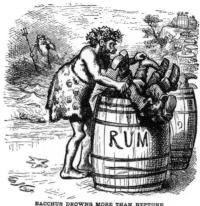
BACCHUS DROWNS MORE THAN NEPTUNE.

CHAPTER LIV

A WRECK AND A REVELATION

It was in the midst of this preparation for a mighty political warfare that the country was shocked by a financial disaster—fatal to an extended circle of investors, great and small—including among its victims General U. S. Grant, his sons, and Thomas Nast. One morning early in May the blighting news of the failure of Grant and Ward stared at Nast from the front page of his morning paper. He turned ghastly and the perspiration stood upon his forehead. Then, scarcely above a whisper,

"Grant and Ward have failed," he said.

It seemed a fatal blow. Not a penny of his savings remained. Even the dividends had been largely reinvested. Everything except his home had been swept away. His dream of an independent paper melted like the webs of morning.

The blow fell even harder on General Grant. Not only had he lost his savings, but a few days before, through the intercession of Ward, he had assisted the Marine Bank with a loan of $150,-000, borrowed in his own name from W. H. Vanderbilt; and this additional liability he must now pay. The country's hero was

penniless; worse, for even the cheques given to shop-keepers were returned unhonored. Houses, horses and carriages were sold. Vanderbilt promptly called for his loan and General Grant unhesitatingly turned over to him every bit of property he had left, even to his military trophies: " all the swords presented to him by citizens and soldiers, the superb caskets given him by the officials of the cities through which he had passed on his way around the world, all the curious and exquisite souvenirs of China and Japan. He spared nothing." *

Nast fortunately had lost only the amount he had put in. But it was a sad blow in that it struck away the bolster of his independence, blighted his fondest hopes and, what was still worse, shook his confidence in men. When Grant learned that Ward had been a rascal throughout—that there had been no legitimate contracts, but that most, if not all, of the dividends had been paid from the principal investments—when he had signed away everything and realized all, he said:

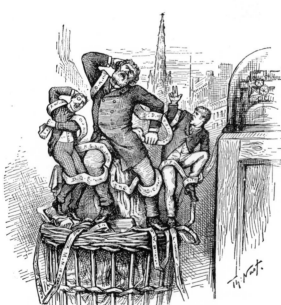

THE TAPE THAT ENTANGLES BOTH LARGE AND SMALL

" I have made it the rule of my life to trust a man long after other people gave him up; but I don't see how I can ever trust any human being again." These words from the old soldier whose long trust of unworthy officials had been the only shadow on his polit-

* Hamlin Garland, in " A Romance of Wall Street."

ical career might have been uttered with equal signifi-
cance by his faithful friend and supporter, his partner now in
misfortune, Thomas Nast. And this, after all, may be reckoned
as the chief sorrow of their crumbled fortunes.

But though fortunes perish, battles must go on. The Na-
tional Republican Convention of 1884 was at hand. Nast did
not lament over the downfall of his hopes, but girded on his armor
for war.

The New York Times made it clear that in event of
Blaine's nomination it would decline to support the ticket.
George Jones, who was still the owner, endeavored to get the
publishers of Harper's Weekly to concord in a declaration to
that effect, and it would seem now a mistake that this was
not done. It would have precisely suited Nast, while Curtis,
who was to be a delegate to the Convention, would have been
able exactly to define his position, and might have avoided
much of the bitterness and many of the accusations of the
trying period which followed. It was in deference to Cur-
tis, however, that the positive position against Blaine was not
taken at this time. It was the desire that Curtis should enter
the Convention a free man, accountable to himself only. He
could hardly have participated in the Convention after such a
manifesto; also it was hoped that his wide influence might
avert disaster. Viewed in perspective, it would seem that an
open declaration made by the paper would have been more
effective than the influence of Curtis as a delegate, and that the
mistake made by Curtis was in not insisting upon such a state-
ment and resigning from the delegation. But Curtis, through-
out his career, clung to the policy of tactful persuasion and con-
ciliation. In spite of repeated lessons, it was not in his nature to
understand that such methods are likely to avail as little in a
political convention as with a pack of wild hyenas, tearing one
another in a cage. Had Fletcher Harper been alive it may be

set down as certain that the radical policy of the Times would have prevailed.

As to an acceptable candidate, opinions in Franklin Square were somewhat divided. Curtis was favorable to Senator Edmunds of Vermont, as were also several members of the Harper firm. Nast was firmly for President Arthur, as was J. Henry Harper, who had the general supervision of the Weekly at this time. It was on the eve of the Convention, during a call made by these two on President Arthur at the Hoffman House, that certain inner details of the Garfield-Conkling rupture were made known to them.

Mr. Harper and Nast had called for the purpose of urging the President to make a more definite personal effort to win the nomination. They believed that a combination might be made which would defeat Blaine and leave victory in Arthur's hands. He listened to all their suggestions and admitted that he greatly desired the honor of the nomination, yet he would make no special effort to obtain it.

" I will accept it of course if it falls to me," he said, " but I can do no more. " I ought not to do that. I am far from a well man, and it is likely that I shall not survive the administration. No, I can't do any more. I can't do it! "

Nobody spoke for several seconds, then Arthur regarded Nast gravely.

" Do you recall that you once caricatured me as a bootblack," he asked, " polishing the shoes of Platt and Conkling? "

Nast nodded unhappily.

" I do, Mr. President," he said.

" It hurt me," continued Arthur. " It hurt me terribly. Yet you were quite right—far more so than you knew—though not altogether in the way you thought."

Then he related the circumstances of that political bargain whose harvest had been a national tragedy.

" With the Maine election of 1880," he said, " matters began to look bad for our ticket, and Mr. Garfield agreed with me that we must in some manner enlist Conkling and Platt in our cause. I advised that we come to New York to see them, and we did so. Meantime, they had heard we were coming, and had taken train for Albany. They refused to meet Garfield, who then suggested that I see them and make any arrangement that would bring them into line. I saw them, and they at first declined to believe in my assurance of Garfield's good faith. ' Gentlemen,' I said, ' I pledge you my word as a man of honor that Mr. Garfield made me that promise, and that I will undertake to see it carried out.'

" It was then understood among us that Conkling and Platt should control the New York patronage, and it was with this assurance that they worked for the ticket. Grant came back from the West and took the stump with Conkling, and everything was done by Platt and Conkling as agreed. You know what happened after the election. I need not go all over that. But there is one thing you do not know. It is true I went to Albany again —I did so far descend from the dignity of my office as to go to see Platt and Conkling, but I did not go to conciliate them. It was worse than that—much worse. I went to Albany that last time because they *sent for me to come.* I went on their *order to come* and explain why I had not made good my pledge. They knew I would not refuse to come, and I did go, and I humbled myself for not having been able to keep my plighted faith. Now you understand why your picture was even truer than you could know."

During the final sentences the President's voice had broken, and when he finished, the tears were streaming down his cheeks. A gentleman of gentlemen—ill, and already nearing the doorway of death—the memory of his broken pledge and his humiliation he could not calmly recall.

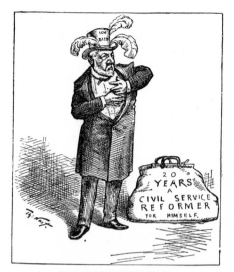

THE GREAT CANVASSER

J. B. (*devilish sly*)—" Civil Service Reform! I just *love it !* In fact, I'm a regular *masher* on that subject."

SENATORS HOAR AND HAWLEY ACCEPT BLAINE

First abhor, then endure, then embrace!

CHAPTER LV

A MIGHTY MAKING OF HISTORY

The Republican National Convention assembled in the Exposition Hall in Chicago on June 3. A larger crowd gathered than ever before, and there was more bitterness of feeling. All sorts of scandalous stories were told. It was declared that " five hundred dollars in money and a good office " were promised for Blaine delegates in event of his election. " Everybody is aware that Clayton was promised the portfolio of Secretary of the Interior if he would deliver the Arkansas delegation to Blaine," was the statement of one leading New York correspondent. The fight of 1880 had been a battle between vast opposing forces. This was a civil war, with all its malice and personal hostility.

Theodore Roosevelt was a member of the New York delegation and George William Curtis was selected as its chairman. Thomas C. Platt was likewise in attendance, and, strangely enough, had

so far and so soon forgotten old injuries as to declare for Blaine.

That the Blaine sentiment was very general was manifest. Curtis said afterwards that it was "essentially a Blaine convention," and he must have immediately realized his mistake in having hoped to stem the tide. Still, able men who were present have thought it not impossible that had a proper combination been formed, or a startling initiative been taken—some seizing of the tide at its flood—there might have been a turn which would have caught up and borne a different captain to victory.

Blaine, Arthur, and Edmunds were ably put in nomination, the last-named being gracefully seconded by Curtis. None of the speeches equalled Conkling's Appomattox oration of four years before, and no such excitement followed, though the name of Blaine awoke an enthusiasm which approached frenzy when Judge West, the blind speaker of Ohio, presented it to the thirteen thousand listening people.

In fact, politically, it was Blaine's time. He had been faithful to party, and had lived long for this hour. More than this, he had a definite place in the hearts of the people, who were willing to forget or to overlook irregularities all too common to politics for the sake of the patriot and statesman of the past. In addition to these things, the memory of a murdered President, whose tenderness for Blaine had been manifest to the very end, was just the sort of sentiment to sway powerfully the American heart.

An attempt on the second day to pledge delegates to support the nominee, whoever he might prove, was promptly opposed by Curtis, who asked the Convention "to assume that every delegate was an honest and an honorable man."

"A Republican and a free man I came to this convention," he said, "and, by the grace of God, a Republican and a free man I will go."

On the first ballot Blaine's vote was 335½, Arthur's 279.
Edmunds of Vermont and Logan of Illinois had 93 and 67½,
respectively. It seemed that if a proper combination could be
made Blaine might be defeated. But this was not altogether
clear. A large element of the scattering vote was known to be a
masked Blaine support, which at the slightest signal of alarm
would be hurried to his rescue. An attempt to combine the
Arthur and Edmund forces failed.

By the third ballot Blaine had 375 votes, and it became evi-
dent that the fourth ballot would be the last. Then, suddenly,
pandemonium reigned. Everybody seemed to be on his feet at
once. Theodore Roosevelt, young, eager and athletic, stood up
in his seat, wildly swinging his arms to attract the chairman's
attention. Surely, if ever, this was flood tide, and amid the
riot of it all there were calls for Curtis—Curtis of New York!

It was the supreme instant in a convention when a dark horse
may appear. Perhaps it was the psychological moment in the
life of a wise and able man whose constitutional lack of initiative
—of doing the bold and unusual thing—lost him that golden
opportunity which is said to come once into every life. Had
George William Curtis leaped to his feet in answer to that call
and made a ringing, patriotic speech for reform, such a speech
as he could make when aroused, who shall say that the Conven-
tion might not have been swayed by a man whose life and record
and purpose were known to be clean, and then and there chosen
him as its leader. If Curtis was ever a presidential possibility,
it was in that moment, which passed as the breaking of a billow,
and was gone. Blaine was chosen on the fourth ballot, and John
A. Logan was accorded the second place. Confused and dazed,
Curtis acquiesced in the nominations, thus letting pass another
opportunity for placing himself officially on record against a
ticket to which later he must refuse his support.

Immediately he wired that he would telegraph an editorial

against Blaine, and added a word for Nast. But presently he remembered that he had acquiesced in the nominations. Roosevelt and others who had pursued a like course considered themselves pledged to the ticket. He had said, " A free man I came to this convention, and, please God, a free man I will go." Reflecting upon the matter now, he was not so sure. The editorial against Blaine was not telegraphed. The situation was very hard.

Nast called briefly at the Harper office on the morning after the nomination, at which time no word from Curtis had been received. Later in the day came the following letter:

Franklin Square, June 7, 1884.

My dear Nast:

As I told you this morning, the firm will talk over the situation on Monday, by which time I hope Mr. Curtis will have returned. Meanwhile he will telegraph from Chicago an editorial against Blaine (which has not yet come), and he, Mr. Curtis, adds, " It is now a good time for Nast."

Yours faithfully,

J. W. Harper, Jr.

By Monday Curtis had returned to face, in the columns of numerous journals, severe criticism from those who believed that he, with Roosevelt, had precipitated the nomination of Blaine by failing to combine with the Arthur forces. The Commercial Advertiser characterized them as the " Holier than thou " Republicans, who had insisted on Edmunds or nothing, and added that it hoped they were satisfied with their work. The Advertiser, it may be added, eventually allowed party to prevail, and supported Blaine. The Times promptly repeated its declaration of independence, and prophesied Blaine's defeat.

" That defeat will be the salvation of the Republican party," it added. " It will arouse its torpid conscience; it will stir it to purification." Which may be said to have been a very excellent prophecy indeed.

The Evening Post and the Herald declared against the ticket,

as well as many of the foremost Republican journals East and
West. The Tribune remained loyal to its party, and Mr. Dana—
who had supported Greeley, Tilden and Hancock—perhaps to
maintain his paper's tradition for being always on the losing
side—advocated the cause of the greenback candidate, General
Butler, which was equivalent to a support of Blaine.

Arriving at the Harper office, still dazed and depressed, Curtis
quickly learned that the Weekly would not give the ticket its
support. Personally he was glad, but the fact did not lighten his
burden. Had it been possible to separate his individual from
his editorial capacity, as it is in these days of impersonal jour-
nalism, the problem might have been solved by giving a pro-
fessional support to the journal, while according his personal
vote and influence to Blaine. With Curtis no such a separation
was possible or even considered. He must revoke his acquies-
cence in the Chicago Convention or he must resign his editor-
ship. In the Saratoga Convention of 1879 he had "distinctly
voted against making Cornell's nomination unanimous—the
only protest then possible," as his paper at the time had de-
clared. He had made no such protest in Chicago on an issue
of far greater magnitude. Even should he resign, it would be
to remain comparatively neutral—a position abhorrent to him.
"A neutral in politics is like a neutral in sex," he had once
said in a letter to Nast. The more he considered, the more diffi-
cult seemed his plight. For the first time he seemed inclined to
lean upon the positive individuality of Nast.

Two of the firm—John W. Harper and Joseph W. Harper, Jr.—
with Curtis and Nast, adjourned to a nearby restaurant for lunch-
eon and further discussion. The situation was fully gone over,
and it was agreed that Blaine was not entitled to their support.
Yet Curtis, with the old reluctance to strike a blow beyond recall,
was willing to temporize—to wait. When the Democratic nom-
ination was made, it might become a choice of two evils.

Nast had said very little up to this point. His views were well known and needed no emphasis. Now, however, he was genuinely irritated.

"It is the business of the Independents to dictate that nomination!" he said hotly. "Speaking for myself, I positively decline to support Blaine, either directly or indirectly, even if the Democrats should nominate the Devil himself." He turned to John Harper. "Will you support Blaine?" he asked.

"No," answered Mr. Harper solemnly.

Joseph Harper also shook his head.

"We cannot support Blaine," he declared, "and we must state our position immediately. We must have a good strong editorial on the subject in our next issue."

"Yes, make it as strong as you like, Mr. Curtis," said John Harper.

Nast's irritation was still dominant.

"Make it stronger than you like, Mr. Curtis," he added.

Curtis rose and bowed gravely.

"It shall be prepared immediately," he said.

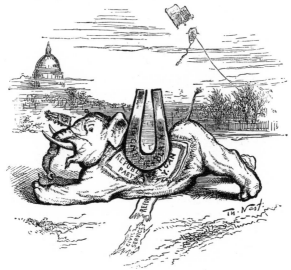

TOO HEAVY TO CARRY

CHAPTER LVI

FOR PRESIDENT, GROVER CLEVELAND

The declaration of revolt appeared in the Weekly of June 14,
though on the 9th the position of Franklin Square was announced
by the press. In the same issue there was a cartoon from Nast
—the Republican Elephant, its back broken by the weight of the
political " magnet." In the issue following there appeared a
double page—the Republican Party as the daughter of Vir-
ginius, about to be slain by her father, rather than to submit to
" Appius Claudius " Blaine. Editorially the Weekly stated its
position, which, in brief, was Nation before Party. In taking this
stand the publishers had fully considered the possibility of
large pecuniary loss.

No political rebellion ever created such a stir as this. It was
literally a " shot heard round the world." The apostasy of
other papers was forgotten in the wild assaults of old and time-
tried friends on the Journal of Civilization. As for Curtis and
Nast, they were pilloried and crucified—drawn, quartered, and

DEATH BEFORE DISHONOR

VIRGINIUS—"On thee, and on thy head be this blood!"

buried at low water mark. Other editors and other cartoonists might pass from one policy, or from one paper to another, almost without comment. With these two it was different. Curtis was denounced as a traitor who had broken faith; Nast was branded as a hired assassin. Old friends wrote to him, pleading or denouncing. Below are a few specimen extracts:

One more such effort from your pen will sweep away your world-wide reputation and make Harper's Weekly accursed among men.

Oh, Nast, how art the mighty fallen! How weak in a bad cause has he become, who for years has been such a Sampson in a good one.

Why in the name of all that's sacred will you cater to the devilishness of George William Curtis, when it is like a dose of quinine to you every time? I know well enough you are not in sympathy with a single cartoon issued by Harper's Weekly.

The last was signed " admirer," and another old " admirer," in pleasanter humor, wrote:

I will close by asking as much as the man who met the bear. " Oh, God, help me to win the fight, but if you can't help me, for God's sake don't help the bear! "

Even Nasby went back on his old friend, and published an " X-Roads " letter in which he said:

Mr. Nast had better quit taking Roman subjex and fly back to the tropix. The best thing he kin do is to fall back on his reglar pictur of a elephant with his back broke by somebody's climin' onto it, with the legend under, ' Broken at Last.' This is his best holt. He has outlived everything else. I wish I'd spent mi $4.00 sent Harper's at Bascoms.

The change of front likewise inspired numerous verses, of which the following from Judge is a fair specimen:

<div align="center">

Poor, poor T. Nast,
Thy day is past—
Thy bolt is shot, thy die is cast—
Thy pencil point
Is out of joint—
Thy pictures lately disappoint.

</div>

It now became important that the Independents should unite with the Democrats upon some man acceptable to all. Of these Grover Cleveland was naturally first choice, with Bayard of Delaware as a possibility. Cleveland was far more acceptable to the Independents than he was to a large element of his own party, but it was believed that for the sake of a President, Democracy as a whole would support him. It was decided to call a meeting of the representative Independent Republicans for the purpose of more complete organization, as well as to pass resolutions that might influence the Democratic choice. This meeting took place on the evening of June 17, at 269 Madison Avenue, the home of J. Henry Harper. Colonel T. W. Higginson called the assembly to order, and George William Curtis was chosen as chairman. It was a very private affair, as the special ticket of admission shows. Some of the foremost

men of the country were present. Others sent letters of encouragement and approval.

Benjamin H. Bristow wrote, "As a Republican I feel it is my duty not to vote for Blaine."

Henry Ward Beecher said, "Put me down against Blaine one hundred times in letters two feet long."

Josiah Quincy, Richard H. Dana and Samuel Hoar were among those present from Bos-

MAKING THE BEST OF IT.
WHITELAW REID. "I'll fix it so that no one will notice it, and make it all right to-morrow's *Tribune*. Washington and Lincoln *always wore their shirts this way.*"

ton. Several of the Harper firm, E. L. Burlingame, Henry Holt, Nast and many other New York representatives were there. Men from Chicago, St. Louis and other Western cities likewise attended. Carl Schurz was actively present, and prepared resolutions condemning the Republican nominees, adding that:

32

" We look with solicitude to the coming nomination of the Democratic Party. They have the proper men. We hope they will put them before the people."

The names of possible candidates were not embodied in these resolutions, but it was orally agreed that such men as Cleveland and Bayard would receive the Independent support. The movement which was to make Grover Cleveland President had crystallized.

The Blaine press hailed this beginning with fierce derision and ribald epithets. They referred to the " Nast-y Particular Party," and finally dubbed the Independents " Mugwumps," an old word which sprang into renewed existence, and survived.

Upon the Democratic leaders the effect of the meeting was prompt and profound. When their National Convention gathered in Chicago it was pretty evident that Grover Cleveland would be the nominee. To be sure, John Kelly declared on the day before the balloting that Tammany would not support Cleveland, though the fact that Tammany, with its doubtful traditions, opposed the reform candidate, would seem to have made more certain his nomination.

" We love him most for the enemies he has made," was the sentiment expressed by General Bragg of Wisconsin, and widely echoed throughout the assembly. The voting took place July 11, and it required only the second ballot to make Grover Cleveland the chosen nominee. As a concession to the old-line Democrats, Thomas J. Hendricks was selected to complete the ticket.

The latter half of the ticket did not gratify a majority of the independents, yet it proved fortunate for Cleveland. Hendricks was acceptable to Tammany and it was doubtless through him that Kelly and his following were eventually brought into line.

Throughout June both Curtis and Nast had been assailing Blaine—the pictures usually showing him as a canvasser with

his " Twenty Year " record, or perhaps donning a clean shirt of reform, which, through lack of familiarity with the garment, he was inclined to wear topside down. In the issue following the Democratic nominations the editorial column was headed,

<div align="center">

For President,
Grover Cleveland of New York,

</div>

the name of Hendricks being conspicuous by its absence. Below was an editorial in support of Cleveland, in which Curtis said:

So firm and clean and independent in his high office has Grover Cleveland shown himself to be, that he is denounced as not being a Democrat by the Democrats themselves.

The same issue contained a page cartoon by Nast conveying practically the same idea—a full-length portrait of " A Man with a Clean Record," stiff and unbending in his attitude for better government. The position of Harper's Weekly was thus clearly defined, and its leading forces, Curtis and Nast, more closely linked than at any time since the Tweed crusade, with the greatest good feeling, were pulling side by side in this their last great campaign.

SUCCESSFUL CANDIDATES HAVE ALWAYS STOPPED AT THE FIFTH AVENUE HOTEL. THE CONSEQUENCES

TROTTING OUT THE CAMPAIGN LIES
(George Jones, Nast and Curtis, as cartooned by " Chip ")

CHAPTER LVII

THE UPHEAVAL OF 1884

The " Mugwump " revolt was a political upheaval without parallel in this nation. Even the War of the Rebellion had been mainly geographical, and the outgrowth of tremendous issues, long debated and clearly defined. The civil revolution of 1884 was universally outspread—a division in hamlets and families— a battle of leaders. North, South, East and West it raged, and whatever were the points of political difference in the beginning, these were presently forgotten in a rancorous contention as to the personal shortcomings of the candidates.

Religious communities were divided. Blaine church officers refused to confer with an Independent church pastor, Blaine church members changed their pews to avoid intercourse with Independent Republicans. A Blaine newspaper, commenting on the fact that Nast had agreed to deliver a lecture in aid of one of the Morristown churches, said: " It is possible that some self-

respecting Republicans may be found among his audience, but we hope they are not many." Boycotts against Independent merchants were attempted. In some places newsdealers were obliged to discontinue handling the Weekly to retain their trade.

Press comment was vitriolic and filled with malice. The personality of the candidates became the only issue. Every previous public or private act of either was microscopically scrutinized, and exploited for good or evil. Not only were political flaws sought out, but old personal scandals were exhumed and paraded in public view. The American people can hardly recall with pride a campaign wherein a large number of its newspapers and citizens forgot national and party principles in magnifying and sowing broadcast every manner of detestable report concerning its presidential candidates.

Next to these chosen leaders, Curtis and Nast became the victims of newspaper violence. Every Blaine organ in the land took occasion in almost every issue to point out their iniquity, and to prophecy their imminent degradation and downfall. Some did not wait for it to arrive. One Pennsylvania editor printed at the head of his editorial column: " Tom Nast, the libellous caricaturist, has become a drunken sot and a bar-room loafer," a statement so wide of any present or future possibility that it gave the artist pleasure to exhibit it to his family and friends.

In the colored caricatures of " Judge," Curtis and Nast rarely failed to figure. Curtis, who had always deplored caricature as applied to men of attainments, now found himself the victim of the grossest pictorial satire. Hamilton and Frank Beard never missed an opportunity of presenting him as a saint, a circus performer, or a " Miss Nancy " in slippers or gaiters, frilled trousers and corsets, usually grinding an organ, while Nast, as a monkey, performed at his command. Nast's own ideas and symbols were turned against him by the picture-makers of the other side. His old co-laborer, A. R. Waud, included him

with Curtis in an army of tatterdemalions, who followed their " Falstaff," Cleveland. He was associated with the ghost of Tweed, who grasps his hand cordially, saying:

" Go right along. You are now arrayed against my old enemy, the Republican Party." The caricature in these was carried to the extreme limits of grotesque and often vulgar exaggeration. They were deadly torture to Curtis. Nast they only amused and spurred to greater things. It was the second great " Campaign of Caricature," and this time Nast had more worthy foemen, though he was likewise not without valuable allies. Bernhard Gillam's " Tattooed Man " will be long remembered. Its first introduction was the result of the Weekly Puck conference, where it was decided to caricature the various candidates as the freaks in a dime museum. It was Mr. Schwartzmann who proposed that Blaine should be tattooed with his record, which feature proved a distinct success. Certainly the Independents, with Gillam, Keppler, and Nast had the strong side of caricature in the campaign of 1884. Speaking of this fact, the London Pall Mall Budget, said: " If caricature decided the election, Mr. Blaine's chances would be hopeless. Unfortunately ridicule does not kill in the United States."

Among the measures used against Harper's Weekly was the reprinting of Nast's former caricatures of Carl Schurz, who was now a co-worker against Blaine. These, with satirical English and German text, were scattered broadcast, as were also the Cleveland caricatures of 1882, though the latter had been too good-natured to prove effective now. A further endeavor was made to show that Harper's had been a Blaine organ hitherto, in reply to which, the Weekly republished ten of Nast's Blaine cartoons, which had appeared during the five preceding years.

It was essentially a Nast campaign, a battle of fierce onslaught and destructive blows, and as the summer waned the onslaughts became more frequent and the blows became ever more severe.

The association of Blaine with Jay Gould was a matter of much discussion, and the face of the great railway magnate frequently appears in the cartoons. That Mr. Gould did not appreciate this is shown by the fact of his anxiety for a personal interview with the cartoonist. Nast finally accepted his invitation to a luncheon, dur-

"OUR FRIENDS, THE ENEMY"

THE CHARMING WIDOW—"Oh! you naughty, naughty men, will you ever abuse your good, true and beautiful one *again?*"

ing which the man of bonded millions put in most of his time explaining that peace has its generals no less than war. They were no more to be reprehended, he said, than conquerors like Julius Cæsar or the first Napoleon—an argument not especially convincing, considering that these great examples had spent most of their lives in smearing the world with blood.

General Butler's nomination by the Greenback and Anti-Monopoly parties, and that of John P. St. John, of Kansas, by the Prohibition contingent, somewhat complicated the political situation. St. John it was believed, would draw strength from the Blaine forces, while Butler was likely to secure a very considerable number of otherwise Democratic votes. The affectionate attention of the Blaine editors to Butler became the subject of an especially humorous cartoon by Nast, and the sudden apparition of St. John before the "Plumed Knight" was supposed

to depict the alarm inspired by the Prohibition candidate in the bosom of Blaine. In another picture Blaine is shown as a prestidigitateur making water or beer disappear at will.

As the day of election drew near the public mind became daily more biased in its attitude toward the political leaders, the public vision became constantly more distorted. No epithet was so violent or so foul as to be withheld. No chapter was too personal or too sacred to be blazoned along the highways and in the public prints. Yet fierce as were the cartoons by Nast, they adhered strictly to the political situation, touching only upon such personalities as were inseparable from Blaine's public career.

And of these there would seem to have been sufficient. Various transactions had already developed wherein Blaine's political deportment had not been wholly independent of personal advantage, yet all became as nothing compared with the exposure which came at the end of September. The Independent managers had been at work with James Mulligan and Warren Fisher, with the result that they had obtained evidence that the letter and telegram of exoneration, sent to the Judiciary Committee in 1876 by Fisher and Caldwell, had been written at Blaine's own dictation—that the vindication had, in fact, been arranged! Mulligan and Fisher now unburdened themselves fully in the matter, and Harper's Weekly, of September 27, was issued with an extra supplement, which contained four full pages of "New Mulligan Letters," with marginal quotations from Blaine's statements of 1876. That the Maine senator, who had avoided the Credit Mobilier, had become involved in a still worse affair of his own devising seemed only too apparent. In one of his letters to Fisher (June 29, 1869), referring to a bond and railroad scheme, he said:

I do not feel that I shall be a dead-head in the enterprise. I see various channels in which I know I can be useful.

In another letter (November 18, 1869), concerning the establishment of a bank at Little Rock:

It will be to some extent a matter of favoritism as to who gets the banks in the several localities, and it will be in my power to cast an anchor to windward in your behalf, if you desire it.

If anything could have ruined Blaine in the eyes of the American people it would seem to have been the testimony of his own letters, that even so far back as 1869 he had been making himself politically '' useful '' and '' casting anchors to windward '' in the matter of building railroads and establishing banks.

But it would appear that nothing could destroy the popularity of the '' Magnetic Man.'' Public orators went mad with eloquence in eulogizing the candidate whom they compared with Lincoln, Clay and Washington. Torchlight processions filled all the streets, overflowing into lanes and byways— their step timed to the measure of '' Blaine, Blaine! James G. Blaine! '' like the tread of a marching army. Mass meetings were truly named, for they were jammed by men and women, surely magnetized in their devotion to the

AT HIS OLD TRICKS AGAIN OUT WEST

JAMES G. BLAINE—'' I will now, in confidence, *take in* 50,000,000 people.''

(Blaine performing before St. John)

Republican nominee. Women risked their lives to touch his garment or to shake his hand.

The majority of the Protestant clergy threw their influence in his favor, and it was at a reception given him by ministers at the Fifth Avenue Hotel, New York, that the Reverend Dr. Burchard made his unhappy reference to the three R's of Democracy, "Rum, Romanism and Rebellion," which is supposed to have cost Blaine many Catholic votes.

The cartoons came very thickly during the final days. Blaine trying to collect his record with a rake—Blaine taking off a Butler mask and showing his own face behind, while still behind him is Jay Gould—Blaine finally disappearing into his "canvas" bag,—these were a few of the later shots of this historic campaign.

THE BLAINE TARIFF FRAUD
CHORUS OF WORKING MEN—"Duped, by gosh!"

The early election returns were mystifying. Cleveland had triumphed in the South, and was believed to have secured Indiana, New Jersey and Connecticut of the Northern States. Blaine had swept the rest of the North, except New York, which was claimed by both parties. When a day or two had passed and brought no decision, there began to be dangerous out-

breaks of feeling, and it was feared that the delays and contentions of 1876 might be repeated. Here and there a mob broke loose and assaulted a newspaper office. Bulletins were discontinued in Boston and Chicago. In New York a crowd collected in front of the Western Union

"THE FOREMOST MAN OF THE TIME "—*Blaineism*
" I do not feel that I shall prove a deadhead "

building and denounced the Associated Press, which was supposed to be concealing the true returns. Cries of " Hang Jay Gould! " were a part of this demonstration, which was presently suppressed.

The suspense was soon over. A careful and closely verified count gave New York to Cleveland by ten hundred and forty-seven votes. Never before had a presidential election been so nearly tied.

Rejoicings throughout the country were very great. Splendid ratifications took place in every city and town in the nation. At Nast's home, Morristown, there was a mighty demonstration, and in front of the artist's house was displayed a big transparency, bearing these words:

<div align="center">

THE WORLD SAYS THE INDEPENDENTS DID IT
THE TRIBUNE SAYS THE STALWARTS DID IT
THE SUN SAYS BURCHARD DID IT
BLAINE SAYS SAINT JOHN DID IT
THEODORE ROOSEVELT SAYS IT WAS THE SOFT SOAP DINNER
WE SAY BLAINE'S CHARACTER DID IT
BUT WE DON'T CARE WHAT DID IT
IT'S DONE

</div>

A list of many other things might have been appended, the absence of any one of which would have meant the election of Blaine. By no means among the least of these causes might have appeared Gillam's " Tattooed Man " and the cartoons of Thomas Nast. A change of five hundred and twenty-four votes would have altered the result. That the influence of Nast alone swayed many times this number will hardly be denied. So, in a sense, it may be fairly claimed that in his last great campaign in the land of his adoption, the Little Lad of Landau had " made a President."

Yet it had been a costly victory. Friends by the hundred he had lost. Enemies by the thousand he had made. It is true he had made new friends of old enemies, but viewed from a purely practical standpoint, counting the loss and gain, the battle of principles had not paid. Neither Nast nor Curtis ever recovered from the stress and bitterness of that campaign. Nor did the house they had so ably served. The Harper Brothers had calculated that their stand for good government would cost them fifty thousand dollars, but the cost was many times that sum. Commercially it had been a vast mistake. Morally, the nation will never cease to be better for that battle, and for that victory.

THE QUESTION DECIDED ON ELECTION DAY

CHAPTER LVIII

There were to be compensations at the close of this trying and turbulent year, other than those of having done righteously and with a free conscience. A happy Christmas picture, a little maid telephoning to Santa Claus, brought to Harper's a letter of grateful acknowledgment from an unknown friend.

Permit a humble admirer to thank your great artist for his greatest and best work in Harper's Weekly. I refer to the two full-page pictures of the sweet, trustful little girl on the one hand, calling up the great, the good, the mysterious Santa Claus through the telephone. This beautiful vision of my own happy childhood, my love and trust and reverence for dear old Santa Claus, came so forcibly before me in the picture I could not keep back the tears. Yes, tears from a worldly minded and I fear somewhat caustic lawyer came at the memory of childhood's golden days, and the gladdest of them all, Happy Christmas time. I know that his own great heart was full when he pictured the love and benevolence of our glorious old Santa Claus, and he will understand my gratitude. Wishing him many happy Christmas days, I am, Yours truly,

H. W. Greer.

Beaumont, Tex.

In spite of a wide spread condemnation for his political action, there was plenty of congratulation over the victory. Conant wrote:

You have done splendid work this year, saying nothing of all the other years, and may well feel proud of the result. I wish you many returns of the season, with years on years of as good work as your pencil has ever done.

His former protege, Charles M. Fairbanks, sent this word:

Well, you've won, and it's funny to see how the straight Republicans say you've lost your power, while the Democratic papers that have always fought you, begin to see that there is something in your pictures, after all. I must say I am not disappointed in the result, though I didn't expect it, and a new hat that I had hoped to wear at Cleveland's expense, will be worn by a good Democrat this fall at my cost.

Among the pleasant letters is still another, from Nast's old friend and instructor, Alfred Fredericks. It explains itself:

New York, Dec. 24, 1884.
Dear Nast:
　I find that I am indebted to you for the commission for the picture, "Genius and Invention," and I am awfully glad of the find, for you are in a position to need no return, and I am afraid I shall never be in one where an adequate return will be possible. Therefore I am proud to remain your debtor.
Yours truly,
Alfred Fredericks.

There are many men who forget their old benefactors. Through all the years the pupil's devotion to Fredericks had never waned. The managers of the New Orleans Exposition had asked Nast to select for them a capable artist for this important commission, with the result noted—a financial salvation to Fredericks at this time.

Yet Nast's own financial position was by no means what Fredericks perhaps believed. As we have seen, his entire savings had been swept away, leaving him only his home. Neither was his income what it had been in previous years, while his expense had not much abated. He resolved, therefore, to undertake a second lecture tour, for the purpose of restoring in some measure his fallen fortunes.

Major Pond had continued at intervals to bombard him with offers and appeals. In January, 1879, he had written:

Is it worth while for me to pay you a visit to tell you the astounding fact that we are prepared to offer you a larger sum

for a hundred lectures than any man living? Also to tell you how loudly the public are clamoring for you? I will go lay the matter before you, if you are come-at-able.

Again in October, 1883, Pond sent a characteristic word:

Have you anything to say why judgment of lecturing should not be passed upon you?

Finally, in the summer of 1884, Major Pond, having dissolved with Hathaway, and established himself in New York, wrote, assuring the cartoonist that he could make another season as great as the first, if he only would return to the platform.

Had Nast yielded and placed himself in Pond's hands at this time, he might have made a greater financial success than he did. His ideas, however, were otherwise. He returned to the old plan, proposed to Mark Twain in 1867, and ten years later proposed by Mark Twain to him, that of making pictures to illustrate another man's address. He arranged with an English impersonator, Walter Pelham, for this part of the entertainment, and under the management of Hathaway, the legitimate successor of his old agent and friend, Redpath, the two were booked for an extended tour. Thomas Nast, Jr., now grown to man's estate, was press agent and general manager in charge.

It was the year that Mark Twain was making a tour with George W. Cable, and the two gave a reading in Morristown, on Thanksgiving Eve, just before the Nast tour began. The cartoonist arranged for them a quiet supper after their entertainment, and they remained over night in the Nast home. Oysters on the shell were served at the little repast, and Mr. Clemens expressed his delight at the quality thereof.

" Won't you have some more? " suggested the host.

" Don't care if I do," assented Clemens in his deliberate way.

So another serving was brought, and approved of at the finish.

" Have another," said Nast.

" Come to think about it, I believe I will," drawled Clemens.

Another plate was served, and another, and another. At the end of the fifth plate the joker called a halt.

" Look here, Nast," he said sorrowfully, " I didn't know you had an oyster ranche in your cellar. I guess I'll let this job out." Then noticing some inviting looking apples which the children and Mrs. Nast were eating he added: " Are there any more apples in this house? Cause if there is, I'd like one."

But he was to have his joke, after all. The reading pair were to leave next morning, by an early train, and Mrs. Nast had agreed to see that they were up in time. When she awoke there seemed a strange silence in the house and she grew suspicious. She rose and going to the servants' room found them sleeping soundly. The alarm clock in the back hall, whose duty it was to arouse them, had been stopped at the hour of the guests retiring. The studio clock was found to be stopped also—in fact, every clock on the premises. The gentle humorist who in the past had had his share in " Roughing It," was determined now to have his proper time of rest, regardless of early trains and engagements. On being accused of duplicity, he said:

" Wal, those clocks are all overworked, anyway. They will feel much better for a night's rest."

A few days later both Mr. Cable and Mr. Clemens sent their acknowledgments. The former said:

Dear Mr. Nast:

Such larks—since we left you! Our jolly evening and morning with you in your happy home seem to have given us the true keynote of a platformer's life, to which we have kept true, ever since. Our wives at home can hardly keep back the tears for thinking of their " poor husbands, working so hard " (Don't you tell). Off we go to Syracuse this morning. I am overflowing with all the sunshine and breeze we took in at your house, and Clemens's appetite is widening and deepening as we go. May joy and light be with you and yours as naturally as it springs up in us at the remembrance of the home that was ours on the day of Thanksgiving. Yours truly,

 Geo. W. Cable.

Mark Twain's letter was no less characteristic:

My dear Nast:

All these days I have been feeling the thanks I owe you and your family for a thoroughly enjoyable night, and for a hospitality which neither oppressed nor made afraid; and if I haven't voiced these thanks before it is only because we have been kept too busy by platform and railroad. Be piously grateful that as yet you are permitted to remain with your household and under the shelter of your delightful home; and do all your praying now, for a time is coming when you will have to go railroading and platforming, and then you will find you cannot pray any more, because you will have only just time to swear enough.

Please remember me gratefully to Mrs. Nast and to all the scions of your house, and also to their sire, and believe me,

<div align="right">Truly yours,
S. L. Clemens.</div>

Nast's own tour extended this time throughout the East, and as far west as Lincoln, Nebraska. As before, it was almost a continuous ovation, though there were not lacking those who were anxious to make him feel his political change.

The entertainment given by Nast and Pelham was a rather pretentious affair. There was a regular programme, which was frequently varied to suit the conditions. A popular feature was the description by Pelham of some scene or personage, while Nast rapidly illustrated his sentences. The performance usually ended with scenes in color, by Nast, who frequently painted them top-side down, then suddenly reversed them with startling effect. The Nast-Pelham show was highly popular and regarded everywhere as a great success.

Financially it did not equal the venture of eleven years before. The receipts were not much less, but the expenses were far greater. The record shows a nightly return of from two to four hundred dollars, and at one point a thousand dollars for two nights. On the whole it was a fairly profitable venture, the more so that the Harper contributions had continued throughout.

33

CHAPTER LIX

CLEVELAND AND REFORM

A GENTLE HINT TO OFFICE-SEEKERS.
"I regard myself pledged to this."—(Letter of President-elect to Civil Service Reform League.)

If evil prophesying could have injured the newly elected President he would have needed all the good luck wished him by his friends. Financial ills were prognosticated by many, and the restoration of slavery by a few. Nothing less than a clean sweep of office-holders was expected by a majority of both parties. For twenty-eight years the country had not elected a Democratic President. The spoils element of the Republican party had been glutted with office, while the same contingent of the Democracy had been famishing.

That Nast did not believe Mr. Cleveland would inaugurate a "clean sweep" policy was shown by continued cartoons where-

in the President-elect is accustoming himself to the use of a convincing-looking club, labelled " Civil Service Reform," this to the dismay of the too persistent Tiger. In fact, the newly-chosen executive himself had discouraged the idea of partisan patronage, in a " Christmas Letter " to the National Civil Service Reform League, which document had given universal satisfaction to the more progressive element of both parties. He said:

" The quiet and unobtrusive exercise of individual political rights is the reasonable measure of their party service." He further declared that no partisan feeling should relax his purpose to enforce the existing law, and that no incumbent should be removed from office, solely upon partisan grounds, except such as had abused their privileges for party purposes. Clearly, the demand to " turn the rascals out " had, for Mr. Cleveland, a literal rather than a party meaning.

Early in January the President-elect resigned his post at Albany in favor of Lieutenant-Governor David B. Hill, to make preparation for his new duties. For there were vast labors ahead and the time of preparation seemed brief. In a letter to Nast from Albany, February 11, he wrote:

I am overwhelmed with work and anxiety, and am frightened whenever I take note of the flight of time and recall how much I have to do before the fourth of March. So I shall stay here and work and worry, I suppose, until I start for Washington.

With J. Henry Harper, Nast called on him at the Hoffman House a few days before the Inauguration. In the course of the conversation Mr. Cleveland turned to Nast, and said:

" If Arthur had been nominated you would not have supported me."

" No," agreed Nast, " If Arthur had been nominated I should not be here."

The final acts of President Arthur worthily closed his administration. One of these was the signing of a bill, appropriat-

ing nearly two million dollars for the up-building of the navy, a policy continued and enlarged upon by President Cleveland. Another last act of Arthur's was the signing of a bill for putting General Grant on the retired list, with full pay, so that he might want for nothing during his few final days. Thus a President whose administration had begun more inauspiciously than that of any of his predecessors, closed a career which had commanded the nation's approval, with an act that won for him a nation's tender regard. His prophecy that he might not survive another administration proved a true one. He died November 18, 1886.

President Cleveland's inauguration was an impressive event; his inaugural address was enthusiastically received and favorably commented upon. His cabinet was impartially selected and was of excellent timber—his early appointments at home and abroad were approved by all reasonable and thinking men. They were made with no special regard to party or color, but on a basis of qualification for place. The political revolution had resulted in a greater good for a greater number.

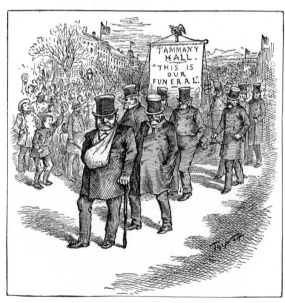

"TAMMANY HALL IS GOING TO THE INAUGURATION"
—*News*
THEY CAN'T HELP THEMSELVES

That the ultra Democratic wing, with a desire for full control, should be disappointed was not surprising. The remark of a Southern congressman, "Gentlemen, we have got an ele-

phant on our hands. I fear there will be some disappointment about the offices," was a comment not overlooked by Nast.

The long and last illness of General Grant claimed the chief interest of the nation during the summer of 1885. The old soldier battling with a deadly disease, yet bravely completing a task which he believed was to be his widow's only means of support— his book of memoirs—was a figure at once so pathetic and so noble that no breath of animosity remained to utter a single word that was not kind. The serene old warrior had lived to see his bitterest foes become his staunchest friends, to see those to whom the news of his death would once have been welcome now praying that he might be spared to complete his task.

And he did so triumph in this his final battle. He wrote as he had fought, simply, nobly and convincingly, and he persisted to the end. The story was finished, and at Mount McGregor, New York, July 23, 1885, the task of living was likewise made complete.

And all the nations mourned. Old errors were forgotten, old asperities put away. Only the great calm soldier was remembered and honored and lamented by all who knew his name. On August 8, public business throughout the nation was suspended, and he was laid to rest in a humble tomb on Riverside Drive, New York City, now replaced by an imposing structure where with him his wife sleeps, the two laid side by side.

No man felt the loss of Grant more keenly than Thomas Nast. The Soldier President was the last of his great heroes. Garibaldi, Lincoln and Grant—they were all gone—for him the world would never know their like again. Though younger than they, he had striven in the same sacred cause of right and liberty, and the old order of conditions, so nearly vanished away, had made them all. He wanted to keep in the march and battle on, but he felt lonely and left behind.

On August 1, he contributed to the Weekly a final tribute,

" The Hero of Our Age—Dead," a fine emblematic double page. Some months later there came a response as from beyond the grave. One day the expressman delivered into his hands a package containing the Grant Memoirs, a finely bound edition. He had already subscribed for the book, but this was an especially handsome copy—one of twenty-five prepared for the author's nearest friends. Upon the fly-leaf was the inscription:

" Sent to Mr. Thomas Nast by direction of the author, and with the compliments of his family."

National politics were kept well in hand by the firm and dignified administration of President Cleveland, and disgruntled office seekers were in no position to disgrace the nation with factional feuds and party dissensions. They complained as individuals rather than as organized bodies, with the possible exception of the Tribe of Tammany, which Nast depicted as a lean tiger wailing at the White House door.

THAT EVERLASTING HUNGRY WAIL

But while Nast and Curtis supported Cleveland and his policy they

AFTER THE NEW YORK ELECTION
It will take more pressure now to keep him out

failed to support Mr. Hill's candidacy for the Governorship of New York. Hill was elected, however, by a large majority, and the old-line Democracy in New York rejoiced, for it believed that a pressure might now be brought to bear which would force the Tiger's entrance through the White House door. Cleveland, grimly regarding the spoilsmen appears in several of the pictures. Then suddenly there is a " Slam-bang! " and the poor starved Tiger, his head caught and held fast in the door, symbolizes the statement—" It looks as if Mr. Cleveland meant business when he ordered the doors closed permanently against office seekers."

A number of happy Christmas pictures closed the year. It had not been distinguished by important work, nor personal doing—a visit with Mrs. Nast to the New Orleans Exposition being the chief domestic incident. The trip was made by way of Cincinnati and Mobile in a private boudoir car, in which Nast had invested money. It proved the only dividend he ever received from that source.

" SLAM-BANG! "
(From the original drawing)

CHAPTER LX

THE FINAL YEAR

THE SPIRIT OF TWEED IS MIGHTY STILL
"And even yet you don't know what you are going to do about it"

With January 1, 1886, began the final year of the combined labors of Thomas Nast and the old journal which, in the words of Roscoe Conkling, he had "made famous," and wherein he had made his fame. In the two dozen years which had elapsed, the nation had passed through its most crucial period, and in its turbulent history he had played a conspicuous part. Now the fierce and bitter issues were passed. The day of the crusader was over—the time for the light jester and the facile harlequin had come.

There were still abuses to be assailed. "Tweed Again" appears in the person of various city officials and contractors who for a measure of ill-gotten return, were willing to risk exposure and disgrace. The heavy personality of the old "Boss," in stripes, was now used as the generic symbol of fraud, and Nast drew sportive groups of Tweeds somewhat as Mr. Opper to-day presents us with his family of merry trusts.

The secret sessions, or Star Chamber proceedings of the Senate, were freely criticised in the cartoons of 1886. That the Senate and the President should be at loggerheads was not conducive to progress, and there is little to be recorded to the credit of those spoilsmen of both parties who made it hard for Cleveland to carry out his purpose of reform. In an editorial (March 13) Curtis says:

"The Democratic party during the first year of its administration has done little to win popular confidence, not because its President has done ill, but because his views and purposes have received no hearty support."

The indiscriminate granting of pension bills was one of the abuses which Mr. Cleveland proceeded to correct. Thousands of palpable frauds had been perpetrated upon the Government. Men, some of them worth fortunes, who had never been near the field of battle, had obtained pensions through disreputable agents, who had been allowed to practice every sort of subterfuge to gain their ends.

BOTH
Equal justice for the briber and the bribed

The numerous vetoes of such bills were made capital of by the President's enemies, but were endorsed by fair-minded people and were heartily approved in the pictures of Nast.

The year 1886 became notable for its labor troubles. The

LAID AT HIS DOOR

POLITICAL TRAMP—"If you don't do exactly as I dictate, and give me all the spoils I want, I'll fall dangerously ill or die."

chief of these began when a discharged foreman on the Texas Pacific Railroad was refused employment by the receivers of that corporation, and a strike was ordered which extended throughout the Gould systems. Riots, with bloodshed and the destruction of property, followed, especially in St. Louis, where one Martin Irons, a local leader, incited continued violence and resistance. T. V. Powderly was then Chief Executive of the Knights of Labor and in course of time ordered the men to resume work, though to little purpose. Irons defied the order, and the disturbance continued. In the end, nothing was accomplished but a vast loss in wages and property, with a general disturbance of labor conditions, East and West.

In Chicago, anarchy manifested itself in its most malignant form. During the St. Louis troubles an eight hour labor strike had been in progress in Chicago, and Anarchist agitators seized upon this opportunity for testing the efficacy of dynamite.

" Of all the good stuff, this is the stuff," wrote Albert R. Parsons, in his paper the Alarm. " A pound of this good stuff beats a bushel of bullets, and don't you forget it! "

Twenty thousand men were idle in Chicago, and on the evening of May 4 a meeting of the more turbulent element was

called together by the publication of an incendiary handbill. The crowds assembled in Haymarket Square, where they were addressed by August Spies, editor of the Arbeiter Zeitung, Albert R. Parsons, before mentioned, and Samuel Fielden—all agitators of the dynamite school. Parsons goaded the crowd to desperation, crying, " To arms! To arms! " whereupon Fielden, the most incendiary of all the orators, sprang to a wagon and with wild gesticulations and shouting, sought to bring the excitement to a still higher pitch of frenzy.

A body of policemen marched up at this juncture and commanded the mob to disperse. The command was hardly given when a spluttering fuse was seen flying through the air toward the policemen. It was a dynamite bomb, well aimed, and it fell directly in their midst. An instant later it had exploded with a deafening report, killing and wounding twenty-nine men.

WHAT'S IN A NAME?

There is a great deal in *his name*, and a great responsibility in the way in which he guards it

The orator closed his harangue abruptly. The policemen were for a moment thrown into confusion. Then quickly reforming they returned the pistol fire of the mob, which now hastily dispersed, leaving, all told, no less than seventy-five of-

ficers and citizens killed and wounded—the victims of the outbreak.

Arrests followed. Bombs and dynamite were discovered in the editorial offices and homes of the various leaders. August Spies and his assistant, Michael Schwab—Fielden, Parsons, Louis Lingg, George Engle, Adolph Fischer and Oscar Neebe were convicted on August 20—the first seven being sentenced to death, the last-named to fifteen years imprisonment. The sentences of Schwab and Fielden were commuted to life servitude, Lingg committed suicide in his cell, while the others were righteously hanged, November 11, 1887. Perhaps Anarchy in Chicago has been no less flourishing, but certainly it has been less flagrant since that day.

New York likewise had its harvest of disorder and boycott that year, resulting in the main from speeches and articles by Herr Most, for which criminal agitation he was dragged from his hiding under a bed and promptly imprisoned. On the whole, it was not a prosperous year for the man of bombs and violent speech.

Throughout the various labor difficulties Nast had shown the ugliness and uselessness of Anarchy, the craven cowardice of Most, and the evil which such agitation brings to the really progressive and industrious workmen. None of the pictures had been unusual, until, with the conviction of the Chicago murderers, he presented a cartoon of the sentenced Anarchists in the clutch of the giant hand of Justice—a picture, in its way, one of the very best of his whole career. The strength, simplicity and startling effect of this drawing are truly marvelous.

It was as the flare of an expiring candle, which burned quietly again as the final year went out—closing with some peaceful Christmas pictures—one of them, the old sweet kind, an illustration of,

" The night before Christmas, when all through the house
Not a creature was stirring, not even a mouse—"

LIBERTY IS NOT ANARCHY

and we have the mice tucked snugly in bed, with holly and mistletoe hung all about, while the kindly face of St. Nicholas contemplates the scene.

The Bazar that year contained a picture of the Christkind—one of the sweetest baby faces Nast had ever drawn. These completed his final exhibit in the periodicals he had served so long. It is proper that they should have conveyed the spirit of forgiveness and goodwill to all mankind.

And so, peacefully enough, even as it had begun, ended that long association of one man with one paper—the like of which has not been known in all pictorial history. Who could have foreseen in the boy of twenty-two the patriot, reformer and statesman, whose pencil, trained only to depict truth and strike home, should leave indelible pages in a mighty nation's story!

Nast's retainer continued for a year longer, but it was understood that he was to have an extended vacation in which to prepare his Christmas pictures and the Ring cartoons for book publication. When this work was finished (only the Christmas pictures were so published) the editorial conditions were such that he did not consider it advisable to continue his contributions.

His pictures in 1886 had been very numerous, but for the most par t they had been small, and many of them of a nature which seemed to him unimportant. He had arrived at the conviction that his natural affiliation with the old firm had ceased to exist—that the old Journal of Civilization no longer held a place for him. He did not feel able to continue in the half-hearted way, so unlike the old fierce days when he had been " the avenger " —a mailed knight with gleaming battle axe to carve out the way of reform.

In 1888, when the Presidential campaign was coming on, the firm telegraphed him: " We await your return for consideration of a new contract," but the arrangement was not completed.

There was no quarrel, no fierce dissension, such as has been so widely reported by the enemies of both artist and publishers. Not in bitterness, but in sorrow, they parted, each hardly knowing why, yet both convinced that the end had come.

" 'TWAS THE NIGHT BEFORE CHRISTMAS, WHEN ALL THROUGH THE HOUSE
NOT A CREATURE WAS STIRRING, NOT EVEN A MOUSE "
(The final picture in Harper's Weekly. From the original drawing)

PART SIX: THE CONSUL

CHAPTER LXI

AT THE END OF POWER

No great career ever came to an end more abruptly and more completely. The one man and the one paper had been combined too long for either ever to be the same apart. Colonel Watterson long afterwards, said:

" In quitting Harper's Weekly, Nast lost his forum: in losing him, Harper's Weekly lost its political importance."

And this was true. Thomas Nast was the pictorial advocate, censor and statesman of his age. Harper's Weekly was his tribunal. Without Harper's Weekly the work of Nast found no adequate setting—no permanent audience. He became as a voice lost in the multitude. Without Nast the old Journal of Civilization was a platform occupied by vice-presidents. The two had been identified through the most tumultuous, if not the most vital, period of this nation's history. Their traditions, their audience and their fortunes had been as one. Neither Nast nor the paper found prosperity apart.

Yet as the journal did not discontinue publication, neither did Nast cease his labors, or his effort to restore his shattered fortunes. As we have seen, he made no drawings through 1887, but he was not altogether idle. A year before, his hope of the

endowed paper had revived—it was a hope that never altogether died—and he had been led once more to invest a last accumulation of savings in a western mine. It would seem that he never could learn not to bury his money in the ground. He still clung to the fond belief that as other venturers had reaped marvelous returns from such a sowing of golden seed, so he too must harvest sooner or later, when, with the sinews of war provided, he could once more make the battle for right and progress which would arouse and uplift mankind. The paper was his one great purpose. With every year of increased restraint in his old field, it had been fostered and magnified until nothing else in the world seemed to him worth while.

He often said: " Such a paper would do more good than any church or library or college ever founded. Why can't some rich man understand that and endow it for all time. Of course, it would not pay—not at first—perhaps not for years. But its time would come, for it would create its own audience, at last."

" Principles, not Men " was to be his old-fashioned motto for this paper, and when he realized that no man of fortune was ready to establish such a journal, he himself was willing to race to the rainbow's end for a buried pot of gold.

He dreamed marvelous dreams of the new mine. Understanding nothing of the business himself, he had his son, Thomas, Jr., taught assaying, and sent him, with an expensive outfit, to manage the new property. This was in May, 1886. The fact that immediate returns did not come may have surprised, but did not discourage, the mine owner.

In January, 1887, Erastus Wiman took a party of his artist friends on a trip through Canada. Keppler, Bernhard Gillam and Nast—all dead now—were among those invited. On the eve of departure, Nast gave the little company a dinner in his Morristown home. Keppler sent regrets " with bleeding heart," but Gillam, John W. Alexander, Baron de Grimm, Harry Mc-

Vickar and others came. Nast's three daughters served as cook and waitresses, and it was a happy affair. All did honor to the "Father of the American Cartoon," who had given them their symbols, elevated prices, and supplied inspiration.

"I never bother to think up subjects," said Gillam. "I just look up Nast's things in the old numbers of Harper's and get what I want. Nast has done about everything."

On his return from Canada the cartoonist with Mrs. Nast journeyed southward, by way of Washington, where at the White House they were made welcome, as heretofore. Proceeding on their way they visited Jacksonville, Florida; also St. Augustine, and followed the course of the St. Johns, returning by steamer the latter part of April. It was the last long journey they ever made together.

It was in September of that year that Nast set out for the West to look after his mine. The inflow of wealth had not begun. In fact, he had added three thousand dollars to his original investment—money borrowed for the purpose—and still there was no return. Just what was the process of enlightenment as to the true value of his property does not matter. It is enough to say that he found the mine was considered worthless, and he returned to Denver prostrated by a nervous attack. He lay ill for a considerable period and upon his recovery did not return home. Instead, he sent for his materials and gave a lecture to a large audience. From Denver he proceeded with his son to the Pacific Coast, lecturing as he went. At Portland, Oregon, he was ill again. Later he gave his lecture there before a crowded house, and subsequently continued his tour through California with varying success.

His trip, as usual, was a succession of social triumphs. He was welcomed and honored by clubs and associations of many kinds, and tendered many testimonials and souvenirs. "Baby" Tabor, the little daughter of Senator Tabor, of Colorado, pre-

sented him with a curious locket, made for him of the various metals of the state. At one point he travelled for a distance in company with the directors of the Midland Railroad, and a lofty snow-clad peak on the line was christened Mt. Nast, in honor of the occasion. One of the highest summits of the range, it will remain a noble monument for all time.

During this trip he renewed acquaintance with his old

"BABY" TABOR—AS THE CHRISTKIND
(From Harper's Bazar, Christmas, 1886-7)

friend Colonel Chipman, who had entered the law business at Red Bluff, California, and the two had a happy reunion and an exhaustive talk over old times and issues. Later, Colonel Chipman wrote him concerning his political attitude. In part, he said:

Mr. Blaine has done what you insisted he would not do, to wit: he has positively refused to be a candidate. It seems to me the Mugwump can now afford to come back, unless, as I suspect, the Mugwump is a Democrat at heart, and hasn't the courage to say so, and will now go over to the party where he belongs. You, however, must not mar your great record by joining that party which lampooned you for years. The time will not come in your life when you can forsake the party that put down the Rebellion.

John I. Covington, another old supporter, had somewhat previously sent a similar letter. A paragraph will indicate its general tone:

If ever there was an artist idolized by the people—that is, the best of them,—it has been Thomas Nast. I know that I understand the sentiment—of the people of the West, at least— when I say this, better than you can. For I hear them talk freely, openly, honestly and without reserve. Ever since you took up Cleveland's side, I have felt that our boys have been whipped, and the old feeling of disaster to our arms has been upon me. I am not a politician or related to a politician that I know of, and I am down on wrong doings of Republicans, but I cannot bring myself to believe that the Democrats are a bit better than they were when they would have gloried in your assassination.

From John Russell Young, also, came a political line:

As to Cleveland, he said, " I have never really had a definite opinion. I have never had a talk with him but one. He has done some things I like, though he might have done more. All my living interest in politics went into the modest grave at Riverside, and I have never known whether I was a Democrat or a Republican since."

Perhaps a good deal of Nast's political interest likewise had gone into the modest grave on Riverside Drive, but he was by no means ready to retire from the field, and his faith in Cleveland was very strong. He returned to New York in June that he might be in time for the campaign.

In spite of financial pressure he had, as we have seen, declined to renew the Harper arrangement. He concluded, instead, a contract with the Democratic Committee to supply cartoons to an assortment of papers, the chief of which was the Daily Graphic. He worked hard, and his drawings did not fail of appreciation. In September, Don. M. Dickinson wrote:

I want to express my personal sense of gratitude to you for the excellent lessons you are giving our people in the Graphic. You reach hundreds with strong virile teaching, where the stock campaign document impresses one.

MT. NAST, ON THE COLORADO MIDLAND RAILROAD

Yet on the whole the work of that year was not a success. The pictures fell with less effect than in former years. The old setting was gone. They were badly reproduced, poorly printed and on cheap paper. The serial element, one of Nast's strongest features, counted for little. Divided among various journals it lost force and purpose. The defeat of Cleveland in November was also the first presidential defeat for Nast. The glory of his prestige had waned. The Democratic Committee refused full payment for his service.

True, the Graphic wished to continue his employment, but the sum offered was unsatisfactory and the paper being already moribund presently died. Tired, heartsick and half ill, Nast sailed for England for a brief trip, taking with him Thomas, Jr., who had been of active assistance during the campaign. They remained six weeks, returning just before Christmas. What with his lectures, his work for the committee and a few additional illustrations it had not been an unprofitable year. But it had been a bitter depressing year, and the path ahead seemed uncertain and obscure.

CHAPTER LXII

A PAPER OF HIS OWN AT LAST

From this time forward the cartoons of Thomas Nast, so recently a national power, were in a large measure lost to the old public and were without national importance. There was still a demand for his work, but such connections as he could make were neither satisfactory nor enduring. Established papers had policies which were controlled by the management, and to the support of these every part of the great machine was expected to contribute. Nast never could work in that way, and it was only a question of a few days, or, at most, weeks, when he must either oppose his pencil to his principles or resign.

"I cannot do it," he once declared sorrowfully, for his need had become sore and the temptation great. "I cannot outrage my convictions;" and he never did. Certainly if there was no place for such a man on the old Journal of Civilization there was not likely to be elsewhere.

New publications, wishing to make a bid for public favor, and older ones on the verge of collapse sent for him and with rosy promises induced him to fling his power and reputation into the balance. In 1889-90 he supplied drawings to a short-lived publication called Time and to another called America—the latter published in Chicago. Occasionally he contributed something to Once a Week, now Collier's Weekly.

There came a time at last when horses were sold and servants let go. Eventually he was obliged to put a mortgage on the home, to live. He was advised to sell it, but to this he would never consent. It had been the scene of his triumphs and of his great domestic happiness. He loved it with every fibre of his heart and he clung to it till the end.

One of his greatest sorrows was that he could no longer afford to give with an open hand to those who appealed to his ready sympathy and ever ready purse. Men and women in many walks of life he had assisted, some of them so wealthy now that they had forgotten. His walls were covered with pictures bought of less fortunate fellow craftsmen, among whom were those who, because of his success, did not fail to belittle his achievements and to ridicule his skill. He had never regretted giving aid, whatever followed. His regret was that he could give no more.

In 1891 he went to Chicago as a judge in the Inter Ocean prize contest—the award to be rendered for the best emblematic drawing of that city. He remained to make some cartoons for the paper, then owned by Mr. Kohlsaat, always a true friend.

It was also during this period that he began work for the Illustrated American—an attractive publication in the days of its early existence—and his connection with that paper proved more important and more enduring than any of this final period of his labors. In the Illustrated American he cartooned Matthew S. Quay, whose political career has now become an unsavory memory; also Chauncey M. Depew, for his attitude during the investigation of one of those tragic tunnel episodes in New York City which have darkened the history of the Harlem and New Haven roads. Mr. Depew as a director was inclined to resent a summons to appear before the judiciary. With airy manner and gay persiflage he referred to the possibility of his imprisonment and " poked fun " at the idea of being held in any way responsible for the death and cremation of the victims. The

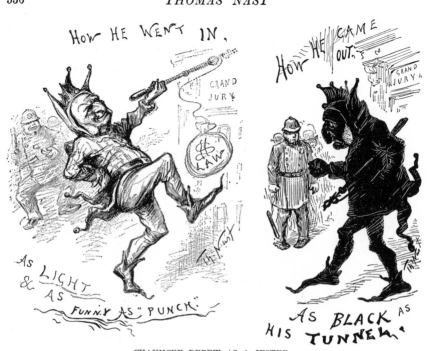

CHAUNCEY DEPEW AS A JESTER
(From the Illustrated American)

press was severe on the joke maker, and Nast cartooned him with a severity and persistence worthy of the cause.

The sale of the paper was immediately stopped on the Vanderbilt lines and Depew never forgave the artist. Neither did he ever forget, though he waited until Nast was safely dead before attempting his revenge.*

* In February, 1903, in the United States Senate chamber, Mr. Depew delivered a discourse on the character and career of Amos J. Cummings, then lately dead. It was this auspicious occasion that Senator Depew selected for his revenge upon Thomas Nast for having cartooned him as a jester a dozen years before. Leading back through the career of Mr. Cummings he reached that of Horace Greeley and the close of the Presidential campaign of 1872. Then, upon his own authority as an eye-witness, he said:

"I have seen many a death-bed in my life; I have witnessed life go out under conditions that were sad or sweet, hopeful or despairing. I never but once saw a man die of a broken heart, and never do I wish to see such a tragedy again.

"I made a speech with Mr. Greeley in his Presidential campaign just before its close. We spoke from the same platform, and both of us knew that he was to be beaten. We returned to his home, and he was jeered on the train and at the depot

The Illustrated American though lingering for a number of years was eventually added to the papers of the past. Others likewise came and went, employing the cartoonist for a period of their brief existence. The name of Nast was still one to conjure with, but alas, it evoked only genii sinister and parades funereal. In the belief that he still had an audience, he was invited to stand at the christening of many a new publication. But if his supporters rallied, they were barely in time to attend the obsequies at which Nast himself was likely to be chief mourner. Speaking of these things afterwards, with that quaint humor

when we arrived. We went to his study, which was littered with those famous caricatures of Nast, representing him as the embodiment of all that was evil or vile in expression or practice in life. Mr. Greeley glanced them over for a moment, and then he said:

" 'My life is a failure; I never have sought to accumulate fortune; I never have cared for fame; but I did want to leave a monument of what I had done for my fellow-men, in lifting them up, in doing away with the curse of slavery and the curse of rum; but here I am, at the close of this campaign, so misrepresented to my countrymen that the slave will always look upon me as having been one of his owners, and reform will believe me a fraud.'

" Then, his head falling upon his desk, he burst into uncontrollable sobs. I sent for his family. The brain that had done such splendid work snapped. The next morning he was taken to an asylum, where he died. His heart literally broke at the moment when he bowed his head upon his desk."

Unluckily for Senator Depew, he did not wait long enough. There was still one man living who could refute the testimony thus solemnly offered and set the matter right before the world. Perhaps the Senator did not believe that Whitelaw Reid—himself in the old days one of Nast's most frequent victims—would come forward to defend his old assailant now. Senator Depew had therefore to learn that there are men who care more for right and truth than for any annoyance of the past. The Tribune of February 18, 1903, in an editorial " To Keep the Record Straight," reprinted the above remarks made by Senator Depew, and then in very clear type added:

" So much for Mr. Depew's vivid recollection. Now for the reality: On Saturday, October 12, 1872, there was a political meeting in Pleasantville, near Chappaqua, which was attended by many of Mr. Greeley's old friends and neighbors, and owing to that circumstance, as he explained, Mr. Greeley took pains to be present and made a speech. Mr. Depew was also there and spoke. At that time Mrs. Greeley, who had long been ill, had become much worse, and thereafter she failed rapidly until her death, on October 30, at the house of Mr. and Mrs. Alvin J. Johnson, in this city. During the last fortnight Mr. Greeley was with her constantly, refusing to take any further part in the campaign, so that, as it happened, the Pleasantville speech was the last speech he made. Immediately after the meeting, Mr. Greeley and Mr. Depew took the train for New York, but Mr. Greeley got off at Williamsbridge to spend the

which rarely deserted him, even in the dark final days, he said: "It kept me busy attending funerals. Finally I started one of my own."

It was not his own in the beginning. In March, 1892, he received a letter carrying the name of the New York Gazette and three editors, at the top. The letter was of the old sort, holding out the promise of work, remuneration, and a " free rein."

And Nast—by this time anxious for anything that offered an outlet for his expression, as well as monetary reward—allied himself with the Gazette. With the usual fortune he presently found himself its chief creditor. A little later he had the journal itself on his hands. Thus, suddenly, without plan, price or the means of conducting it, the paper he had dreamed of so long had in some sort become a reality. He established Thomas Nast, Jr., as a publisher, employed an editor and put another mortgage on his home for capital.

There have been a great many bad combinations in publishing enterprises, but probably never a worse one than that which took over the remnants and fortunes of the Gazette. No one of those interested had the smallest idea of practical business, especially of the business side of publishing. Their advertising

night with Waldo Hutchins, while Mr. Depew came on to New York. So vanishes the touching fable about Mr. Greeley's confession of failure to Mr. Depew, the uncontrollable sobs, the broken heart, the sending for the family, the snapping of the brain that had done such splendid work, the removal to an asylum the next morning.

"The facts are, that in a signed communication written on the day after the election Mr. Greeley resumed the editorship of The Tribune in full possession of his mental faculties, wrote and published several articles in the course of the next few days, but after November 12 abandoned the effort to visit the office regularly, gradually succumbed to exhaustion, due chiefly to his sleepless vigil at his wife's bedside at the end of a hard campaign, and died at the residence of Dr. Choate, near Chappaqua, inflammation of the brain covering having ensued on November 29, more than six weeks after the Pleasantville meeting, at which he made his last speech and where Mr. Depew also spoke. Of course Mr. Depew will understand that our sole motive in setting him straight is to prevent his speech, preserved in ' The Congressional Record,' from being carelessly accepted as accurate and possibly to some extent supplanting or confusing the truth."—New York Tribune, February 18, 1903.

agent demanded, and received, his commission on contracts which proved worthless in the end. An attack on police corruption resulted in the paper being discontinued by the news company and there was no influence sufficient to combat this order.

True, the measures of reform undertaken by Nast in the Gazette met with approval, as well as a modicum of moral sustenance at the hands of certain leaders in the cause of Municipal Purity. Financial support was thought to be forthcoming. In April, Dr. C. H. Parkhurst wrote a number of encouraging letters. In one of these he said:

A CARTOON FROM NAST'S WEEKLY

Nothing but the shattering of the entire Tammany system can accomplish thorough results or yield issues that you and I can ever be satisfied with. I am exceedingly pleased at the position of the Gazette, and hope to be the means of extending its circulation.

Again, on May 3, Dr. Parkhurst wrote:

Tammany is disturbed, and on the whole I think the outlook rather promising. (And on May 31:) You can rely upon it that a certain number of subscriptions to the Gazette will be pledged by us. The very opposition to the Gazette which has been displayed on the part of our opponents makes us the more anxious to stand by you. If you will see Mr. Whitney, I am sure he will express himself as feeling exactly as I feel, and as ready to commit himself in behalf of the board in the matter that I have specified.

But it was the old story of disappointment and ill-fortune. Mr. Whitney died, and the plans to sustain the Gazette fell through. In July Dr. Parkhurst wrote from Switzerland, expressing his obligations to Nast and his sorrow that the purpose

to aid the paper had been upset by Mr. Whitney's death. Nothing substantial had been accomplished. The borrowed thousands melted and would have vanished even sooner than they did but for the fact that it was a campaign year and a cartoon paper was worth keeping alive. Nast with many others believed that the old party had been regenerated under Harrison, and in the campaign of 1892 accorded him a full support. In appreciation, the Republican managers guaranteed the paper—now to be called Nast's Weekly—a circulation of one hundred thousand copies, with which support it was able to survive the winter. Leon Mead and Charles M. Fairbanks supplied the letter press, and with Nast's pictures the paper was sufficiently creditable.

NAP. McKINLEY: "OH, TAKE ME TO THE HOTEL DES INVALIDES!"

MR. McKINLEY AFTER HARRISON'S DEFEAT IN 1892

(From Nast's Weekly)

But it could not go on. After the presidential defeat in November—the second, now, for Nast—the fictitious circulation slipped away; the advertising brought little or no return; the editor, artist, and publisher were obliged to earn a living. By the spring of 1893, Nast's Weekly, with its dreams and schemes and wasted effort, had joined the long procession of dead papers that file back through library archives to the catacombs of time.

Nast was now many thousand dollars in debt and his income was less than the cost of living.* He continued work, but his efforts were for the most part lost to the old public which had

* There was no indebtedness left against the paper. Nast paid everything and was rated A-1 by the commercial agencies. His chief consolation in his various enterprises was that he lost nobody's money but his own.

valued them so long. His pictures were not without purpose but they showed a lack of the former spirt of assuredness, and with this lack the old care of preparation could not long survive. No man who has passed the half-way mark can persist enduringly in the face of repeated discouragement and defeat. The time will come when he must waver and weaken and let go. In the fullest sense of the phrase—though hope in him never entirely perished, and confidence in his power and purpose survived to the end—Thomas Nast while still in the prime of life was " out of the running."

As for the public it could not understand. It could not comprehend that a man who had but recently been so great a power could be so completely ef-
faced. For years after his
retirement, letters of in-
quiry came to Harpers and
to Nast himself, and con-
tinued to come even after
it had been made clear that
the old alliance was really
ended. Newspapers short
of items filled their columns
with belated explanations
of the Harper-Nast diffi-
culty—most of them wholly
imaginary as to details.
Some, doubtless written by
a younger generation who
perhaps never even referred
to the Harper files, went so
wide of the mark as to as-
sert that he had left Har-
per's Weekly in 1884 be-

RICHARD CROKER AT A STANDSTILL

(From the New York Recorder. Nast was first to point out Mr. Croker's rather striking resemblance to the tiger)

cause they had asked him to caricature Blaine. Others declared he had been bought off. Nearly all repeated the old fiction that he had received a retainer for years after his retirement, and in return had been compelled to draw each week a cartoon which did not appear. Nast never took the trouble to deny any of these things. Neither did he give heed to the old slanders which his enemies still circulated, save only to the story that he had once

A BREEZE FROM THE WEST
(From the original drawing)

caricatured Lincoln as a sot. This lie he promptly checked wherever it appeared.

For years the bitter, blighting struggle went on. He planned a return to the lecture field, but to no purpose. Lyceums that in the hour of his great triumph had begged him for even a few engagements now put him off with pleasant words that led to nothing in the end. It was the same with his drawings. Picture after picture was sent out and returned with thanks and complimentary excuses. Perhaps a new editor, not comprehending the change in public taste, would give him brief encouragement. But it never resulted in more than a temporary connection. Either the paper died, or the editor awoke to the altered conditions. In art it would seem that the struggle for recognition must come at one end of life or the other. Many meet it at the beginning and sometimes it is long, wearying, and embittering to the soul. With Nast it was just the reverse. Success crowned his youth. His old age was a heart-breaking effort to

regain a lost prestige. It became a struggle at last to maintain any footing which would keep him in the march he had led so long.

And he was so ill-fitted to cope with the problem. With an entire lack of business training, and with those long years of success, when there had been no question as to his market or his return, he found himself now far more helpless than the unknown youth who goes out to win recognition with a first bundle of sketches under his arm.

Of course Nast himself was last to comprehend that the world no longer wanted his work. At first he had been in-credulous, then amazed. Fi-nally he was heart-broken. Once, back in the old Tweed days, John Ireland, a relative of George Jones, had said to him:

MARCH
(From the original drawing)

"Tommy Nast, some day you will not be so popular as you are now. People will not understand you, or care."

But Nast, so sure of his purpose of right, so strong in his convictions and so deeply in sympathy with human-kind, could not understand that such an hour might come. Now it was here. Such pictures as he could dispose of appeared in the newspaper syndicates and trade journals, his periodical market becoming more meagre each year, as each year younger men with more nimble fingers claimed attention, and with some new trick of manner made a successful bid for public favor. He did not envy them and he was rarely bitter. Perhaps he was sustained by meeting on every hand his old symbols—the Tiger, the Ele-phant, and all the others, and by the realization that though his own pen was no longer a power, he still potently survived through

these successors, who by daily use were making his old-time emblems immortal.

For himself the times were out of joint. The public no longer demanded pictorial crusades, but only a pageant of clever burlesque with the light hits and mock warfare that amused to-day and to-morrow were forgotten for all time. The windmills had become too powerful for those who would gird on their armor and go forth to redress wrong; the day of knight errantry was over. Somehow the gentle and pathetic figure of Don Quixote cannot fail to present itself to those who in his final days were familiar with the dreams, and struggles, and disappointments, and with the lovable personality of Thomas Nast.

In time, he, too, realized that the land of his adoption, for which he had striven so fearlessly and well, did not want him any more. Yet he never ceased to believe that by some chance his day might come again; and it may be that had some burning issue suddenly developed—with the need of great and simple conviction, and with some strong human force like Fletcher Harper to swing wide the gates of expression—it may be that the old inspiration would have come back and with it the deftness of hand and the power to achieve mighty things. The crisis will always produce the hero, and Thomas Nast, still in his prime, might once more have been that man.

Speaking of Nast's retirement, a New York correspondent said:

The pressure of the great issues of the war raised up a Lincoln, a Grant and a Nast. Lincoln broad in love, firm in purpose; Grant brave and unyielding; Nast an inspired artist to encourage the hearts of the rulers and the soldiers of the people.

So, with those others, whom he had honored and served, he had once filled his niche in the nation's history. He was not old, he had only lived beyond the time of the nation's need and never in his day was the hour of his opportunity to return.

CHAPTER LXIII

THE LAST CONGENIAL OCCUPATIONS

The toilsome way was not to remain unillumined to the end. In 1894 Nast sailed for Europe in the hope that his work might still be needed there. He made no permanent arrangement for drawings, but he met his old friend Kohlsaat in London, and was commissioned by him to paint a large picture of the scene of Lee's surrender to Grant. The order came like a gift from heaven, for it was the thing of all others he most wished to do, and the price was to be liberal.

MR. KIPLING ON THE STEAMER, 1894

"I should never have come back," he wrote, "if it had not been for this. Now I can take new heart."

Nor was this all. One evening, while still in London, he was with Henry Irving at the Beefsteak Club, where Irving entertained his friends after the

35

PEACE IN UNION. THE SURRENDER AT APPOMATTOX, APRIL 9, 1865
(Painted for H. H. Kohlsaat. Now in the Public Library, Galena, Illinois)

theatre, and during their talk the great actor, knowing Nast's love of Shakespeare, invited him to make a painting which would convey his devotion to the immortal dramatist.

So he returned with these two commissions, and all that winter worked on the big Appomattox picture, which he finished on April 9, 1895, the thirtieth anniversary of the scene it presented, the last touches being added at the hour when the surrender took place. Then he put the date on the palette he had used, hung it up and never touched it again.

The picture was presented by Mr. Kohlsaat to the public library at Galena on Grant's birthday, with appropriate ceremonies. It was universally reproduced and commended by the press. It is Nast's largest and most important painting.

He did not begin immediately on the Irving picture. He had worked very hard and rapidly on the larger canvas, and the

old lameness of his right arm had in a measure returned. He perfected his idea, however, and duly submitted it to Irving. Immediately there came a cablegram of approval:

London, July 20, 1895.
Love and greeting, old friend. Shall be delighted (with) what you suggest.　　　　　　　　　　　　Henry Irving.

So that winter he did " The Immortal Light of Genius "— a scene of the interior of the room where Shakespeare was born, with a bust of the poet, his head surrounded by a light that radiates from his forehead. The spirits of Comedy and Tragedy advance to crown the bard with laurel. It was completed on Shakespeare's birthday, April 23, of 1896, and was presented to the William Winter Memorial on Staten Island. A replica of it afterward was made for the Shakespeare Memorial at Stratford, and was presented by Mrs. Nast in 1903, in time for the birthday celebration. In the report made by the Governors of the Stratford Memorial the picture is thus mentioned:

The conception is in Mr. Nast's best manner. The rich sombre tones heighten the effect of the supernatural light surrounding the poet's image, and the marvellous treatment of the ghost-like figures is inimitable. The picture is a finely executed work of art, worthy of the high reputation of the artist.

In 1899 Nast received an order for a third painting—this time from William L. Keese, who, with Nast, was one of the remaining admirers of the old character actor of their childhood, William E. Burton. The painting is a study of Burton in his favorite impersonation of " Toodles," as they both recollected him so long before. It was presented by Mr. Keese to his club, The Players, and it holds to-day an honored place among the works of many of the world's great painters.

Had Nast received an art education in youth, and had his aim not been diverted in the direction of the political cartoon, his name, also, might have been recorded with theirs. In Jarvis's

"Art Idea" *—a volume published by Hurd and Houghton, 1864,
—the author includes Nast, then a boy of twenty-four, with

WILLIAM E. BURTON AS "TOODLES"
(Painted for William L. Keese—now in The Players, New York City)

Inness, Darley and Vedder. On page 242 he says:

Judging from the wood-cuts in Harper's Weekly of compositions relating to the various stages of war, Nast is an artist of uncommon abilities. He has composed designs, or rather given hints of his ability to do so, of allegorical, symbolical or illustrative character far more worthy to be transferred in paint to the wall-spaces of our public buildings than anything that has yet been placed on them. Although hastily got up for a temporary purpose, they evince originality of conception, freedom of manner, lofty appreciation of national ideas and action, and a large artistic instinct.

But the lack of time and means, and his surging convictions concerning public issues, then at white heat, led him to find expression in the political cartoon. Here academic draughtsmanship counted for less. The chief purpose was to make pictures that would carry the truth and strike home. No man has ever done that so ably as Nast. No man of this generation is likely to do so.

* "The Art Idea," by John Jackson Jarvis.

John A. Mitchell, of Life, the foremost American authority on the subject, speaking of the Tweed cartoons said:*

Not only the reading public but the entire people—men, women, and children—those who read and those who did not, became interested, then angry, and finally determined: and, this accomplished, the wrong was speedily righted. It is doubtful if the power of caricature was ever more forcibly illustrated than on this occasion, and the somewhat sudden development of this branch of art on our side of the Atlantic was largely due to the force and courage of Thomas Nast.

The painters are few indeed who in their chosen field have achieved an eminence which will compare with the distinction thus accorded. It seems most unlikely that Nast would have done so. Often he lamented his lack of technical training. At another time, looking at a group of pictures, he would say, "But how much alike they are, after all." Technical training might have made a

* Contemporary American Caricature, Scribner's Magazine, December, 1889.

THOMAS NAST, 1895
(Photographed by Rockwood)

painter of Nast, but it is more than likely that it would have lost to us the great master of the cartoon.

In the later days, the life of Nast became one of contemplation rather than activity. Now and then some one came with a plan for a publication, or a syndicate, or for some other enterprise which was to restore him to his old place, but for the most part he regarded such schemes with but dubious interest. Not that he ever entirely gave up hope, or wholly lost confidence in his fellow men. Neither did he become harsh and disagreeable to those about him. No man ever had warmer and more devoted friends, and they were drawn nearer to him by the cheerful manner and gentle resignation of his final days. His old seat at The Players, where on an occasional evening he loved to sit quietly, was always surrounded by men who knew him for his true worth, who loved and honored him for all that he was, and had been.

Nast accepts an invitation from Charles Harvey Genung

It was in acknowledging kindly attentions of his friends that Nast in his last years found the greatest comfort in his art. Always averse to letter-writing, throughout his life it had been his custom to send a hasty sketch which conveyed his message more fully than he could have expressed it in words. Sometimes when asked if he ever wrote anything but his signature, he replied, " Not if I can help it. My pen won't spell right, anyway."

So he had nearly always sent a picture, exhibiting himself in some appropriate attitude of reply. Sometimes, however, he added a line or two to complete the idea. Once, in the old days, during very hot weather, there came a letter from Murat Halstead, whose penmanship was Nast's despair. In reply he sent a small caricature showing his state of bewilderment, the perspiration dripping from his brow. To this he added:

" Dear Halstead: You write a very running hand. I have

been running after it ever since. Please don't write any more until it is cooler.''

The convenient make-shift of his early life became now his chief diversion. His friends recollected him in many small ways, and the quaint little caricature acknowledgments were always highly prized, and duly treasured. In a letter recently received by the writer, one recipient expresses something of his appreciation of a souvenir drawing, as well as of the artist himself. He says:

"THE LANDING OF A 'FATHER'
(Sent to James Whitcomb Riley)

From the memorable days of our great Civil War I recall the thrill of a boy's delight over the pictures of Th. Nast in Harper's Weekly, and of his cheery Christmas pictures—his Santa Claus—his Dickens characters, and the annual '' potshot '' of fun to be found in his Comic Almanac. It was not until I was long come to man's estate that I was blessed by meeting this wonderful genial genius himself; and was by him humored to refer to my first impressions of his various work —but especially I recalled to him one little funny tailpiece in his Almanac. Then *he* recalled it and with me laughed over it again. And about two months later—wholly to my surprise and vast delight—came to me this copy of that self-same, funny little picture I had so happily for myself recalled to the memory of the distinctive

A WARM DAY IN MORRISTOWN
(Sent to Cyril Nast)

master of both pathos and humor (God bless him!) and God bless us every one! Hastily and very heartily yours,

James Whitcomb Riley.

Riley, in his letter to Nast, expressed a still further obligation:

Nor would I neglect the acknowledgment of a certain art influence of yours that has been not only a constant pleasure to me since that far-off time, but has helped and blessed my efforts in an humbler yet somewhat kindred line.

> An alien wind that blew and blew:—
> I had blurred my eyes as the artists do,
> Coaxing life to a half-sketched face,
> Or dreaming bloom for a grassy place.

The hearty appreciation which is balm to the battle-scarred veteran was never lacking in the letters. Mr. Kohlsaat just after a birthday wrote:

AN ACCEPTANCE OF A MILITARY INVITATION

My dear Nast:

I received yesterday by mail your little birthday greeting. Many thanks for remembering me. How did you know it was my birthday?

I saw a good deal of Irving last week. He is surely a charming man. We talked about you and your work and he spoke of you in very loving terms. I do not know a man whom greatness has spoiled so little as Sir Henry.

I hope you are well and getting along nicely. Wishing you and yours all the good things of life, I remain Sincerely yours,

H. H. Kohlsaat.

There are many of the little souvenir sketches in existence. Most of Nast's intimate friends treasure one or more. A collection of them would make an interesting volume. Several are possessed by The Players, for he never failed to respond to the Founders' Night invitation with a jolly pictorial acceptance.

He likewise found comfort in calling on old friends, especially on those whom he had seen grow up, perhaps had helped into a high inheritance. Pushed aside himself, he did not envy

these successful ones who had stepped into public favor, and if they had done so honestly it gave him pleasure to do them honor. When Theodore Roosevelt, as President of the New York Police Board, had made his excellent showing, Nast called one morning to congratulate him on his work. Mr. Roosevelt smiled and in his impulsive manner said:

" Well, Nast, I ought to make a good official. I learned my politics of your cartoons."

Naturally this tribute was acknowledged with a sketch, and Mr. Roosevelt expressed a further appreciation in his reply.

Nothing could give me more pleasure than your gift. The mere fact that your name is signed to it gives it such value that I shall have it framed and kept in a prominent place for my children to see. I thank you from my heart.
Faithfully yours,
Theodore Roosevelt.

In another letter Mr. Roosevelt said:

I have always felt that in the fight for civic honesty you played as great a part as any soldier could possibly play in the fight for the Union.

As years went by there grew up an impression in the public mind that Thomas Nast—the original Nast who had destroyed Tweed—was dead. The occasional pictures which appeared signed by that name were usually attributed to his son, Thomas, Jr., who had inherited a measure of his father's skill. The reports that he was dead hurt him deeply,

WHEN REFERRED TO AS " THE LATE THOMAS NAST"

ACKNOWLEDGMENT, CAPT. JOSHUA SLOCUM'S "SAILING ALONE AROUND THE WORLD"

ACKNOWLEDGMENT OF A NAVAL HAT SENT HIM BY "TOM" HALLOWELL

but he seldom let the wound appear. He merely laughed and caricatured himself as being fierce over the matter, or as a lively corpse.

"What is the use to cry about it," he said. "The paper is right—I'm dead enough to the public."

He was reminded of his great achievements—all the cartoon properties he had created, still in daily use—his victories over wrong, the things which men would not forget. He nodded with a sort of grave satisfaction.

"Yes," he said, "I was alive enough once—and I really did those things. They can't rub that out."

And the fire in him did not die, and the old keen insight remained undimmed. Often after reading the papers, he would rush out to her who had been his helpmeet through all the years, to describe some picture which he wished to make. He would

talk with all the old enthusiasm—one could see how apt was the idea. Then suddenly he would remember—his face would fall— he would add, " and nobody will publish it."

Sometimes he said: " Well, I suppose I shall go on like this till I am eighty. Who will care? Tommy Nast, you're dead! " Again he would say: " I feel like a caged animal—so helpless."

When a chance to get something published did appear, his need was so great, he was so anxious to please, he became timid. Oh, it was hard—the blight of poverty to a spirit like his.

And curiously enough he was to appear once more in the periodical where forty-five years before he had made his beginning. There had been some managerial change in the conduct of Frank Leslie's Weekly, and someone there remembered and still had faith in Nast. He was engaged to do the Christmas picture for 1901, and in the holiday edition of that year he made his last appearance, where he had made his first, in any literary journal. The orbit of his labors was complete.

AN APPLICATION FOR ADOPTION BY WALTER OTTELL, STEWARD OF THE PLAYERS

ACKNOWLEDGMENT ON RECEIPT OF " THE BREAD LINE," FROM THE AUTHOR

ON RECEIPT OF AN IMPORTANT CLIPPING
FROM F. P. POWERS

ON RECEIPT OF A VERY LARGE PICTURE FROM
OLIVER HERFORD

CHAPTER LXIV

THE CONSUL

It was one evening in March, 1902—after Theodore Roosevelt had become President of the United States—that Nast received a letter from his old friend, John Hay, Secretary of State, offering him a consular post. Nast had asked for nothing, for he realized that there was no strict political reason why he should receive anything at the hands of the Administration. But the impulses of Theodore Roosevelt have not always been repressed, even when not politically justified. He recalled those cartoons which had been his political text-books, and it is likely that he had learned the needs of their author. The letter ran:

Department of State,
Washington, March 10, 1902.

My Dear Nast:
The President for some months has been anxious to offer

you some place in the consular service, but no vacancy has turned up exactly filling the requirements. There is to be a vacancy in Guayaquil on the Pacific coast, Ecuador. It is worth, I believe, some four thousand dollars. The President would like to put it at your disposition, but if you think it too far away and too little amusing to a man with the soul of an artist, please say so frankly, and he will keep you in mind if anything better should turn up: but it is heartbreaking business waiting for vacancies. Our service is so edifying and preservative that few die and nobody resigns.

Please let me know what you think about Guayaquil, and believe me always, Sincerely yours,

John Hay.

Nast was in a quandary. He needed the position badly, but it was far away, among a people whose language and customs he did not know, and in a dangerous climate, especially as he was no longer young. Yet he could not afford to decline and wait for a more congenial post. Neither had he ever refused any service, at whatever cost or risk, wherein he believed he might be of value to the nation. His understanding of international problems remained undimmed. If he could no longer serve in his old way, perhaps this was an opportunity to prove his usefulness as a diplomat.

A letter was written, thanking the powers at Washington for their kind remembrance, asking only a little delay to complete the biographical notes then in preparation. Meantime, if a more congenial post offered he would

HIS NOTICE TO SECRETARY HAY THAT HE WAS READY TO START FOR HIS POST

be glad. In April he replied to a second letter from Colonel Hay:

My Dear Colonel Hay:

I thank you for your kind favor of the 5th. I hope to visit Washington soon, and will then consult with you in the Guayaquil matter. My desire is only to serve the administration in the manner best suited to my capabilities, and at such times and seasons as may fall within the requirements of such service. Believe me,

As ever,

Th: Nast.

He made the trip to Washington, still in the hope that a post less unsuited might be found for him—something in England, perhaps, or his native Germany, where the language and climate and the people were familiar. He was already far from well, and the humid atmosphere of an equatorial port was not likely to improve his condition.

But vacancies were few and the Guayaquil post alone remained. So, sadly enough, it happened that his old friend, Hay, and the President who had learned politics from his cartoons, were the ones at last to send him away, to die on a far and fever-smitten coast.

His appointment was heralded far and wide. Those who had believed him dead bestirred themselves to congratulations and to a recalling of his past. For a brief moment Tommy Nast was again in the public eye.

In the weeks remaining before his departure, he was hurried and worried with preparation and his health did not improve.

" All that I have put off for years comes on me now," he said, as he stood amidst a medley of unassorted correspondence and business papers. Ill and half distraught, he was less like the old Nast during those final weeks than at any other period of his life. A photograph, taken just before he sailed, shows him worn, old and sad. Beside him is an unfinished painting

THE HOUR OF SURRENDER

of Lee, showing the hero of the Confederacy at Appomattox, awaiting the arrival of Grant. It is a pathetic picture, for with Nast, as with Lee, it represents the end of a long struggle—the surrender.

The thought of leaving the old home grieved him sadly. Sometimes he lingered about the grounds regarding the different objects and recalling many memories. Everything was growing old. The house was in need of paint—the drive-gate was rusty on its hinges.

" It looks as if it hadn't been opened in years," remarked a visitor.

" It hasn't," said Nast. " General Grant drove out in eighty-three. It has never been opened since."

Yet for the most part he strove to keep up good cheer. He gave his friends pleasant souvenirs and spoke gaily of his new career. He found amusement in the various pronunciations of the name of his new post.

" What are you going to that God-forsaken place for? " one of his friends asked.

" I'll tell you," laughed Nast. " I am going there to find out how to pronounce the name of it."

Sometimes he spoke of what he would do on his return. Perhaps he would again visit the mines, which he still owned.

"It can't be that everything I ever bought was bad," he said quaintly. "Something must turn out well. Maybe it will be the mines."

Perhaps he was joking. Perhaps he had never really lost faith.

But somewhere within him lay the knowledge that he would not return. For among the hasty sketches given to reporters just before his departure there was one crude drawing of himself confronting the dangers of the equator, and yellow-jack in the foreground is the death's head which awaits him. It was the old touch of unconscious prophecy we have so often noted in his work. It seems fitting that it should at last have foretold the end.

THE FINAL PROPHETIC GOOD-BYE

He sailed on the first day of July. Friends accompanied him to the dock and cheered him as he leaned over the rail of the steamer Orizaba waving a little American flag handkerchief.

"The United States loves peace," he called to them, "so do I. I would not be much surprised if we had plenty of peace after my arrival in Guayaquil."

So he sailed out of the harbor which he had first entered as a little boy of six, just fifty-five years before. The shores then had seemed beautiful to him. Perhaps they seemed even more beautiful now that he was leaving them behind. Then he had been the little lad of Landau, entering the world which he was to conquer in his own good time and way. Now the victories and the defeats were over. The fanfare of conquest and the heart-break of surrender—he was sailing away from it all. With Cassius he could say:

" And where I did begin, there do I end: my life is run his compass."

Did he recall his first sight of America's beautiful shores? Did he review the years of labor that had gone between? Did it occur to him that as once he had welcomed these green slopes so now he might be gazing for the last time on the land of his adoption? We cannot know what were his thoughts as he sailed away, but it is likely that all of this entered into them, and much more.

Benefited by his sea voyage, he arrived at Guayaquil in a cheerful frame of mind. A disastrous fire had just occurred, destroying a considerable portion of the city, and fearing the newspaper reports might alarm those at home he cabled July 18, " Safe and well."

And now almost for the first time since his youth he became a writer of letters. Once before—during the brief visit to Washington in 1872—he had put by the pencil for the pen. Now, as then, he found relief in correspondence, though how widely different his reported round of events. In his isolation, his comfort was in setting down from day to day his impressions of the place, the scope of his duties, his battle with the hard conditions of the tropic port. The scourge had been ominously augmented by the demoralization following the fire, and mails were irregular. Written as occasion permitted and mailed as opportunity offered, in these letters home he has told us the final chapter in his own way and words better than it could be done by any other pen whatever. Beginning, he wrote:

July 24.*—I don't know what I am about, really. The fire, the yellow fever and the dirt do not help to clear one's mind. . . . I am having the carpenter make some alterations, to get more light, so one can see the dirt and try to get rid of

* The dates given are those at the head of each letter. A single letter sometimes covered a period of days.

36

it. I am very much tired out, but think I will get along really better than I thought. My appetite is so good.

I send the newspaper. It had a very rough article in it about me before I came—said the people ought to rise against such Americans as the U. S. sends, and put them out.

Mr. Jones (his vice-consul) is very kind, wants to please. I think they would care for me if I am ill.

August 3.—Things are working very slowly. I have a bath but no water as yet. The cry is, " to-morrow, to-morrow," and their to-morrow is longer coming than it is in the States. I am still well, but the people say here I shall be laid up with a chill. I am not afraid. . . . I must get a bed. Mr. Jones says the hammock will not do (when I get sick). I have engaged a secretary, he has been in the British service. His name is Morales, polite, lame and has a cough. When he is late, the cough is worse.

They told me to be careful of the night air. Can't see how it can be kept out. There is not a pane of glass in the whole city—open day and night. There are shades, we can shut them, but the air goes through them. The river is so close—the tides are very strong, out and in. When the tide is out the smell is in; when it comes back again, it washes the smell away.

The picture of you and the grandchildren is up. As I look at it and see all laughing, I laugh too. It does seem funny that I am here, but my greatest happiness is that you are not here.

August 4.—The nights are cool. One must be careful about catching cold. . . . Last night the bands played in the square for the first time since the fire. One very good, the other rather loud and brassy.

Oh, what a place this is for gossip; it runs wild, like the rats.

Do you remember saying, " You will get good coffee, anyway? " The coffee is vile. The nearer one gets to the place it grows the worse it is made. . . . Send the semi-weekly Evening Post. Send it to " our home " first. When you are through with it, send it to me. It does not matter how late.

The papers here make the most of the yellow fever cases. I am afraid we won't have any mail. I commence the morning with an orange or a melon—even the melons agree with me.

Limes are good with water. Bananas very fine—pineapples just great and pretty cheap. Then there is a fruit called the " puppie " *—like a melon, but more like the best pumpkin pie ever invented. The fruit scare is a humbug, it doesn't hurt me.

August 12.—Am well, that's all. No knowing when this will reach you. About four dead as near as I can make out, but the doctors say it was the genuine yellow fever. One cannot get anything—delay from day to day, nothing finished. My place still in chaos. Am waiting for the carpenter this very minute.

Mice, rats, bats, mosquitoes, fleas, spiders and dirt all thrive. Water scarce. I haven't had a real bath yet. There is not enough to fill the tub. Hot water is unknown here, except in coffee, and that is nearly all water.

Have to buy bed, mattress, pillows, sheets and so forth, and set up housekeeping myself. I don't think I can stand boarding.

Oh, the people are very poor. Times are hard—no work, nothing doing. I am so glad no one else came.

My messenger is a colored boy. I astonish him every few minutes; when I want anything his expression is sad to look at. When I say: " John, I want you to do something," his face falls, he looks as if he would cry. But when he wants anything—to go early—to call on a sick friend—any old excuse—his face beams. Forgetfulness is his chief virtue.

The captain of a sailing ship with lumber from Oregon wants one of the sailors arrested. He told me that the man was coming to see me. The sailor came. He looked like a sober, straight kind of a man, which is more than I can say of the captain. The sailor wants to be relieved, paid up, and to go home. The captain wants him put in jail while he is in port, or with my permission put in irons on board, and then when the vessel sails to take him off with him. The captain is a very strong ass and says he wants him so he can give him just one blow. That one would finish him, I think. So you see the kind of troubles a Consul-General has.

August 15.—Fête day for some saint—what saint don't know. The streets are quiet—a great relief from the dreadful noise that

* Probably the *papaya,* or South American papaw.

women and animals can make. The nights are not still even. The police whistle all night long. Firemen have a special turn-out to find a fire, now that a third of the town has been destroyed.

The army have their drums and bugles every morning at half-past four. The church bells begin before that. Then there is a toy railroad that the Custom House runs, which begins at half-past six. The people are up early—they can't help it. They are a sickly set, poor things! . . . The yellow fever is not so bad as they make out, but it will do.

Yesterday, to-day, and to-morrow, feast days for " St. Jacinto," who cures all diseases. We will not have any mail from the United States as quarantine is outside the harbor. Ships do not stop but go south with the mail on board, and we may get the letters in a month when the ship returns. The mail goes out to the north. You may get letters from me, but there will be none from you for your poor, homesick old man.

August 19.—Well, had to get a coffee-pot; coffee worse and worse. Could not stand it any longer. Alcohol lamp does the

"Bunts"

boiling. Washing up is hard. No hot water. They don't use hot water here. They are in it all the time and need no other. . . . I have bread, fruit, coffee, milk for my breakfast. At last I am filled up. I need not eat so much any more. At first I could not get enough I was so hungry. Washing is not so dear—nor so clean either, but it will have to do, like everything else. My bed is ready, but I have no sheets yet, so I sleep in a room with my landlord. He is really very kind. There always seems to be somebody to help make life so one can stand it and keep up hope.

August 21.—The coffee-pot works well—so do I—nothing new—dirt, dust and what follows. . . . A steamer is outside, but as it comes from Panama is not allowed to land. Oh, I want my mail. It is astonishing there is not more sickness. If it were not for the tides, there would be a plague. They change everything and make it clean again. Another man gave in to Yellow Jack yesterday at noon. No new cases, but the steamer wouldn't wait any longer—went south—mail on board.

A month ago I took charge of this office—only a month—

heavens! How long it seems! Well, I must make the best of it. I hate the place, but don't say anything about that!

August 24.—I put up a line—a rope—to keep my bread and fruit from the rats, but behold, they got it; they thought it was a mistake of mine. I see C—— is going to outdo M—— in the trusts. The trusts are going to make a panic, some day. Tell Cyril to make a trust of good boys and see how many will come into it.

August 27.—Just came from mid-day dinner. They call it breakfast. It is from half-past eleven till one, but people like myself that get coffee at half-past six A.M. are pretty hungry about noon. Tea-supper is about seven P.M.

It would go hard indeed with me if it were not for the Ashtons, because one needs somebody—in case—well—trouble of any kind. But I must not give in. If sticking will do it, stick I will. It does bring more money than I can make at home, and time may do something, too.

The time in the dark is long between six and eight. About eight is my bed-time, sometimes even before. I am always glad to get into my little bed. I sleep now through all the noise, which is nearly all night, and when there is no noise it wakes me up to hear what is the matter.

August 28.—In the last four days, between the rats and the captain, my time has been much taken up. The rats come from next door through the open window. They did not go for my bread last night. I found it in good order to-day. The tin is slippery.

The paper has put in my portrait and an article that made a good impression. I think it will help.

August 29.—The captain came before seven this morning and was sober—gave me a letter in which he stated that the seaman went ashore without leave, so he has real trouble. He said the sailor had been put in jail by the captain of the port. Now we have straight sailing. I told him he had taken the case off my hands. After, he rushed in again, said the man refused to work because he was sick. I told him he did the right thing by placing the case in the hands of the captain of the port, and now to do a better one, get a doctor and see if the man is sick or not. He said that would cost money. Then he wanted to know if he would have to pay the board of the man in jail. I told him yes. After paying a few bills he will come to his senses.

" La Nacion " published a sketch I gave them, but put in extra lines for reasons of its own. The understanding was not

to say who did it, and they kept their word. They thought it rather strong, and had to explain it in type. Will give them another one in a few days about the steamboat whistles, if they are not afraid.

The rats got the best of me again—cut the string and got the bread. I will try again to-night.

August 30.—Captain called again. More trouble. Doctor says hard to say whether the man is sick or not. Captain says mate saw him dancing. Am afraid he did disobey orders by leaving the ship.

Had to study up on " Seamen and Masters," but couldn't find anything where the captain " didn't care about having a man that was not a sailor and made a great disturbance, yet at the same time would take him home with him." The poor sailor does not want to go with him if he can get out of it. I cannot discharge him. The law reads " discharge only by mutual consent of master and seaman."

September 5.— . . . It is such a new life. It takes a little time to get into it. . . . Things are settling down though, and I see after a while I shall be able to do a good deal of my own work. The trouble is one does not know when a person will come. These people have so much time on their hands, and when I paint and they do come, it's hard.

September 10.—Am well—working—signing papers—waiting for new rows from sailors or somebody else—ready for anything—but tired of all things—oh, so tired of this! After all it is very funny, often, in a way, when the ball is over, but not while it lasts, and I hope it may not last too long. It hasn't killed me so far. I hope I will live to die in some other place. Things are bad enough without my being buried here.

The seaman that was put in jail by the captain of the port, to-day made his appearance. I told him if he would like to see his captain ashore he could find him around the corner in a drinking place, as he spent the whole day there. So I sent John with him. He saw him—John saw enough to get out before the end of the conversation. The seaman left the captain. John tells me that he crossed the river on the ferry and is safe till the ship leaves. I am very glad of it.

September 15.—The best thing is, I keep so well. I think I am too old to catch the fever. I have a little hope left yet. Let's

stick on for another year, anyway. You say the summer is damp
—that is the trouble here, too. No thunder storms, just cloudy.
People call it " fever weather."

September 16.—The trouble is, when a person has the slightest
fever or headache they get so frightened—doctor and patient
make up their minds that it is yellow fever. The last report has
put the poor people in a panic. They are just like children.

September 21.—You say my poor old mocking bird misses me.
I am very sorry. I do miss him, poor fellow, and his mocking
sounds.

September 25.—This change has done me good in spite of
everything. It is true there is a great deal of fever in this place,
but I hope I shall escape it. They look at me and say, " Well, you
have not blue eyes. You are more like a native, and you are too
old to catch it." What a blessing to be old. One is going to the
next world soon, anyway, so one is exempt. For the first time I
feel glad that I am old.

September 29.—Everything very quiet. The so-called " best
people " have made their exits on account of the yellow fever.
The steamers do not stop here. They go on south. That alarms
these people still more. We get the mail from the north, after it
goes south and returns. I believe the next steamer is to stop.
That should have a good effect.

October 13.—The fever seemed better
last week—worse this. It seems to take
the light-eyed, the light-haired people. I
do keep well in spite of all.

They say every dog has its day. They
have their nights, too. They bark all
night. They fight on feast nights. It is
simply unendurable. They have no own-
ers, but run wild. The people say they eat
the refuse that is thrown in the street and
they are glad to have them. Coming home
after the band plays, I see piles of refuse,
and dogs eating it and fighting over it.
The last week has been dog-nights. I do
long to have a stillness such as we have in
Morristown. I long to " hear no sound." But I'll get used to
it. I *am* getting used to it. Nothing like getting used to every-
thing . . . I am not reconciled, but hate to give in and still
think I will get a better place. I will make a good record.

People are hard up here for reading matter. Look over our
books and send a box of twelve volumes. I think the despatch

agent will send them on. The Union Club wants books very much indeed, poor things! and we can spare them. Send by the Government. It will be cheaper. Cheapness is what I have to study now, day and night. I have time to think it out. . . .

The 9th of October is the 4th of July in this warm country. At the Union Club they had a fine ball, not exactly the 400, but they made a very good show. I was invited and went over for about an hour. They did all they could for me, but I did not want to tax the young people, so I left early.

The ball broke up about half-past six in the morning. The ladies got into carriages, the gentlemen went back and danced as only men can dance, but think of it, all sober! They greeted me most cordially, and I afterwards found out I was the only foreigner asked. They keep up the celebration for days—don't know when to stop—all well-behaved and good-humored. They are just like children. . . . Well, I am scratching for a living, and working to keep out of the hands of the fever devil.

The other night it was so quiet I woke up and could not get to sleep again. No noise of any kind. I thought something was going to happen, but it did not. It reminded me of being on board a sleeper, stopping at a station. There was nothing in the room, but some fruit in the air, protected with thick tin, so the rats cannot get into it. Their usual ball takes place, though. Every little while I clap my hands and they get. They seem to like the place. I am growing to think better of rats. Even they like a clean place to dance in.

Every day from two to four cases of yellow fever. Nearly all fatal. The Germans have the hardest time. It stays cool. The weather is cloudy, and when the sun does get through the clouds about noon, it is warm. , People say it's cooler than usual. If the fever continues while it is like this, I am afraid it will go hard with us all. One must hope for the best. There is no help for it.

At Quito it was reported that Nast already had the fever and inquiry came from the American Minister there. Nast refers to this and adds:

Sampson made quite a commotion with his telegram. Many people thought the report true. . . .

I can save more money now as I don't have dinner at night any more. At first I had to, I was so hungry. I could hardly get

filled up. I take rolls and butter—they call it butter. When I leave this country I can sell my bed and all. Your plans about rats are good, if you were only here to carry them out, but thank God you're not!

A steamer came in the night. Delayed outside on account of yellow fever on board from Panama. I am anxious to see if we get the mail.

The steamer gone. We got no mail. Before the doctors got on board a sick man died. The steamer was ordered to go on. What will happen? Where will they be allowed to go? When will we get the mail? Questions I am afraid will not be answered soon. I am just thinking how horrible to be on board. Think of the well people there.

My secretary keeps about the same—slow—lame — romantic—honest—. He has just come hobbling along, was a little late, and when late he has that cough. It does make me smile when I hear that cough. . . . One great thing about my rooms is, they are very airy now. I manage to keep things pretty clean, but it is hard work to do it. People notice, when they call, what a nice air I have here.

October 17.—It's too bad to see a steamer on the stream, my letters on board, on account of a row between the Board of Health and the British Steamship Company. Everything at a standstill over a childish quarrel. It makes talk at the café where they get drunk over it. I keep out of it. From the first I saw it would not do for this old man.

October 20.—Well—well—what with painting when I am able to do it (it dries so very slowly), and what with the Encyclopædia Britannica I manage to kill time. I have been reading it steadily and enjoy it very much. Knowledge is a great thing, but what a nuisance to find out how little we know, no matter how long we live and how much we study.

October 21.—Your letter just came. You say you have nothing to write, but write anything, even about the October days, the turning of the leaves. It makes me homesick, but I'd rather be homesick than have any other kind of sickness. Most of the people here look as if they were already dead.

A German at the Union Club with his secretary didn't turn up for two or three days; yellow fever. His secretary then didn't turn up; yellow fever. So no one can tell.

The priests are taking hold of the yellow fever now. Yesterday afternoon they had a pious procession, monks, images, etc., men, women and children with prayer books and candles, ending up with a regimental brass band. They will talk it over in their energetic way, and that will be about all they will do.

Well, things are coming nearer—nearer. During my midday meal, Wheeler, an Englishman, said to me, "Do you remember that Englishman by the name of D—— that was with me so much? Well, he went up to Quito with Jones, got as far as Alasan, took sick and died. I got the news this morning."

Now that young man was as hearty a boy as you would wish to see. He was clean and knew how to live in a decent way, but he was blonde, blue eyes, fever took him. This kind of news is not encouraging. It gives one the blues.

October 30.—For the last week things have looked pretty bad. The German that dined at the club died. His secretary, who disappeared, wanted to go home on the last steamer, but the doctor on board would not take him. I am afraid he will follow his master. All of a sudden one of our "floorers"—(that is what John calls the Germans that live on our floor) kept his door closed. Doctor and nurse came and went. They denied that anything was wrong, but I knew better, so we kept our door closed and I put carbolic acid about the hall, also chloride of lime. That makes the place smell like a hospital. Mr. Miller, my landlord, sniffed it out. I said nothing. He went in the room, saw that one was sick in bed, and for the sake of the other "floorers" had him removed. It was a relief. He is better so far, but I must say it is uncomfortable.

First club, then on our floor. It is coming very near. The German Consul's son died of it this week. But with all these scares I am still well. I do not brag, only for the day that I am; nothing more, nothing less. That's a good idea to make Roosevelt a British Colonel.

November 21.—You say the money arrived safely and it is in the bank. Just think of it! bills paid, and money, real money in the bank again. Well, well, I shouldn't have thought such

a thing possible. And so Mr. T—— thinks I should get leave of absence from a place where I am making money? No, I must stick it out, no matter what takes place. I do think I am making an impression, too, on the State Department. They have sent no complaints at all, and they may promote me, at least I hope so—and leave of absence would cost too much. I must stick. Now my job is all right, if we only get a little money ahead. Oh, how I do wish the mail was more regular. I must go to work, Consular work, for your old boy who is making money, money to put in the bank again. . . .

One of the dogs came in the hall to die to-day. John took him out. There was a great howling and snapping. He was pretty far gone and weak, but very snappy. I have not seen a good-looking dog in this town—dirty, starved and wild. They carry infection and spread fever and disease. They fight all night and eat refuse thrown into the street from the houses.

Yellow fever people do not say anything about the " grip " they have here. The doctors say there are a great many cases of it. I myself know five persons that had it and they all thought they had the yellow fever. I find it very crampy, too. My limbs get stiff and crampy. It must be the draughts one gets into after being so hot and moist. I wake in the night with cramps and have such stiffness in shoulders and arms, but I must not forget I am getting old. It is funny, though, no matter what you have, the natives all come to the conclusion that it is the yellow fever.*

November 25.—Mails as usual went south. Expect them to return by 26th or 27th.

November 27.—No steamer yet from the south, to bring the news from the north. Oh, these English steamers. I should think something would have to be done soon. The Government and the merchants can't stand it much longer. Steamer arrived but no mail from the south, so I have nothing to answer. I am anxious to hear from you—something to be thankful for on Thanksgiving Day.

There was but one letter after this—a brief note written on the back of a circular announcing a Colombian peace ceremonial which he attended. He tells of it, and adds:

What a lot of tomfoolery there is still in this world all about nothing. Now, if the Colombians would only strike a bargain

* It is possible that in this paragraph he gives us the earliest symptoms of his own illness.

with Uncle Sam, let us go to work and stop fooling, all would be right. If not, I hope Uncle Sam will take the Nicaragua route.

Enclose me a list of the different colleges. A lawyer here wants the terms to send his delicate son. If you send them it will save him postage. He looks up law information for me and has been very kind to your old man.

The date of this letter was " Sunday, Nov. 30." The next day —humid and sultry as so many days are there—he complained a little of nausea and lay all day in the hammock. His secretary, F. Morales, to whom he had referred in his letters, was attentive to his wants. Tuesday Mrs. Morales called, and later sent some tea, which the Consul could not swallow. On Thanksgiving evening he had dined with the Ashtons, presenting them with the traditional American Turkey. He had seemed in his usual good spirits, indeed quite merry. He declared now that he was only a little bilious from high living and would be better presently. During the day he got up and attended to his duties of despatching a steamer which had dared the dangers of the pest. Vice-Consul Jones, who had been out of the city, returned on Wednesday and found him still lying in the hammock, but very cheerful and fully dressed. Yet the vice-consul called a physician, who diagnosed the case as liver trouble.

The Consul did not improve, and on Friday took to his bed. On that day he sent his private keys to the English vice-consul, Mr. Ashton. This seemed strange, though Nast still protested that he was not seriously ill. Even on Saturday, when a second and a third physician were called and pronounced his case the fever in its worst form, he smiled and said cheerfully that he had been ill with such fever many times before. His secretary in a letter tells the final scene.

" At eleven o'clock (Saturday night) he spoke to me and to Mr. Ashton and said that he felt much better. After this he became unconscious and he did not speak any more. On Sunday,

at 11.35 A.M. he died, notwithstanding the personal care and attention of Mr. Jones, Mr. Ashton and myself.''

And so at last it was all over. The little lad who had played in the meadows back of Landau, the youth who had so gaily marched with Garibaldi, the man who helped to preserve a nation and to rid a city of dishonor—who in his old age had found only poverty and defeat and surrender—lay dead at last in the service of his adopted land.

Then all of those to whom he had endeared himself during the few months of his dwelling among them—all the consular corps —the Governor and the local authorities—the staff of the paper which had once condemned him unseen, but which now spread flowers upon his bier—the members of his club— the citizens of his own land, and a vast concourse of natives who, because he had been kind to them, had learned to love the '' little American,'' turned out to do him final honor, and at five o'clock on the day of his death bore him to his last resting place, wrapped in the flag he had loved and defended so long.

THE VACANT DESK AT MORRISTOWN

The news came to his home—to the big quiet house which through all the years he had never let go—to the wife who had made his life her life, his battle her battle, who could not now follow the path he had taken or know the comfort of being near his grave. First there came the official cable, brief, bald and hopeless. '' Nast died to-day, yellow fever ''—the story told in five words. Then followed the formal letter from the Department at Washington, and by and by came letters from those who had been near him at the end. Each told the story of his last hours, with words of comfort; each referred to his efficient service and how he had won his way to the hearts of the people.

In his official letter to the Department at Washington, Vice-Consul General Jones closed by saying:

'' His death was very generally regretted, as during his short term of office he had made many friends.''

Mrs. Sampson, wife of the American Minister at Quito, wrote:

'' He seemed to have a gift in dealing with these most peculiar people.''

British Vice-Consul Ashton, in a letter to Cyril Nast, said:

'' Your father was very popular and considered the best Consul ever sent to Guayaquil,'' while Mrs. Ashton, in a letter to Mrs. Nast, added:

'' During his short residence here Mr. Nast became a great favorite. He was always so genial, and the natives had a great admiration and respect for him. I have heard many comment on the able way he filled a very difficult position and entirely succeeded in diverting the strong focus of attention from the American colony. We, personally, have lost an honored and dear friend, whom we miss and deplore daily.''

But perhaps the little secretary, he of the limp and the cough, brings us a shade nearer to the Nast we knew best, when, in closing his letter, he says:

'' I do not write more, as I am deeply affected by this sad

affair. During the four and a half months that I have served under your kind father I had learned to esteem him dearly, and he had shown me great kindness and also friendship to my family and self.''

Here is suggested the personal Nast we know—the man who on a train would take a sick baby to relieve its jaded mother, who was always ready to hold out a helping hand, to make easier a toilsome way.

And now once more the press throughout the land echoed the name and deeds of the '' Father of the American Cartoon.'' Old enmities were put aside and old injuries forgotten. North and South he was honored and his name linked with the nation's heroes. Once more he held his old place in the '' Journal of Civilization ''—his portrait on the front page, with reproductions of his famous cartoons within. Colonel Watterson, his ancient antagonist and friend, paid him a noble editorial tribute. He spoke of him as a man of '' surpassing genius and private worth,'' and added:

'' He was a sturdy, undoubting positivist, was Thomas Nast. To him a spade was a spade and he never hesitated to call it so. He had the simple, childlike faith of the artist, crossed upon the full-confident spirit of the self-made man. To the younger generations the name of Thomas Nast is but a shade. Yet a century hence his work will be sought as an essential sidelight upon the public life in the United States during the two decades succeeding the great sectional war. His satire flashed upon a rogue and discovered a rascal like a policeman's lantern. Always unsparing and direct, sometimes cruel, he was the old Saxon warrior over again. Yet to those who knew him with his armor off and his battle axe hung upon the wall, one of the heartiest and healthiest of men; quick to requite the proven wrong; ready to give and take, to live and let live, an ideal comrade and a model of the domestic virtues.''

CHAPTER LXV

In the making of this book, the writer has not attempted to prepare a minute personal biography, or essayed to compile a complete catalogue of events. In the main, the effort has been to tell the story of a series of pictures which became an important part in this nation's history. Also to present such episodes and conditions as would make clear their meaning to a younger generation, with the moral reason of existence which lies behind them all.

For primarily, and before all, Thomas Nast was a moralist. One may be a warrior and a patriot, a statesman, even an agitator of reform, without being wholly free of self-interest— ready to lay down life and fortune for a principle, asking for no return beyond the earning of his hands. The life of Thomas Nast was lived throughout with an unselfishness of purpose and a moral purity seldom equalled. He was in the fullest sense the arch enemy of evil in every form, never letting pass an opportunity to strike it down. He saw in a straight line and aimed accordingly. He never lost sight of the end in view, and it was to his great singleness of purpose and the increasing fierceness of blow after blow landed on the same spot that his startling achievements were due.

It was natural that such a man should make enemies as well

as friends. Men concerned in political intrigue and the practices of corruption, men seeking to ride down and disregard the rights of their fellow men, those who would cloak ill-doing with a mantle of righteousness—in a word, every intruder upon human privilege and the pursuit of happiness—these were his enemies.

His friends were among the heroes and the benefactors of mankind. Lincoln, Grant, Booth, Whitman, Bergh, Henry Irving, George W. Childs—such as these honored his genius and his integrity and were accounted among his friends. But there was a host of others—scores of lesser note, and all the vast multitude of burden bearers who recognized in him a champion that never failed to strike for humanity and the cause of right. Preëminently Thomas Nast was a man to be honored for the friends and loved for the enemies he had made.

His purely political opponents seldom cherished more than a brief bitterness. It was the moral offender who had been brought within range of his searchlight who never forgave him or missed the opportunity of crying down his capabilities and his deeds. Sadly enough they were upheld by a small but venomous coterie of his fellow craftsmen, who, with more of academic knowledge in the matter of mere technique, comprehended neither his genius nor his success, and hated him according to their lights. It was these who gave color and official voice to the oft and loudly repeated declaration that Nast was not an artist, that he had not the least notion of drawing, that his ideas could not be his own but were supplied by George William Curtis or Fletcher Harper. It seems hardly necessary to dwell upon this now. Throughout the pages of this book are many letters which put to ridicule any statement that Nast did not conceive his own ideas—those inventions born of fierce issues and fervent and righteous convictions. What Nast did require was the sympathy and the confidence of those about him.

37

Fletcher Harper understood and gratified this need, and in this peculiar and beautiful sense became his surest inspiration.

As a matter of fact he had ten ideas for every one that he used. Nature never created a more fertile brain, a keener mental vision or a more absolute individuality than were combined in the person of Thomas Nast. In a recent conversation, Mr. J. Henry Harper said to the writer:

" Nast was one of the great statesmen of his time. I have never known a man with a surer political insight. He seemed to see approaching events before most men dreamed of them as possible. His work was entirely his own, and done in his own way. He never could bear interference or even suggestion. Sometimes a good idea came in that we thought he might use, but he never did so. He always had more than enough without it. He was likely to plan a whole campaign of pictures before one was drawn. I never knew him to use an idea that was not his own."

As for Nast's ability to draw, the pictures speak for themselves. If they are not academic, they are at least the powerful embodiment of an idea and purpose—all the more powerful, it may be, for their rugged disregard of rule. It is not always the trained talker, or the fluent penman, or the perfect draughtsman who has the most to say. There is a divine heritage which rises above class-drill and curriculum—a God-given impulse which will seek instinctively and find surely the means to enter and the way to conquer and possess the foreordinated kingdom. Such a genius was that of Thomas Nast. Lacking a perfect mastery of line, he yet possessed a simplicity of treatment, an understanding of black and white color values, with a clearness of vision, a fertility of idea, and above and beyond all a supreme and unwavering purpose which made him a pictorial power such as this generation is not likely to know again. Perhaps all this is not art. Perhaps art may not be admitted without the

grace of careful training—the touch that soothes and fills the critic's eye. But if it be not art, then, at least, it is a genius of no lesser sort. There are men who will tell you that Grant was not a general. There are others who will hold that Nast was not an artist. Yet these two were mighty warriors—each in his own way—and the world will honor their triumphs when the deeds of their critics have vanished from the page of memory, and their bodies have become but nameless dust.

And Nast was something more. He was a thoughtful reader, a careful student of history, a philosopher whose reasonings and deductions were rarely to be gainsaid. Research into the life and manners of the older civilizations—the uncovering of buried cities—the tracing of the way that leads from the mystery of the past to the marvel of the present, always appealed to him, and some of his conclusions were strikingly conceived and aptly phrased. Once commenting on the statement that history repeats itself, he said:

"It does—but not quite. It travels forward like a corkscrew, never returning quite to the same place."

We need not review Nast's achievements here. The support of the Union and of the nation's armies, the triumph over Tweed, the continuous battle for political betterment, these have all been told. He was the first of those who to-day constitute a great and worthy following. In the same spirit that the modern playwright goes back to the well-spring of the drama, so the American cartoonist turns legitimately for inspiration to the pictures of Nast. "Shakespeare has said it all" is our common expression, and it was Bernhard Gillam who declared, "Nast has about done everything." Being first, it was necessary for him to establish fundamentals, to construct the alphabet of an art. The work was not arbitrarily done, nor were the results due to accident. The symbols which to-day confront us on every hand were each the inevitable expression of some

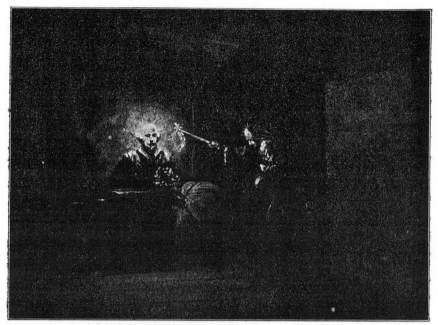

ORIGINAL STUDY FOR "THE IMMORTAL LIGHT OF GENIUS"
(See page 547)

existing condition which by strong, sure mental evolution found
absolute embodiment, and became a pictured fact. We can no
more efface them than we can alter the characters of our spel-
ling book. The Brother Jonathan of England we accepted as
our Uncle Sam,(though Nast dignified the uncouth figure), and
later cartoonists have added to his Emblems. But the old Tiger,
Elephant, Donkey, Rag-baby, and all the others we have noted,
still do daily service, and the pictorial world without them would
be poor indeed.

Yet while the symbols do not die, certain types of Nast are
happily extinct. In the North, the fighting Irish immigrant
with his shillalah; in the South, that benighted relic of the dark
ages, the illiterate slave-driver. They survive now chiefly in
memory, but they existed once in reality, and it was a part of
Nast's mission to aid in their extermination.

Looking through the cartoons of that time and comparing

them with those of to-day we are impressed with something more than the difference in types and treatment.

To-day the merit of our cartoons lies mainly in their technique and the clever statement of an existing condition. They are likely to be the echo of a policy, a reflection of public sentiment or a record of daily events. The cartoons of Thomas Nast were for the most part a manifest, a protest, or a prophecy. They did not follow public events, but preceded them. They did not echo public sentiment, but led it. They did not strive to please the readers, but to convince them. They were not inspired by a mere appreciation of conditions, but by a powerful conviction of right and principle which would not be gainsaid. In the words of Mr. Mitchell,* " men, women, and children—those who read and those who did not "—were stirred by them to the depths of their being. They applauded them or they condemned them, but they never passed them by. C. G. Bush recently said to the writer: " Nast more than any other man demonstrated that a cartoon is not necessarily a humorous caricature, but a powerful weapon of good or evil."

The altered attitude of our pictures of to-day is not due to the individuals but to the conditions. Nast began when the nation was in a flame of conflict. When the fierce heat of the battle had subsided, it left the public in the ebullient formative state where human passions run high and human morals and judgment are disturbed. At such times strong human personalities leap forth to seize the molten elements and shape the fabric of futurity. Such men have little place to-day. The New York Herald not long ago (March 7, 1902) said editorially:

" The press of America merely mirrors public opinion instead of commanding it."

And it is this that the cartoonist of the present must be content to do. He can but mirror the procession of events—not

* See extract quoted fully, page 549.

direct them. Yet should the time return when issues once more are blazing white, when right and wrong press fiercely upon the hearts of men, then from among the craftsmen of to-day there will rise those who shall seize the glowing metal and strike as firmly and with as sure a blow as did Thomas Nast.

For nearly a quarter of a century, through the pages of Harper's Weekly, Nast gave his strength to the American people. He was profoundly moved by every public question, and his emotions found expression in his pictures. Such a man can but awaken a powerful response. He was continually in the public eye. His every utterance was watched and considered, and, as we have seen, there came to him letters of every sort. Many of them reviled him—some were like benedictions. Women, and men also, often wrote, " God bless you! " Others said, " God aid you in your work! "

Often in the hour of his elevation he was charged with arrogance, self-assurance and conceit. Yet these were never his characteristics. It was not self-assurance, but self assuredness; not self-conceit, but self-certainty; not arrogance, but a proud impatience with anything that savored of surrender or compromise.

It is true that he realized his power. To his wife he sometimes said: " I am overwhelmed with responsibility. I must make no mistakes." And when we recall the positive attitudes he assumed on every issue and the number of his pictures, it seems marvellous the few mistakes he made. In the twenty-five years of his chief labor he produced no less than three thousand pictures, and not one of them was ever drawn for evil or against his convictions in a cause.

From such a busy life as his, and from such a mass of material as he left behind, there is but a small part which we may sift out and preserve. The writer has tried to do this without bias and without neglect. Yet now that the work is finished

and the labor lies all behind, he feels that he has been helplessly unequal to the sacred task. For it is the story of a man and a period such as this nation may not know again.

Thomas Nast was a genius of the people and for the people, and his impress shall not perish from the world of art. Yet it may be that the generations of the future will not write him down an artist. Even so, to have been named, by thoughtful and sincere men, with Lincoln and Grant as a benefactor of his people—to have placed a great city and a nation's armies in his eternal debt, and to have died at last in his country's service, may perhaps be counted enough. He was often charged with being a partisan, and this is a title which I think we may accept with honor. I think when the day comes, as it surely will, that men shall raise a tablet to his memory, then reverently we may inscribe upon it—

<div style="text-align:center">

Thomas Nast, Patriot and Moralist,

A Partisan of The Right.

</div>

<div style="text-align:center">

A SKETCH FOUND IN NAST'S DESK AT
MORRISTOWN

</div>

INDEX TO TEXT

(The Index to Illustrations will be found on pages xvii *et seq.*)

I

INDEX TO ILLUSTRATIONS